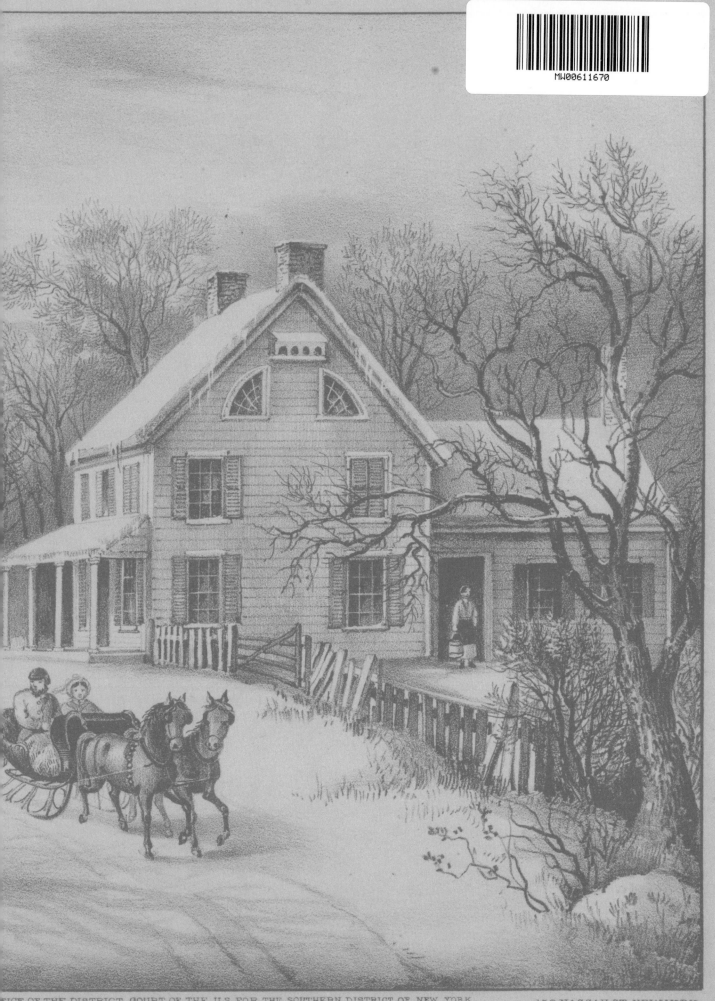

Twas The Night

The Art and History of the Classic Christmas Poem

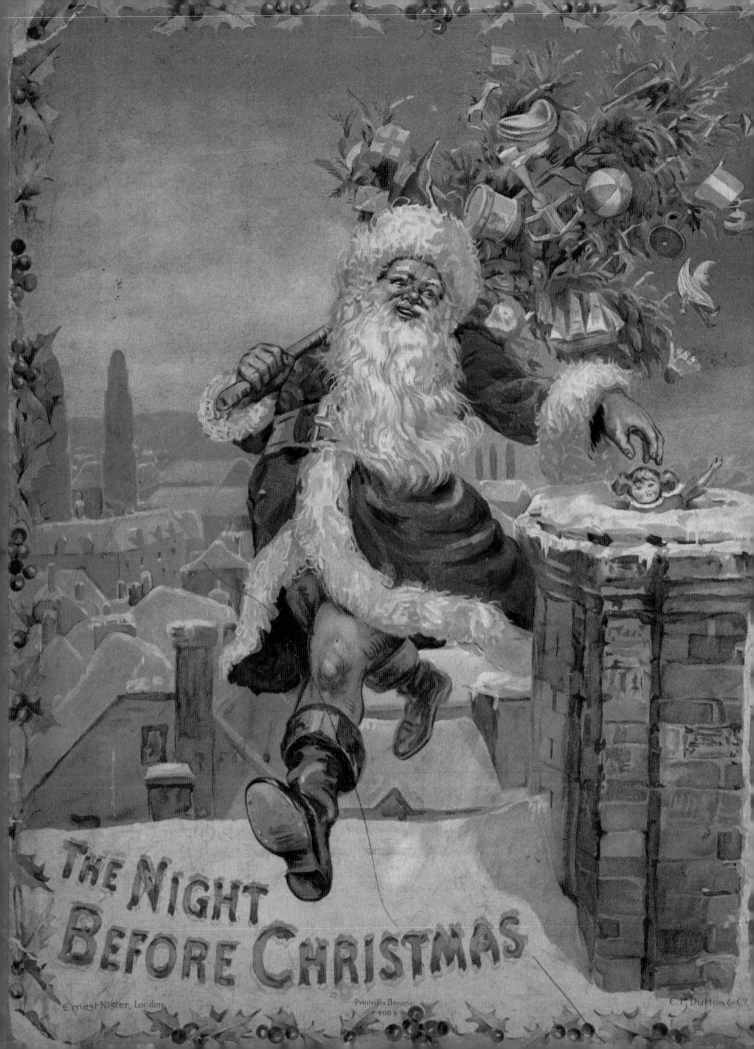

THE NIGHT BEFORE CHRISTMAS

Ernest Nister, London. Printed in Bavaria E. P. Dutton & Co

Twas The Night

The Art and History of the Classic Christmas Poem

Written and compiled by

Pamela McColl

GRAFTON AND SCRATCH PUBLISHERS

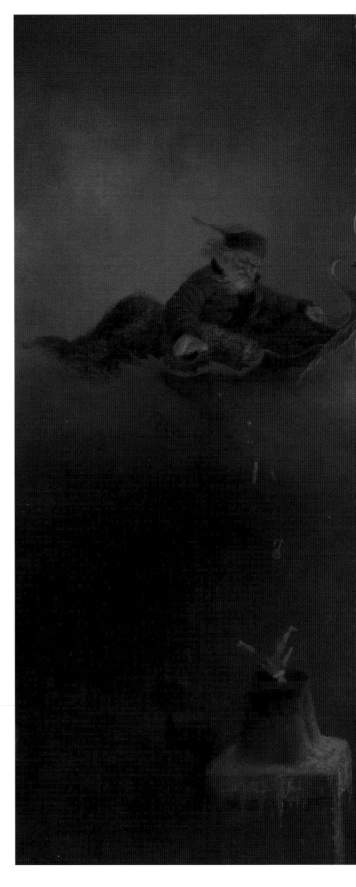

CREDITS:

FRONT COVER: Artist – Helen Chamberlin (American). *The Night Before Christmas*, (M.A. Donohue & Company, Chicago, ca. 1920). Rare Book – *Nancy H. Marshall Collection*, Special Collections Research Centre, William & Mary Libraries.

FRONT FLAP: Artist – unidentified. *A Visit from St Nicholas* by Clement Clarke Moore (L. Prang & Co., Boston, 1864). *L. Prang & Co. and Marian S. Carson Collection*, Library of Congress item 73169323.

ENDPAPERS: Currier & Ives. *American Homestead Winter.*, ca. 1868. (New York: Published by Currier & Ives, 152 Nassau St.) Photograph. https://www.loc.gov/item/90708553/. Library of Congress.

BACK COVER: *A Visit From St. Nicholas* (Christmas card Prang & Company, Boston, ca. 1870). Unidentified illustrator. Rare Book - *Nancy H. Marshall Collection*, Special Collections Research Centre, William & Mary Libraries.

PAGE 2: *The Night Before Christmas*, (Ernest Nister and E.P. Duncan, London and NY, ca. 1900). Unidentified illustrator. Rare Book – *Nancy H. Marshall Collection*, Special Collections Research Centre, William & Mary Libraries.

PAGES 4-5: Artist – William Holbrook Beard (American, 1824-1900). *Santa Claus*, ca. 1862, oil on canvas. Courtesy of the RISD Museum, Providence, RI.

PAGE 6: Artist - Norman Rockwell (American,1894-1978) *Is He Coming?* (*Life Magazine* cover, NY, December 16, 1920).

NOTE: The image for the cover was created by Helen Chamberlin ca. 1920. Very little is known about the life of artist Helen Chamberlin. In 2004, an article about the artist written by Gerry Beegan appeared in the journal *Dot Dot Dot 8*. Beegan had stumbled upon several discarded drawers full of images on a sidewalk in Queens, NY. He ascertained that the image files had belonged to Helen Chamberlin. By reading notes on the documents Beegan discovered that she had been an art student in Chicago during the 1920s and 1930s, that she had exhibited her artwork and illustrated Christmas cards and books. Chamberlin never married. Beegan's intriguing article, along with some of the images, can be accessed at: *Dot Dot Dot 8* by Peter Bilak, Gerry Beegan, *I've Gone Modern* (Google Books).

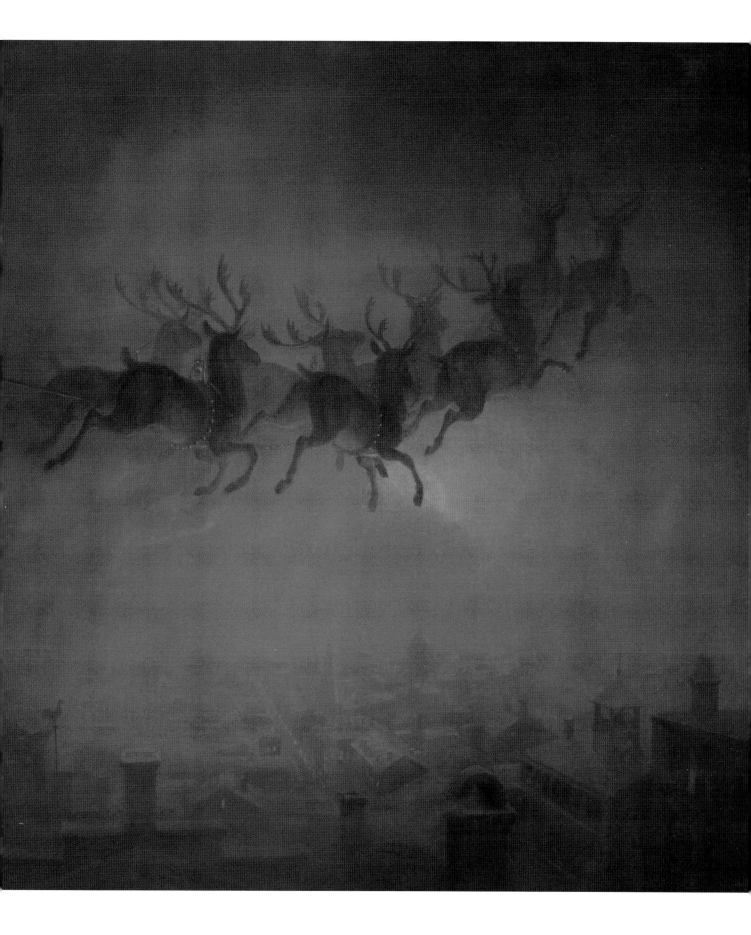

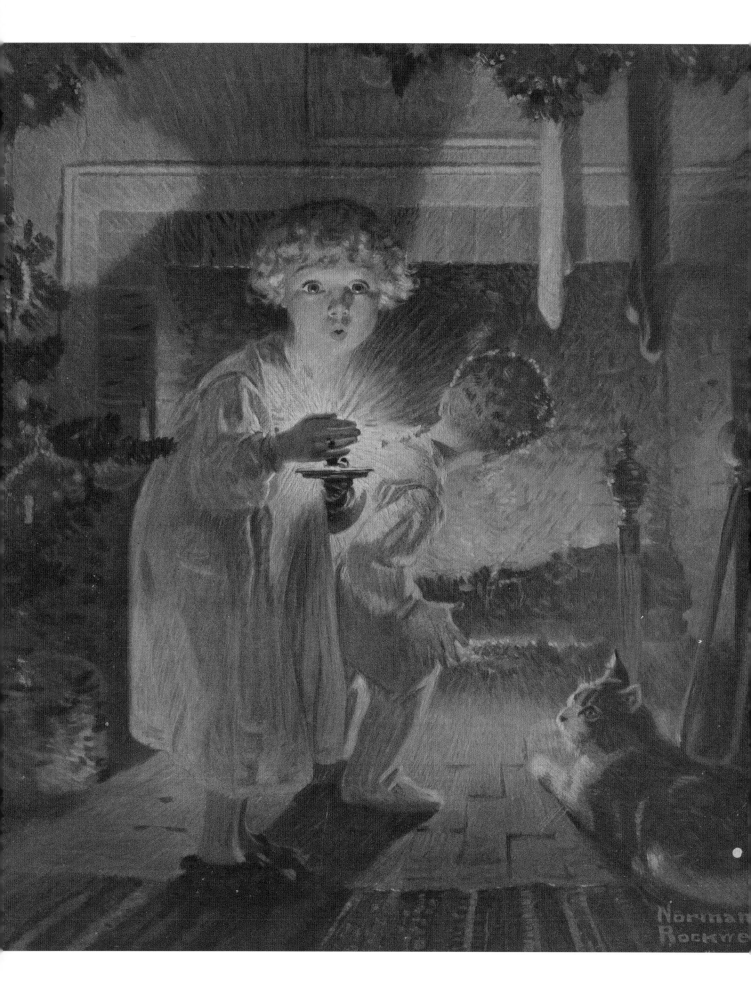

CONTENTS

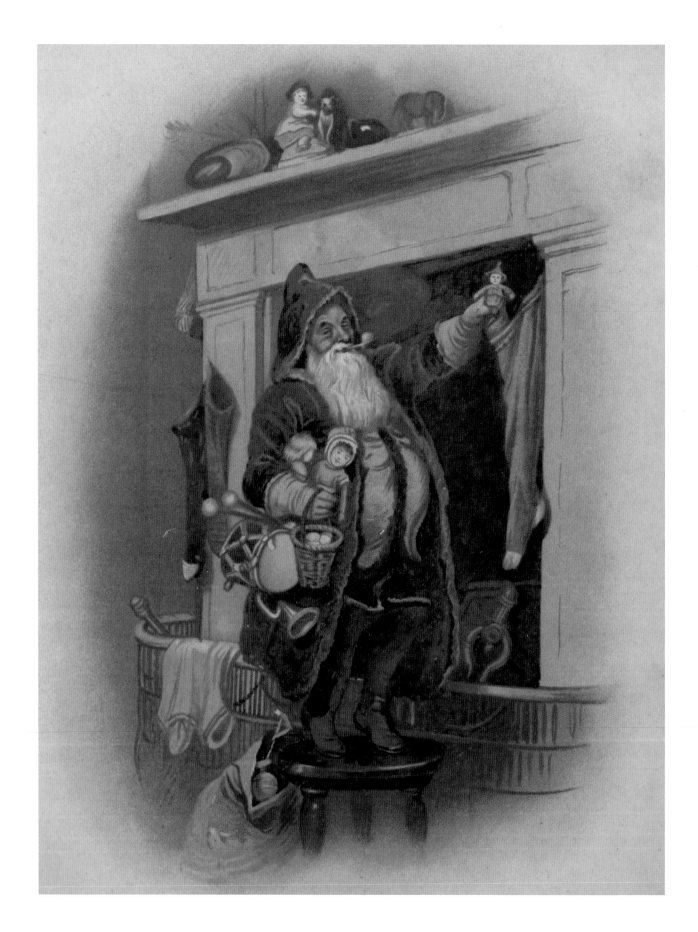

CHAPTER 1

Introducing the Poem

This publication celebrates the classic Christmas poem, *A Visit From St. Nicholas*, also known as *Twas The Night Before Christmas*, as it marks two bicentennial milestones: The recited debut on Christmas Eve 1822 at the home of the Clement Clarke Moore family on the outskirts of Manhattan, NY, and the first printing on December 23, 1823, by the *Troy Sentinel* newspaper of Troy, NY. The poem has been published thousands of times, delighting all with its magical imagery, and spirit of good cheer. The poem herein is referred to as: *Twas The Night* and Clement Clarke Moore with the initials C.C.M.

"*The Visit From St. Nicholas* is a little masterpiece of juvenile poetry. It is one of the best poems for children ever written. It begins and ends with children; everything is designed in miniature. Mamma and Papa are mere spectators. Mamma even disappears altogether after the first mention. But who cares? Papa is only a reporter of sight, not a sharer. Children love motion, and the *Visit* is all about motion. Papa flies to the window. The reindeer fly, too. So do the dry leaves. Santa Claus is all action, though no words. The adjectives all suggest childhood. Snug, rosy, jolly, happy, quick, are all in the child's world. So is the "up" and "down," the "on" and "away," of the reindeer. The tempo is that of the happy child, who must run to express his excitement. It is this breathless quality that gives speed to the rhythm of the anapaestic gallop." HENRY NOBLE MACCRACKEN, *Blithe Dutchess*, 1958.

Within weeks of the Troy publication other papers printed the poem, even though the holiday season had well passed - such was the enthusiasm for the piece. However, not one of the early reprints appeared exactly as it had first been published. Originally published anonymously, editors could tinker with the piece without any restrictions. In a printing of the poem for a holiday broadsheet for the *Troy Sentinel* a total of fifty-five changes were made to the 1823 copy of the poem before it went to press. *The Troy Sentinel* 1830 edition would be the one that C.C.M. would submit, with additional changes, for publication of his collected works of poetry in 1844.

CREDIT: Pages 8-13: Artist: Eliza Fanny Manning (British, 1867-1943). *A Visit from St. Nicholas*, (Hildesheimer & Co., London, UK, ca 1889-90). Rare Book – *Nancy H. Marshall Collection*, Special Collections Research Center, William & Mary Libraries.

NOTE: E.F. Manning also wrote and illustrated dozens of other works including, *The Coming of Father Christmas* (1894). She was professionally known as E.F. Manning.

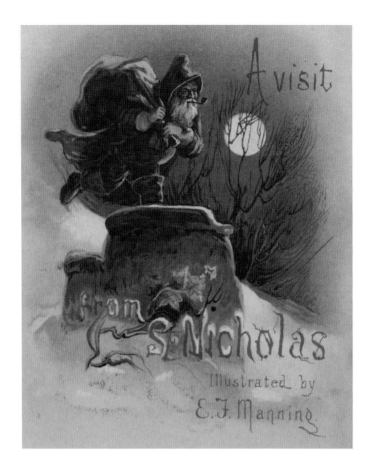

The poem as published in the *Troy Sentinel* - December 23, 1823, p.4; along with a preface written by the paper's editor Orville Holley (American, 1791 – 1861):

"We know not to whom we are indebted for the following description of that unwearied patron of children - that homely, but delightful personification of parental kindness - SANTE CLAUS, his costume and his equipage, as he goes about visiting the firesides of this happy land, laden with Christmas bounties; but from whomsoever it may have come, we give thanks for it. There is, to our apprehension, a spirit of cordial goodness in it, a playfulness of fancy, and a benevolent alacrity to enter into the feelings and promote the simple pleasures of children, which are altogether charming. We hope our little patrons, both lads and lasses, will accept it as proof of our unfeigned good will toward them - as a token of our warmest wish that they may have many a merry Christmas; that they may long retain their beautiful relish for those unbought, homebred joys, which derive their flavor from filial piety and fraternal love, and which they may be assured are the least alloyed that time can furnish them; and that they may never part with that simplicity of character, which is their own fairest ornament, and for the sake of which they have been pronounced, by authority which none can gainsay, the types of such as shall inherit the kingdom of heaven."

For the Sentinel

ACCOUNT OF A VISIT FROM ST. NICHOLAS

'Twas the night before Christmas, when all thro',
the house,
Not a creature was stirring, not even a mouse;
The stockings were hung by the chimney with care,
In hopes that St. Nicholas soon would be there;
The children were nestled all snug in their beds,
While visions of sugar plums danc'd in their heads,
And Mama in her 'kerchief, and I in my cap,
Had just settled our brains for a long winter's nap -
When out on the lawn there arose such a clatter,
I sprung from the bed to see what was the matter,
Away to the window I flew like a flash,
Tore open the shutters, and threw up the sash.
The moon on the breast of the new fallen snow,
Gave the lustre of mid-day to objects below;
When, what to my wondering eyes should appear,
But a miniature sleigh, and eight tiny rein-deer,
With a little old driver, so lively and quick,
I knew in a moment it must be St. Nick.
More rapid than eagles his coursers they came,
And he whistled, and shouted, and call'd them by name:
"Now! Dasher, now! Dancer, now! Prancer, and Vixen,
"On! Comet, on! Cupid, on! Dunder and Blixem;
"To the top of the porch! to the top of the wall!
"Now dash away! dash away! dash away all!"
As dry leaves before the wild hurricane fly,
When they meet with an obstacle, mount to the sky;

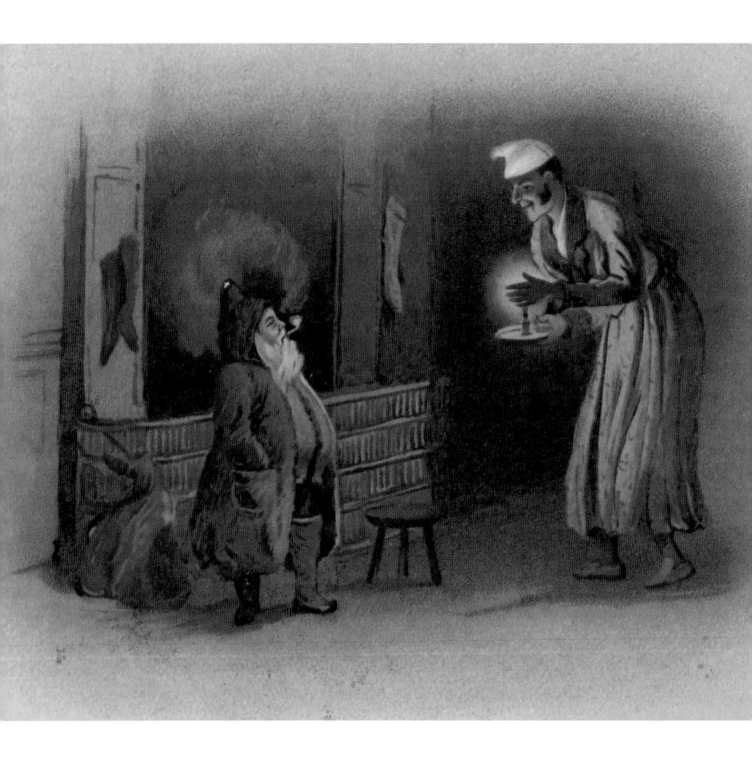

So up to the house-top the coursers they flew,
With the sleigh full of Toys - and St. Nicholas too:
And then in a twinkling, I heard on the roof
The prancing and pawing of each little hoof.
As I drew in my head, and was turning around,
Down the chimney St. Nicholas came with a bound:
He was dress'd all in fur, from his head to his foot,
And his clothes were all tarnish'd with ashes and soot;
A bundle of toys he had flung on his back,
And he look'd like a peddler just opening his pack:
His eyes - how they twinkled! his dimples how merry,
His cheeks were like roses, his nose like a cherry;
His droll little mouth was drawn up like a bow,
And the beard of his chin was as white as the snow;
The stump of a pipe he held tight in his teeth,
And the smoke it encircled his head like a wreath.
He had a broad face, and a little round belly
That shook when he laugh'd, like a bowl full of jelly:
He was chubby and plump, a right jolly old elf,
And I laugh'd when I saw him in spite of myself;
A wink of his eye and a twist of his head
Soon gave me to know I had nothing to dread.
He spoke not a word, but went straight to his work,
And fill'd all the stockings; then turn'd with a jirk,
And laying his finger aside of his nose
And giving a nod, up the chimney he rose.
He sprung to his sleigh, to his team gave a whistle,
And away they all flew like the down of a thistle:
But I heard him exclaim, ere he drove out of sight -
Happy Christmas to all, and to all a good night.

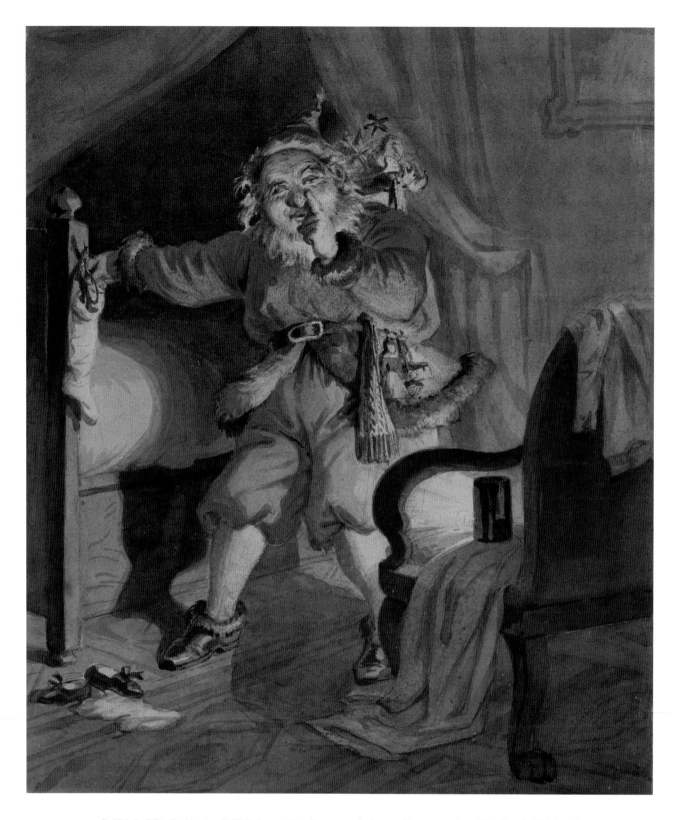

CREDIT: *St. Nicholas Filling Stockings in a Child's Bedroom*, 1862, from a study for an illustration for; *A Visit From St. Nicholas*. Illustrated from drawings by Felix Octavius Carr Darley (American, 1822-1888) – (James G. Gregory, NY, 1862). Watercolor, ink, and graphite on off-white wove paper. Composition: 12 ⁷/₁₆ x 9 ⅛ inches, sheet: 13 ⁵/₁₆ x 10 ⅛ inches. Courtesy of the Delaware Art Museum (Acquisition Fund, 1983).

This publication presents selected images, along with dozens of literary excerpts, to illustrate the way in which the poet of *Twas The Night* drew inspiration from the historical record of artistic expression and winter celebrations in western culture. The poem was written in the 19th century. It was centuries in the making and threads can be drawn between the imagery in the poem and those from both the secular and sacred realms as far back as antiquity. The following is a cultural history that tells the poem's own story, featuring the individuals and the events that contributed to the poem becoming a cherished classic and publishing phenomenon.

Robert Frost (American, 1874-1963), four-time Pulitzer Prize winner for poetry, said of his poem *Stopping by Woods on a Snowy Evening* (1923) that it was the kind of work he would like to print on one page followed by forty pages of footnotes. C.C.M. may not have received accolades for the poem *Twas The Night* during his lifetime; however, today, he is credited with bringing more joy to children over the past two centuries than any other author. The following is a 264 page footnote to the classic Christmas poem *Twas The Night*, considered to be the most read, most often recited poem in the library of English literature, with the poem's jolly St. Nick - the most influential fictional character of all time.

CREDIT: Robert Frost's quote documented in his biography at Poetry Foundation.org.
Artist – F.O.C. Darley (American, 1822-1888), *A Visit From St. Nicholas* (James G. Gregory, NY, 1862). Rare Book – *Nancy H. Marshall Collection*, Special Collections Research Centre, William & Mary Libraries.

NOTES: "Creativity is just connecting things." – Steve Jobs (American, 1955-2011). *I, Steve: Steve Jobs In His Own Words* (Agate Publishing, IL, 2011).

An illustration by Darley accompanied the poem on the cover of *Harper's New Monthly Magazine* for December, 1857.

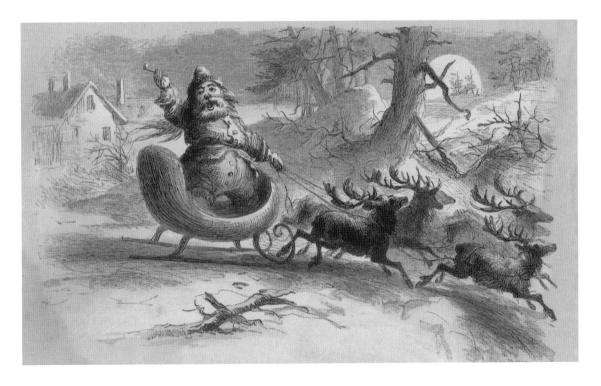

CREDITS: Artist – Thomas Nast (German, 1840-1902 American). Pages 16-17-19: Images accessed from *Christmas Drawings for the Human Race* (Harper & Bros, NY, 1890).
Page 16: *The Watch on Christmas Eve* also published in *Harper's Weekly* - January 1, 1876.
Page 17: *Twas The Night Before Christmas* also published in *Harper's Weekly* - December 25, 1886.
Page 18: *The Coming of Santa Claus* and *Santa Claus Rebuke* (*Harper's Weekly* - December 30, 1871).
Page 19: *Merry Old Santa Claus* (*Harper's Weekly*, NY, January 1, 1886).

NOTES: Between 1863 and 1888, Nast as an illustrator and producer of political cartoons in America, presented his interpretation of Santa Claus based on the poem to the public, primarily through the pages of *Harper's Weekly A Journal of Civilization* published by Harper & Bros. of New York.
The Macculloch Hall Historical Museum, in Morristown, NJ, holds a major collection of Thomas Nast's work. A permanent gallery of the artist's work is on display in the Macculloch-Miller-Post mansion. Annual exhibits of Nast's Christmas drawings are exhibited during the holiday season.

"St. Nicholas is painted for all time as a jolly, fun-loving old elf, whose ruddy skin and bright eyes belie his snow-white beard, who dimples with merriment and makes one laugh just to look at him. Clad in furs, his sack of toys slung across his back, he skims over the housetops in his little sleigh, whistling and shouting to his reindeer." - BURTON STEVENSON, *Famous Single Poems, and the Controversies Which They Raged* (Dodd, Mead & Company, NY, 1923).

He was dress'd all in fur, from his head to his foot,
And his clothes were all tarnished with ashes and soot,
A bundle of toys he had flung on his back,
And he look'd like a pedlar just opening his sack

- Twas The Night

This publication gives center stage to a treasure trove of vintage illustrations that have been produced over the past two centuries for hundreds of editions of *Twas The Night*. Included are many iconic images created during the Golden Age of American Illustration (1880-1920), an era of unprecedented accomplishment in the arts. Also included in this publication are images created by artists who did not illustrate stand-alone editions of the poem, but whose commercial illustration, works of fine art, and work on other Christmas stories contributed significantly to the development of the character of Santa Claus and the popularity of the poem, including American artists Norman Rockwell, Joseph Leyendecker, Gertrude Kaye, N.C. Wyeth, and Andy Warhol.

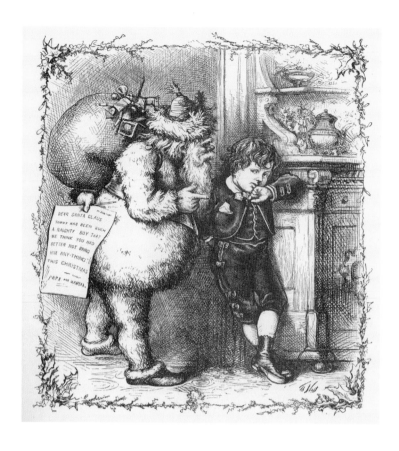

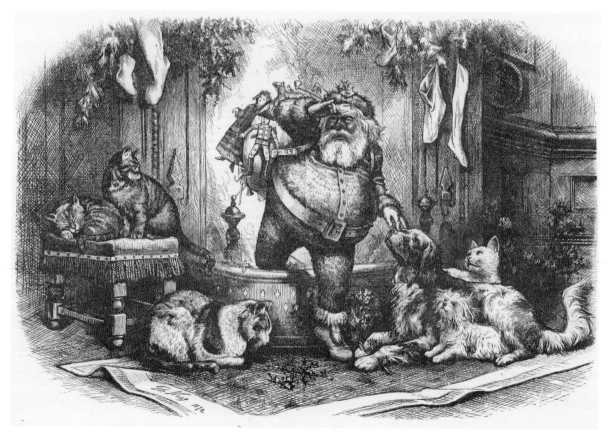

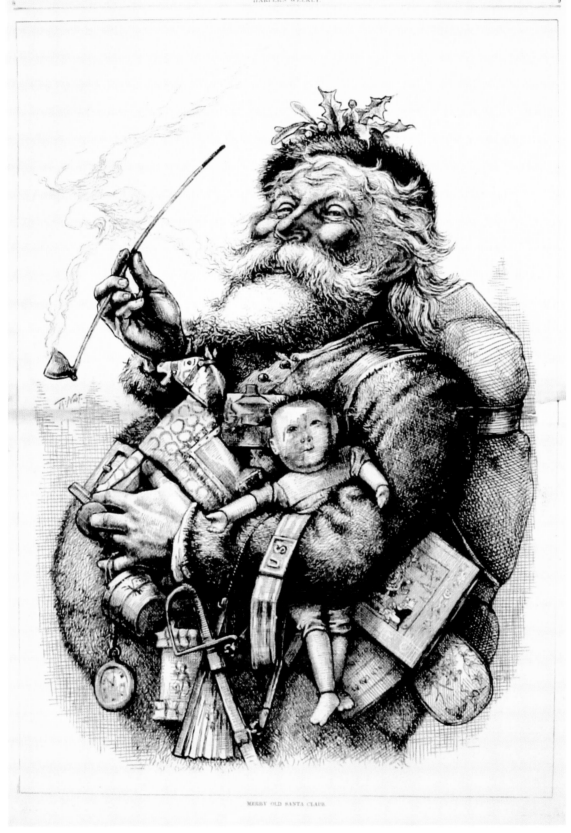

MERRY OLD SANTA CLAUS.

CREDITS: Page 20: Artist - Gertrude Kaye (British, 1884-1939 American). *The Boy Who Lived in Pudding Lane, Being a True Account, if only you believe it, of the Life and Ways of Santa, Oldest Son of Mr. and Mrs. Claus*, written by Sarah Addington (American, 1891-1940). (*The Atlantic Monthly Press*, Boston, 1922). Redesigned and published by Grafton and Scratch Publishers, 2017.

Page 21: Artist – William Balfour-Ker (Canadian, 1877-1918). *Santa Checks His Toys*, (*Life Magazine* - cover, December 24, 1908).

NOTE: Gertrude Kaye, studied with Howard Pyle at the Drexel Institute in Philadelphia, PA. Pyle championed women's right to work and stipulated that fifty percent of his classes be filled with female students. Many women worked in the field of illustration throughout the 19th century, first as hand-colorists for engravers, and then as artists and illustrators. By the early years of the 20th century Jessie Willcox Smith, who studied with Pyle, had become one of the most successful illustrators of the era. She illustrated *Twas The Night* in 1912. The edition is one of the most popular of all time, with her illustrations often reprinted to be enjoyed by new generations. Kaye is best known for her illustrations for the 1923 edition of Lewis Carroll's *Alice's Adventures in Wonderland*.

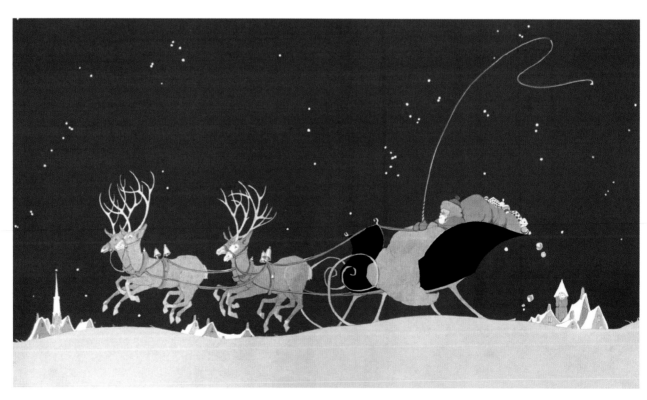

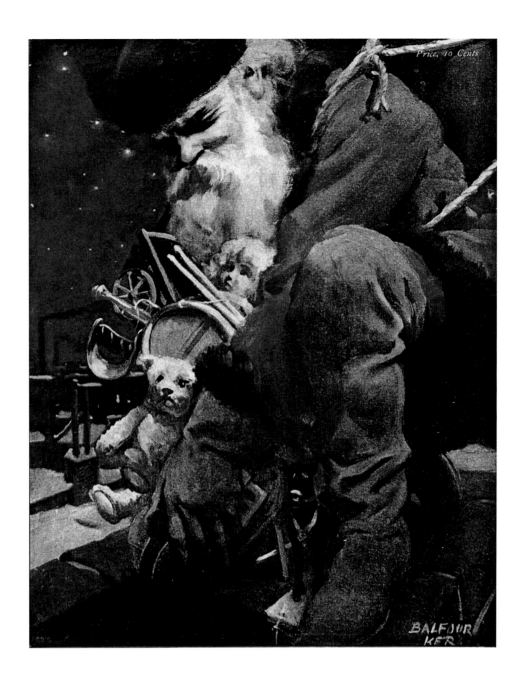

The poem has been published under numerous titles including: *Christmas Times – Santa Claus – Visit From Santa Claus – The Night Before Christmas – St. Nicholas' Visit – Annual Visit From St. Nicholas – An Account of a Visit From St. Nicholas or Sante Claus – Account of a Visit from Santa Claus – A Visit From St. Nicholas, Christmas Eve – Santa Claus on his Holiday Visit to his Children – Visit From St. Nicholas – Twas The Night Before Christmas – Twas The Night Before Christmas, edited by Santa Claus for the Benefit of Children of the 21st. Century – A Visit From Saint Nicholas or Old Belsnickle – The Night Before Christmas, or, Kriss Kringle's Visit.*

NOTE: *Belsnickle*, and *Kriss Kringle* are Christmas characters of European folklore.

Twas The Night was not the first literary work to portray St. Nicholas/St. Nick arriving by sleigh on a frosty Christmas Eve, accompanied by magical reindeer. At least one other poem in circulation prior to 1823 related such details. Other poetic works published between 1810 and 1820 presented the Saint as an all-knowing judge of children's behavior and one who wielded a birchen rod – a device used to beat upon children found to be naughty. *Twas The Night* was written to entertain a juvenile audience and there is not the slightest hint of punishment anywhere in the poem, an important differentiation that must have especially delighted children who read it in the era in which it was written.

CREDITS: Pages 22-23: Artist – William Wallace Denslow (American, 1856-1915) *Denslow's Night Before Christmas* (G.W. Dillingham Co., Publishers, NY, 1902).

Oh! Bring the bright orange so juicy and sweet,
Bring almonds and raisins to heighten the treat;
Rich waffles and dough-nuts must not be forgot,
Nor Crullers and Oley-Cooks fresh from the pot.
But all these fine presents your Saintship can find,
Oh! Leave not the famous big Cookies behind.
Or if in your hurry one thing you mislay,
Let that be the Rod - and oh! Keep it away.

 - *Spectator*, NY, December 15,1810. (Excerpt).

But where I found the children naughty,
In manners rude, in temper haughty,
Thankless to parents, liars, swearers,
Boxers, or cheats, or base tale-bearers,
I left a long, black, birchen rod,
Such, as the dread command of God
Directs a Parent's hand to use
When virtue's path his sons refuse.

 - *Old Santeclaus with Much Delight - The Children's
Friend: A New-Year's Present* -1821. (Excerpt).

NOTE: St. Nicholas cookies were customarily eaten on St. Nicholas Day or for New Year's Eve in England ca. 1680; a custom popularized in the colonies in the 18th century. The St. Nicholas cookie tradition continues today, with some bakers using molds from the 17th and 18th century.

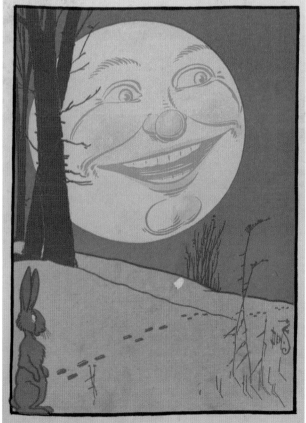

C.C.M is known to have drafted hand-written manuscripts of *Twas The Night*, to have submitted the poem for publication in a collection of his works of poetry, and to have vigorously defended his claim to authorship of the piece after a newspaper editor credited the poem to someone else. Despite these events, and only decades after the death of C.C.M., did the question of the poem's attribution come to the attention of the public.

In 1923, Burton Stephenson wrote in defense of C.C.M: "Conclusive indeed must be the proof to convince anyone that he (C.C.M.) would soil himself by the theft of another man's poem in order to add more leaf to his wreath of laurel. The only final and absolute proof would be the discovery of the poem in published form prior to 1822. Until such proof is forthcoming, Dr. Moore's claim to its authorship cannot be justly denied, and the children whom it has delighted need not hesitate to gather around his grave, as to heretofore, on Christmas eve; to do him honor."

The edition printed in the *Troy Sentinel* for December 23 of 1823 remains the earliest printing of the poem identified to date.

The most riveting points of discussion on the topic of attribution are presented in this publication. However, the author and publisher prefer not to take an emphatic position on the issue at this time and heeding the words of Benjamin Franklin adopt a position of "modest diffidence" (never advancing anything which may be later disputed).

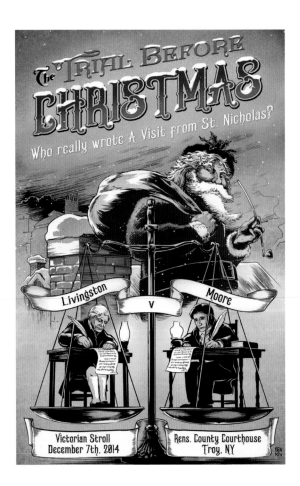

CREDITS: Page 24: Artist - Ben Karis Nix, *The Trial Before Christmas*, 2014. Courtesy of Duncan Crary and Jack Casey, christmastrial.com
Page 25: Artist - Jessie Willcox Smith (American, 1863-1935). *The New Book*, illustration for *When Christmas Comes Around*, written by Priscilla Underwood (1915).

NOTES: A *Hallmark* movie, *Twas The Night Before Christmas* (2022), portrays the authorship debate.
In 1911, The Church of Intercession of NYC started a tradition of reading of *Twas The Night*, followed by a procession to the grave of C.C.M. at Trinity Church Cemetery and Mausoleum, on the last Sunday service before Christmas. In 1919, a visit to the grave of Alfred Tennyson Dickens was added. A.T. Dickens died in 1912, while on a tour to New York in honor of his father – Charles Dickens. Alexander Hamilton's grave is also at T.C.C.

The poem is read on the Sunday before Christmas at the Chelsea Community Church in NYC. C.C.M. provided the land for St. Peter's Episcopal Church; home to the congregation of the C.C.C. since 1974.
Clement Clarke Moore Park (Opened, 1968 – Named, 1969) in Chelsea, Manhattan was created in gratitude to C.C.M. During the holidays the public gathers in the park to recite the poem.

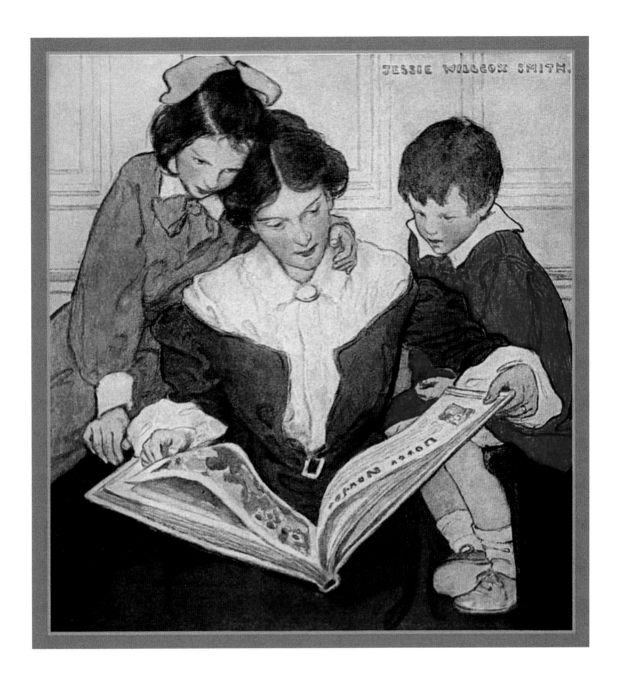

Children continue to enjoy the poem as originally written - the lines are often modified with the following alternate word choices: mama/mamma, jirk/jerk, pack/sack, nestled/nested, our brains/down, breast/crest and ere/as. The original reindeer names of Dunder and Blixem are commonly replaced with Donner, Donder, Blixen, or Blitzen.

The first use of Merry Christmas versus Happy Christmas, a phrase of the last line of the poem, appeared in the *Charleston Mercury* for Christmas 1829.

CHAPTER 2

The Enchanted Past

A Toast To Santa Claus

The good old Saint is everywhere
Along life's busy way.
We find him in the very air
We breathe day after day –
Where courtesy and kindliness
And love are joined together,
To give sorrow and distress
A touch of sunny weather.
So here's to good old Kindliheart,
The best bet of them all,
Who never fails to do his part
In life's high festival;
The worthy bearer of the crown
With which we top the Saint.
A bumper to his health, and down
With them that say he ain't!

- KENDRICK BANGS (*Harper's Weekly*, December 16, 1911).

"The mythology of Santa Claus is a natural means of expanding wonder, for what could be more wonderful to the child's heart than a man, a saint, who delivers presents on Christmas Eve to good children, a precursor to the Great Gift-Giver who gives himself to us? Not only children but adults should strive to rekindle in their hearts the belief in Santa Clause and adapt a more child-like faith and belief, to see the 'bigness' of the world again. As Charles Dickens said, it is good to sometimes be children and never better than at Christmastide." – NATHAN STONE, *In Defense of Santa Claus, Crisis Magazine*, December 21, 2017.

NOTE: Joseph J. Campbell (American, 1904-1987) scholar, mythologist, and author of *The Hero With A Thousand Faces*(1949) was interviewed in 1988 for the PBS series - *The Power of Myth*. In the series Campbell discussed the power of storytelling and how ancient narratives influence modern culture. Campbell viewed Santa Claus as a way to connect with the unseen and the mystery to which we are all apart.

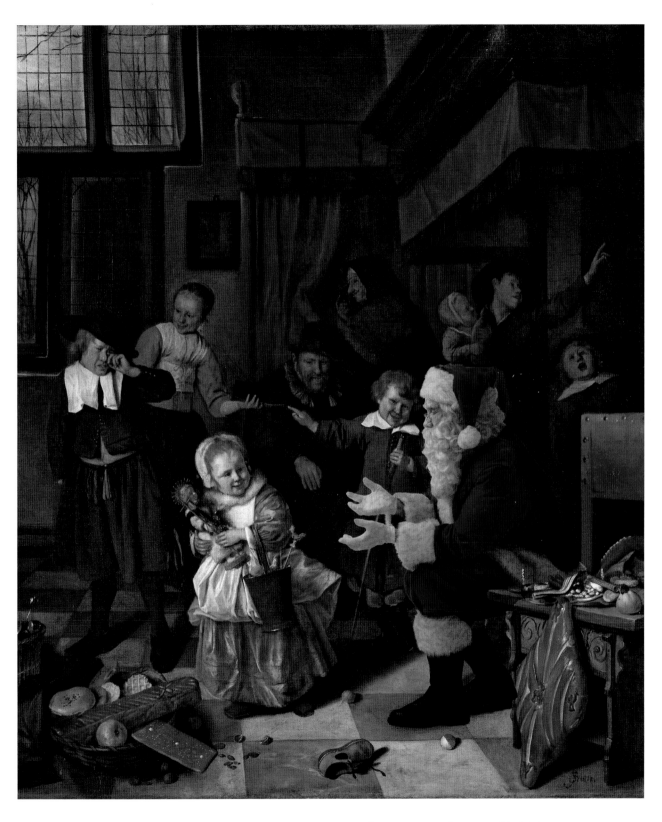

CREDIT: Artist – Ed Wheeler, *Santa Classics*, inspired by Jan H. Steen's (Dutch, 1626-1679), *The Feast of St. Nicholas*, ca.1663-1665. (Copyright Ed Wheeler 2022).

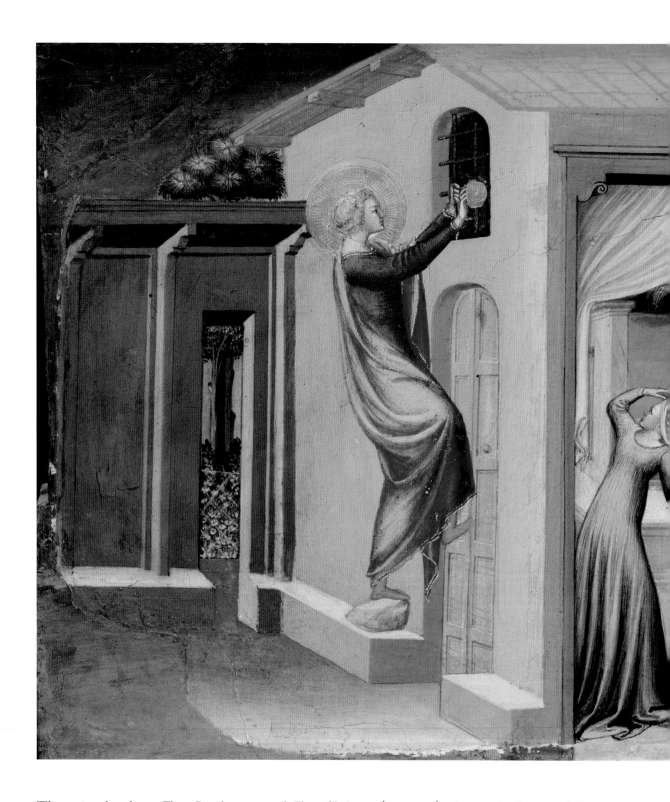

The miracle plays: *Three Daughters 13* and *Three Clerks 44* (ca. 1100), dramatized two of St. Nicholas' legendary acts. In the first drama, Nicholas rescues three young women from being sold into slavery by providing each with a dowry. He arrives at night, intending for the gift to be given anonymously, and tosses gold coins through an open window.

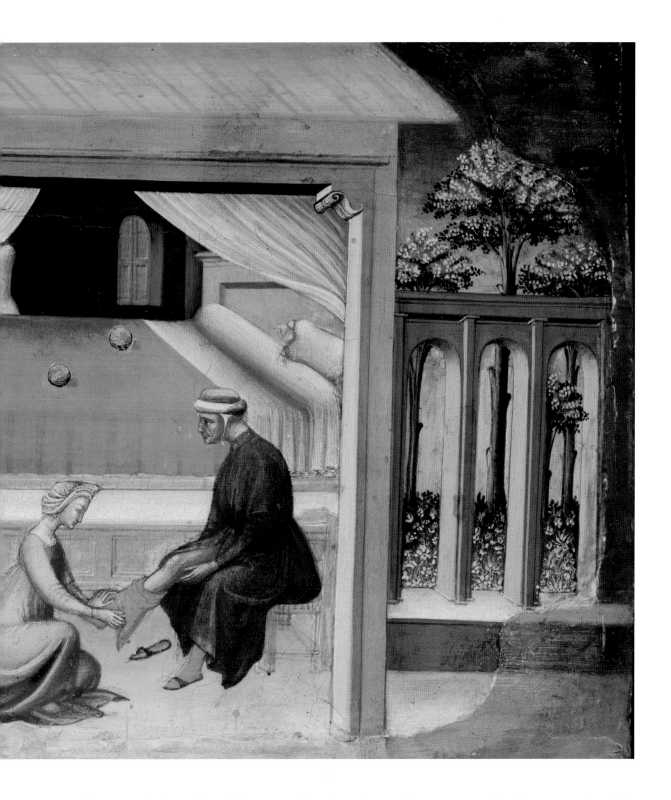

The second play tells of three murdered students who are miraculously returned to life through the prayers of Saint Nicholas.

CREDIT: Artist - Bicci de Lorenzo (Italian, 1373-1452), *Saint Nicholas Providing Dowries*, 1433-35 (Gift of Coudert Brothers, 1888, Metropolitan Museum of Art, New York, NY.).

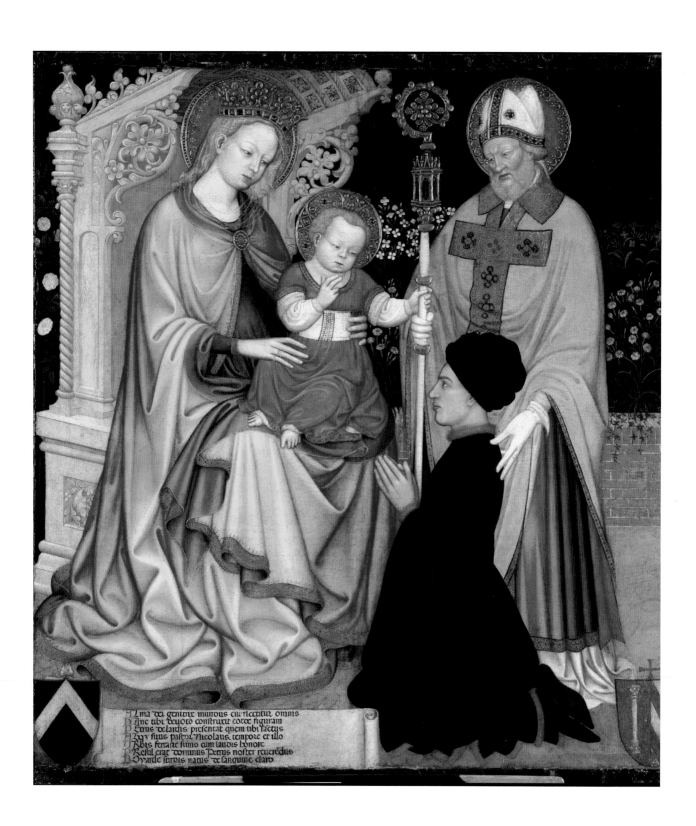

Lma dei genitrix mundus cui flectitur omnis
Hanc tibi deuoto construxit corde figuram
Petrus delarchis presentat quem tibi factus
Lux fuus pastor Nicolaus, tempore et illo
Robis ferante sumo cum laudis honore
Reful erat dominus Petrus noster reuerendus
Grande suuis natus de sanguine claro

The poet of the magical *Twas The Night* brought the legend of the patron saint of children – St. Nicholas into the lives of children of the early 19th century in an enchanting and engaging way. The poem has traveled over two centuries because all who read it are struck with a sense of wonder, of hope and the promise of belief.

For many people hearing even just the first few opening lines of the poem brings back fond memories from delightful Christmas-times spent in childhood:

"Twas the night before Christmas, when all thro' the house,
Not a creature was stirring, not even a mouse...."

"The common belief is that Saint Nicholas lived at Myra in the first half of the fourth century, but there is no evidence or document before the reign of the emperor Justinian in the mid-sixth century." – CHARLES W. JONES, *Saint Nicholas of Myra, Bari, and Manhattan, Biography of a Legend*, University of Chicago, Chicago, IL, 1978.

"To dispute the historicity of a bishop of Myra named Nicholas would be methodological error. We can grant a bishop of that name who had a great impact on his homeland. We can accept December 6 as the day of his death and burial. These are the facts we can hold to. Further we cannot go." - GUSTAV ANRICH

"Indeed, the life of one of those men who have lived according to God's will, expressed in speech, draws and summons many men to virtue and will completely inflame them to similar zeal. An example of this, to be sure is the life of our father Nicholas. His life more than another's both delights our ears and causes our souls to be happy and stirs us to the performance of good deeds. Therefore, the story of his life should be related and recounted in speech for reconsideration of the merits. Even if they have been known to many before and on that count need no telling (if not for recalling and refreshing your memories), then to gladden your souls, which love virtue." - Preamble to *Symeon the Metaphrast Life of Nicholas* (ca. 1000 AD).

CREDIT: Page 30: Artist - Master G.Z. (possibly) Michele dai Carri (Italian, d. 1441) *Madonna and Child with Donor, Pietro dé Lardi*. Credit: Bequest of Adele Lehman, in memory of Arthur Lehman, 1965. The Metro Collection, The Metropolitan Museum of Art, New York, NY.

Gustav Anrich, and Symeon documented by Charles W. Jones, *Saint Nicholas of Myra, Bari, and Manhattan* (The University of Chicago Press, Chicago, 1978).

NOTE: In 2014, the BBC released a facial reconstruction created from the remains accessed from the crypt of St. Nicholas in Bari, Italy in the documentary - *The Real Face of Santa Claus*. Researchers associated with Oxford University in 2017 analyzed a fragment of remains that had been in the possession of Father Dennis O'Neill of the *St. Martha of Bethany Church Shrine of All Saints* in Morton Grove, Illinois, USA. The artifact was authenticated through advanced technology to be of the 4th century.

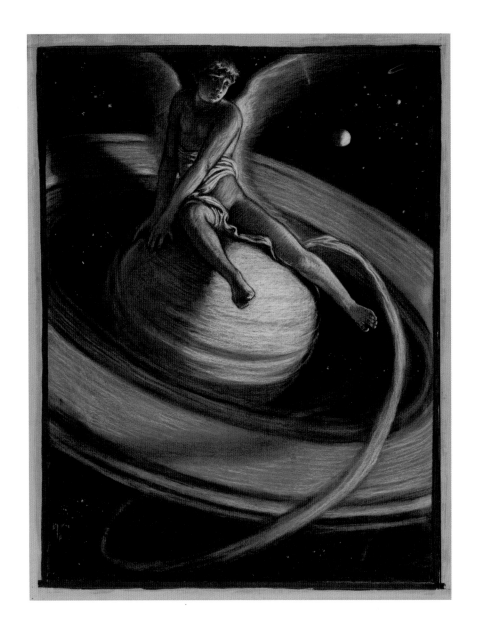

Prior to the acceptance of Christianity by the Roman Emperor Constantine in 313 AD, the most popular festival in the Julian calendar was Saturnalia. The pagan festival was a multi-day celebration with high revelry in honor of the God Saturn and to mark winter solstice. Saturn was thought to have been an early King of Rome, often depicted with a long white beard - sometimes portrayed with wings. He was the God of wealth, abundance and of agriculture, and regarded for his just ways and belief in equality for all.

"It is now the month of December, when the greater part of the city is in a bustle . . . Were you here, I would willingly confer with you as to the plan of our conduct; whether we should eve in our usual way, or, to avoid singularity, both take a better supper and throw off the toga." - SENECA THE YOUNGER (4 BC – 65 AD).

During Saturnalia, the Romans decorated their homes and the streets with greens. Social inversion was practiced during the festival with slaves taking on their master's clothing and activities, while peasants ran the city of Rome.

"The ghost of the present" in Charles Dickens' *A Christmas Carol. In Prose. Being a Ghost Story of Christmas* (1843) is often illustrated with elements of the personification of Saturn or of Dionysus the Greek God of Fertility, later to be known by the Romans as Bacchus, the god of wine and pleasure.

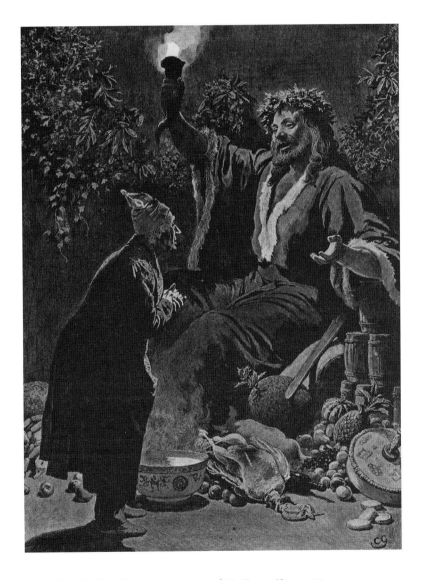

NOTE: In 323 AD, Christianity became the official religion of the Roman Empire. The poet Albius Tibullus (54 BC) authored the poem *Saturn's Day*, from which the English word Saturday is derived, which for many people is the most celebratory day of the week.

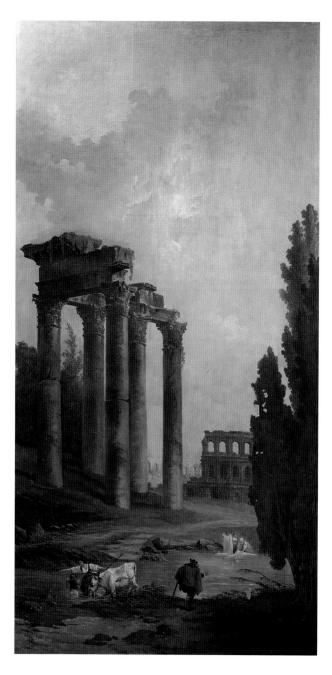

CREDIT: Artist – Hubert Robert (French, 1733-1808) *Architectural Capriccio with ruins of the Temple of Saturn and the Colosseum in the background.*

It is Pope Julius I, Bishop of Rome from 337 to 352, who is credited with declaring December 25 as Christmas Day – and the date of the birth of Jesus Christ. The early Christian Church, in wanting to convert followers of paganism to their faith, set out to infiltrate the winter festival of Saturnalia and the celebration of Mithra the Sun God. Mithra was honored on winter solstice, marked as December 25 in the Julian Calendar. By placing this important date for the Christian faith in the middle of what were very popular pagan celebrations, the church created a division in the way winter festivals in the Northern Hemisphere would be celebrated for centuries to come.

In 800, Charlemagne was crowned Holy Roman Emperor at St. Peter's Basilica in Rome on Christmas Day. By which time Christmas had grown in importance, however, people of agrarian societies would continue to recognize the return of longer hours of daylight, which brought the promise of new crops, the continuation of life, and to celebrate in exuberant and excessive style. With the Roman Empire's conquest of Europe, including Britain, from the second to the fourth century, the festival of Saturnalia was introduced, with certain aspects of the boisterous event to remain a part of Christmas festivities into modern times. Caroling door to door, decorating with greens, Christmas parades, and the rowdy office party all can trace their roots to the merry, and jolly days enjoyed and celebrated by the Romans.

In 878, Alfred the Great, the King of the Anglo Saxons (848-899), declared the period between Christmas to Twelfth Night an official holiday period. December 25 remained a Holy Day, with festivals and feasting held on the other days enjoyed by all.

In 1087, sailors from Bari, Italy, removed what were thought to be the remains of St. Nicholas

from his burial site in Myra, of Greco-Roman Lycia (current Demre, Turkey) and transported them back to Italy. The very popular pilgrimage to the saint's shrine had become too dangerous with political conflict in the region. The remains were re-enshrined in the Basilica di San Nicola, in Bari, Italy. Further remains of St. Nicholas were brought from Myra to Venice, Italy during the First Crusade.

By the Middle Ages, the legend of Saint Nicholas' great and wonderous deeds had reached Europe and hundreds of churches were built in his honor. In the Netherlands twenty-three were constructed, in England over five hundred, in Belgium three hundred, and in Rome there were at least thirty four.

In Norse mythology, Odin is a pagan character who was thought to appear during the winter festival of Yul, riding the stormy night skies on an eight-legged horse named 'Sleipnir,' or travelling in a sleigh pulled by magical and sometimes terrifying beings.

A medieval Icelandic manuscript known as *The Codex Regius* contains thirty-one poems and was written during the 13th century. *The High One* is a single poem in *The Codex Regius* with the verses attributed to Odin who shares his wisdom: "Cattle die, friends die, and the same with you; but I know of something that never dies and that's a dead person's deeds."

Odin relied on raven scouts who scoured the earth and reported back to him on who was worthy of reward or deserving of punishment or even death. Thor, Wodin and other winter spirits are referred to in old Norse legends and ballads, often portrayed alongside menacing companions. Odin was particularly popular in the 19th century with the Romantics. Many artists and writers found inspiration for their own works through the imaginary world and legends these characters inhabited.

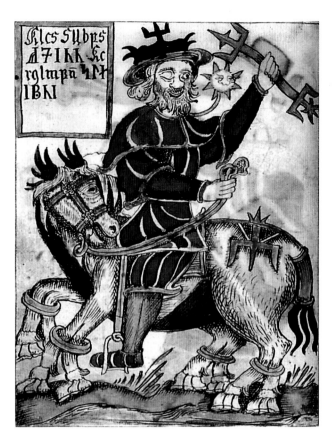

CREDIT: Artist – Unidentified. *An illustration of the god Odin on his eight-legged horse Sleipnir.* From an Icelandic 18th century manuscript (1867). *Wikimedia Commons,* Public Domain.

NOTES: Stone carvings discovered in Gotlant, Sweden of the eighth century depict an eight-legged horse.

The St. Nicholas Church in Steventon, Hampshire, UK, was author Jane Austen's place of worship for the first twenty-five years of her life. The church is a Norman building ca. 12th century. It stands today. The medieval St. Nicholas Church, of Chawton, Hampshire, UK, was located on lands owned by the author's brother Edward and served as Jane Austen's parish after she moved from Steventon. The ancient church was destroyed by fire in 1871.

The Wild Hunt of Asgard raids the county
Whilst fall and winter on stormy nights.
But it favors to travel at Yuletide…
They feast with trolls and giants;
They closely ride by meadow and path
And pass the fearful nation.
Then, take care, farmer! Keep all in order!
As the wild hunt of Asgard may visit your home!
We'll ask Odin to keep us in mind
He gives gold to those who are worthy
He gives victory to some, money to others, eloquence to many, and
common sense to all.
He gives waves to the sea, word-skill to the poets,
he gives many the happiness of love.

- *The Asgard Rise*, (Excerpt) JOHAN S. WELHAVEN (Norwegian, 1807-1873)

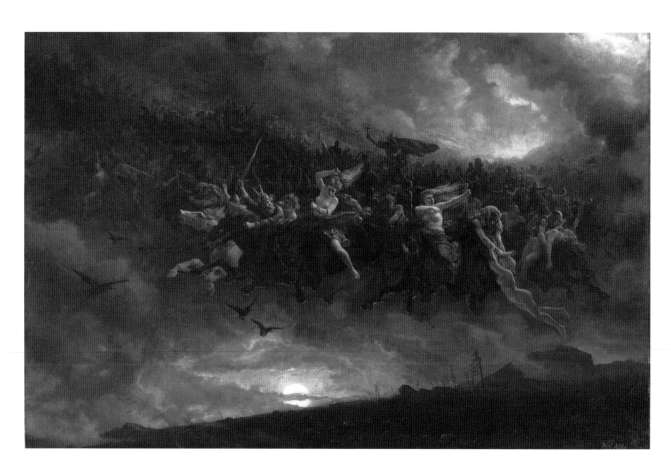

In October of 1517, Martin Luther (German, 1483-1546), theologian and author, along with his followers began the reformation of the Protestant church in Europe. All the days set aside to honor saints, including St. Nicholas day, were made illegal in Protestant countries during the Reformation. December 6th - St. Nicholas Day, had been a day of celebration. Luther chose December 24 as the date to commemorate the birth of Christ with the giving of gifts to children. He introduced a character he called the "Christchild" or "Christkindl" in the hope of displacing the popular figure of St. Nicholas. Luther's Protestant Christmas character was portrayed as an angel child, a representation of Jesus as a baby, who would sometimes be portrayed as a young female angel with long blond hair and wings. By the end of the 16th century many children looked forward to the arrival of this character and the presents of candy and trinkets they might receive.

With the repression of St. Nicholas, a series of Christmas characters emerged who kept to the shadows of Protestant society. Many of these characters wore disguises of long hooded robes or were wrapped in furs. These characters came to represent a fondness for the old ways before the Reformation, to the times of entertainment, feasting and merry making during the Twelve Days of Christmas.

A character known as "Sire Christmas" is an early incarnation of the character and is attributed to a public procession in 16th century England. Father Christmas emerges and is given the appearance of an old man, often with a wreath and elements of Bacchus and Saturnalia. He is associated with mummer's plays, songs, and poems

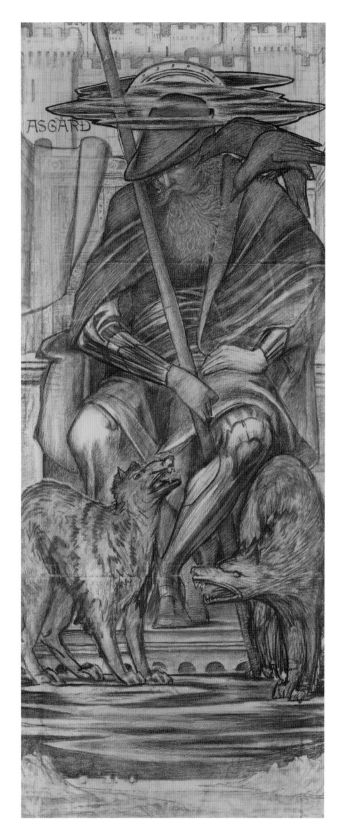

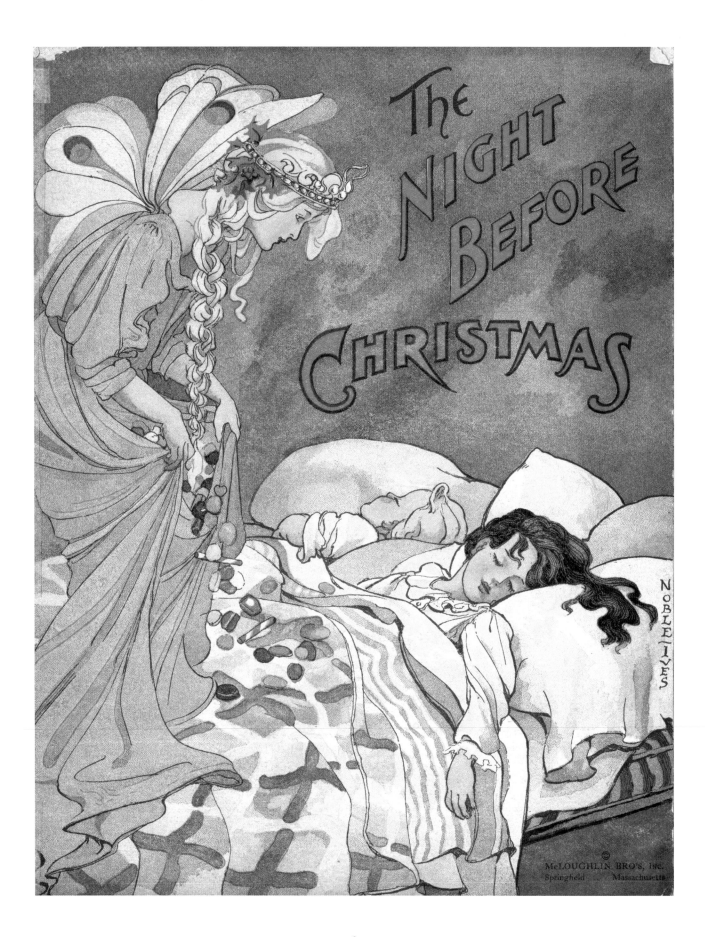

NOBLE-IVES

McLOUGHLIN BRO'S, Inc.
Springfield Massachusetts

with references to intoxication and feasting and not as a child-oriented character who delivered gifts. Illustrators of *Twas The Night* have been inspired by the winter characters of Odin, Father Christmas and the Christkindl.

"But is old, old, good old Christmas gone? Nothing but the hair of his good, old head and beard left? Well, I will have that, seeing I cannot have more of him." – *Hue and Cry after Christmas* (1643). Documented by Washington Irving in *Old Christmas*.

CREDITS: Page 38: Artist – Sarah Noble Ives, *The Night Before Christmas*, (McLoughlin Bros. ca.1920). Rare Book – *Nancy H. Marshall Collection*, Special Collections Research Center, William & Mary Libraries.
Page 39– Artist: Firmin Bouisset, *Noel Poster*, (1893). Wikimedia, Public Domain.

CREDIT: Artist - Giuseppe Marchesi (Italian, 1699-1771) *Allegory of Winter.*

A Song For A Christmas Tree (1871)

Cold and wintry is the sky,
Bitter winds go whistling by,
Orchard boughs are bare and dry,
Yet here stands a faithful tree.
Household fairies kind and dear,
With loving magic none need fear,
Bade it rise and blossom here,
Little friends, for you and me.
Come and gather as they fall,
Shining gifts for great and small;
Santa Claus remembers all
When he comes with goodies piled.
Corn and candy, apples red,
Sugar horses, gingerbread,
Babies who are never fed,
Are handing here for every child.
Shake the boughs and down they come,
Better fruit than peach or plum,
'T is our little harvest home;
For though frosts the flowers kill,
Though birds depart and squirrels sleep,
Though snows may gather cold and deep,
Little folks their sunshine keep,
And mother-love makes summer still.
Gathered in a smiling ring,
Lightly dance and gayly sing,
Still at heart remembering
The sweet story all should know,
Of the little Child whose birth
Has made this day throughout the earth
A festival for childish mirth,
Since the first Christmas long ago.

- Louisa May Alcott (American, 1832-1888)

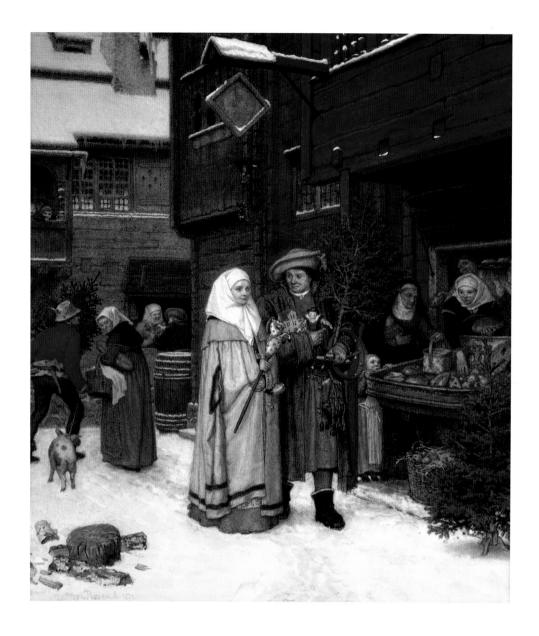

"Christmas - Of all the old festivals, however, that of Christmas awakens the strongest and most heartfelt association. There is a tone of solemn and sacred feeling that blends with our conviviality and lifts the spirit to a state of hallowed and elevated enjoyment It is a beautiful arrangement, also, derived from days of yore, that this festival, which commemorates the announcement of the religion of peace and love, has been made the season for gathering together of family connexions, and drawing closer again those bands of kindred hearts, which the cares and pleasures and sorrows of the world are continually operating to cast loose; of calling back the children of a family, who have launched forth in life, and wandered widely asunder, once more to assemble about the paternal hearth, that rallying place of the affections, there to grow young and loving again among the endearing mementos of childhood

Where does the honest face of hospitality expand into a broader and more cordial smile – where is the shy glance of love more sweetly eloquent – than by the winter fireside; - and as the hollow blast of wintry wind rushed through the hall, claps the distant door, whistles about the casement, and rumbles down the chimney – what can be more grateful than that feeling of sober and sheltered security, with which we look round upon the comfortable chamber and the scene of domestic hilarity!" - Washington Irving

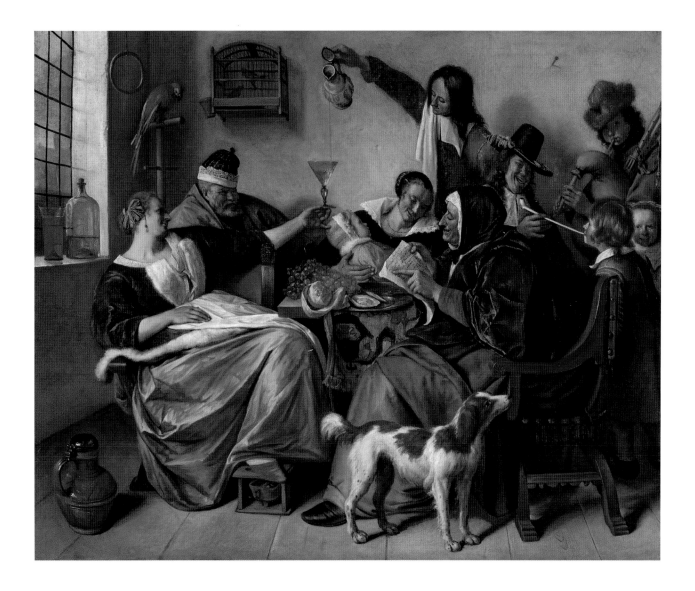

CREDITS: Image Page 42: Artist - Georg Von Rosen (Swedish, 1843-1923) *The Christmas Fair*, 1872.
Image Page 43: Artist Jan Steen (Dutch, 1626-1679) *As The Old Sing, So Pipe the Young*, ca. 1668-1670.
Pages 42-45: Washington Irving, *The Sketch Book of Geoffrey Crayon, Gent.*, 1819-1820.

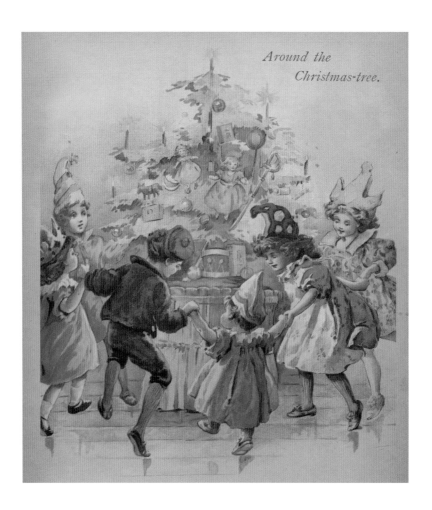

Around the Christmas-tree.

"The preparations making on every side for the social board that is again to unite friends and kindred – the presents of good cheer passing and repassing, these tokens of regard and quickeners of kind feelings - the evergreens distributed about houses and churches, emblems of peace and gladness – all these have the most pleasing effect in producing fond associations and kindling benevolent sympathies. Even the sound of the Waits, rude as may be their minstrelsy, break upon the midwatches of a wintry night with the effect of perfect harmony. As I have been awakened by them in that still and solemn hour ' when deep sleep falleth upon man,' I have listened with a hushed delight, and connecting them with the sacred and joyous occasion, have almost fancied them into another celestial choir, announcing peace and good will to mankind How delightful the imagination, when wrought upon these moral influences, turns everything to melody and beauty. The very crowing of the cock, heard sometimes in the profound repose of the country, 'telling the night watches to his feathery dames,' was thought by the common people to announce the approach of this sacred festival." – WASHINGTON IRVING

Some say that ever 'gainst that season comes
Wherein our Saviour's birth is celebrated,
This bird of dawning singeth all night long:
And then, they say, no spirit dares stir abroad;
The nights are wholesome – then no planets strike,
No fairy takes, no witch hath power to charm,
So hallowed and so gracious is the time.

– WILLIAM SHAKESPEARE, *Hamlet* (Act I, Scene I).

"Amidst the general call to happiness, the bustle of the spirits, and stir of the affections, which prevail at this period, what bosom can remain insensible? It is, indeed, the season of regenerated feeling – the season for kindling not merely the fire of hospitality in the hall, but the genial flame of charity in the heart." – WASHINGTON IRVING.

CREDIT: Artist – Adrien Marie, *The Holiday Letter From School – A Boy's Dream of the Coming Christmas*, (*Graphic Xmas*, 1889, London).
Washington Irving, *The Sketch Book of Geoffrey Crayon, Gent.*, 1819-1820.
William Shakespeare, *Hamlet, Prince of Denmark*, (1596 first performed, first published 1603).

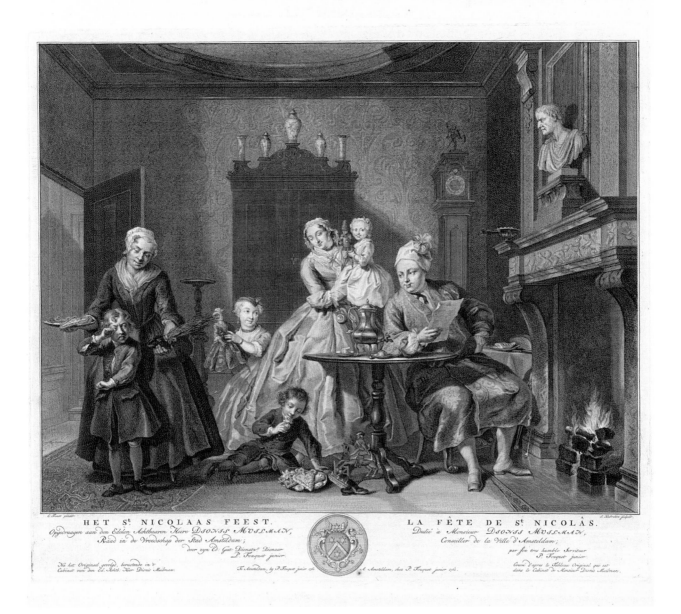

HET St. NICOLAAS FEEST.

Opgedraagen aan den Edelen Achtbaaren Heere DIONIS MUSLMAN,
Raad in de Vroedschap der Stad Amsteldam;
door zyn Ed. Gut. Dienstr. Dienaar
P. Fouquet junior

Na het Origineel gevolgt, berustende in 't
Cabinet van den Ed. Achtb. Heer Dionis Muslman.

T' Amsteldam, by P. Fouquet junior 1761.

LA FÊTE DE St. NICOLÂS.

Dedié à Monsieur DIONIS MUSLMAN,
Conseiller de la Ville d'Amsteldam;
par son tres humble Serviteur
P. Fouquet junior

A Amsteldam, chez P. Fouquet junior 1761.

Gravé d'apres le Tableau Original qui est
dans le Cabinet de Monsieur Dionis Muslman.

Let us lift our joyful voices
in vocalic harmony
On the day of blessed Nich'las,
marked with due festivity

'twas manifestly God's decree,
By which straightway
in Bishop's robes by merit he
exalted to a high degree.

Character in him was marked
by notable benevolence.
He relieved oppression's victims
with a true munificence.

– Congaudentes 47

NOTES: December 6 has been remembered as a special day to honor St. Nicholas for centuries by the Protestant and Roman Catholic churches, with the Orthodox preferring December 15. In 1969, Pope Paul VI made *Saint Nicholas Day* optional, in consideration of the church's position that as a saint must be immortal, death can not be officially recognized.

French nuns in the 11th century started the tradition of handing out candy and gifts to children on St. Nicholas Day. Today the oranges or coins that children find in their stockings are symbols of the gold deposited by St. Nicholas and candy canes a symbol of St. Nicholas' staff.

CHAPTER 3

Crossing the Seas

By the second decade of the 17ᵗʰ century the Dutch Republic had set its sights on North America, primarily to expand commercial interests in the reportedly favorable conditions of the Hudson River area. The first settlers to the area, that is now the southern tip of the island of Manhattan, were employed by the Dutch West India Company. They were governed by Dutch laws and lived by the doctrine of the Dutch Reform Church. As Reformers, they were opposed to the celebration of Saint's Days, and the excesses in behavior and the flaunting of the law, as some dared to do during the season of misrule.

One Dutch law that applied in New Netherland was the banning of any public observance of St. Nicholas: "Since the magistrates of Amsterdam have learned in previous years, not withstanding of the Bylaws, on Saint Nicholas Eve various persons have been standing on the Dam and other places in the town with candy, eatables, and other merchandise, so that a large crowd from all over town gathered. The same magistrates, to prevent all such disorders and to take the superstition and fables of the papacy out of the youth's heads, have ordered, and opined that on Saint Nicholas Eve no persons, whoever they may be, are to be allowed on the Dam or any other places and streets within this town with any kind of candy, eatables, or other merchandise under penalty of very severe fines." – Ordinance 81. Documented by the St. Nicholas Center.

NOTES: Saint Nicholas Harbor in Haiti was named by Christopher Columbus on St. Nicholas Day December 6, 1492, on his discovery of the island.

C.C.M.'s wife, Catherine Elizabeth "Eliza" Taylor Moore was a descendent of the Van Cortlandt family who were early Dutch settlers to New Amsterdam. Like many of the early settlers, they came to the colonies with wealth and to invest and develop commercial opportunities. Her first ancestor in the colonies was Oloff Van Cortlandt who arrived in New Netherland on March 28, 1638. Her great grandfather Pierre Van Cortlandt (1721-1814) became the Governor of the State of New York, President of the convention that formed the Constitution thereof, during the Revolutionary War with Great Britian. Pierre Van Cortlandt was married to Joanna Van Cortlandt, daughter of Gilbert Livingston and Cornelia Beekman, an ancestor of Henry Livingston Jr.

In 1609, a "John Moor" explored the Hudson River area with Henry Hudson.

The Dutch Golden Age spanned from 1588 to 1672, during which time the Dutch Republic excelled in commerce, the arts and sciences, and naval dominance. Harmenszoon van Rijn Rembrandt "Rembrandt" (Dutch 1606-1669) was the pre-eminent artist of his day. *Rembrandt's World: Dutch Paintings from the Clement Clarke Moore Collection* exhibited at The Morgan Library & Museum in 2011. The collection is owned by a descendant of C.C.M. In 2011, a drawing created by Rembrandt in 1655 was discovered at the St. Nicholas of Myra Episcopal Church of Encino, California. At first it was thought to have been a donation but after learning it was stolen work the drawing was given to the authorities.

By 1624, thirty families were living at Fort Amsterdam, which later became New Amsterdam of the colony of New Netherland. A document dated 1643, when the colony was still under control of the Dutch Republic, shows that eighteen languages were spoken among fewer than five hundred inhabitants of New Amsterdam. Some of these colonists may have continued their own customs and carried on with celebrations out of sight of the authorities. The 1643 report was documented in *Saint Nicholas of Myra, Bari, and Manhattan*, Charles Jones (University of Chicago Press, Chicago, and London, 1978).

The Dutch were not the first Europeans to settle in North America. In 1607, a contingency of one hundred adventurers arrived on the banks of the James River, Virginia with the Virginia Company. By the end of the first year only forty had survived the devasting conditions and shortage of supplies. The group's captain wrote in his journal for Christmas 1608 that they had gathered in their small chapel and had then feasted at the camp of Indian Chief Powhatan's son: " where we were never more merrie, nor fedde on more plentie of good oysters, fish, flesh, wild fowle, and good bread; nor better fires in England than in the drie smokie houses of the Kecoughtan." – CAPTAIN JOHN SMITH (1608).

The James River settlers were predominately Jacobeans. Rather than taking issue with the more rambunctious customs and elements of traditional Twelfth Night festivities, they welcomed the continuation of celebrating the days of Christmas to the new year with high revelry. Good wine, a great deal of carousing, fiddlers, a jester, a tight-rope

CREDIT: Artist - Gustaf Wappers (Belgian, 1803-1874). *Der Abschied nach Amerika oder die Einschiffung auf der Mayflower.*

walker and an acrobat were written about by a French visitor to Virginia in 1680: Documented by Harold B. Gill, Jr., *Christmas in Colonial Virginia*, 1999.

On September 6, 1620, the Mayflower sailed from England with one hundred and two passengers onboard. The ship arrived off the coast of what is now Cape Cod, MA, on November 9, 1620. Christopher Jones, the shipmaster of the Mayflower, wrote on December 25, 1620: "At anchor in Plymouth harbor, Christmas Day, but not observed by these colonists, they are opposed to all saints' days."

"They were, every man and woman of them, English to the backbone. From Captain Jones who commanded the ship to Elder Brewster who ruled and guided in spiritual affairs, all alike were of that stock and breeding which made the Englishman of Bacon and Shakespeare, and in those days, Christmas was knit into the heart of every one of them by a thousand threads, which no after years could untie. Christmas carols had been sung to them by nurses and mothers and grandmothers; the Christmas holly spoke to them from every berry and prickly leaf, full of dearest household memories. Some of them had been men of substance among the English gentry, and in their prosperous days had held high festivals in ancestral halls in the season of good cheer. Elder Brewster himself had been a rising young diplomat in the court of Elizabeth, in the days when the *Lord Keeper of the Seals* led the revels of Christmas as *Lord of Misrule* though this Sunday morning arose gray and lowering, with snowflakes hovering through the air, there was Christmas

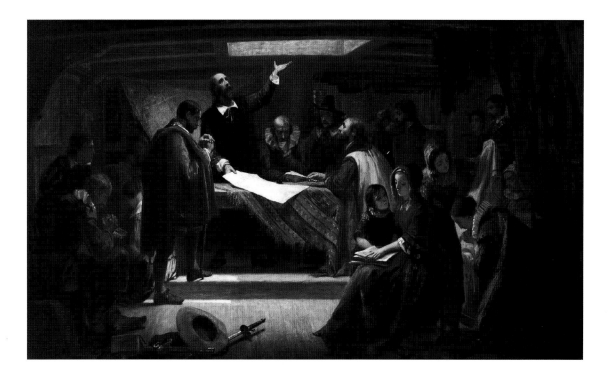

CREDIT: Artist - Edwin White (American, 1817-1877). *The Signing of the Compact in the Cabin of the Mayflower* (1856).

NOTE: *Christmastide in Virginia*, is an annual interactive exhibit that showcases the early customs of holidays in the colonies - held at the Jamestown Settlement and American Revolution Museum at Yorktown, VA.

in the thoughts of every man and woman among them - albeit it was the Christmas of wanderers and exiles in a wilderness looking back to bright home-fires across stormy waters. And so it happens that the only record of Christmas Day in the pilgrims' journal is this: 'Monday, the 25th, being Christmas Day, we went ashore, some to fell timber, some to saw, some to rive, and some to carry; and so no man rested all that day.' And at the very time that all this was doing in the wilderness, and the men were working yeomanly to build a new nation, in King James' court the ambassadors of the French King were being entertained with maskings and mummerings, wherein the staple subject of merriment was

"Christmas
for
Ever!"

the Puritans!" - HARRIET BEECHER STOWE, *The First Christmas of New England*, 1875.

William Shakespeare (English, 1564-1616) wrote plays to be performed at the court of both Queen Elizabeth I (English, 1533-1603) and King James I of Great Britain (Scottish, 1566-1625) during the festivities of Twelfth Night. King James made himself the patron of Shakespeare's theatre company and named the players *The King's Men*. In 1644, the Puritans demolished The Globe Theatre in London, England, fearing that Christians would be corrupted by the words of the bard.

In 1647, an ordinance was passed by the Puritan controlled English parliament, abolishing all festivals: "The result of this Act was that shops were required to be open on Christmas Day and town criers walked the streets calling, 'No Christmas! No Christmas!' In London, soldiers were reported to be patrolling the streets seizing any items they discovered that they believed were to be used to celebrate Christmas." Margaret Wood, *Christmastime in England: Prohibitions and Permissions*, December 21, 2017.

In 1659, it became a criminal offense in the Massachusetts Bay Colony to celebrate Christmas. Although the ban was lifted in 1681, most New Englanders did not celebrate Christmas, either as a day of religious ceremony or of celebration until the end of the 18th century.

"By the latter half of the century, progressive religious leaders in New England had decided that if Christmas could not be defeated out-

CREDIT: Artist unidentified - *Father Christmas, Enjoying a Christmas Feast* (1864).

NOTE: "During Anglican Governor Sir Edmund Andros' tenure (December 20, 1686 – April 18, 1689) - the royal government closed Boston shops on Christmas Day and drove the schoolmaster out of town for a forced holiday. On Andros' overthrow, however the Puritan view reasserted itself." – REV. FRED SMALL, *How the Unitarians and Universalists Saved Christmas* (Sermon), First Parish in Cambridge, MA, December 11, 2011.

right, perhaps it could be tamed and domesti-
cated. Universalist and later Unitarian churches
led the movement to take back the holiday from
the streets by scheduling worship on Christmas
Day." – REV. FRED SMALL, *How The Unitarians and Uni-
versalists Saved Christmas* (Sermon, First Parish in
Cambridge, MA, December 11, 2011).

In 1664, the British had taken control of the
colony of New Netherland. In honor of the Duke
of York, New Amsterdam became New York.

CHRISTMAS SONG OF THE PURITANS (1911)

Not feast do we twelve idle days
While foolish mummers dance and sing
Round boar's head, garlanded with bays,
And flaming pudding, implous thing.
No holly wreath and mistletoe,
No priestly and no pagan rite,
In our bare cabins banked with snow
Shall desecrate Thy holy night.
Instead, our heads we humbly bend,
And thank Thee that at last Thy light –
We use no senseless repetend –
Hath pierced the black of bishops' night.
Why need we feast who Joyous bow
Before Thy Son, who came from Thee?
His Word, unchained from altar now,
Shall teach Thy people how to see!

– AMY HASLAM DOWE.

CREDIT: Artist - Edwin White (American, 1817-1877). *The Signing of
the Compact in the Cabin of the Mayflower* (1856).
Artist - Henry William Bunbury (British, 1750-1811) *The Duel
'Twelfth Night Act III, Scene IV*, William Shakespeare, c. 1790.

NOTE: The Puritan calendar included three hundred days of work.
The only days they commemorated in New England in colonial
times were Harvard Commencement Day, Election Day and days
set aside for Sabbath and special days of thanksgiving. Birthdays
were not celebrated, nor the death date of a Saint that is not men-
tioned in the scriptures.
George Washington and Martha Dandridge Curtis married on
Twelfth Night – January 6, 1759.

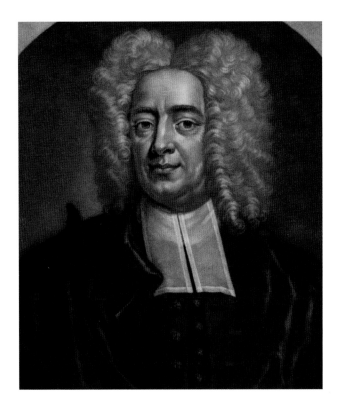

NOTES: Elizabeth Fones Winthrop Feake Hallett (England, 1610-1673 American) arrived in Salem, MA, in 1631. On the death of her husband, she joined the family of her uncle and father-in-law John Winthrop of the Massachusetts Bay Colony. She taught her sons and her daughters how to read. Her grand-daughter Charity Hallett (American 1685-1758) married Samuel Moore, an ancestor of C.C.M.'s, in 1705 in Newton, Long Island, NY. Elizabeth Hallett has been the subject of several literary works.

Anne Broadsheet, also immigrated from England to Salem, MA. She became the first published colonial poet when *The Tenth Muse Lately Sprung Up In America* was published in London, England in 1650. A young Broadsheet had read Virgil, Plutarch, Livy, Pliny, Suetonius, Homer, Hesiod, Ovid, Seneca, Thucydides, Spencer, Sidney, Milton, Raleigh, Hobbes, and others along with the Bible.

Literacy was a foundation of the puritan way of life. Having the ability to read was essential to both understanding the scriptures and to educating oneself. The New England puritans enacted laws to assure all children and servants were taught to read with teacher's salaries to be paid from public funds.

"Cotton Mather (American, 1663-1728) was one of the most learned men of his time and possessed the largest private library in the country. No one had read so much or retained more of what he read, and he could write and speak in seven languages

Of his 'Essays to Do Good' Benjamin Franklin thus writes in a letter to Samuel Mather, dated Passy, France, November 10, 1779: 'When I was a boy I met a book entitled 'Essays to Do Good,' which I think was written by your father. It gave me such a turn of thinking as to have an influence on my conduct through life; for I have always set a greater value on the character of a doer of good than any other kind of reputation, and if I have been, as you seem to think, a useful citizen, the public owes the advantage of it to that book." - James Haltigan, *The Irish in the American Revolution* (P.J. Haltigan, Washington, DC, 1908).

Cotton Mather enrolled at the age of twelve at Harvard University and during his life wrote over 450 books and pamphlets.

Mather expressed his displeasure with those who observed Christmas: "Can you in your conscience think, that our Holy Savior is honored by Mad Mirth, by long Eating, by hard drinking, by lewd gambelling, by rude reveling; by a Mass fit for one but a Saturn or a Bacchus, or the Night of a Mahometan Ramadan? You cannot possibly think so!" - Cotton Mather (Sermon, December 25, 1712).

Benjamin Franklin (American, 1706 – 1790), raised in Boston, MA, wrote in his autobiography: "My early readiness in learning to read

(which must have been very early), as I do not remember when I could not read." Franklin developed a positive outlook on life well beyond the limitations of his puritanical upbringing. He is considered one of the greatest thinkers of the 18th century and he is known to have embraced Christmas.

"A good conscience is a continual Christmas." – BENJAMIN FRANKLIN.

"O blessed Season! Lov'd by Saints and Sinners / For long Devotions, or for longer Dinners." – BENJAMIN FRANKLIN, *Poor Richard's Almanac* (Philadelphia, 1739).

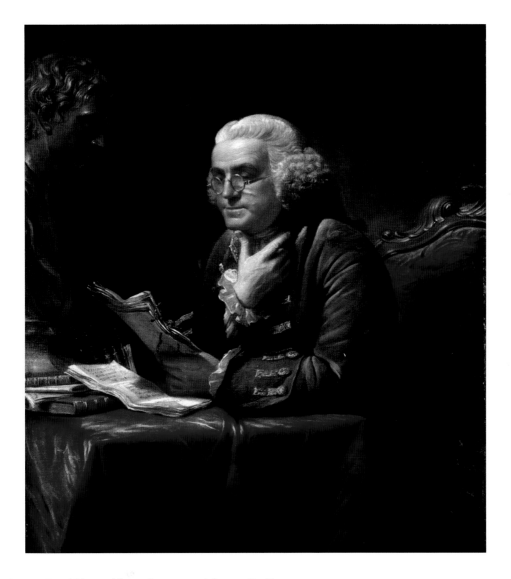

CREDIT: Artist – David Martin (Scottish, 1737 -1797) *Benjamin Franklin 1767.*

NOTE: "There being no type-foundry in the colony, his brother James (Benjamin Franklin's brother), during the preceding year, 1717, had been to England to procure the necessary apparatus for a printing-office, and on his return had established himself in Boston, as a printer . . . Benjamin Franklin at the age of twelve was duly indentured as an apprentice to his brother, so to continue till he should be twenty-one years old, and, for the closing year of the term, to be paid the full wages of a journeyman." - ORVILLE HOLLEY, *The Life of Benjamin Franklin* (G.F. *Cooledge & Brother,* 1848).

There was an old woman tossed in a blanket
 Seventeen times as high as the moon;
But where she was going no mortal could tell,
 For under her arm she carried a broom.

"Old woman, old woman, old woman," said I,
Whither, ah whither, ah whither so high?"
To sweep the cobwebs from the sky,
And I'll be with you by and by."

Little Jack Horner
 Sat in a corner
Eating a Christmas pie;
 He put in his thumb,
 And pulled out a plum,
And said: "Oh, what a good boy am I!"

A manuscript inscription of 1691, written to a page of a first edition of Cotton Mather's work - *The Triumphs of the reformed religion in America* (a biography of John Eliot 1691), is thought to be the earliest reference to the *Mother Goose Nursery Rhymes* in America.

> A man of words and not of deeds
> Is like a garden full of weeds
> And when the weeds begin to grow
> It's like a garden full of snow
> And when the snow begins to fall.

According to Percy B Green, author of *A History of Nursery Rhymes* (1899), the lines of the Puritan couplet were composed as a satire of King Charles II.

Mother Goose or *Mere L'Oye* is a collection of French fairy tales credited to Charles Perrault (French, 1628-1703) published in 1697 in France, 1786 in America. A pantomime based on the *Mother Goose* character debuted in London for Boxing Day 1806. The holiday production continues to amuse theatre goers each year. Elizabeth Foster Vergoose (American, 1665-1758) read poetry to her 16 children. Her son-in-law printed her poems as *Song for the Nursery or Mother Goose's Melodies* in 1719, causing confusion over the origin of the rhymes.

Harriet Elizabeth Beecher Stowe (American, 1811-1896), was born into a staunch Calvinistic Connecticut family. Her father Lyman Beecher was a preacher. She is best known for *Uncle Tom's Cabin*, which became the best-selling novel of the

CREDIT: *Richardson's Mother Goose, French Fairy Tales and English Nursery Rhymes*, Library of Congress.

NOTES: "*The Eliot Indian Bible* in the Natick dialect of the region's Algonquin tribes, printed in Cambridge Massachusetts (1660-1663) was the first complete Bible printed in the Western Hemisphere." - *Printed 1691, Earliest Extant Evidence of American Mother Goose?* February 28, 2009.

19th century. Her Christmas stories portray the changing progressive movement in the religious life of New England and the rise of the Episcopalian church – the church of Bishop Benjamin Moore – C.C.M.'s father.

Stowe's short story *Christmas In Poganuc* was published in *A Budget of Christmas Tales by Charles Dickens and Others* in 1895. In the story young "Dolly" ventures out on Christmas Eve to see for herself the festivities being held at the Episcopalian church in her village.

"'I wish, my dear,' said Mrs. Cushing, after they were retired to their room for the night, 'that to-morrow morning you would read the account of the birth of Christ in St. Matthew and give the children some advice upon the proper way of keeping Christmas.'

'Well, but you know we don't keep Christmas; nobody knows anything about Christmas,' said the Doctor. 'You know what I mean, my dear,' replied his wife. 'You know that my mother and her family do keep Christmas. I always heard of it when I was a child; and even now, though I have been out of the way of it so long, I cannot help a sort of kindly feeling toward these ways. I am not surprised at all that the children got drawn over last night to the service. I think it's the most natural thing in the world, and I know by experience just how attractive such things are. I shouldn't wonder if this other church should draw very seriously on your congregation; but I don't want it to begin by taking away our own children. Dolly is an inquisitive child; a child that thinks a good deal, and she'll be asking all sorts of questions about the why and wherefore of what she saw last night.'

He rose up early on the following Sabbath and proceeded to buy a sugar dog at the store of Lucius Jenks, and when Dolly came down to breakfast, he called her to him and presented it,

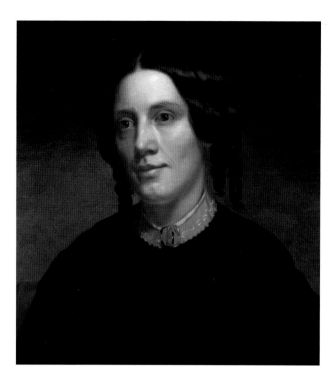

CREDIT: Artist – Alanson Fisher (American, 1807-1884). *Harriet Beecher Stowe*, 1853.

NOTES: The belief in witchcraft that permeated New England in the 1700s was propagated by the writings of Cotton Mather and his father Increase Mather. "I am resolved after this never to use but just one grain of patience with any man, that shall go to impose upon me a denial of devils or of witches." – COTTON MATHER, *Memorable Providences* (Boston, MA, 1688). Documents establish that the number of executions for witchcraft were thirty thousand in Britain in the 17th century and that between 1646 and 1692 thirty-two individuals were put to death for witchcraft in New England. None of whom were put to death by burning.

"The conditions of life in New England made such a publication (Cotton Mather's *Memorable Providences* 1689 and Increase Mather's *An Essay for recording the Illustrious Providences* - 1684) peculiarly dangerous. The human imagination, starved by asceticism, robbed of all natural and wholesome ailment, revenged itself by seizing greedily on the marvels presented to it."– Mr. J. A. Doyle, Puritan Colonies, Documented by Justin Winsor, *The Literature of Witchcraft in New England*, American Antiquarian Society.

Samuel Sewell immigrated to Salem, MA in 1662 and kept extensive diaries including how Christmas was spent in his parish. He was a judge in the Salem Witch Trials, and later apologized for participating. His diaries are useful in understanding the age in which he lived.

Christmas' or The Good Fairy, was printed for December 26, 1850, in the *National ERA*. Stowe's character practises "good fairyism" by remembering the less fortunate. It was one of many works written in the second half of the 19th century that emphasised Christian charity at Christmas including *Little Women*, written by Louisa May Alcott.

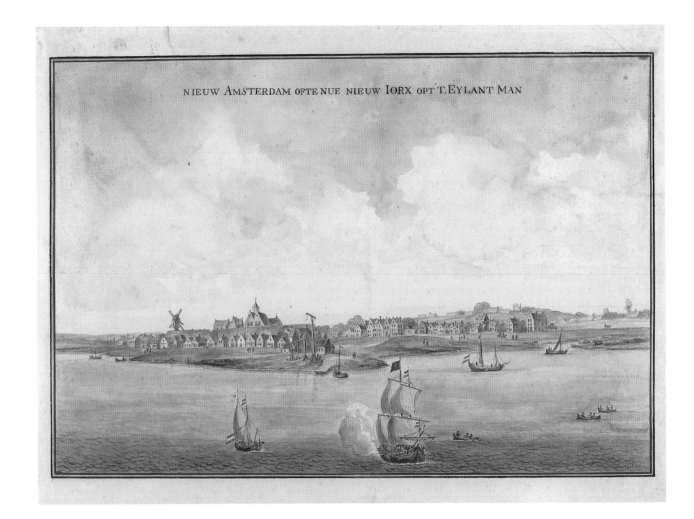

NIEUW AMSTERDAM OFTE NUE NIEUW IORX OPT'T EYLANT MAN

saying as he kissed her: 'Papa gives you this, not because it is Christmas, but because he loves his little Dolly.' 'But isn't it Christmas?' asked Dolly with a puzzled air. 'No, child; nobody knows when Christ was born, and there is nothing in the Bible to tell us when to keep Christmas.' And then in family worship the Doctor read the account of the birth of Christ and of the shepherds abiding in the fields who came at the call of the angels, and they sung the old hymn: 'While shepherds watched their flocks by night.'

'Now, children,' he said when all was over, 'you must be good children and go to school. If we are going to keep any day on account of the birth of Christ, the best way to keep it is by doing all our duties on that day better than any other. Your duty is to be good children, go to school and mind your lessons.'"

Although Christmas was celebrated on a regional and ethnic basis in colonial times, there is only one document that mentions Saint Nicholas in the colonies prior to 1740.

The earliest reference to St. Nicholas in the colonies is a baker's receipt made out by Wouter de Backer (Walter the Baker) to Maria (nee Loockermans) Van Rensselaer in 1675. Maria purchased "suntterclaesgoet" - which translates as "Sinterklass goods" or "St. Nicholas goods." The receipt is in the collection of the *Van Rensselaer Manor Papers*, held at the New York State Library.

Oloff Van Cortlandt (Dutch, 1600-1684), arrived in New Netherland in 1638 from Amsterdam as an employee of the Dutch West India Company. He married Annetje Loockermans (d. 1689). Annetje had arrived in 1642 from Turnhout, a region of Holland that had not converted to the Dutch Reform Church. Maria was their daughter. The couple's two sons, Stephanus (1643-1700) and Jacobus (1658-1739), were both mayors of the City of New York. The family became one of the wealthiest in the colonies, through their involvement in a successful brewery and trading business. Stephanus' daughter Maria married Jeremias Van Rensselaer and the couple lived in Albany, NY.

Catherine Elizabeth "Eliza" Taylor Moore, the wife of C.C.M., was of English, Scottish and Dutch "Van Cortlandt" ancestry, her mother Elizabeth Van Cortlandt, her grandparents Philip Van Cortlandt and Catherine Ogden. In the 1823 printing of *Twas The Night*, two of the reindeer's names represent the Dutch oath, "Dunder and Blitzen". Translated, this term reads as "thunder and lightning". For the four copies penned by C.C.M. in the 1850s, the two reindeer names are written in the translation of "Donder and Blitzen". It is plausible that "Eliza", with her Dutch heritage, had some influence over the poem – or possibly the naming of the reindeer.

CREDITS: Page 59: Artist unidentified. *Children Playing On The Ice In Winter* (Taber Prang Art Co. 1904).
Page 58: Artist unidentified. *The Miriam and Ira D. Wallach Division of Art, Prints and Photographs: Picture Collection: Nieuw Amsterdam ofte Nue Nieuw Iorx opt 'Teylant man (The New York Public Library Digital Collections*, 1915).

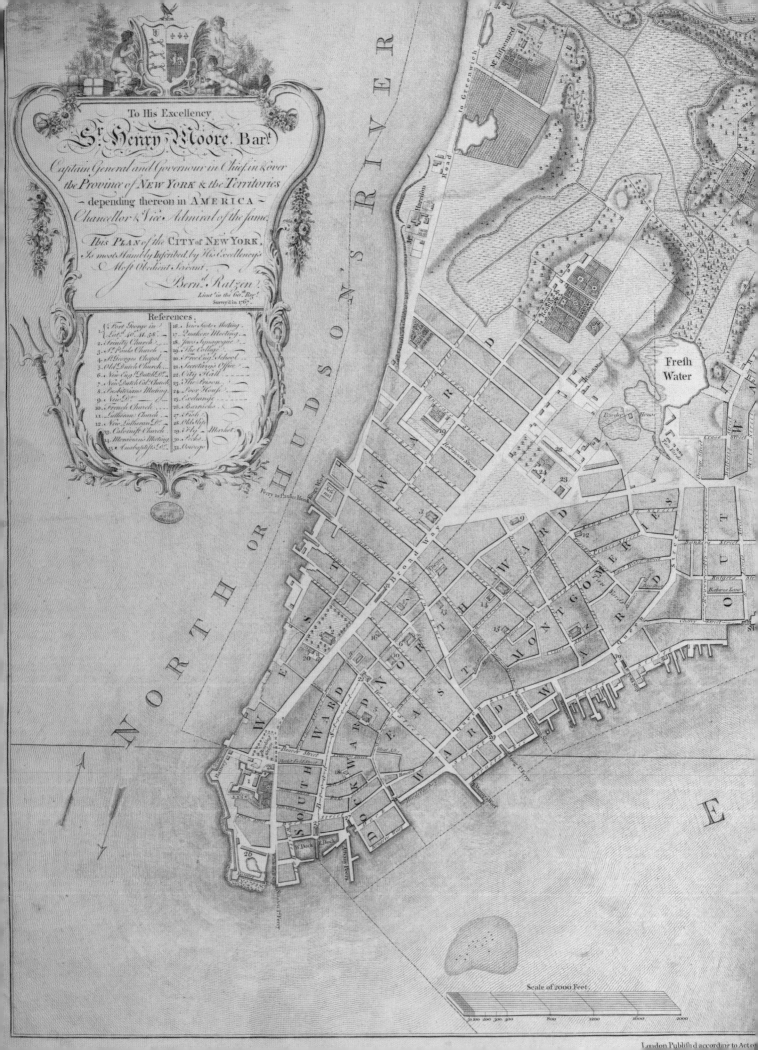

To His Excellency
Sr. Henry Moore, Bart.
Captain General and Governour in Chief in & over
the Province of NEW YORK & the Territories
— depending thereon in AMERICA —
Chancellor & Vice Admiral of the same.
This PLAN of the CITY of NEW YORK,
Is most Humbly Inscribed, by His Excellency's
Most Obedient Servant
Bernd. Ratzen.
Lieut. in the 60th. Regt.
Survey'd in 1767.

References.

1. Fort George in
 Lat. 40.° 41.° 58."
2. Trinity Church
3. St. Pauls Church
4. St. Georges Chapel
5. Old Dutch Church
6. New Eng. Dutch Do.
7. New Dutch Cal. Church
8. Presbyterians Meeting
9. New Do.
10. French Church
11. Lutheran Church
12. New Lutheran Do.
13. Calvinist Church
14. Moravians Meeting
15. Anabaptists Do.

16. New Scots Meeting
17. Quakers Meeting
18. Jews Synagogue
19. The College
20. Free Eng. School
21. Secretary's Office
22. City Hall
23. The Prison
24. Poor House
25. Exchange
26. Barracks
27. Fish
28. Old Slip
29. Fly Market
30. Picks
31. Oswego

NORTH OR HUDSON'S RIVER

EAST RIVER

WEST WARD

SOUTH WARD

DOCK WARD

EAST WARD

MONTGOMERY WARD

OUT WARD

Fresh Water

Powder House

to Greenwich

Mr. Lespenard

Mr. Harrison

Broadway

Road

Ferry to Paulus Hook

Scale of 2000 Feet.

London Publish'd according to Act of

Henry Livingston Jr. identified himself as a Scotsman through his lineage to Robert Livingston (Scottish, 1654-1728 American). R. Livingston came to the colonies in 1674 and became the secretary to Nicholas Van Rensselaer. Van Rensselaer was a Dutch Reform clergyman and brother of Jeremias Van Rensselaer, husband of Maria. Henry Livingston's first wife was of British descent; his second wife of Scottish heritage.

C.C.M.'s first ancestor to the colonies was John Moore of British and Scottish descent; arriving in New England in 1647. He was the first minister in Middleburg, which become Newton, and then Elmhurst. Moore was involved in politics and in the founding of Harvard University. The family's Newton Pippin apples were the first commercial apples grown in America, enjoyed by George Washington and Queen Anne of England. Throughout C.C.M.'s life the estate stayed in the ownership of his family, however, most of the land had been sold by the early 1800s. The Elmhurst community had long celebrated their connection with the poem and until the property was taken over for the construction of the Elmhurst subway station, children would visit the homestead on Christmas Eve.

In 1750, Major Thomas Clarke (British, 1692-1776 American), C.C.M.'s maternal grandfather bought 94 acres of farmland on Manhattan Island from Jacob Somerindyck for $5,000. The land ran from the Hudson River to 8th Avenue, from 21st to 24th Street. He named the property Chelsea after a veteran's hospital in London, England. Sir Peter

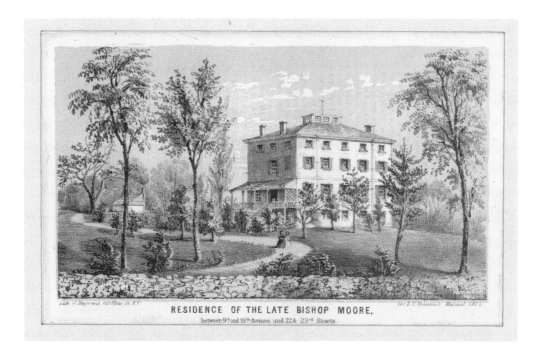

RESIDENCE OF THE LATE BISHOP MOORE,
between 9th and 10th Avenues and 22 & 23rd Streets.

CREDIT: Page 60: *To his excellency Sr. Henry Moore this plan of the city of New York. The New York Public Library Digital Collections* (1776).

Page 61: Residence of the late Bishop Moore between 9th and 10th Avenue and 22nd and 23rd Streets. *The New York Public Library Digital Collections*, 1801 - 1886.

NOTE: A portion of Moore's Elmhurst property was designated for a park in 1954, named The Moore Homestead Park in 1987. A major expansion of the park's C.C. Moore Homestead Playground was completed in 2022.

Warren's property to the south of Chelsea was named Greenwich - after London's Green, wich Hospital. Major Clarke married Mary "Mollie" Stillwell (American, 1714-1802), who was a descendent of early colonist Nicholas Stillwell (British, 1603-1671 American). In 1776, Chelsea was destroyed by a fire that also claimed the life of Major Thomas Clarke. The home was rebuilt out of brick in the Regency style. Many homes during this era burned during winter when fires and candles were ablaze and water reserves were frozen. In 1822, Chelsea was the home of C.C.M. and his wife and young family, along with his mother Charity Clarke Moore.

Between 1768 and 1774, as the conflict between the British Government and the colonies was brewing, Charity Clarke (American, 1747-1838), wrote a series of letters to her cousin Joseph Jekyll in London, England. "November 6, 1768: When there is the least show of

oppression or invading of liberty you may depend on working ourselves to the utmost of our power. March 31, 1769: The attention of every American is now fixed on England. The last accounts from hence are very displeasing to those who wish a good understanding between Britain and her colonies. September 10, 1774: On what instance pray are the Americans called Rebels? What have they done to deserve the name? They have asserted their rights and are determined to maintain them. Great Britain stands ready to destroy her sons for inheriting her spirit ”

The second identified reference to St. Nicholas from the colonial period is an announcement printed in the *Rivington Gazette* for December 23, 1773: “Last Monday the anniversary of St. Nicholas, otherwise called Santa Claus, was celebrated at Protestant Hall, at Mr. Waldron’s, where a great number of sons of that ancient saint celebrated the day with great joy and festivity.”

commercial interests in the region. In 1822, the northern bank of the St. Johns River, that was controlled by the British became of the town of Jacksonville with the southern bank being retained by the Spanish as San Nicolas.

The Rare Book and Manuscript Library, at Columbia University Library, holds the original letters written by Charity Moore, letters she wrote to her sister, Lady Mary Clarke Vassal Affleck, and to other family members and friends; a letter C.C.M. wrote to his cousin Lady Mary Elizabeth Fox Powys Lilford in 1840 and his diary of 1856-1863, with notations up until two days before his death. The front page of the diary reads: “A diary which ought to have begun at least sixty years ago”. Clement C. Moore, city of New York, Nov.20, 1856.

NOTES: When Robert "Robbie" Burns submitted *Auld Lang Syne* to the Scots Musical Museum in 1788, he wrote of the poem: "The following has never been in print, nor even in manuscript until I took it down from an old man." During the 1840s, abolitionist William Lloyd Garrison, applied new words to *Auld Lang Syne*, to stir up enthusiasm for emancipation.

The papers of first American president George Washington (1732-1799) are held in the Manuscript Division of the Library of Congress. They constitute the largest collection of original Washington papers and consist of approximately 77,000 items accumulated by Washington between 1745 and 1799. Included are documents pertaining to Washington's childhood education, career and experiences as a surveyor, as a militia colonel, as a politician, as general of the Continental Army during the Revolutionary War, and his presidency of the Constitutional Convention in 1787, and two terms as president (1789-1797), life in retirement, management of Mount Vernon, Virginia and on the lives of his family, servants, and slaves. Washington's papers are a valuable resource for almost virtually every aspect of colonial and early American life.

William B. Ellery (American, 1727-1820) of Newport, RI, a signer of the *Declaration of Independence*, was related to C.C.M. through the Moore lineage.

December 16, 1773: The Boston Tea Party. Patriots protested the *British Tea Act* and taxation without representation.

April 19, 1775: First shots of the Revolutionary War were fired at Lexington and Concord, MA.

December 25, 1775: Missionary Philip Fithian wrote in his diary while staying with Scottish Presbyterians in Virginia: "Christmas morning – Not a gun is heard – no company or cabal assembled – today is like other days every way calm & temperate – people go about their business with the same readiness & apply themselves to it with the same industry." Documented in *The Colonial Williamsburg Interpreter*, vol. 16, no. 4, 1995-1996.

July 4, 1776: The United States *Declaration of Independence* was adopted by the Second Continental Congress.

September 16, 1776: The location of General Washington's first battlefield victory in the Revolutionary War - The Battle of Harlem was chosen as the site for the St. Nicholas of Myra Park of NYC in 1906. It is located at the intersection of St. Nicholas Avenue, 127th Street, St. Nicholas Terrace and 141st Street.

December 25, 1776: General George Washington with his troops crossed the Delaware River in a surprise attack and defeated a garrison of Hessian mercenaries stationed at Trenton, New Jersey. The estimated casualties were five Americans and twenty-two British.

December 25, 1777: Hendrick Roddemore, a hessian soldier, put up a Christmas tree in Windsor Locks, CT. It is the first identified Christmas tree in America.

April 20, 1778: Rev. Benjamin Moore married Charity Clarke, at Trinity Church, New York, NY. Their only son C.C.M. was born on July 15, 1779.

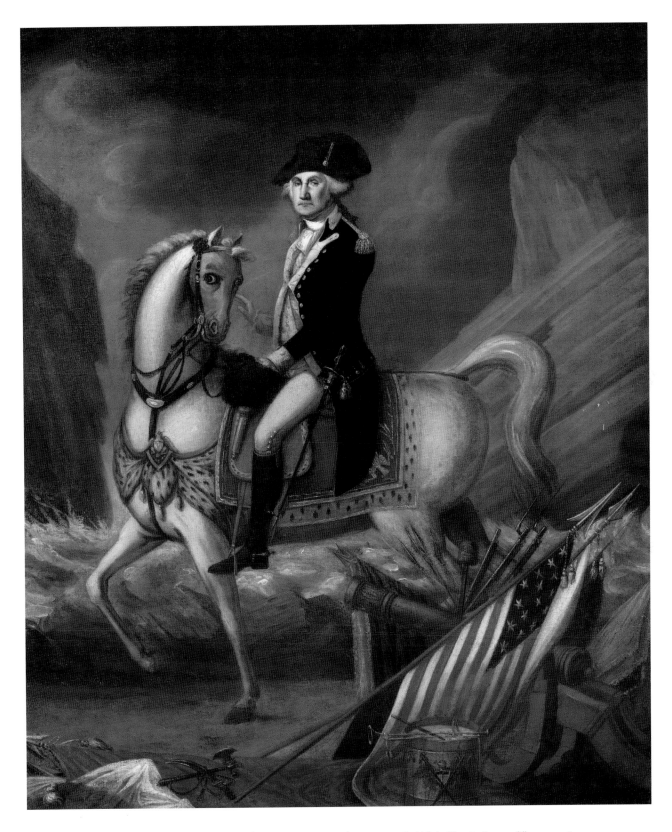

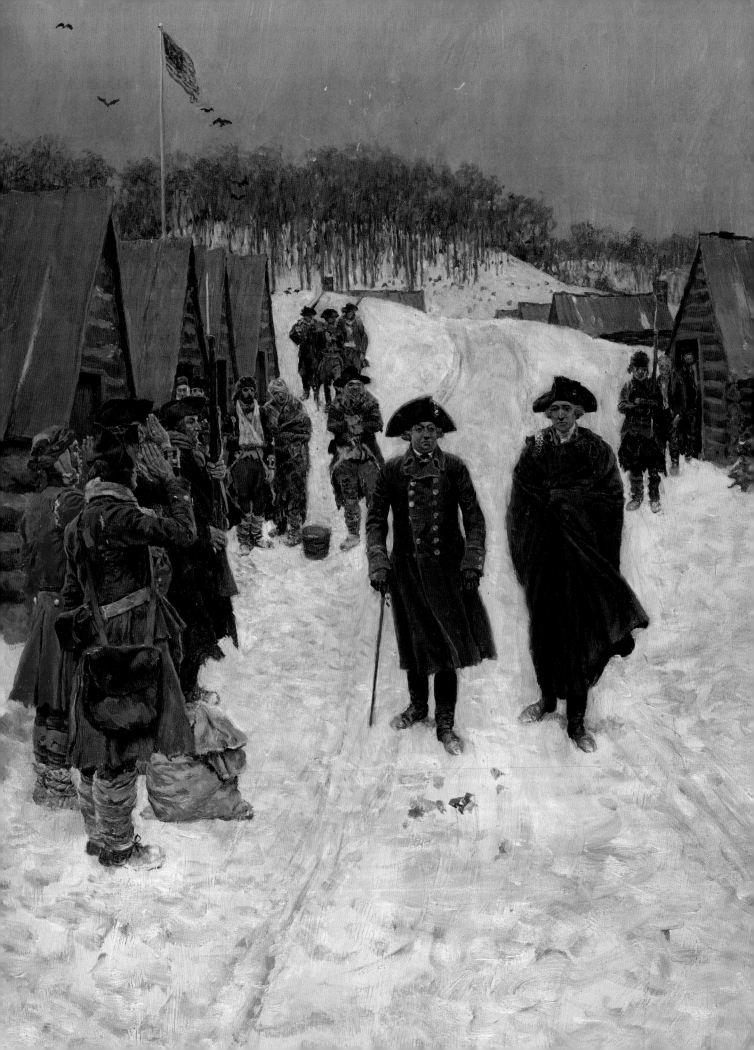

October 19, 1781: The fighting of the Revolutionary War came to an end when British General Charles Cornwallis surrendered at the Siege of Yorktown.

September 3, 1783: The Treaty of Paris officially ends the war with the ratification of the independence of the 13 North American states.

November 25, 1783: The British troops leave the colonies.

December 23, 1783: George Washington, as Commander in Chief of the Continental Army, addressed the Continental Congress in Annapolis, MD, to resign his military commission, a position he had been appointed to on May 9, 1775. After his speech he departed for Mount Vernon, Virginia, for his first Christmas at home in nine years.

April 30, 1789: First inauguration of George Washington as the First President of the United States. Bishop Benjamin Moore (American, 1748-1816) attended the ceremony.

Christmas Eve, 1805: *The Commercial Advertiser* of January 31, 1806, reported that on December 24, musket fire had hit the Rochelle, NY home of Thomas Paine (British, 1737–1809, American) - narrowly missing him. Paine's argument for American independence from British rule, published in 1776 in a pamphlet entitled *Common Sense*, became the most read original work in 18th century America.

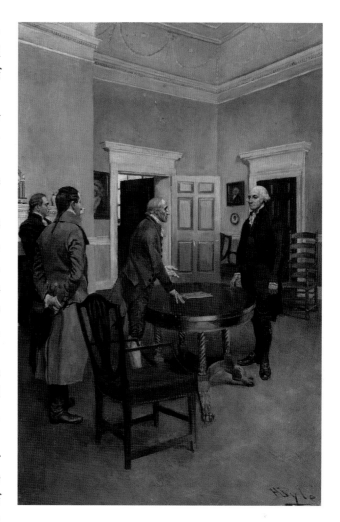

CREDITS: Page 66: Artist - Howard Pyle (American, 1853-1911) *Washington and Von Steuben at Valley Forge*, ca 1890-1896.
Page 67. Top: Artist – Howard Pyle. *Thompson, The Clerk of Congress, Announcing to Washington, At Mount Vernon, His Election To The Presidency*, ca. 1890-1896.
Bottom: Artist – Howard Pyle. *The Revolt of the Holiday*, 1883.

NOTES: Howard Pyle was a prominent American illustrator of the 19th century. Vincent van Gogh wrote in a letter to his brother that the work of Pyle "struck me dumb with admiration." Howard Pyle's only published illustrations of the character Santa Claus were produced for "*The Revolt of the Holidays*". The book was written

by E.I. Stevenson and published in *Harper's Young People* for December 18, 1883. The two now faint original drawings are held by the Delaware Art Museum.

"I find that *Common Sense* is working a powerful change there in the minds of many men. Few pamphlets have had so dramatic an effect on political events." – George Washington. Documented by the Thomas Paine Society.

CHAPTER 4

An American Saint

Washington Irving, certainly the country's most famous resident, became one of the nation's most beloved and respected citizens and is considered by many as this country's first genuinely American author. The village of Irvington renamed itself in his honor during his lifetime and by the time he died in 1859, both the man and his house in Tarrytown were almost national shrines. A romantic best remembered for his humorous sketches; Washington Irving conceded that he "looked at things poetically rather than politically." Irving also observed, "I have always had an opinion that much good might be done by keeping mankind in good humor with one another When I discover the world to be all that it has been represented by sneering cynics and whining poets, I will turn to and abuse it also." – TESSA MELVIN, *The Washington Legacy, The New York Times*, April 3, 1983.

Washington Irving (American, 1783 – 1859) is best known for his humorous *The History of New York From The Beginning of the World To The End of the Dutch Dynasty* (1809), herein referred to as *Knickerbocker*, which he published under the name of Diedrich Knickerbocker, and for *The Sketch Book of Geoffrey Crayon, Gent.* (1819-1820), to be referred to as *The Sketch Book*. His iconic *The Legend of Sleepy Hollow* and *Rip Van Winkle*, along with five chapters of stories set at Christmas were published in *The Sketchbook*. Irving's last work was a multi volume biography on the life of George Washington which he finished just months before his death.

Knickerbocker was published on St. Nicholas Day 1809 and Irving dedicated the work to the New York Historical Society of which he was a member. Sir Walter Scott wrote to Irving's close friend and business manager Henry Brevoort upon reading *Knickerbocker*: "I beg to accept my best thanks for the uncommon degree of entertainment which I have received from the most excellently written history of New York . . . I have been employed these few evenings in reading them aloud to Mrs. Scott and two ladies who are our guests, and our sides have been absolutely sore with laughing." William Cullen Bryant wrote of his fellow Knickerbocker's work: "I can remember learning a passage from it for a declaration and drawing myself in laughter."

With the literary success of *Knickerbocker* Irving abandoned the profession of law; with the release of *The Sketchbook* he became an internationally acclaimed writer. "A work like the *Sketchbook*, welcomed on both sides of the Atlantic, showed the possibility of an American author acquiring a fame bounded only by the limits of his own language, and gave an example of the qualities by which it might be won." – WILLIAM CULLEN BRYANT.

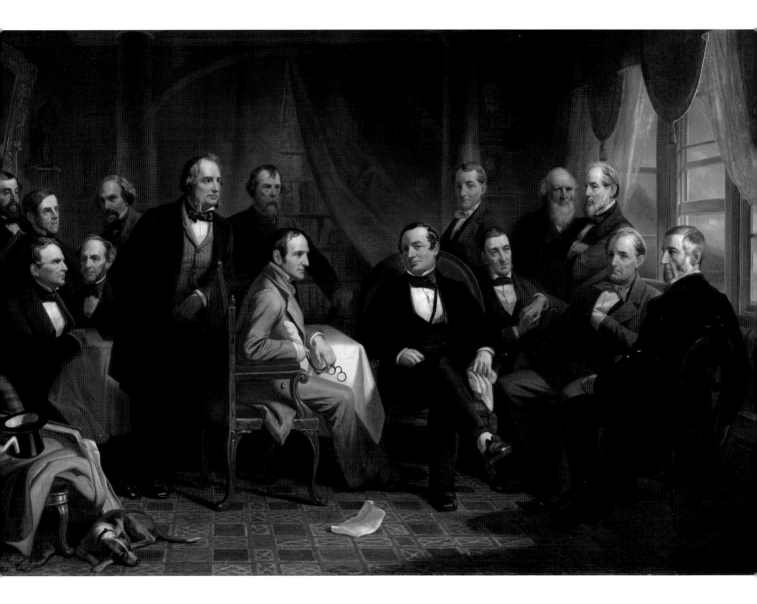

The Knickerbockers came to refer to an informal group of writers of the early 19th century primarily of New York to which C.C.M. was a peripheral member.

"They (the Knickerbocker writers) were our first crop . . . they did something toward fertilizing the soil from the products of which we are getting a part of our food." – *Nation*, December 5, 1867.

CREDIT: Artist - Christian Schussele (French, 1824-1879 American) composition designed by Felix Octavius Darley, *Washington Irving and his Literary Friends at Sunnyside*. National Portrait Gallery, Smithsonian Institute. The sitters are listed on the following page. Page 68. *Washington Irving; Commemoration of the Birth and Death of the Great Historian. Eulogy Delivered Before the New-York Historical Society by William Cullen Bryant*. April 4, 1860.
Sir Walter Scott, Abbotsford, letter signed to Henry Brevoort, April 23,1813. Boston Public Library.

The sitters in portrait on page 69:
Washington Irving (1783-1859)
Henry Theodore Tuckerman(1813-1871)
William Cullen Bryant (1794-1878)
Henry Wadsworth Longfellow (1807-1882)
John Pendelton Kennedy (1795-1870)
Nathaniel Parker Willis (1806-1860)
James Kirke Paulding (1778-1860)
Oliver Wendell Holmes (1809-1894)
Nathaniel Hawthorne (1804-1864)
William Hickling Prescott (1796-1859)
Ralph Waldo Emerson (1803-1882)
James Fenimore Cooper (1789-1851)
George Bancroft (1800-1891)
William Gilmore Simms (1806-1870)
Fritz-Greene Halleck (1790-1867)
Other Knickerbockers include:
James Russell Lowell (1819-1891)
Charles Fenno Hoffman (1806-1884)
Clement C. Moore (1779-1863)
Gulian C. Verplanck (1786-1870)
Samuel Woodworth (1784-1842)
James Gordon Percival (1795-1856)
Lydia M. Child (1802-1880)
Bayard Taylor (1825-1878)
Joseph Rodman Drake (1795-1820)
Robert Charles Sands (1799-1832)

"If you young writers will consult their own taste and genius and forget there ever were such writers as Scott (Sir Walter Scott), Byron (Lord Byron), and Moore (Thomas Moore), I will be bound they produce something original; and a tolerable original is as much superior to a tolerable imitation, as a substance is to a shadow. Give us something new – something characteristic of yourselves, your country, and your native feelings, and I don't care what it is. I am somewhat tired of licentious love ditties, border legends, affected sorrows, and grumbling misanthropy. I want to see something wholesome, natural, and national. The best thing a young American writer can do, is forget that any body ever wrote before him; and above all things, that there are such caterpillars as critics in this world." - JAMES K. PAULDING.

CREDITS: Artist – Edwin Austin Abbey (American, 1852-1911) Study of figure scene in seventeenth century Dutch costume, New Amsterdam.

James K. Paulding, *The Southern Literary Messenger*, Vol I, No1, August 1834.

NOTES: Herman Jansen Van Wye Knickerbocker was an early Dutch colonial settler. Washington Irving was acquainted with his descendants. The family's home, constructed in ca 1780, operates as a museum in Schaghticoke, NY. Anne McVicar Grant was brought by her father to America to be raised by the Schuyler family of Albany, NY, relations of the wife of Alexander Hamilton. Writing in Scotland in adulthood she authored - *Memoirs of an American Lady* in which she documents the customs of the Albany area at the end of the 18th century, including winter holiday activities including sledding and antics of young boys who steal turkeys. Her writing was greatly admired by Sir Walter Scott.

In 1783, the City of New York had a population of an estimated twenty thousand inhabitants.

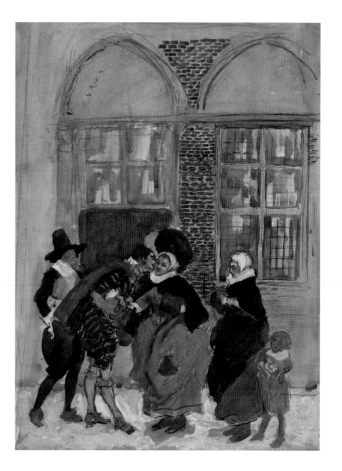

"Washington Irving was born in New-York on the third day of April 1783, but a few days after the news of the treaty with Great Britain, acknowledging our independence, had been received, to the great contentment of the people. He opened his eyes to the light, therefore, just in the dawn of that sabbath of peace which brought rest to the land after a weary seven years' war — just as the City, of which he was a native, and the Republic, of which he was yet to be the ornament, were entering upon a career of greatness and prosperity, of which those who inhabited them could scarce have dreamed. It seems fitting that one of the first births of the new peace, so welcome to the country, should be that of a genius as kindly and fruitful as peace itself, and destined to make the world better and happier by its gentle influence

William Irving, the father of the great author, was a native of Scotland — one of a race in which the instinct of veneration is strong — and a Scottish woman was employed as a nurse in his household. It is related that one day while she was walking in the street with her little charge, then five years old, she saw General Washington in a shop, and entering, led up the boy, whom she presented as one to whom his name had been given. The General turned, laid his hand upon the child's head, and gave him his smile and his blessing, little thinking that they were bestowed upon his future biographer. The gentle pressure of that hand Irving always remembered, and that blessing, he believed, attended him through life. Who shall say what power that recollection may have had in keeping him true to high and generous aims

In 1832 Irving returned to New-York. He returned after an absence of seventeen years to find his native city doubled in population; its once quiet waters alive with sails and furrowed by streamers passing to and fro, its wharves crowded with masts, the heights which surround it, and which he remembered wild and solitary and lying-in forest, now crowned with stately country seats, or with dwellings clustered in villages, and everywhere activity and bustle of a prosperous and hopeful people. And he, too, how had he returned? The young and comparatively obscure author, whose works had only found here and there a reader in England, had achieved a fame as wide as the civilized world. All the trophies he had won in this field he brought home to lay at the feet of his country. Meanwhile all the country was moved to meet him; the rejoicing was universal that one who had represented us so illustriously abroad was henceforth to live among us." *Washington Irving; Commemoration of the Birth and Death of the Great Historian. Eulogy Delivered Before the New-York Historical Society* by William Cullen Bryant. April 4, 1860. The complete eulogy is available online via *The New York Times*.

During the American Revolution symbols of British rule in the colonies were being abandoned, the names of institutions, and streets in the cities changed. Holidays such as the Queen's Birthday of January 18, King Charles' Martyrdom Day - January 30, Saint George's Day - April 23, King Charles' Restoration Day - May 29, Prince of Wales Birthday - August 12, Coronation Day - September 22, Accession Day - October 25, All

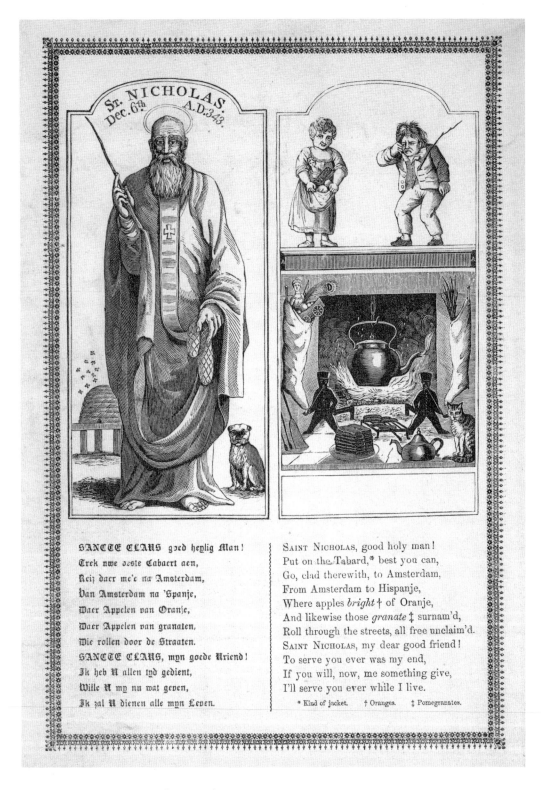

CREDIT: Artist - Alexander Anderson (American) *The first celebration of the festival of St. Nicholas by the New-York Historical Society, December 6, 1810* (Library of Congress, 1864).

NOTE: The New York Historical Society was established in 1804 as New York's first museum. The eleven founders were John Pintard, William Linn, John N. Abel, Samuel Bayard, David Hosack, Anthony Bleecker, Samuel Miller, John M. Mason, Dewitt Clinton, Peter G. Stuyvesant, Egbert Benson. Bishop Benjamin Moore was also involved with its establishment.

Saint's Day - November 1, Powder Plot Day - November 5, became a thing of the past. In 1775, Pope Day had been stricken from the colonial calendar.

In 1793, New Yorker and patriot John Pintard recorded in his personal almanac the date of St. Nicholas Day, and George Washington's birthday as a special day of commemoration. Doing so well before the President's birth became a national holiday. John Pintard was particularly interested in seeing Saint Nicholas become the patron saint of the City of New York. In association with the newly formed New York Historical Society, for which Pintard had drafted the constitution, at his instigation the saint began to be honored by the society's membership at an annual banquet held on St. Nicholas Day.

At the 1809 New York Historical Society St. Nicholas Banquet a toast was read: "To the memory of St. Nicholas. May the virtuous habit simple manners of our Dutch ancestors be not lost in the luxuries and refinement of the present time." The interest in the revival or establishment of Saint Nicholas reflected Pintard's desire to create a sense of identity for the city. It was a sentiment shared by Irving who wrote: "The main object of my work . . . was to embody the traditions of our city in an amusing form; to illustrate its local humors, customs, and peculiarities; to clothe home scenes and places and familiar names with those imaginative and whimsical associations so seldom met with in our new country, but which live like charms and spells about the cities of the Old World, binding the heart of the native inhabitants to his home." *Old South Leaflets*, series 3, no 69, p. 23. (Documented by Charles W. Jones, *Saint Nicholas of Myra, Bari, and Manhattan*, University of Chicago Press, 1978).

For the St. Nicholas Day Banquet held on December 6, of 1810, John Pintard commissioned a broadsheet that was distributed at the event.

Saint Nicholas, good holy man!
Put on the Tabard, best you can,
Go, clad therewith, to Amsterdam,
From Amsterdam to Hispanje,
Where apples bright of Oranje,
And likewise those granate surnam'd,
Roll through the streets, all free
Unclaim'd.
SAINT NICHOLAS, my dear good friend!
To serve you ever was my end,
If you will, now, me something give,
I'll serve you ever while I live.

CREDIT: Artist – Charles R. Leslie (British, 1794-1859) *Washington Irving* 1820 (New York Public Library).

NOTE: Irving was the first Chairman of the Astor Library, the forerunner of the New York Public Library.

Excerpts from: *Salmagundi or the Whims-Whams and Opinions of Launcelot Langstaff, Esq. & Others*, penned by Washington Irving, James Kirke Paulding and Irving's brother William, published by Longworth between January 24,1807 and January 25, 1808. The work includes the first literary mention of St. Nicholas by an American writer and the beginning of the construction of the American Saint – Santa Claus.

January 25, 1808: "This honest grey-beard custom of setting apart a certain portion of this good-for-nothing existence, for purposes of cordiality, social merriment, and good cheer, is one of the inestimable relicks handed down to us from our worthy Dutch ancestors. In perusing one of the manuscripts from my worthy grandfather's mahogany chest of drawers, I find the new year was celebrated with great festivity during that golden age of our city, when the reins of government were held by the renowned Rip Van Dam, who always did honour to the season, by *seeing out the new year*, a ceremony which consisted of plying his guests with bumpers, until not one of them was capable of seeing.

In his days, according to my grandfather, were first invented those notable cakes, *hight new-year cookies*, which originally were impressed on one side with the honest burley countenance of the illustrious Rip, and on the other with that of the noted St. Nicholas, vulgarly called Santaclaus - of all the saints in the kalendar the most venerated by the true hollanders, and their unsophisticated descendants. These cakes are to this time given on the first of January, to all visitors, together with a glass of cherry-bounce, or raspberry-brandy. It is with great regret; however, I observe that the simplicity of this venerable usage has been much violated by modern pretenders to style, and our respectable new-year cookies, and cherry-bounce, elbowed aside by plumb-cake and outlandish liqueurs, in the same way that our worthy old Dutch families are out dazzled by modern upstarts, and mushroom cockneys."

NOTES: In 1798, at five years of age Washington Irving was sent to live with the Paulding family in Tarrytown, NY, to escape an outbreak of yellow fever in the City of New York. He and Paulding maintained a lifelong friendship with Paulding marrying Irving's sister and one of Irving's brothers marrying into the Paulding family. After *Knickerbocker* Irving reworked passages, adding and deleted lines and sections, including his references to St. Nicholas, for decades. He did not continue to write about St. Nicholas, however, he did continue to write about Christmas. Paulding wrote on his own about Santa Claus in several publications including *The Book of St. Nicholas* in 1836.

The use of the word 'Gotham" in association with New York City first appeared in *Sagamundi*.

James Kirke Paulding (American, 1778-1860) wrote to Washington Irving on January 20, 1820:
"In reading over the last edition of Knickerbocker, after some years during which I had not looked into it, I was struck with several enormous plagiarisms. I had unconsciously committed upon you. The public may not, but you who know me I hope will, give me credit when I assure you, I was not aware of the offence. Indeed, my memory is of that vague kind, that half the time I can't distinguish between my own ideas and those I have from books. These I believe are all the sins I can at present charge myself with on the score of apparent rivalry, or plagiarism, against my old friend Farewell, and believe me your friend, J. K. Paulding."

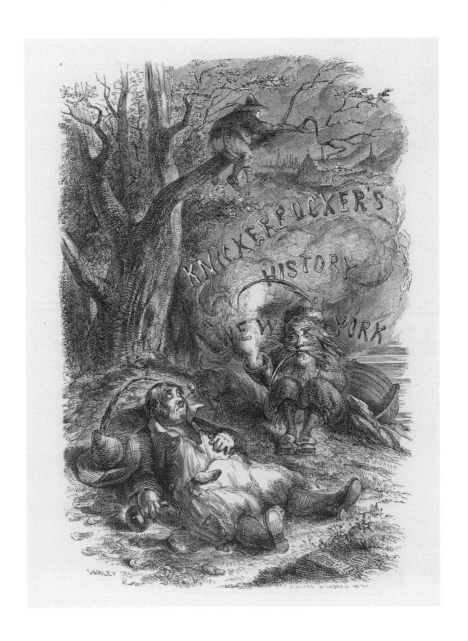

Excerpts from Washington Irving's *Knickerbocker*: Chapter II - "Containing an account of a mighty Ark which floated, under the protection of St. Nicholas: The architect, who was somewhat of a religious man, far from decorating the ship with pagan idols, such as Jupiter, Neptune, or Hercules (which heathenish abominations, I have no doubt, occasion the misfortunes and shipwreck of many a noble vessel) he I say, on the contrary, did laudably erect for a head, a goodly image of St. Nicholas, equipped with a low, broad brimmed hat, a huge pair of Flemish trunk hose, and a pipe that reached to the end of the bow-spirit . . . " – *Knickerbocker.*

CREDIT: Artist – F.O.C. Darley (American, 1822-1888) *The Knickerbocker Sketches from the History of New York*, J.B. Lippincott & Company, 1886.

"And as of yore, in the better days of man, the deities were wont to visit him on earth and bless his rural habitations, so we are told, in the sylvan days of New Amsterdam, the good St. Nicholas would often make his appearance in his beloved city of a holiday afternoon, riding jollily among the tree-tops, or over the roofs of houses, now and then drawing forth magnificent presents from his breeches pockets, and dropping them down the chimney of his favorites. Whereas, in these degenerate days of iron and brass he never shows the light of his countenance, nor ever visits us, save one night of the year, when he rattles down the chimney of the descendants of patriarchs, confining his presents merely to the children, in token of the degeneracy of the parents." - *Knickerbocker.*

CREDIT: Artist - Edward W. Kemble (American, 1861-1933) *Knickerbocker's History of New York* by Washington Irving (G.P. Putnam's Sons, NY, and London, The Knickerbocker Press, 1894).

"Every man who voluntarily submitted to the authority of his British Majesty should retain peaceful possession of his house, his vrouw, and his cabbage garden. That he should be suffered to smoke his pipe, speak Dutch, wear as many breeches as he pleased, and import bricks, tiles and stone jugs from Holland, instead of manufacturing them on the spot Finally that he should have all the benefits of free trade, and should not be required to acknowledge any other saint in the calendar than St. Nicholas, who should thenceforward, as before, be considered the tutelar saint of the city.

Chapter V: And the safe *Oloffe* dreamed a dream, and lo! the good St. Nicholas came riding over the top of the trees in that self-same wagon wherein he bring his yearly presents to children, and he came and descended hard by where the heroes of Communipaw had made their late repast; and he lit his pipe by the fire and sat himself down and smoked, and, as he smoked, the smoke from his pipe ascended into the air and spread like a cloud overhead And when St. Nicholas had smoked his pipe, he twisted it in his hatband, and laying his finger beside his nose, gave the astonished Van Kortlandt a very

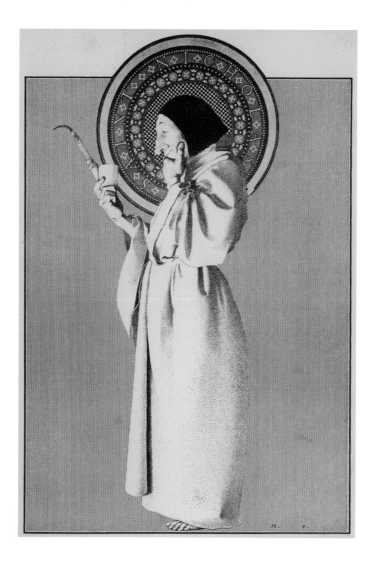

significant look; then, mounting his wagon, he returned over the tree-tops and disappeared." – *Knickerbocker*.

Charles Jones wrote in 1954 – "without Irving there would no Santa Claus. *The History* contains two dozen allusions to him, many of them among the most delightful flights of imagination in the volumes. Here is the source of all the legends of N (St. Nicholas) in New Amsterdam – of the emigrant ship Goede Vrouw, like a Dutch matron as broad as she was long, with a figurehead of Saint Nicholas as the prow; here are the descriptions of festivities on N Day in the colony, and of the church dedicated to him; here is the description of Santa Claus bringing gifts, parking his horse and wagon on the roof while he slides down the chimney – all sheer fiction produced by Irving's *Salmagundi* crowd." – Charles W. Jones, *Knickerbocker Santa Claus* (New York Historical Society, 1954).

CREDIT: Pages 78 and 79: Artist Maxfield Parrish (American, 1870-1966) *Knickerbocker's History of New York* by Washington Irving, Dodd Mead & Company, NY, 1915.

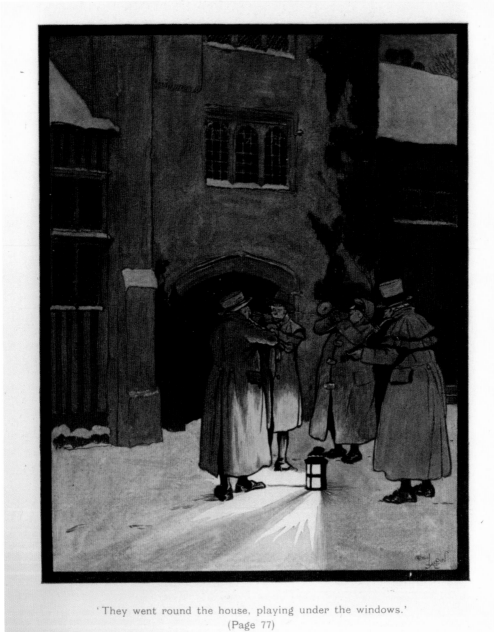

'They went round the house, playing under the windows.'
(Page 77)

"*Deidrich Knickerbocker*, I have worn to death in my pocket, and yet I should show you his mutilated carcass with a joy past all expression," – CHARLES DICKENS.

"I wish to travel with you . . . down to Bracebridge Hall (a fictional location)." – CHARLES DICKENS.

CREDIT: Artist - Cecil Aldin (British, 1870-1935) *Old Christmas* by Washington Irving (Hodder & Stoughton, London, 1908).

In 1817, Washington Irving traveled to Scotland to visit Sir Walter Scott at Abbotsford. Whereupon Scott introduced Irving to German literature and folktales, as well as to the superstitions found in antiquarian books he had amassed through the auspices of book collector Richard Heber. *The Sketch Book*, with its famous spooky tales and five Christmas stories was published in serialized format between 1818-1819. In 1822, Irving expanded upon the characters first introduced in *The Sketch Book* and of the jolly Christmas at *Bracebridge*. Since 1927, the Washington Irving Society has hosted Bracebridge Dinners at the Ahwahnee Hotel in Yosemite National Park. Photographer Ansel Adams was the director of the first Bracebridge Dinner and performed as one of the main characters.

"He (Irving) did not 'invent' the holiday, but he did all he could to make minor customs into major customs – to make them enriching signs of family and social togetherness." ANDREW BURSTEIN, biographer (Documented in Daniel Heitman, *How Washington Irving Shaped Christmas in America*, (*Humanities*, Fall 2016, Volume 37, Number 4).

Excerpt from *The Sketch Book: Christmas Day*: "When I awoke the next morning, it seemed as if all the events of the preceding evening had been a dream, and nothing but the identity of the ancient chamber convinced me of their reality. While I lay musing on my pillow, I heard the sound of little feet pattering outside of the door, and a whispering consultation. Presently a choir of small voices chaunted forth an old Christmas carol, the burden of which was 'Rejoice, our Saviour he was born. On Christmas day in the morning.'

I rose softly, slipt on my clothes, opened the door suddenly, and beheld one of the most beautiful little fairy groups that a painter could imagine. It consisted of a boy and two girls, the eldest not more than six, and lovely as seraphs. They were doing the rounds of the house and singing at every chamber door, but my sudden appearance frightened them into mute bashfulness. They remained for a moment playing on their lips with their fingers, and now and then stealing a shy glance from under their eyebrows, until as if by one impulse, they scampered away, and as they turned an angle of the gallery, I heard them laughing in triumph at their escape." – WASHINGTON IRVING

NOTE: "Now mark the picture of the present time: Instead of a firm roast beef, that fragrant pudding, our tables groan with luxuries of France and India. Here a lean fricassee rises in the room of majestic ribs, and there a scoundrel syllabub occupies the place of our well-beloved Home brewed. The solid meal gives way to the slight repast and forgetting that good eating and good poerter are two greater supporters of the *Magna Carter* and the *British Constitution*, we open our hearts and our mouths to new fashions in cookery, which will one day lead us to ruin. Writing from London." – *An Old Fellow* (*The Virginia Gazette*, 1772).

"The way was long, the night was cold, The Minstrel was infirm and old." – SIR WALTER SCOTT (1815). These were the first lines of Walter Scott's writings to be published in America.

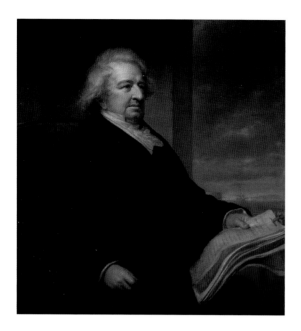

Washington Irving founded the Saint Nicholas Society of the city of New York, with Peter G. Stuyvesant, Gulian Crommelin Verplanck, along with others in 1835. At which time New York City also hosted a Saint Andrew Society (Scottish), The Saint David Society (Welsh), Saint George (English – although subdued), and a society for Saint Patrick (Irish). The society members met for lighthearted events, but they also concerned themselves with attempting to preserve the history of the city at a time of rapid change, as it was becoming a leading center of commerce and of culture in America.

The Knickerbocker Magazine was founded in 1833 by Charles Fenno Hoffman, with Lewis Gaylord Clark, and Willis G. Clark as editors. Washington Irving, Gulian C. Verplanck, and other Knickerbockers wrote for the publication.

Verplanck edited Shakespeare's plays for Harper Brothers in 1847. In the 19th century, the bard's play *A Midsummer Night's Dream* was his most popular, with the Victorians particularly fascinated with the world of fairies, nymphs, and spirits. He was a founding member of the American Academy of Fine Arts, a member of the American Antiquarian Society, involved with John Pintard in establishing the New York Historical Society, and a professor on the faculty of the General Theological Seminary with C.C.M., with whom he had attended Columbia College, now Columbia University. His grandfather was the first president of King's College, which became Columbia College after the American Revolution. Passenger lists establish that Verplanck's first Dutch colonial ancestors arrived in 1634 from Edem, Holland to New Netherland. The Verplanck homestead is a museum located in Beacon, NY, with ancestorial furnishing on permanent display in the Verplanck Room at the Metropolitan Museum of Art, New York, NY.

In 1838, Verplanck purchased from Robert Weir one of his paintings of Saint Nicholas. Verplanck also owned Weir's painting, *Landing of Henry Hudson, 1609, at Verplanck Point*.

The preeminent St. Nicholas scholar Charles W. Jones discussed Verplanck in his article *Knickerbocker Santa Claus* – New York Historical Society in 1954: "And in 1822 Verplanck's enthusiasm was Santa Claus. So, there is, I believe an element of truth in the myth about Clement Moore's Dutch gardener; only the gardener is Gulian Crommelin Verplanck, collaborator with Sands and Bryant on *The Talisman, Peter Puff,* and pseudonymous author of *Bucktail Bards,* friend of Fenimore Cooper (who refers to Santa Claus in *The Pioneers,* which he was writing at this moment), a founder of the St. Nicholas Society and the St. Nicholas Club. At Christmas 1822 Verplanck and Moore were close indeed and if you think, as I do, that St. Nicholas is a little out of Moore's natural channel, look to Gulian Verplanck, in some ways the most typical of the *Knickerbockers.*"

Gulian C. Verplanck was known to use the pseudonym John Smith and preferred that his written work not be published anonymously.

Verplanck was invited by Harper Brothers in 1837 to write an introduction to *The Fairybook: With Eighty-one Engravings.* A poem of Cinderella was published in the work credited to "The Anti-Jacobins" entitled *The Love of the Triangles, Canto 1:*

> "So she, sad victim of domestic spite,
> Fair Cinderella past the wintry night,
> In the lone chimney's darksome nook immured,
> Her form disfigured and her charms obscured;
> Sudden her godmother appears in sight,
> Lifts the charmed rod and chants the mystic rite;
> The chanted rite the maid attention hears,
> And feels now ear-rings deck her listening ears;
> While midst her towering tresses aptly set,
> Shines bright with quivering glance the smart aigrette;
> Brocaded silks the splendid dress complete,
> And the GLASS SLIPPERS grasp her fairy feet.
> Six bob-tailed mice transport her to the ball,
> And liveried lizards wait upon her call."

CREDIT: Page 82, left: Artist – Daniel Huntington (American, 1816-1906) *Gulian Crommelin Verplanck,* 1857.
Right: Artist - Thomas Sully (American, 1783-1872) *Cinderella At The Kitchen Fire,* 1843.

NOTE: Daniel Huntington created over one thousand portraits throughout his career, including portraits of both President Abraham Lincoln and Martin Van Buren and of C.C.M., Charity Clarke Moore, and of Washington Irving. The C.C.M. portrait is in the collection of the General Theological Seminary in Chelsea, New York. Huntington was the Vice-President of the Metropolitan Museum of Art from 1870 until 1903.

On the death of G. C. Verplanck in 1870 the quintessential Knickerbocker was eulogized by William Cullen Bryant.

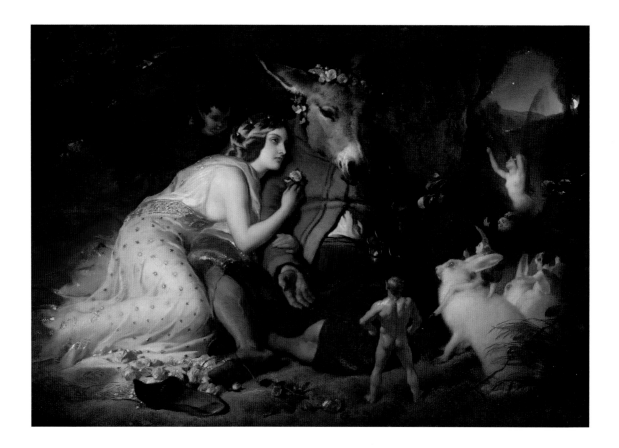

That the poet of Christmas Eve found inspiration in the language of other works is indisputable, from Shakespeare to Irving, the connections are established with ease. The work of Joseph Rodman Drake may have also provided inspiration for the elfin qualities and magical tonality of the Christmas lines. Joseph Rodman Drake (American, 1795-1820) and Fitz Greene Halleck (American, 1790-1867) collaborated in writing poems called the *Croakers* – published in the *New York Evening Post* in 1819.

"Such work indicated not only a diversified circle of readers, who were not subject to the religious and political stress of earlier days, but it also shows a desire to be entertained, which would have been promptly discouraged in Puritan New England."– *Drake and Halleck: Contribution to American Poetry.*

> There is fun in everything we meet,
> The greatest, worst, and best;
> Existence is a merry treat,
> And every speech a jest.
> - (Excerpt). *The Croakers*, 1819.

CREDITS: Page 84: Artist - Sir Edwin Landseer (British,1802- 1873) *Scene from Midsummer Night's Dream, Titania and Bottom* (1851). Page 85: Artist - John Ferguson Weir (American, 1841-1926) *Christmas Eve* 1865. J. F. Weir was the son of artist Robert Weir.

At the age of 21 in 1816, and shortly before his tragic death Drake wrote *Poems of Fancy: II. Fairies: Elves: Sprites. The Culprit Fray*.

'Tis the hour of fairy ban and spell:
The wood-tick has kept the minutes well;
He has counted them all with click and stroke
Deep in the heart of the mountain oak,
And he has awakened the sentry elve
Who sleeps with him in the haunted tree,
To bid him ring the hour of twelve,
And call the fays to revelry;
Twelve small strokes on his tinkling bell
('Twas made of the white snail's pearly shell;)
"Midnight comes, and all is well!
Hither, hither wing your way!
'Tis the dawn of the fairy-day."
. . . And his courser follows the cloudy wain/Till the hoof-strokes fall like pattering rain.

Upon reading, *Anstey's New Bath Guide* (1766), *The Toast* published in the 1830s, and the *Day of Doom* (1662), written by Massachusetts clergyman Michael Wigglesworth, the presumption can be made that the poet of *Twas The Night*, had these works in their repertoire. *Anstey's* (Excerpt):

> This morning, dear mother, as soon as 'twas light,
>
> I was wak'd by a noise that astoish'd me quite,
>
> For in Tabitha's chamber I heard such a clatter,
>
> I could not conceive what the deuce was the matter . . .

The Toast was originally written in Latin by Frederick Scheffer and then translated by Reverend William King. It was published in 1732 in Ireland and then in 1736 in England. C.C.M. was well versed in Latin. *The Toast* (Excerpt):

> So swift are the coursers, they think it mere play,
>
> Or a breathing, to measure the globe in a day....
>
> Made to prance and curvet with so martial a grace,
>
> Yet unable to move half an inch from his place
>
> In his mounting, what grace ! in his driving, what skill!
>
> Nor his horses he spar'd, tho' the way was uphill;
>
> Never stopping to kiss a young wife, or to drink;
>
> Never whistling or swearing – because he can't think.

The Day of Doom (Excerpt):

> Amazed with fear, by what they hear each one of them ariseth.
>
> They rush from Beds with giddy heads, and to their windows run,
>
> Viewing this light, which shines more bright than doth the Noonday Sun.
>
> Straightway appears (they don't see with tears) the Son of God most dread;
>
> Who with his Train comes on amain to Judge both Quick and Dead.

For Christmas 1821, New York bookseller and publisher William B. Gilley released the first lithographed book in America and the first literary work to portray "SANTECLAUS" as being driven by a reindeer-led sleigh and arriving on Christmas Eve. The full title of the book reads: *The Children's Friend. Number III: A New Year's present, to the little ones from five to twelve, and adorned with elegant cuts, engraved in a method entirely new: The designs, as well as the matter which accompanies them, are original. Copy-right secured.* The author was not identified, which has led to conjecture that perhaps the story was authored by C.C.M.

C.C.M. was well acquainted with William B. Gilley. Gilley was a printer of publications and produced works for the General Theological Seminary. The illustrator was Arthur J. Stansbury, and the engravings were done by Isaac Doolittle and William A. Barnet. Gilley and Stansbury were both fathers of young children in 1821 and can be considered as having authored the work. Arthur J. Stansbury (American, 1781-1865) was a published author, an illustrator and a Presbyterian minister. Stansbury is known for his deathbed portrait of John Quincy Adams.

The American Antiquarian Society discovered an edition of *The Children's Friend* in a collection of the papers that Stephen Salisbury III had bequeathed to the society. The inscription shows that the book was given to Salisbury as a Christmas gift in 1841. A second copy of *The Children's Friend* is held by the Yale University Library.

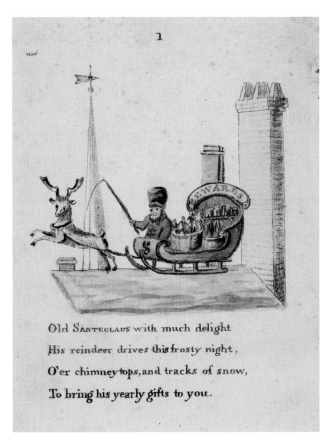

Old SANTECLAUS with much delight
His reindeer drives this frosty night,
O'er chimney tops, and tracks of snow,
To bring his yearly gifts to you.

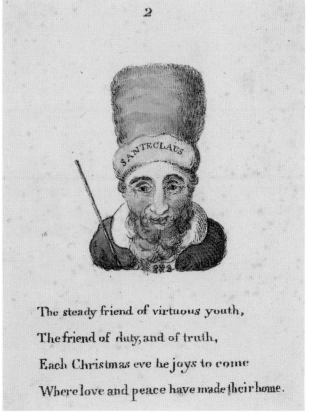

The steady friend of virtuous youth,
The friend of duty, and of truth,
Each Christmas eve he joys to come
Where love and peace have made their home.

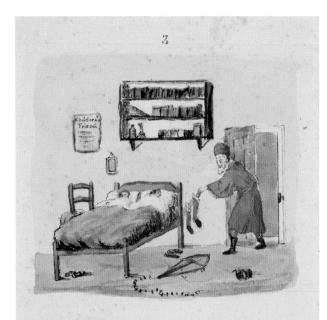

3

Through many houses he has been,
And various beds and stockings seen;
Some, white as snow, and neatly mended,
Others, that seem'd for pigs intended.

4

Where e'er I found good girls or boys,
That hated quarrels, strife and noise,
I left an apple, or a tart,
Or wooden gun, or painted cart;

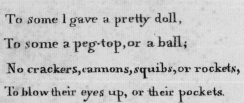

5

To some I gave a pretty doll,
To some a peg-top, or a ball;
No crackers, cannons, squibs, or rockets,
To blow their eyes up, or their pockets.

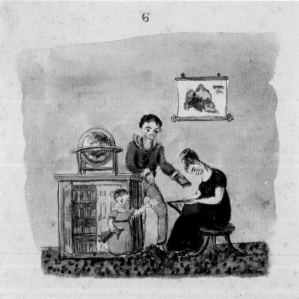

6

No drums to stun their Mother's ear,
Nor swords to make their sisters fear;
But pretty books to store their mind
With knowledge of each various kind.

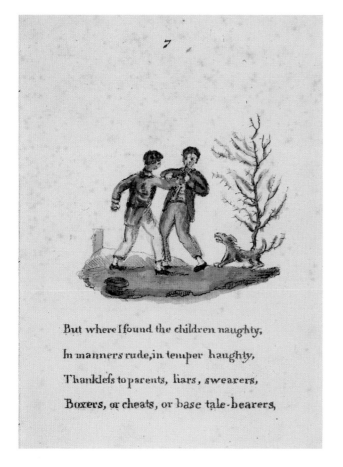

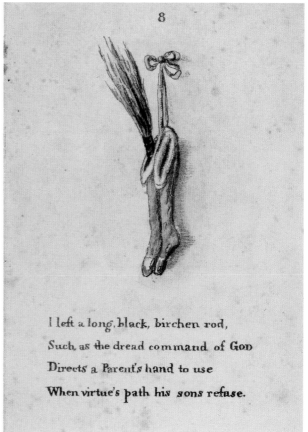

But where I found the children naughty,

In manners rude, in temper haughty,

Thankless to parents, liars, swearers,

Boxers, or cheats, or base tale-bearers,

I left a long, black, birchen rod,

Such as the dread command of God

Directs a Parent's hand to use

When virtue's path his sons refuse.

A letter written by publisher William Gilley addressed to editor Orville Holley has been published to the internet and reprinted in several locations. The letter is cited without reference but with the suggestion that it was originally published in the *Troy Sentinel* in 1822: "Dear Sir (Orville Holley), the idea of Santeclaus was not mine, nor was the idea of a reindeer. The author of the tale submitted the piece, with little added information. However, it should be noted that he did mention the reindeer in subsequent correspondence. He stated that far in the north near the Arctic lands a series of animals exist, these hoven antlered animals resemble the reindeer and are feared and honored by those around, as you see he claims to have heard they could fly from his mother. His mother was an Indian of the area." - WILLIAM GILLEY.

The Troy Sentinel began publishing in July of 1823, prior to which it had been called the *Daily Troy Budget*. A review of the historical newspaper records did not locate the Holley-Gilley letter.

CREDIT: Author and illustrator unidentified. *The Chidren's Friend*, William Gilley Publisher, 1821. Beinecke Rare Book and Manuscript Library, Yale University.

NOTE: Gilley had previously published *The Holiday Reward, or Tales to instruct and amuse good children, during the holiday and midsummer vacations* by Harriet H. Ventum in 1819 and Owen Chase's narrative of the sinking of the Essex whaleship in 1821.

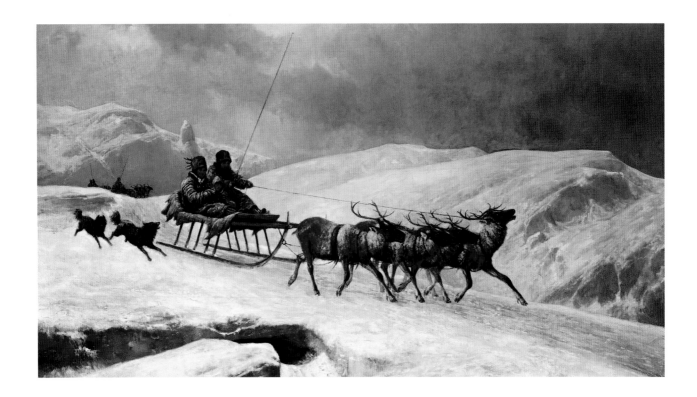

The Pioneers, James Fenimore Cooper's work of fiction, opens with a character - Judge Marmaduke Temple and his daughter journeying home to Templeton, NY in a horse-drawn sleigh on Christmas Eve. The Judge tells Aggy, another character in their traveling party: "Aggy! Remember that there will be a visit from Santa Claus to-night."

Cooper finished his manuscript in 1822, which makes his novel a very early addition to the stories of Santa Claus. Unlike Irving, Cooper chose Christmas Eve for Santa Claus' arrival as had the author of *The Children's Friend*. Cooper named two of the horses pulling the Judge's sleigh, "Donner" and "Blitzen". *The Pioneers* was released in February of 1823, ten months before *Twas The Night* appeared in the *Troy Sentinel* for Christmas of that same year.

In *Knickerbocker* 1809 (Washington Irving): "Dunder and blixum! swore the dutchmen." From *Guy Mannering* written in 1815 by Sir Walter Scott: "'True, But to return to this youngster - ' 'Aye, aye, donner and blitzen! he's your affair,' said the Captain."

Fenimore Cooper requested that no one publish his biography and his daughter saw to it by having his diaries buried with him upon his death. If he knew anything about the

CREDIT: Artist – Andras Marko (Hungarian, 1824-1895) *A Brisk Reindeer Sleigh* (1882).

NOTE: Sir Walter Scott's writing was published anonymously until 1828.

writing of the poem *Twas The Night* it followed him to the grave. Gulian Verplanck left ten linear feet of personal correspondence and yet not a trace of word about the circumstances regarding the writing of *Twas The Night*.

The transcript of the following lines is unsigned and although in the writing of C.C.M., the authorship remains in question and may have been a transcription by C.C.M. of someone else's work. The poem was not included in *Poems* (1844). The original copy is with the Museum of the City of New York ca. 1816-1830.

From Saint Nicholas

What! my sweet little Sis, in bed all alone;
No light in your room! And your nursy too gone!
And you, like a good child, are quietly lying,
While some naughty ones would be fretting and crying?
Well, for this you must have something pretty, my dear;
And I hope, will deserve a reward too next year.
But speaking of crying, I'm sorry to say
Your screeches and screams, so loud every day,
Were near driving me and my goodies away.
Good children I always give good things in plenty;
How sad to have left your stocking quite empty:

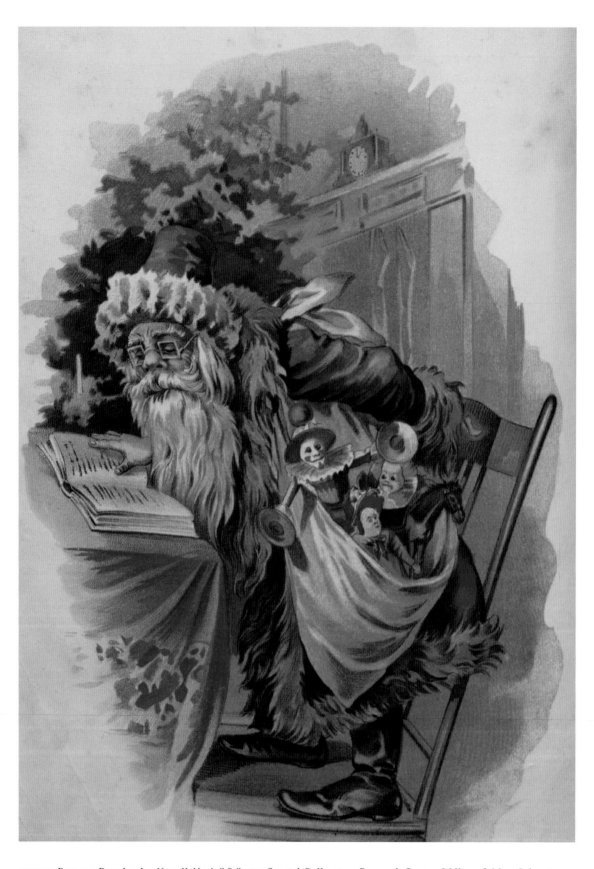

But you are beginning so nicely to spell,
And in going to bed behave always so well,
That, although I too oft see the tear in your eye,
 I cannot resolve to pass you quite by.
I hope, when I come here again the next year,
I shall not see even the sign of a tear.
And then, if you get back your sweet, pleasant looks,
And do as you're bid, I will leave you some books,
Some toys, or perhaps what you still may like better,
And then too many write you a prettier letter.
At present, my dear, I must bid you goodbye;
Now, do as you're bid; and remember, don't cry.

A minister by the name of Theodore Ledyard Cuyler recalled receiving "an autograph letter from Santa Claus, full of good counsels" during his childhood in 1820s western New York as cited in *Letters to Santa Claus, by the Elves* (Indiana University Press, 2015). It could well be the first Santa Claus form letter known to exist.

A Seminary student wrote of his teacher C.C.M. - "Santa Claus himself could not be more welcome to children than this odd and genial man upon his appearance in the Hebrew class. He was very particular in his ways; but one great feature of his peculiarity was that he was utterly unartificial. He was droll, but unconsciously so. He never joked in the class, but always something made the class seem merry when he was in it." – CLARENCE AUGUSTUS WALWORTH, *The Oxford Movement in America,* documented by Scott Norsworthy, *Melvilliana.*

C.C.M. wrote a poem to his granddaughter Eliza on May 19, 1849. (Excerpt)

Old Chelsea once again looks gay
With all the op'ning bloom of May.
The leaves break forth, imprison'd long;
And birds awake their morning song.
Fresh flowers the chestnut branches crowd,
And hold their heads all straight and proud.
The purple lilacs and the white
Unveil their beauties to the light;
And humbler flowers of various hue
New deck the green and sip the dew.
The greenhouse plants begin to scold,
And cry to John - "Why 'tis not cold;
"This heat is more than we can bear;
"We want to breathe the open air."

Aunt Terry, to drive out is crazy,
And uncle Clem is Lawrence Lazy.
The house is all too dull and quiet;
I long to hear you romp and riot.
Whene'er you're full of harmless fun,
I dearly love to see you run.
The pattering of your little feet
Is music to my ear more sweet
Than song of birds among the trees,
Or distant strains that swell the breeze.
And Heav'n, I trust, my prayer will hear,
And give me back my Eliza dear,
That I may press her to my heart
Before we shall for ever part.

CHAPTER 5

The Legend

The popular legend of the writing of the poem *Twas The Night*, has C.C.M. setting off in a horse-drawn sleigh, on the afternoon of December 24, 1822, to purchase a turkey for his family's Christmas dinner from the Washington Market in New York City. As he makes his way back home, snow is softly falling, dusk is approaching, and the tinkling of the horse's jingle bells give inspiration for the composition of a poem for his young children. C.C.M. presented *Twas The Night* later that evening, as friends and family were gathered for Christmas Eve at the family's estate of Chelsea House, located on the outskirts of the city.

In 1897, William Pelletreau wrote of *Twas The Night*: "The poem was written by Dr. Moore in 1822 as a Christmas present for his children, and with no thought that it would ever be published. Up to the end of his life, indeed, he seems to have regarded it as merely a nursery jingle without any serious merit. Among the many friends of Dr. Moore's family was the family of the Rev. Dr. David Butler, then rector of St. Paul's church in the city of Troy, NY, and Dr. Butler's eldest daughter Harriet happened to be visiting the Moore children and to be present when Dr. Moore read the verses. She liked them so much that she copied them in her album - an essential property of all young ladies of that epoch - and carried them home with her to read to the children at the rectory. When the following Christmas season rolled around, she thought of the verses which she had found so delightful and could not resist the inclination to make them public. Accordingly, she made a copy of them and sent it to Mr. Holley, the editor of the Troy Sentinel, without other communication of any sort or any indication of the authorship, and Mr. Holley used the poem, as has been stated, in his issue of December 23, 1823." - WILLIAM PELLETREAU, *Life of Clement C. Moore*, LL.D. July 15, 1897, NY.

Pelletreau's commentary on the circumstances surrounding the poem was widely distributed through an article written by Clarence Cook that appeared in *The Century Magazine* for December 1897.

On December 23, 1920, a statement letter was prepared by a relative of the Moore family in which she outlined her knowledge of the events of 1822. Maria Jephson O'Conor was requested to write the letter by Casimir de R. Moore, who had recently learned of a challenge to his grandfather's claim to the poem. Maria Jephson O'Conor of New York

wrote: "Clement C. Moore married Catherine Eliza Taylor, sister of my grandfather Elliot Taylor. My late father, Colonel Henry V.A. Post, married Maria Farquahar Taylor, daughter of my grandfather. Under these circumstances my father became very well acquainted with Mr. Moore. My father told me Mr. Moore himself related to him the following circumstances under which he came to write the poem entitled *A Visit From St. Nicholas*. It was Christmas Eve and Mrs. Moore was packing baskets of provisions to be sent to various people in the neighborhood, as was her custom. She found one turkey was lacking and so told her husband. Though late, he said he would try to get one from the market. On his return from the market he was struck by the beauty of the moonlight on the snow and the brightness of the star lit sky. This, together with the thoughts of the holiday season, suggested to him the idea of writing a few lines in honor of St. Nicholas. He told my father he immediately went to his study and wrote the poem. Mr. Moore also told my father when he came to publish the same, with some of his other poems, he only made two slight changes in the lines as originally written by him."

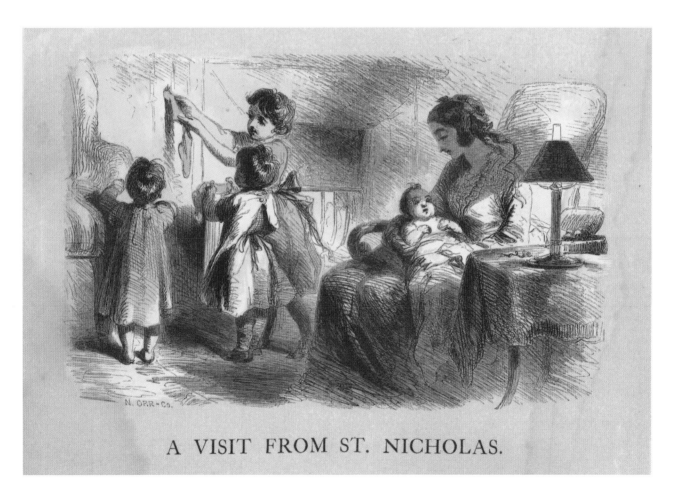

A VISIT FROM ST. NICHOLAS.

CREDIT: The original of the letter is held by the Museum of the City of New York.
Artist - F.O.C. Darley (American, 1822-1888) *A Visit From St. Nicholas*, (James G. Gregory, 1862). Rare Book – *Nancy H. Marshall Collection*, Special Collections Research Center, William & Mary Libraries.

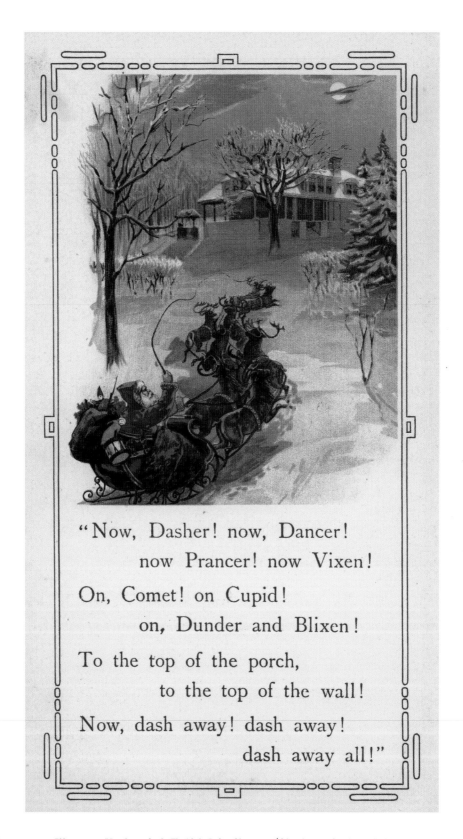

"Now, Dasher! now, Dancer!
 now Prancer! now Vixen!
On, Comet! on Cupid!
 on, Dunder and Blixen!
To the top of the porch,
 to the top of the wall!
Now, dash away! dash away!
 dash away all!"

CREDITS: Pages 96-97: Illustrator Unidentified, *The Night Before Christmas*, (Charles E. Graham & Company, NY, 1870).

NOTE: Flavia Gag was the sister of Wanda Gag (American, 1893-1946). The integration of images with text in *Millions of Cats* (Coward-McCann, NY, 1928), illustrated and authored by Wanda Gag, pioneered the children's picture book format.

In 1943, Thyra Turner wrote the *Christmas House, The Story of A Visit From St. Nicholas* for Charles Scribner's Sons of New York, a fictionalized storybook with vignette illustrations, provided by artist Flavia Gag. In Turner's version a gardener named "dear old Peter", who had been employed for many years at the Moore's property, provides C.C.M. with the inspiration for the poem's character of St. Nick. "Dear old Peter" is described in the story as having a "beautiful flowing beard" - "a red and ruddy face with dimples" - and "blue eyes that twinkled merrily". In the story, C.C.M. is accompanied by the jolly gardener, as they set off by sleigh to deliver gifts on Christmas Eve. On their return home, C.C.M. goes to his study where he writes out the poem in "his fine handwriting". With the verses completed C.C.M. reads his poem aloud to all who are gathered in the family's parlour, in keeping with the classic legend.

The Visit, The Origin of The Night Before Christmas, (Schiffer Publishing LTD, 2013), by Mark T. Moutlon and illustrated by Susan Winglet, tells the story from the point of view of Florence Dinghy Sharp, a great-great-granddaughter of C.C.M. In this version C.C.M. sets off by himself for the market to fetch "a tender, fat goose" for the family's Christmas dinner.

> "He harnessed his coursers,
> hitched up his red sleigh,
> and with the flick of the reins
> they were soon on their way."
>
> *— The Visit.*

On his travels he remembers that a new story has been promised for daughter Charity – "a thick snow was falling". He encounters the elderly man named Jan-Peter who is gifting firewood to his neighbours.

> "He had a white beard
> and a heart made of gold.
> He was rotund and jolly
> and appeared very old."
>
> *— The Visit.*

In witnessing Jan-Peter's generosity, the poet had found the inspiration needed to write the promised poem.

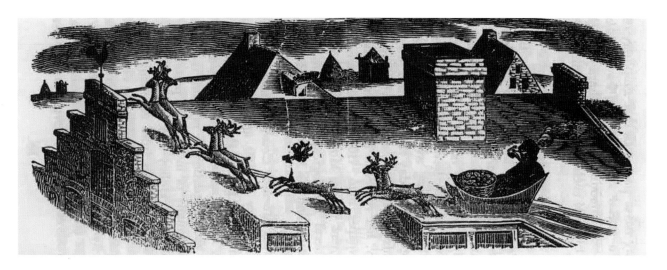

On February 26, 1844, Norman Tuttle, of the *Troy Sentinel*, replied in writing to an inquiry made by C.C.M. regarding the paper's 1823 printing of the poem. Orville Holley, who had been the editor of the paper in 1823, had moved to Albany, New York in 1842 and William Parker, who had been the publisher at the time, was deceased.

> February 26, 1844.
> Prof. C. C. Moore
> Sir: Yours of 23rd making enquiries concerning the publication of "A Visit from St. Nicholas" is just received. The piece was first published in the *Troy Sentinel* December 23rd, 1823, with an introductory notice by the Editor, Orville L. Holley Esq: and again, two or three years after that. At the time of its first publication, I did not know who the author was, but have since been informed that you were the author. I understand from Mr. Holley that he received it from Mrs. Sackett, the wife of Mr. Daniel Sackett who was then a merchant of this City. It was twice published in the *Troy Sentinel* and being much admired and sought after by the younger class, I procured the engraving which you will find on the other side of this sheet and have published several editions of it. The *Sentinel* has for several years been numbered with the things that were: as Mr. Holley, I understand, is now in Albany editing the *Albany Daily Advertiser*. I was myself the proprietor of the *Sentinel*.
>
> <div align="center">Your Respectfully
Yours & c
N. Tuttle</div>

N. Tuttle's letter is in the collection of the New York Historical Society, NY, NY. The Rensselaer Historical Society holds a letter that was written by Orville Holley that a researcher discovered in the early 21st century that states that the poem was in fact delivered to the paper by "Mrs. Daniel Sackett", who was a Sunday School teacher at St. Paul's

Episcopal Church in Troy. Evidently, William Pelletreau was not privy to the letters written by N. Tuttle or by Orville Holley, as he makes no mention of Sarah Sackett.

A woodcut depicting Santa Claus riding in a sleigh drawn by reindeer was designed by Myron King of Troy, NY, and printed on two *Troy Sentinel* broadsheets of the poem that were distributed in 1830. Different decorative borders and word variations distinguish the two broadsheets from one another. One of the original broadsheets is held by the Museum of the City of New York with the second in the *Anne Haight Collection* at Carnegie Mellon University. Together, they represent the first illustrated publications of the poem. Norman Tuttle included a copy of the 1830 broadsheet with the February 1844 letter that he provided to C.C.M. There had been fifty-five editorial changes made to the lines of the poem as published in 1823.

In 1844, C.C.M.'s book of collected works of poetry was released under the title *Poems* by his publishers Barlett & Welford, in which *Twas The Night* was included. There are thirteen editorial differences between the 1830 broadsheet provided to C.C.M. and the text of the poem as it appears in *Poems*. C.C.M. was willing to accept and see, published under his name, dozens of editorial changes to the poem as originally printed in 1823. In good probability, these changes were made by someone other than he.

MRS. CLEMENT C. MOORE

CREDIT: Artist unidentified. *Portrait of Catherine Elizabeth Taylor Moore.* Source: *Recollections of Clement C. Moore,* written by Mary Moore Sherman (The Knickerbocker Press, NY, 1906). Rare Book – *Nancy H. Marshall Collection,* Special Collections Research Center, William & Mary Libraries.

NOTE: Two poems attributed to Eliza Moore were published alongside her husband's work in *Poems 1844: Lines - By my late wife on being requested to write in an album* and *And To the Memory of Miss Susan Moore, written by my late wife.* The New York Historical Society holds a collection of papers belonging to C.C.M., Catherine ("Elisa") Taylor Moore, Bishop Benjamin Moore, and Charity Clarke Moore. There is no mention of *Twas The Night* in any of these documents.

Harriet Butler (American, 1791-1842) of Troy, NY, was a woman of thirty-one years of age in 1822 and was well acquainted with the Moore family. It is therefore plausible that Harriet indeed visited Chelsea House for the Christmas season of 1822 and may have transcribed the poem into an album, as has often been repeated in the relaying of the traditional legend constructed by Pelletreau and others. It is also plausible that

Harriet transcribed several poems including *Twas The Night* from an album that was on display in the foyer of the Moore home as suggested by John Parker in *The Troy Daily Times* on December 23, 1871: "Presuming you will publish, as usual, the *Visit of St. Nicholas,* quoted above, I send you the enclosed history of it for the benefit of the young Trojans who sleep with one eye open on the night before Christmas. As it has a Trojan

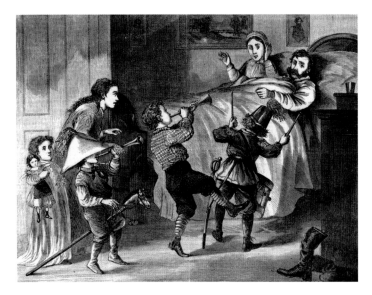

birth, it may interest even the editor to hear its narrative as related to me. In the year 1825, I think, the eldest daughter of Rev. David Butler, first rector of St. Paul's church, Miss Harriet Butler, on a visit to Prof. Clement C. Moore of Columbia College, New York, found on the centre table this *Visit of St. Nicholas*, composed by the Professor for his children "

Both Harriet Butler and Sarah Sackett of Troy, NY, were acquainted. In 1824, Harriet and Sarah signed their names to an invitation requesting the Marquis de Lafayette (French, 1757-1834) to visit the Troy Female Seminary on his tour of America, to which he would later agree and attend. Sarah (nee Pardee) Sackett (American, 1793-1867)and her husband Daniel Sackett (American, 1788-1845) operated the Lane Crockery Shop located at 221-222 River Street in Troy, NY, steps from the *Troy Sentinel* newspaper located on the same street at # 225.

"Eliza" Moore, Charity Moore or the eldest of the Moore children, may have transcribed the poem into a family album, making changes to the poem in the process. With the suggested involvement of Harriet Butler and Sarah Sackett in the transmission of the poem to Troy, either one of these women could have amended the copy before it was placed into the hands of Orville Holley.

In 1956, author, and educator, Samuel W. Patterson wrote, *The Poet of Christmas Eve, A Life of Clement Clarke Moore*, in which he provides a romanticized version of the events surrounding the introduction of the poem. Patterson writes that "Christmastide" was observed at Chelsea House for years after 1822 and that in the 1830's grandmother Charity Moore wrote to her sister in London: "Here is another Xmas coming, children all expectations and their dear father preparing little presents to make them happy . . . " Patterson added: "But there does not appear to have been another like the Christmas Eve when Margaret, Charity, Benjamin, Mary, Clement, and Emily first heard their 'dear father' introduce St. Nicholas at Chelsea House."

Patterson in attempting to write the first full-length biography of the man he deemed "The Poet of Christmas Eve", unfortunately allowed himself to take flights of fancy that make the work that is part romanticized fiction and part biography confusing for the reader. Without footnotes and references the work lacks the robust credibility needed to qualify it as a serious biography, something that Patterson may have been aware of as revealed in his chosen subtitle of *A Life* versus *The Life* of Clement Clarke Moore. A serious claim made by Patterson regarding the life of C.C.M. is that he was an enslaver while he resided on the estate of Chelsea.

"So why do people think Moore was? Because his biographer, Samuel White Patterson, said so in 1956." – JUSTIN FOX, December 22, 2021, *A Gift for America's Christmas Poet: Rehabilitation* (Bloomberg.com).

Samuel Patterson wrote on page 76 of his work on the poem: "Moore had no qualms of conscience on either slavery or liquor."

Accessing the *New York Slavery Records Index, of Records of Enslaved Persons and Slave Holders in New York from 1525 through the Civil War*, administered by the John Jay College of Criminal Justice, and using the name of Clement Clarke Moore the result as accessed in March of 2022 reads: "No records were found, so no table is presented. This means that, for the locality specified, there were no records in the database for the table. That may be because the records have not yet been found and indexed, or it may be because the category of activity did not take place in the locality."

Historical records establish that C.C.M.'s grandparents and his father Bishop Benjamin Moore, like many of their generations were enslavers. Most affluent landowners in the state of New York owned slaves in the 1700's until a call for abolishment of slavery was

NOTES: Records of slavery as a legally authorized activity appear in 1625 in New Amsterdam, and end for the state of New York in 1829 with the completion of the process of gradual abolition under the 1799 abolition law and its amendments. Records as early as 1525 show enslavement was practised in the area and extend to the period prior to and during the Civil War, when fugitives from southern-state enslavement were captured and subjected to re-enslavement under prevailing federal and state laws. Census records show 75 slaves for New York State in 1830.

The Poet of Christmas Eve by Samuel Patterson includes reproductions of portraits of members of the Moore family, including those of C.C.M. and Charity Clarke painted by Daniel Huntington, of C.C.M. as a boy, of C.C.M. as painted by Henry Inman in the early 1840's, of Mary Stillwell Clarke and her husband Captain Thomas Clarke that are in the private collection of descendants of C.C.M.

raised in the 1780s. The Livingstons of Poughkeepsie, including Henry Livingston Jr., are known to have been enslavers, and involved in the purchase or transport of slaves in the state of New York. Henry Livingston Jr., along with others including Benjamin Franklin would radically change their views and come to denounce slavery later in their lives. In 1785, John Jay, who had been an enslaver founded The Society for Promoting the Manumission of Slaves and as the Governor of New York in 1798 he called for the gradual abolition of slavery.

A search for the name Benjamin Moore of the Borough of New York showed a record of an investment in a slave ship out of Curacao and one slave in 1741. This Benjamin Moore is, with a good probability, the great grandfather of C.C.M.

C.C.M.'s father Benjamin Moore 1748-1816

C.C.M.'s paternal grandfather Samuel Moore 1711-1788

C.C.M.'s paternal great grandparents Benjamin Moore 1679-1750 and Anna Sackett Moore 1691-1757.

The second record for a Benjamin Moore is for 1810 and lists two slaves and cites the 1810 Census as the source document. The next record is for 1811 and lists one male adult slave who is named Benjamin Dunbar, and the last record dated 1813 for Benjamin Moore shows one male slave by the name of John Betson.

Patterson in 1956 wrote: "Everyone was on his best behavior, Thomas and Charles, slaves, had brought in the logs for the large fireplace, and Ann or Hester, slaves, had prepared the kitchen for the turkey." Justin Fox was able to ascertain that the slaves mentioned by Patterson, were referenced in the 1802 will of C.C.M.'s grandmother Mary "Molly" Stillwell.

In locating the land deed that was used to transfer the Chelsea Estate in 1813 to C.C.M., Justin Fox writes that the deed reveals that no enslaved persons were associated with the property at the time of the transfer. This contradicts the writing of Patterson who wrote that enslaved persons were associated with the estate as late as 1827.

Justin Fox was able to establish on his review of the records of the Manumission Society at the New York Historical Society in New York, NY, and the 1810 Census, along with other documentation kept by the city of New York, that Bishop Benjamin Moore manumitted Charles Smith on July 30, 1803, that John Betson was manumitted in October 1811 and Benjamin Dunbar in November 1813. Fox supplies additional evidence to support his argument but with the caveat that the evidence does not prove with certainty that C.C.M. never owned slaves. Justin Fox's compelling essay is available online.

Author, and educator Samuel W. Patterson in 1956 wrote: "Clement Clarke Moore deserves a full-length biography. He lived a significant life in a significant period of American history, the first eight decades after the *Declaration of Independence*." A full-length documented biography of C.C.M. remains to be written.

Reverend David Butler of Troy had served in the Connecticut Line of the American Army during the American Revolution. He was ordained in 1792, and in 1805 he was

instituted as rector of the Episcopalian parish in Troy and Lansingburgh, NY, by Bishop Benjamin Moore. His son was named after C.C.M, who took the career path of his father and became Reverend Clement Moore Butler (1810-1890). The Rev. Clement Moore Butler was the brother of Harriet Butler, and he marries Henry Livingston Jr's niece Francis Livingston Hart (1816-1895) in 1836; the same year he graduated from the General Theological Seminary, New York where C.C.M. had been one of his teachers.

The Butler and the Sackett families of Troy were connected to the Clement Clarke Moore and Henry Livingston Jr. families by marriage and through lineage. These four families were also associated through a circle of acquaintances and colleagues. That no correspondence, diary entry or communication has ever been discovered, written in the hand of any one of the many people who were in a good position to know the accurate story behind the writing of the poem, remains one of the most compelling arguments in favor of C.C.M. as the true poet of Christmas Eve. This includes C.C.M.'s many fellow Knickerbockers, particularly James Kirke Paulding and Gulian C. Verplanck, both of whom were especially interested in Santa Claus, and who knew C.C.M. very well.

Sarah Sackett's husband, Daniel Sackett, Harvard graduate and editor-writer Orville Holley, along with Harriet Butler's father Rev. David Butler (1762-1842) were the founding members of the Troy Colonization Society. On December 30, 1823, Orville L. Holley gave a speech on the colonization of Africa to a meeting of citizens of Troy, NY.

A mahogany, poplar and pine desk crafted by Michael Allison ca.1800 - 1820 is on permanent display in the New York Historical Society in New

CREDIT: Artist – Auguste Edouart (1788-1861) Rev. *David Butler, Rector of St. Paul's Episcopalian, Troy,* 1841. Courtesy National Portrait Gallery, Smithsonian Institute, Gift of Robert L. McNeill, Jr. C.C.O. Dedication.

York, NY, for which a label reads: "New Yorker-Clement Clarke Moore (1779-1863) is believed to have written the Christmas poem, 'A Visit from St. Nicholas' at this desk. He composed the poem at his Manhattan home on West 24th. Street on December 22, 1822. Although scholars continue to debate whether he actually wrote the poem, the neoclassical desk was bequeathed to the Society in 1956 along with extensive documentation that connects it to Moore. Provenance: Per donor: Moore; bequeathed to Harriet Butler; bequeathed to H. Judd Ward (cousin); to Anne Lansing Austin; to Blanche Austin Rockhill: to NYHS."

In C.C.M.'s last will dated for 1855, he specifies three desks be bequeathed to his heirs without a reference to Harriet Butler.

An early 19th century mahogany desk owned by C.C.M., and crafted by Duncan Phyfe (Scottish, 1770 – 1854, American), is on display at The Newport Historical Society Museum & Store. C.C.M. summered in Newport, Rhode Island with his family at Cedars - located at 25 Catherine Street which he purchased in 1851. C.C.M. passed away in July of 1863 at this residence. The funeral was held at Trinity Church in Newport. Cedars was bequeathed to C.C.M's daughter Maria T.B. Moore. E.T. Potter, the architect of the 1871 Mark Twain House in Hartford, CT, acquired Cedars in 1873 and made notable changes to the exterior. Cedars remains a residential property. A festive plaque at the entrance commemorates C.C.M.

As it is not possible, due to a lack of credible documentation, to ascertain with certainty where the poem was written, there has been speculation that it was written somewhere other than at Chelsea House.

The General Theological Seminary of the Episcopal Church of New York, NY, situated on 60 acres of lands donated by C.C.M. in 1818, has been suggested as a possible location, given C.C.M.'s close association with the institution and his position on the faculty. In 1821, Jacob Sherred left a legacy of roughly sixty thousand dollars for the establishment of a General Theological Seminary in New York City. Rev. Samuel H. Turner wrote in 1864 that in the year 1825: " the trustees assembled at the residence of Professor Moore, and with the faculty, students, clergy, and an assemblage of citizens, formed a procession to the site of the intended building, where after an address and prayers by the Presiding Bishop, the

cornerstone was laid by him." The poem appeared in print for December 23, 1823, which predates the opening of the seminary by several years. Temporary offices had been used by the faculty and students of the General Theological Seminary prior to the opening of East buildings in 1827 and the West buildings in 1836, but no credible evidence has been found that makes the connection between this location and the writing of the poem.

A portion of the General Theological Seminary, that is now the High Line Hotel in Chelsea Manhattan, was designed by architect Charles Coolidge Haight and built in the mid 1800s. Haight also designed The Chapel of the Good Shepherd in a collegiate Gothic style in the 1880s to be the centerpiece of the seminary. The grounds upon which this Federal Historic Landmark was constructed were once the apple orchards of the Moore family. During the Revolutionary War C.C.M.'s grandmother "Molly" Stillwell Clarke had reprimanded Hessian soldiers for chopping down her orchards in order to make fires for warmth during the cold winter evenings they spent billeted to her Chelsea property.

The language of the poem implies that in the mind of the poet the scene of the father leaping from his bed to greet the commotion out on the lawn involved first the opening of the shutters and then the raising of the sash. Interior as well as exterior shutters were commonplace in the era. Chelsea House has rarely been used as a backdrop for illustrations that accompany *Twas The Night*.

Mary Ogden, the daughter of C.C.M. and Eliza Moore, drew Chelsea House in 1855.

Away to the window I flew like a flash,
Tore open the shutters and threw up the sash.

To the top of the porch! to the top of the wall!
Now, dash away! dash away! dash away all!

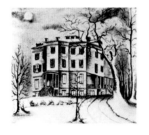

CREDITS: Page 104: Artist/Photographer - Nathaniel Fish Moore (American,1782-1872) *Chelsea house*, Columbia Universities Online Exhibitions, accessed October 19, 2012. Reproduced with permission. Page 105: Artist – Mary Clarke Ogden, *Old Chelsea Mansion House*, 1855.

NOTES: Nathaniel Fish Moore was C.C.M.'s cousin. He was an avid photographer and processed his own salt and albumen prints. He was a student of Columbia, a professor of Greek and Latin, Columbia's first full time librarian 1837-1839 and their 8th President (1842-1849). A collection of his photographs is in the Columbia Universities Rare Book and Manuscript Library. N.F. Moore's photographs of his home Highland on the Hudson show interior shutters as described in Twas The Night.

It is not known where the Moore family gathered over the years for Christmas. After Chelsea House, C.C.M. moved to a townhouse at 444 West 22nd Street in Manhattan. It was built for him between 1835-1836. The family is known to have vacationed at Saratoga Springs, NY, at their ancestral homestead in Elmhurst and at C.C.M.'s Rhode Island property.

A chess set, now in the possession of Constable Hall Museum, is believed to have been gifted by C.C.M. to a member of the William Constable family sometime in the 1800s. The museum which opened in 1949 is housed in the original Constable family home located in Constableville, NY. It has been suggested that at one time, the family possessed a hand-written and signed copy of *Twas The Night* produced by C.C.M. He and his family are thought to have visited Constable Hall to console C.C.M.'s cousin Mary McVikar Constable on the death of her husband: *The New York Evening Post* June 02, 1821. "At Turin, Lewis County, on Monday, 28th May, William Constable Esq. in the 36th year of his age. His life was adorned by many virtues; he sustained a fair character and died a Christian death."

The descendants of the Constable family can recount special details of the story of the Moore family's visit. It has been suggested that the poet had been inspired by the impressive Constable home and that a Dutch speaking gardener working on the property had inspired the poet's St. Nick. The Constable family story also proposes that C.C.M.

both penned the poem during his stay at Constable Hall and dedicated the work to his cousin – Mary McVikar Constable.

John Constable gave an interview at Constable Hall in 1988. "I stood lost between the reverie and history, in a place where myth and actuality are indistinguishable." - MARGOT BADRAN, " . . . *and all through the house . . .* " (*Adirondack Life*, Nov-Dec. 1988).

Another reason that the Clement Clarke Moore family might have left New York City and headed North to Constable Hall at some time late in 1821 or in 1822, was a particularly deadly outbreak of yellow fever in the city.

C.C.M. wrote a poem regarding the epidemic of 1822 in lines of: *Address to the Fashionable People of New York, Upon Their Return To the City, After the Disappearance Of The Yellow Fever In The Autumn* (Excerpt):

> Dread pestilence hath now fled far away;
> And life and health, once more, around
> us play;
> The din of commerce spreads from street
> to street;
> And parted friends with new warm'd
> friendship meet.

New York City saw the spread of diseases that reached epidemic proportions in 1791, 1795, 1798, 1803, 1805, 1819, 1822 and into the 1830s. The outbreak in 1822 had finally abated by November.

NOTE: "As the disease began to spread, the public authorities took protective measures which had become customary in 1822. Quicklime and coal were burned in the gutters to "purify" the "contaminated" air. When these measures failed to check the malady, the officials ordered the residents of the affected section to leave, whereupon they sealed it off with high wooden fences." - *A Knickerbocker Tour of New York State*, 1822, Johnston Verplanck, NY. (Introduction Page 2, Louis Leonard Tucker, The University of New York, Albany, NY, 1968).

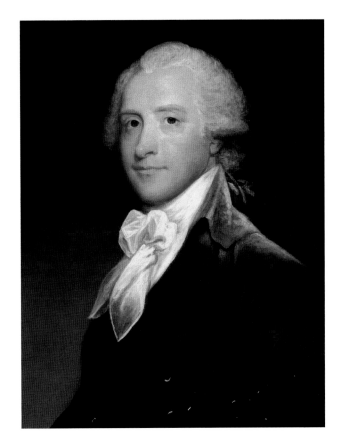

NOTE: The painting is one of several copies of a portrait of William Kerin Constable (Dublin, Ireland 1752 - New York, NY, 1803) by Gilbert Stuart (American 1755-1828) in 1796. The original is on view at the Metropolitan Museum of Art, New York, NY. Bequest of Richard De Wolfe Brixey, 1943. The Jay Heritage Centre received a portrait of Constable executed by Henry Augustus Loop in 1868 based on the portrait by Gilbert Stuart. John Jay introduced artist Gilbert Stuart to George Washington, who the artist painted numerous times, including the portrait that appears on the US dollar bill.

William Constable commissioned two portraits by Stuart of George Washington, one as a gift in 1797 to Alexander Hamilton. After the American War for Independence, W. K. Constable was relieved of duty as the aide de compte to Lafayette. He acquired 4 million acres of wilderness known as the Macomb's Purchase, with Alexander Hamilton drafting the deed. William Constable was a founding partner in Constable, Rucke and Company which outfitted the first American vessel to trade with China and India. His closest associates were John Jay, Alexander Hamilton, Robert Morris and "other master spirits of the time".

William Constable's daughter Emily married into the Moore family, and his daughter Anne Marie married Hezekiah Pierrepont.

It is suggested in the stories, passed down over the decades by Henry Livingston Jr's heirs, that a manuscript of the poem *Twas The Night* in his handwriting had been found in a desk after his death, but that the copy had subsequentially been destroyed in a house fire in Wisconsin. In the possession of his descendants, remain a music manuscript book, along with a manuscript book of his poems; a series of his drawings have also been preserved.

With the remarriage of Henry Livingston's wife after his death, the couple's home was sold to the Phoenix Horseshoe Company to use as offices. When the enterprise ceased operating at the turn of the century the building was demolished but care was taken to remove the mantle and hearth. It was thought that had Henry Livingston Jr. written the poem, these items could potentially have significant interest. The mantle and hearth were donated to the Poughkeepsie chapter of the Daughters of the American Revolution, and then passed along at a later date to the Clinton Museum.

Samuel Finley Breese Morse (American, 1791-1872), inventor of the telegraph and co-developer of the Morse code, remarried on the death of his first wife, to Sarah Elizabeth Griswold, the grand-daughter of Henry Livingston Jr. In the 1850s, Morse proceeded to have built an impressive Italianate style home on the lands of the original estate of Henry Livingston's first ancestors in the colonies, who had settled in the region in 1688. Colonel Peter Schuyler of Albany had purchased the property from the "Men of the East Land – the Wapani" in that year and obtained a crown patent to settle the property. Robert Livingston the Elder (Scottish, 1654-1728

CREDIT: Artist – Engraver: Cornelius Tiebout (1777-1832). *The sawmill of Henry Livingston Jr. near Poughkeepsie*, 1792. Photograph. Retrieved from the Library of Congress www.loc.gov/item/2004671563.

NOTE: The New York Public Library collection has a large number of surveys that were drawn by Henry Livingston Jr. to which he frequently added drawings.

American) was granted a parcel of 160,000 acres along the Hudson River and became the first lord of Livingston Manor. The property is now the site of the Locust Grove Museum.

Samuel Morse's first career was as an artist, painting the portraits of the Marquis de Lafayette, Presidents John Adams, and James Monroe. He was one of the founders of the National Academy of Design. His painting, *Landing of the Pilgrims* is one of his better-known paintings. He was raised and lived according to the principles of Calvinism.

Mary Van Deusen, who had been chasing down the Moore/Livingston authorship story for years, heard one day from a Robert Hancock of a story that she had not heard before. She wrote to her website, dedicated to the authorship issue, that Hancock told her that he heard through his father, who in turn heard it through an Episcopa-

lian priest named Father Thomas, of a story that involved the naming of the poem's eight reindeer. Hancock told her that he believed the reindeer were named after the horses in Henry Livingston Jr's stable. Mary recruited the help of her cousin and they embarked on a search for the documentary evidence for the horses. Unfortunately, and certainly disappointing for Mary, the records that could be used to substantiate this claim were not found.

The immensely wealthy land baron Richard Harison (1747-1829) and his son William Henry Harison (1795-1860) owned three mansions complete with Victorian stables in Canton, New York in the first half of the 19th century. They operated a famous-stock breeding farm that was also located in Canton. C.C.M. is known to have visited his friends the Harisons, with one of their homes named in honor of his visit, The Clement Moore Mansion on Upper Judson Street in Canton. No records of the Harison's horses have been located and it is but conjecture to consider that eight of their prize horses bore the names of the eight reindeer of the poem – it is a magical thought, nonetheless.

Henry Livingston Jr. was born in 1748 in Poughkeepsie, New York. During the Revolutionary War he held a commission as a Major under Richard Montgomery. He wrote poetry for his friends and family throughout his life, with some of his works published in the *New York Magazine* and the *Poughkeepsie Journal* and to broadsheets. He allowed his work to be published both anonymously and with the initial "R".

NOTE: Seth Kaller concludes in *The Moore Things Change, Journal of American History*, Winter 2004; that there is both historical and documentary evidence that supports C.C.M.'s claim to the poem and that the same can not be said of the argument for Henry Livingston Jr.

Hail home! sacred home! to my soul ever dear;
Abroad may be wonders but rapture is here.
My future ambition will never soar higher
Than the clean-brushed hearth and convivial fire
On your patience to trespass, no longer I dare
So, bowing, I wish you a Happy New Year.

— HENRY LIVINGSTON JR.

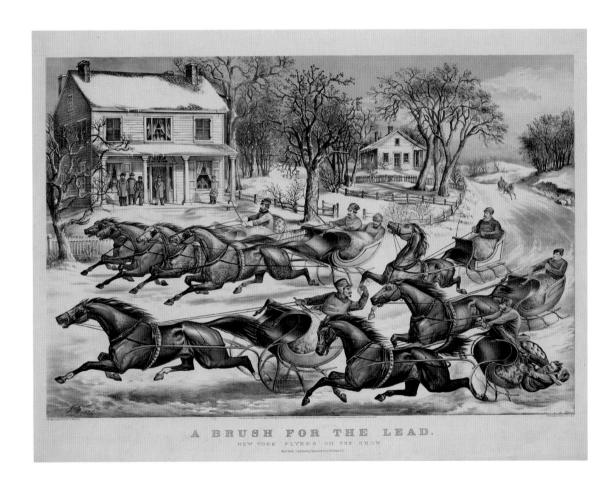

CREDIT: Artist – Currier and Ives, *A Brush for the Lead: New York Flyers on the Snow* (Currier & Ives. 1867). Photograph. Retrieved from the Library of Congress, www.loc.gov/item/90713010.

NOTE: Henry Livingston died in February of 1828 at this home in Poughkeepsie, NY. The last lines he is thought to have written were found in a letter he was writing to his family shortly before his death: "put a few sleighs in requisition." His daughter Susan finished the letter with a mention of the family's recent Thanksgiving celebrations: "We have had pretty gay times, I tell you – 4 horse sleigh and bells had to fly." As documented by Mary Van Deusen on henrylivingston.com.

CHAPTER 6

The Manuscripts

The earliest hand-written copy of *Twas The Night* was discovered in the Jonathan Odell Family Papers, part of the Loyalist Collection in the New Brunswick Museum Archives in Fredericton, New Brunswick, Canada.

"The copy of "A Visit From Saint Nicholas" found in the Odell Family Papers was written on paper which has an 1824 watermark, therefore must have been penned after Jonathan's death in 1818 by a family member, likely his daughter Mary (1773-1848). The manuscript appears to be in her handwriting, as samples of her writing also from the same collection show similarities. The direct source of this copy of the poem is unknown, and some variants in words and punctuation that do not occur anywhere else are found in this version. The Odell copy must have been an early iteration of the poem and may have been re-written by memory because two instances of crossed-out and corrected words appear: "up the chimney he goes" was changed to "rose" and "a little old driver so tiny" exchanged for "lively" - As well, the script appears to have been written fairly quickly, suggesting the writer was transcribing from memory The Odell version of the poem differs slightly from common, modern versions. Unique word forms which appear include: "sugar plumbs" instead of "sugar plums" (as appears in the first published version); "danc'd thro" versus "danced in" - "pawing and prancing" versus "prancing and pawing;" "was slung over" vs " was flung over;" "in a wreath" vs "like wreath". As well, many punctuation differences occur, particularly at ends of lines of verse. The manuscript of the Odell Papers also contributes to one of the biggest points of discussion in the authorship debate which concerns a certain pair of reindeer: "Donner and Blitzen," or as they were recorded in the original published version, "Dunder and Blixem," these being the common New York Dutch words and spellings of thunder and lightning versus the German words which are used in modern versions of the poem. In the Odell version, an intermediate form is used with the spellings "Donder and Blixen." The names of some of the reindeer are also reordered." - Courtesy LEAH GRANDY, PhD, History, *A Visit From St. Nicholas: The New Brunswick Odells and the Authorship Controversy, Atlantic Loyalist Connections.*

CREDIT: Artist - John West Giles, (English, 1799-1876) after Captain John Campbell, English (1807-1855), Graf & Soret, print: *New Brunswick Fashionables!!!* Fredericton, Jany, 1834, c 1834. *John Clarence Webster Canadiana Collection* W581.
Pages 112-113: Odell Papers, manuscript of *A Visit From St. Nicholas*. Courtesy of the New Brunswick Museum.

A Visit from St. Nicholas

'Twas the night before Christmas when all thro' the house
Not a creature was stirring, not even a mouse —
The Stockings were hung by the chimney with care,
In hopes that St Nicholas soon would be there;
The children were nestled all snug in their beds,
While visions of Sugar plumbs danced thro' their heads;
And mama in her kerchief, and I in my cap,
Had just settled our brains for a long winter nap;
When out on the lawn there arose such a clatter,
I sprang from the bed to see what was the matter;
Away to the window I flew like a flash
Tore open the shutters and threw up the sash —
The moon on the breast of the new fallen snow,
Gave the lustre of mid-day to objects below
When what to my wondering eyes should appear,
But a miniature sleigh and eight tiny reindeer!
With a little old Driver so lively and quick,
I knew in a moment it must be St Nick.
More rapid than Eagles his coursers they came
And he whistled and shouted and called them by name
"Now Dasher, now Dancer, now Prancer and Vixen,
"On Comet, on Cupid, on Donder and Blixen —
"To the top of the porch to the top of the wall —
"Now dash away! dash away! dash away all!" —
As dry leaves that before the wild hurricane fly,
When they meet with an obstacle, mount to the sky,
So up to the house top his coursers they flew
With the sleigh full of toys & St Nicholas too;
And then in a twinkling I heard on the roof
The prancing and pawing of each little hoof,
As I drew in my head and was turning around
Down the Chimney St Nicholas came with a bound
He was dressed all in fur from his head to his foot
And his clothes were all tarnished with ashes & soot
A bundle of toys was flung over his back
And he looked like a pedlar just opening his pack
His eyes how they twinkled, his dimples how merry
His cheeks were like roses, his nose like a cherry

His droll little mouth was drawn up like a bow,
And the beard of his chin was as white as the snow,
The stump of a pipe he held tight in his teeth,
And the smoke it encircled his head in a wreath,
He had a broad face and a little round belly,
That shook when he laughed like a bowl full of jelly,
He was chubby and plump, a right jolly old elf,
And I laughed when I saw him in spite of myself.
A wink of his eye, and a twist of his head
Soon gave me to know I had nothing to dread.
He spoke not a word but went straight to his work,
And filled all the stockings — then turned with a jerk,
And laying his finger aside of his nose,
And giving a nod, up the chimney he rose,
He sprung to his sleigh, to his team gave a whistle,
And away they all flew like the down of a thistle,
But I heard him exclaim, as he drove out of sight,
Happy Christmas to all — and to all a good night —

Jonathan Odell (American, 1737-1818 Canada) was an ordained clergyman, a Doctor of Medicine and surgeon, a satirist and poet. He was a descendant of William Odell, a founder of the Massachusetts Bay Colony. Odell graduated from Princeton in 1754 and by 1756 had joined the British Army. Odell became an Episcopal minister in England before returning to the colonies in 1767. Odell remained loyal to the British crown and functioned as a spy decoder during the Revolutionary War, assisting in the defection of Benedict Arnold in 1779-1780. British officer John Andre rewrote Arnold's correspondence into code form, from which Odell decoded the letters for Loyalist secret agent, poet, and satirical song writer Joseph Stansbury (British, 1742-1809 America) and British General Sir Henry Clinton (British, 1730-1795). *The Loyal Verses of Joseph Stansbury and Doctor Jonathan Odell*, by J. Munsell was published in 1860.

Bishop Benjamin Moore and Charity Moore where closely acquainted with Jonathan Odell and chose Odell to be C.C.M.'s godfather. Odell attended C.C.M.'s baptism in New York City in 1779, traveling to New York from his home in Burlington, Virginia, under the protection of a letter dated February 8, 1777, signed by Commander of the Continental Army and First President of the United States George Washington. The letter that offered Odell safe passage during his lifetime is in the collection of the *George Washington Papers, Series 4*, held by the Library of Congress.

In 1781, Odell became assistant secretary to the Board of Directors of the Associated Loyalists, a political group headed by William Franklin, the

son of Benjamin Franklin whose political views contradicted those of his father who was committed to the patriot cause.

"As a satirist, no one on that side of the controversy approached Odell, either in passionate energy of thought or in pungency and polish of style." - MOSES COIT TYLOR, *Literary History of the American Revolution 1763-1783*,(1941).

Jonathan Odell stayed in America, acting as chaplain and then as assistant secretary to Sir Guy Carleton, until the peace treaty of 1783 at which time he left for England. In 1784 he left with a government-assigned position for the newly established province of New Brunswick in the British colonies. Odell never returned to America and with his family made Fredericton, New Brunswick home. Fredericton in 1785 became the capital of the province, named after a son of King George II of England.

Two poems written out in the same hand as *Twas The Night* are also in the Odell Collection. The poems, identified as *Lines Written After a Snowstorm*, and *A Husband to His Wife* were included in C.C.M.'s collected works published in 1844. The Odell copies of these two poems are not titled; a heading for the poem *Lines Written After A Snowstorm* reads: "To Margaret and Elizabeth". There are eight-word variations in the Odell version of *Lines Written After a Snowstorm* and eleven variations between the Odell copy of *A Husband to His Wife* and the 1844 published version. C.C.M.'s initials appear on the manuscript of *A Husband to His Wife*; not on the other two Odell transcripts.

Lines Written After a Snowstorm was published in the Troy Sentinel, without a title or author attribution on February 20, 1824. *Lines Written After a Snowstorm*, appeared with the heading: "For the *Troy Sentinel*", as *Twas The Night* had appeared twenty eight days earlier. How the second poem reached Orville Holley remains a mystery.

CREDITS: Page 114: Unknown artist painter, *Jonathan Odell*,1737-1818, c 1770. Watercolour on ivory, overall: 5.5 x 3.5 *John Clarence Webster Canadian Collection*, gift of Mary Kearny Odell. W 1294. Courtesy of the New Brunswick Museum. Unknown artist silhouette: *Mary Odell*, c. 1800, hollow cut wove paper on black wove paper, frame (excluding hook): 13.8 x 11.3 x 1.5 cm. Gift of Florence A. Bowman, 1971. 1971.169.4. Courtesy of the New Brunswick Museum.

NOTES: Odell used the pen name Camillo Querno, a reference to a court jester. In the Odell family papers there are two letters, one dated May 12, 1810, and the other September 25, 1808, written by C.C.M. addressed to Jonathan Odell; both concern C.C.M.'s work regarding the Hebrew language: "My Father and Mother join me in respects to you and all the family. Yours, with sincere respect. C.C. Moore."

J. Odell's maternal grandfather was Jonathan Dickinson (1688-1747, American); the co-founder and first president of The College of New Jersey (Princeton University).

The Chilton Copy is discussed in *Chilton Manuscript of A Visit from St. Nicholas*, written by Scott Norsworthy, posted to *Melvilliana* for December 24, 2019. The first eighteen lines of *Twas The Night*, written in the handwriting of C.C.M., appeared in the January 1875 issue of *St. Nicholas: Scribner's Illustrated Magazine for Girls and Boys*. The lines are neither signed nor dated. An editorial regarding the facsimile was printed adjacent to the lines:

"The original manuscript of these famous verses is in the possession of the Hon. R.S. Chilton, United States Consul to Clifton, Canada, whose father was a personal friend of Mr. Moore, and who very kindly allowed us to make this fac-simile copy of a page of the manuscript for St. Nicholas." St. Nicholas, January 1875, p. 161 (Excerpt).

The whereabouts of the original *Chilton Copy* is not known.

Four manuscripts of the poem have been located and authenticated as in the handwriting of C.C.M. Three of the copies are in public collections, while the fourth remains in private hands, having changed ownership numerous times.

The Strong Museum Copy, of Rochester, New York was written by C.C.M. in August of 1853 and was accompanied with a note from C.C.M. which reads: "Written many years ago; I cannot say exactly when". Clement C. Moore, Aug. 1853. The Strong Museum acquired the document in 1977 at an auction held at Kennedy Galleries of New York for the price of $4,000. The manuscript had previously been in the possession of Henry Paul Beck of Philadelphia, his son Henry Dwight Beck, and Beck descendants John B. Webster and Gloria B. Webster.

The William K. Bixby Copy dates from March 6, 1856, produced at the request of Oscar T. Keeler. The copy was purchased by Henry Huntington from the *Bixby Collection* in 1918, at which time it was donated to the Huntington Library and Art Gallery of San Marino, California. A letter from C.C.M. to Keeler regarding the copy is in the possession of the New York Public Library.

The Hugh Bullock Copy remains in a private collection. J. Clarence McCarthy of Pennsylvania purchased the copy from Goodspeeds, a booksellers of Boston in 1932, it sold to J. Clarence McCarthy, whose heirs sold it to Calvin Bullock of New York, and then on to his son Hugh Bullock who sold it in 1944 to a private collector. In December 1994, it sold for $255,500 to Ralph P. Gadiel, in December 1997 for $211,500 and in 1999 offered in the Christmas catalogue of the retailer Neiman Marcus of Dallas, Texas for an asking price of $795,000. The copy sold in 2006 for $280,000 to a private collector who was reported by Associated Press to be a chief executive of a media company.

CREDIT: Pages 117-119: *The Strong Museum Manuscript Copy* (1853). Courtesy *The Strong*, Rochester, NY.

NOTE: Hon. R.S. Chilton (American, 1822-1911). Father of R.S.C.: Dr. George Chilton (American, 1768-1836). *The St. Nicholas 1875* issue is available on *Internet Archives*; submitted by *VictorianVoices.net*.

'Twas the night before Christmas, when all through the house

Not a creature was stirring, not even a mouse;

The stockings were hung by the chimney with care,

In hopes that St. Nicholas soon would be there;

The children were nestled all snug in their beds,

While visions of sugar-plums danced in their heads;

And Mamma in her 'kerchief, and I in my cap,

Had just settled our brains for a long winter's nap;

When out on the lawn there arose such a clatter,

I sprang from the bed to see what was the matter.

Away to the window I flew like a flash,

Tore open the shutters and threw up the sash.

The moon on the breast of the new-fallen snow

Gave the lustre of mid-day to objects below;

When, what to my wondering eyes should appear,

But a miniature sleigh and eight tiny rein-deer,

With a little old driver, so lively and quick,

I knew in a moment it must be St. Nick.

More rapid than eagles his coursers they came,

And he whistled, and shouted, and call'd them by names;

"Now

"Now, Dasher! now, Dancer! now Prancer and Vixen!

On, Comet! on, Cupid! on, Donder and Blitzen!

To the top of the porch! to the top of the wall!

Now dash away! dash away! dash away all!"

As dry leaves that before the wild hurricane fly,

When they meet with an obstacle, mount to the sky;

So, up to the house-top the coursers they flew,

With the sleigh full of toys, and St. Nicholas too.

And then, in a twinkling, I heard on the roof

The prancing and pawing of each little hoof —

As I drew in my head, and was turning around,

Down the chimney St. Nicholas came with a bound.

He was dressed all in fur, from his head to his foot,

And his clothes were all tarnished with ashes and soot;

A bundle of toys he had flung on his back,

And he look'd like a pedlar just opening his pack.

His eyes — how they twinkled! his dimples how merry!

His cheeks were like roses, his nose like a cherry!

His droll little mouth was drawn up like a bow,

And the beard of his chin was as white as the snow;

The

118

The stump of a pipe he held tight in his teeth,

And the smoke it encircled his head like a wreath;

He had a broad face and a little round belly,

That shook, when he laughed, like a bowlfull of jelly.

He was chubby and plump, a right jolly old elf,

And I laughed when I saw him, in spite of myself.

A wink of his eye and a twist of his head,

Soon gave me to know I had nothing to dread.

He spoke not a word, but went straight to his work,

And fill'd all the stockings; then turned with a jerk,

And laying his finger aside of his nose,

And giving a nod, up the chimney he rose;

He sprang to his sleigh, to his team gave a whistle,

And away they all flew like the down of a thistle.

But I heard him exclaim, ere he drove out of sight,

"Happy Christmas to all, and to all a good night."

Written many years ago; I cannot say exactly
when.
 Clement C. Moore.
 Aug. 1853

The original unidentified recipient of The Hugh Bullock Copy wrote a note on the original transcript: "I passed the month of August 1860 in Newport, where I had the pleasure of meeting with Dr. Moore, then in (his) 83(rd) year, who very kindly took the trouble to transcribe his verses for me and to subscribe to them his name. Dr. Moore has been some years Emeritus Professor of Oriental and Greek Literature to the Genl. Theological Sem. in N.Y. and was the son of the late Bishop Benjamin Moore of N.Y."

The New York Historical Society copy of the poem was produced by C.C.M. on March 13, 1862. The copy was provided by C.C.M. at the request of George Moore and facilitated by T.W.C. Moore. The original letter of request is held by the New York Historical Society.

March 15, 1862, 73 East 12th. St. New York
Geo. H. Moore Esqr, Librarian of the New-York Historical Society:

Dear Sir:

I have the pleasure to inform you that Doctor Clement C. Moore has been so kind as to comply with my request (made at your suggestion) to furnish, for the Archives of our Society, an Autograph Copy of his justly celebrated *Visit from St. Nicholas*. I now enclose it to you. - I hardly need (to) call your attention to the distinctness and beauty of his handwriting: - very remarkable, considering his advanced age, (he completed his 82d year in July last) and his much-impaired eyesight.

These lines were composed for his two daughters, as a Christmas present, about 40 years ago. - They were copied by a relative of Dr. Moore's in her Album, from which a copy was made by a friend of hers, from Troy, and much to the surprise of the author, were published (for the first time) in a newspaper of that city. In an interview that I had yesterday with Dr. Moore, he told me that a portly, rubicund Dutchman, living in the neighbourhood of his father's country seat, *Chelsea*, suggested to him the idea of making St. Nicholas the hero of this "Christmas piece" for his children. I remain very respy.

Your obt. St. T.W.C. Moore.

Thomas William Channing Moore (American, 1794-1872) was an antiquarian, an expert in the proper methods of documenting collectibles. T.W.C. Moore was well positioned to know if there had been a mistake in the attribution regarding the poem.

Scott Norsworthy wrote in 'Key Witness Letter by Livingston Cousin and Genuine Antiquarian TWC Moore' - Melvilliana, February 7, 2018: "If Henry Livingston, Jr. had written *The Night Before Christmas* as alleged by some Livingston descendants, T.W.C. would have known it, and for the honor of his dear mother Judith Livingston Moore and her native Poughkeepsie and her worthy cousin Henry Livingston Jr. he would happily have told the world."

Judith Livingston Moore (1750-1813) and her husband John Moore (1746-1828) had lived adjacent to the Henry Livingston Jr. family in Poughkeepsie, NY. Two of the couple's nine children were Thomas William Channing Moore and Lydia Hubbard Moore.

Thomas C. Moore's sister, Lydia, married into the Moore family and her daughter, Francis, had married Reverend Clement Moore Butler of Troy, New York. Reverend Moore's sister was Harriet Butler. Thomas C. Moore is known to have been close to his niece Francis and C.C.M.

The Moore family and the Livingstons were related both by marriage and through their lineage to the Sacketts and the Butler families. Henry Livingston Jr. was of C.C.M.'s parents' generation. Several of Henry Livingston's children, from both his first and second marriage, would have been adults at the time *Twas The Night* had achieved notoriety in the 1830s and assuredly by the 1840-1850s. They would have been well positioned to address the issue of authorship, even despite reservations given C.C.M.'s position in society. Between the artistic community, professional contacts, the extended family of both C.C.M. and Henry Livingston Jr., and circles of influence, nothing has been found in terms of documentary firsthand evidence to support the theory that the poem was written prior to 1822 and by anyone other than C.C.M.

In December of 1823 Orville Holley had stated in his preface for *Twas The Night* that he had not known who authored the poem. In 1829 he choose to elaborate:

"A few days since the editors of the New York Courier, at the request of a lady, inserted some lines descriptive of one of the Christmas visits of that old Dutch saint. St. Nicholas, and at the same time applied to our Albany neighbors for information as to the author. That information, we apprehend, the Albany editors cannot give. The lines were first published in this paper. They came to us from a manuscript in possession of a lady in this city. We have been given to understand that the author of them belongs by birth and residence to the city of New York, and that he is a gentleman of more merit as a scholar and a writer than many of more noisey (noisy)pretensions. We republish the lines in a preceding column just as they originally appeared, because we still think them as at first, and for the satisfaction of our brethren of the Courier, one of whom, at least, in an Arcadian. – *Troy's One Hundred Years* – Orville Holley." - *The Troy Sentinel*, 1829.

In 1836, Orville Holley stated in the *Ontario Repository and Freeman* of Canandaigua, New York:

"The following lines appeared in print for the first time – though very often copied since – in the Troy Sentinel of December 23, 1823, which paper we then conducted. They were introduced, on that occasion, with the following remarks; which, as they continue to be a the true expression of our opinion of the charming simplicity and cordiality of the lines, as well as of our unchanged feelings toward the little people to whom they are addressed, we repeat them, only observing that although when we first published them, we did not know who wrote them, yet, not many months afterwards we learnt that they came from the pen of a most accomplished scholar and estimable man, a professor in one of our colleges."

An early connection between the poem and C.C.M. appears on a page dated December 31, 1833, in a diary belonging to Francis Prioleau Lee, a student at the General Theological Seminary while C.C.M. was on the faculty. Lee writes about his impressions of a visit to a Christmas fair in Morristown, New Jersey: "a figure called St. Nicholas was robed in fur and dressed according to the description of Prof. Moore in his poem." The Lee diary is held by the General Theological Seminary.

On December 2, 1823, the poem *Faithful Love* was published anonymously in the *Troy Sentinel*, published alongside a letter addressed to Mr. Holley – "The following lines were copied from the manuscript of one of our most distinguished American bards, whom composed them in 1822, in New York, while the yellow fever was (word illegible) here. I believe they have never been published, and it would give me much pleasure to see them in the Sentinel. They exhibit a picture of devoted and faithful and courageous love, in my estimation well drawn and tenderly interesting."

The letter is signed: "One of Your Female Readers". *Faithful Love* was written by James G. Percival (American, 1795-1856) and published as *Night Watching* in a collection of his work – *Poems* (1823). The author of the letter to Holley remains unidentified.

> She sat beside her lover, and her hand
> Rested upon his clay-cold forehead. Death
> Was camly(calmy) stealing o'er him, and his life....

> - *Faithful Love* (Excerpt) *Troy Sentinel*, December 2, 1823.

In 1844, C.C.M. defended his claim to the authorship of the poem by writing to the editors of a newspaper who had attributed the poem to Joseph Wood: "Dear Sir - My attention was, a few days ago, directed to the following communication, which appears in the *National Intelligencer* of the 25th of December last.

> Gentleman - The enclosed lines were written by Joseph Wood, artist for the *National Intelligencer*, and published in this paper in 1827 or 1828, as you may perceive from your files. By republishing them, as the composition of Mr. Wood you will gratify one who has now few sources of pleasure left. Perhaps you may comply with this request if it be only for *Auld lang syne*. The above is printed immediately over some lines, describing a visit from St. Nicholas, which I wrote many years ago, I think somewhere between 1823 and 1824, not for publication, but to amuse my children. They, however, found their way, to my great surprise, in the *Troy Sentinel*: nor did I know until lately, how they got there. When *The New York Book* was about to be published, I was applied to for some contributions to the work. Accordingly, I gave the publisher several pieces, among which was the *Visit from St. Nicholas*. It was printed under my name, and has frequently since been republished, in your paper among others, with my name attached to it. Under these circumstances, I feel it incumbent on me not to remain silent, while so bold a claim, as the above quoted, is laid to my literary property, however small the intrinsic value of that property may be. *The New York Book of Poetry* was published in 1827. (sic:the publication was released in 1837).

> Yours, truly and respectfully, CLEMENT C. MOORE."

For December 24, 1869, the *Richmond Whig*, of Richmond, Virginia printed the poem: "The occasion would not be properly honored were we to omit that delightful inspiration for which our young people are indebted to a son of the venerated and beloved Bishop Moore, who for so many years presided over the Episcopal Church of Virginia."

C.C.M.'s father Bishop Benjamin Moore presided over the Episcopal Church of New York. The bishop mentioned by the *Richmond Whig* was the Right Reverend Richard C. Moore. His brother Reverend Thomas Lambert Moore (1758-1799) had married Judith Moore, the sister of Bishop Benjamin Moore. The error does not appear to have been corrected.

William S. Thomas on December 12, 1920, wrote to C.C.M.'s grandson: Mr. Casimir de Rham Moore, 109 East 38th Street, New York.

Dear Sir:

Would it be presuming of your patience and good nature for me to ask if you can recall the fact that either you or your elder brother at the school (before he went to the Civil War) heard Mr. Thomas state that his grandfather, Henry Livingston, wrote the "Night Before Christmas"? Father once told his sister that he had discussed the matter with a grandson of Dr. Clement C. Moore, while at Churchill's Academy. Quite aside from the merits of the case, I should be glad to know if you can recall the matter, trifling as it is. The courtesy of a reply will be gratefully received by.

Yours respectfully,
William S. Thomas (Great grandson of Henry Livingston Jr.)

Thomas received a reply the following day - December 13, 1920:

Dr. William S. Thomas 240 West 71st St. New York City,

Dear Sir:

By your letter I see you are a cousin of Mr. Livingston who lays claim, on behalf of his grandfather, to the authorship of the little poem. I will not therefore go into the question of the true authorship with you further than to say it would be an impossibility for Clement C. Moore to have assumed the authorship wrongly. His whole past and future life would have been a lie: and Mr. Benchley says he never was caught in one. I fear Mr. Livingston will have to try again before he can persuade people to accept his claim . . .

Your very truly, Casimir de R. Moore

CREDIT: Page 125: Unidentified illustrator. Rare Books – *Nancy H. Marshall Collection*, Special Collections Research Center, William & Mary Libraries.

NOTE: Casimir de R. Moore was the son of C.C.M.'s eldest son Benjamin. Henry Livingston Jr.'s daughter Jane was grandmother to William S. Thomas. Henry Livingston Jr. had a first family of five children with his wife Sarah Patterson, their first born 1775 and last in 1794. With his second wife Jane Patterson he had eight children born between 1796 and 1814. His descendants that support a claim of authorship purport that he authored the poem for his second family who would have been young of age ca. 1800-1820.

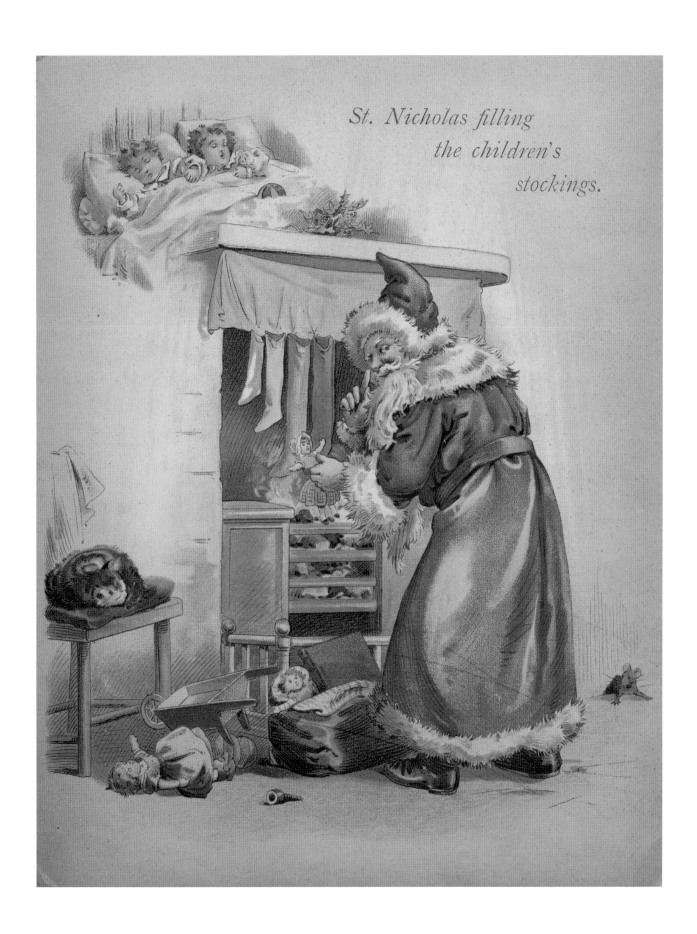

St. Nicholas filling the children's stockings.

CHAPTER 7

Clement Clarke Moore

"Nothing is harder to kill than a nursery rhyme. Once let it become part of the pattern of childhood and its immortality is assured. *Jack Spratt, King Cole, Miss Muffet* and *Boy Blue* are known and loved by thousands upon thousands who have never heard, nor cared to hear, of *Endymion* or *Prometheus*, or *Childe Harold*. *Mother Goose* will probably be the last work of English literature to perish. It is astonishing how a mere jingle will sometimes win a tremendous vogue. When Henry Wadsworth Longfellow tried to soothe his second daughter by chanting:

> There was a little girl
> Who had a little curl
> Right in the middle of her forehead,
> When she was good
> She was very, very good,
> But when she was bad she was horrid.

As he walked up and down the garden carrying her in his arms, he would have been aghast had he suspected that these lines were to become more widely known than *Evangeline* or *Hiawatha*.

Similarly, when a learned professor of Oriental and Greek literature in the General Theological Seminary of New York City, the editor of a monumental Hebrew lexicon, and a thoroughly grave and learned man, as far unbent as to write some merry Christmas verses for his two little daughters, he would have been indeed disillusioned and impressed with the vanity of human attainments had he foreseen that all of his works this jingle alone was destined to survive. Yet such was the fate which befell Clement Clarke Moore." - BURTON STEVENSON, *Famous Single Poems, and the Controversies Which They Raged* (Dodd, Mead & Company, NY, 1923).

CREDIT: Page 127: *Clement Clarke Moore*, 3/1810 (James Sharples, 1751-1811) Bristol Museum and Art Gallery, UK Purchased 1931/ Bridgeman Images.

NOTE: A portrait by an unknown artist was painted of C.C.M. when he was a young boy. Artists Daniel Huntington, Henry Inman and J.W. Evans created portraits of C.C.M. in his adult life. Sculptor Joseph Fleri (1889-1965) created a bronze work of C.C.M. and his father Rt. Rev. Bishop Benjamin Moore.

C.C.M.'s granddaughter shared her understanding of her grandfather's life in her booklet: *Recollections of Clement C. Moore, Author of 'A Visit From St. Nicholas', written by his Granddaughter Mary Moore Sherman*, (The Knickerbocker Press, NY, 1906). Sherman's booklet includes reproduced images of portraits painted of C.C.M. and members of his immediate family, which are understood to be held in private collections. (Excerpted):

I wonder if any of the numerous people who pass the crowd of laborers along the river front in the neighborhood of West 23rd Street, and see the great works now in progress there—the stone piers where steamers that hold a townful of folk will find accommodation, the ferry-houses were ever increasing throngs hurry to and from the city;—I wonder if any one of all the passers-by gives a thought to the peaceful country place whose green lawns sloped down to the river so short a time ago, and under whose stately trees lived little more than a century since the genial gentleman, scholar, poet, and musician, Clement C. Moore, the author of *'Twas the Night Before Christmas*.

In this spacious, comfortable house that was almost hidden in its foliage from outsiders, surrounded by a large family, extending hospitality to many of the distinguished strangers who visited New York.

A versatile man was Mr. Moore, being Professor in the General Theological Seminary, which he enriched with a princely fortune; organist in St. Peter's Church, which he contributed largely to erect, whose gray-stone walls and towers remain unchanged; in his idle moments playing skillfully on his violin, and composing for his children poems, of which one, at least, touched the heart-cords of the children of the world. Even now, from all the distant corners of the globe, wherever the English-speaking race has penetrated, their joyful voices lisp forth the dearly loved verses. And when, after calling up the chimney to their faithful friend not to forget this or that much longed for present, they go to their little beds, are not their curly heads full of dreams all night of the reindeer on the roof, and are they not certain they heard St. Nicholas whistling and shouting and calling them by name? And the magician who wrought them these visions was Clement C. Moore.

Captain Thomas Clarke, a retired army officer, bought a farm on the banks of the Hudson River in 1750. Roughly speaking, it comprised a tract of land lying between the 19th and 28th street, Eighth avenue and the river. This estate Captain Clarke named *Chelsea*, "as being the retreat of an old war-worn veteran who had seen much service in the British army." He left three beautiful daughters, who after their father's death found their position in New York rather unpleasant, because of Tory sympathies, which drew upon them sneers and jibes when they walked in the streets Like the three princesses in the fairy story, they went abroad to seek their fortunes, and only one returned to America again. They were much admired in England. One of them - Maria Theresa - married Captain (afterwards Lord) Barrington and was lost at sea; while her sister Mary first married Mr. Vassall, a rich West Indian, and after his death Sir Gilbert Affleck.

It was her daughter by the former marriage who became the great Lady Holland, wife of Henry Richard Fox, third Earl of Holland.

The third sister, Charity, rejected all her numerous offers, insomuch that her relatives bade her beware, or she would be like the stork in the fable, who, rejecting many excellent dainties because he wanted a turbot, had to make his dinner off a frog. She returned to America, where in 1778, she married Mr. Benjamin Moore, afterwards Bishop of New York

She was probably the handsomest of the three sisters, for her portrait, which hangs in Holland House, was so beautiful as to enrapture the poet Rogers. I have in my possession a volume of his poems, which he sent her as a token of his admiration, which is written in his own delicate handwriting: "From the author to Lady Holland, for her Aunt Mrs. Moore, March 22nd, 1834." Another interesting heirloom I am fortunate enough to own is a lithograph copy of the famous snuff box Napoleon gave to Lady Holland, with his autograph inscription, "L'Empereur Napoleon, à Lady Holland", and underneath in her Ladyship's own handwriting: "To Mrs. Moore, from her affectionate niece, E.V.HOLLAND."

Clement C. Moore, the son of Bishop and Mrs. Moore, was born July 15th, 1779. In 1813 he married the beautiful daughter of William Taylor, Lord Chief Justice of Jamaica, W.I. She was only nineteen years old at the time, and her friends wondered why such a lovely maiden should select for her husband a student, a bookworm, and with a man considerably older than herself.

To these criticisms she made reply in the graceful verses below, which show that Mr. Moore found in her not only youth and beauty, but a poetic soul which could sympathize with his own, and also appreciate his great learning:

MY REASONS FOR LOVING

You ask me why I love him ?
I'll tell the reasons true;
Because he said so often
With fervour "I love you."

I loved him, yes, I love him
Because he told his flame
With such a skilled variety
And whispered "Je vous aime."

Because so sweetly tender
As any swain on Arno,
In crowded streets he'd woo me
With Petrarch's own "Vi amo."

Because whenever coldly
I'd answer him "Ah, no,"
He'd call my coldness banish
By faltering "Te amo."

Because when belles surrounded
He'd still address to me
The words of love and learning,
And sign "Philea se."

Because his English, French,
Italian, Latin, Greek,
He Crowned with noble Hebrew
And dulcet, "Ahobotick."

This charming lady died at the age of thirty-six, leaving nine surviving children, my mother being one of them Mr. Moore never married again, but lived with his widowed mother and large family in Chelsea. The city, however, gradually encroached on the quiet country place, and the house was finally pulled down to give way to the demands of the times. Mr. Moore then built for himself a house at the southwest corner of 23rd Street and Ninth Avenue, and one for my mother adjoining it. His summers were spent in Newport, and there he died in July 1863, in the eighty-fourth year of his age. He was universally mourned, for both old and young loved the gentle, courteous, childlike scholar He composed the *Visit from St. Nicholas* one afternoon while being driven home from the city, and it was published for the first time anonymously in the *Troy Sentinel*, Dec. 23d, 1823. Mr. Moore was much astonished at the enthusiasm which it drew forth.

These few remembrances of him I have collected from family papers and traditions for my little nephew, niece, and cousins, and for descendants, yet unborn, of the gentle scholar, that his memory may be kept green in their hearts, so that when they teach their own little ones to lisp *'Twas the night before Christmas* they may also tell them about the author. Dearly did he love children, and it is only right that he as well as his verses should live in their memories. We all know and love *'Twas the night before Christmas,* but in Clement C. Moore's book of verses there is another short piece for which I always had a warm affection, and perhaps some cold winter's day, when the little ones go out just after a snow storm to build their snow castles and snow men, some of the more thoughtful ones may pause for a moment before beginning their work, and, surveying the lovely scene, may think of these lines.

LINES WRITTEN AFTER A SNOWSTORM BY THE AUTOR OF A VISIT FROM ST NICHOLAS

Come, children dear, and look around -
 Behold how soft and light
The silent snow has clad the ground
 In robes of purest white.

The trees seem decked by fairy hands,
 Nor need their native green;
And every breeze appears to stand,
 All hush'd, to view the scene.

You wonder how the snows were made
 That dance upon the air
As if from purer worlds they stray'd,
 So lightly and so fair.

Perhaps they are the summer flowers
 In northern stars that bloom,
Wafted away from icy bowers
 To cheer our winter's gloom.

Perhaps they're feathers of a race
 Of birds that live away
In some cold, dreary, wintry place
 Far from the sun's warm ray.

And clouds, perhaps, are downy beds
 On which the winds repose;
Who when they rouse their slumb'ring heads
 Shake down the feath'ry snows.

But see, my darlings, while we stay
 And gaze in fond delight,
The fairy scene soon fades away
 And mocks our raptur'd sight.

And let this fleeting vision teach
 A truth you soon must know -
That all joys you here can reach
 Are transient as the snow.

As a young boy C.C.M. was tutored at home by his father and then educated at Columbia College in classical and biblical studies. C.C.M. graduated from Columbia in 1798 and gave a valedictorian address he titled "Gratitude" to his class of eighteen. C.C.M. served as a Trustee of the College (1813-1857), and Clerk of the Board (1815-1850). Students at Columbia have enjoyed hearing the poem at the college's Yule Log Ceremony each year since 1954.

C.C.M.'s published written works included: *Juvenalis. A New Translation with Notes, Of the Third Satire of Juvenal* (E. Sergeant, NY, 1806). An unsigned preface and six poems included in *Juvenalis* are credited to C.C.M. The poems were republished in the collection of C.C.M.'s poetry in 1844. *Plain Statement, addressed to the proprietors of real estate, in the city and county of New-York* was written by C.C.M. in 1818, as his family's estate was facing encroachment due the expansion of New York City.

C.C.M. wrote *A Compendious Lexicon of the Hebrew Language* in eight volumes (Collins & Perkins) in 1809. In 1825, he wrote *The Early History of Columbia College: An Address Delivered Before the Alumni*. His last published work *George Castriot, surnamed Scanderbeg, King of Albania* (D. Appleton, NY, 1850), a story of Scanderbeg was well received.

In 1813, the nuptial notice of his marriage to "Eliza" read: "Married, By the Rt. Rev. Bishop Hobart, Clement C. Moore Esq. son of the Rev. Bishop Moore, to Miss Catherine (Elizabeth "Eliza") Taylor, daughter of the late William Taylor, Esq." C.C.M. and "Eliza" had nine children: Margaret Elliot Moore Ogden 1815-1845, Charity Elizabeth Moore 1816- 1830, Benjamin Moore 1818-1886, Mary Clarke Moore Ogden 1819-1893, Clement Moore 1821-1889, Emily Moore 1822-1828, William Taylor Moore 1823-1897, Catherine Van Cortlandt Moore 1825-1890, Maria T.B. Moore 1826-1900. Two websites, *Find a Grave* and *Geni.com* list a William Hill Moore, born in 1804, as being a son of C.C.M. The relationship is unverified.

C.C.M. wrote poetry throughout his life. For December 27, 1848, he wrote - *To Miss Jeannette McEvers*, a poem written to a friend's daughter. (Excerpt):

> And when, at last, thy worldly cares shall end,
> And then awaken from life's empty dream,
> May thy glad spirit to the skies ascend
> And, mid the lights of Heav'n, send forth its beam;
> And like the lovely star of evening shine,
> In modest glory clad, serene though bright;
> And, near th' eternal, bounteous Source divine,
> For ever and for ever dwell in light.

CREDIT: Mary Moore Sherman, Pages 128-130.

C.C.M. wrote a preface addressed to his children to accompany the 1844 published collection of his poetry.

MY DEAR CHILDREN: In compliance with your wishes, I here present you with a volume of verses, written by me at different periods of my life. You may perceive that the pieces contained in it are not arranged in the order of the times at which they were composed; for, not only would it be impossible for me now to make such an arrangement with precision, but it was thought best that the serious should be intermingled with the gay, and the shorter with the longer compositions. I have not made a selection from among my verses of such as are of any peculiar cast; but have given you the melancholy and the lively, the serious, the sportive, and even the trifling, such as relate solely to our own domestic circle, and those of which the subjects take a wider range. For, as you once persuaded me to sit for my portrait, which was the occasion of one of the pieces in this collection; so, I flatter myself that you will be pleased to have as true a picture as possible of your father's mind, upon which you and your children may look when I shall be removed from this world. Were I to offer you nothing but what is gay and lively, you well know that the deepest and keenest feelings of your father's heart would not be portrayed. If, on the other hand, nothing but what is serious or sad had been presented to your view, an equally imperfect character of his mind would have been exhibited. For you are all aware that he is far from following the school of Chesterfield with regard to harmless mirth and merriment; and that, in spite of all the cares and sorrows of this life, he thinks we are so constituted that a good honest hearty laugh, which conceals no malice, and is excited by nothing corrupt, however ungenteel it may be, is healthful both to body and mind. And it is one of the benevolent ordinances of Providence, that we are thus capable of these alternations of sorrow and trouble with mirth and gladness.

Another reason why the mere trifles in this volume have not been withheld, is that such things have been often found by me to afford greater pleasure than what was by myself esteemed of more worth. I do not pay my readers so ill a compliment as to offer the contents of this volume to their view as the mere amusements of my idle hours; effusions thrown off without care or meditation, as though the refuse of my thoughts were good enough for them. On the contrary, some of the pieces have cost me much time and thought, and I have composed them all as carefully and correctly as I could. I wish you to bear in mind that nothing which may appear severe or sarcastic in this collection, is pointed at any individual. Where vice or absurdity is held up to view, it is the fault, and not any particular person that is pointed at. Notwithstanding the partiality of you and my friends, I feel much reluctance to publish this volume; and have much doubt as to its merit. Had she who wrote the lines signed *La Mere de Cinq Erifans*, and those upon the death of your cousin, Susan Moore, which appear in this collection, been still spared to me, her native taste and judgment would have afforded me great assistance in putting together

this little work and would have enabled me to act with much more confidence than I now can. But whatever be the merit of the offering which I here make to you, receive, and look upon it as a token of the affection of your father. C.C.M., March 1844."

"Nothing that adds to the happiness of the world can be justly called little. Men have labored and toiled and passed sleepless nights and laborious days, and for what? For immortal fame. It has fled from them like a shadow and has alighted uncalled for and unexpectedly on such apparently trivial things as *Home, Sweet Home*, and the *Legend of Rip Van Winkle*, and the *Visit From St. Nicholas*. It shows that it is the great body of readers, and not the authors, and least of all the professional critics, whose mission it is to decide what is valuable and what is worthless." – WILLIAM PELLETREAU, July 15, 1897.

CREDIT: Artist - J.M.K. *Daybreak* (1871). Courtesy of the Library of Congress.

NOTES: C.C.M's grandson, William Scoville Moore (1882-1944) assisted President Franklin Delano Roosevelt in the development of Warm Spring Institute for Rehabilitation in 1927. Two of C.C.M.'s great grandsons, sons of his grandson Clement Clarke Moore, were killed in W.W.II, a third grandson survived and was a decorated W.W.II fighter pilot.

The song "Home Sweet Home" melody was composed by Sir Henry Bishop, with lyrics by John Howard Payne. *Rip van Winkle* was written by Washington Irving.

Samuel Rogers (British, 1763-1855), mentioned in Sherman's *Recollections of Clement C. Moore*, was an English romantic poet. He along with other literary figures including Sir Walter Scott and Charles Dickens, paid court to Charity Moore's niece Lady Holland of Kensington, London. In 1823, Samuel Roger's poem *Ginevra* was published in *Italy*. The poem tells of a young bride who marries at Christmas. A game of hide and seek ensues, but the bride cannot be found. Years pass and finally the corpse of the bride still holding her wedding bouquet is discovered in a locked trunk. It appeared that the bride had hidden herself in the trunk and in doing so sealed her fate. The poem was immensely popular and in 1830 was made into a song called "The Mistlebough" that remained very popular for decades.

On December 23, 1837, The Slave Compensation Act was passed by the English Parliament. The Act provided compensation for those who could prove a loss due to the expropriation of slaves or who had suffered economic losses with the termination of the slave trade. Records of the individuals who made claims and were compensated are open to the public. Lady Holland's husband received compensation in association with his wife's family and their properties in Jamaica. The Slave Compensation Act was the biggest financial payout in British history. No compensation was granted to individuals who had been enslaved.

Queen Victoria writes in her teenage diaries of conversations she had with Lord Melbourne regarding Lady Holland's support for Napoleon Bonaparte. "She (Lady Holland) never knew Napoleon, Lord Melbourne added, but saw him at Paris at the Peace of Amiens - when he was at St. Helena, she sent him gateaux and chocolate, & c. She was half on his side, Lord M continued."

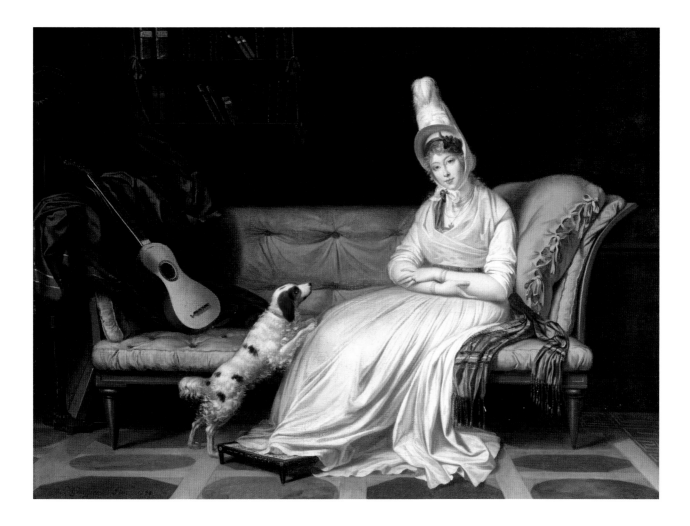

Napoleon Bonaparte bequeathed a snuff box to Lady Holland in his will. Lord Carlisle urged her to throw it in the river:

> "Lady, reject the gift, beneath the lid
> Discord, and Slaughter, and relentless war."

To these lines Lord Byron replied:

> "Lady, accept the box a hero wore,
> In spite of all this elegiac stuff,
> Let not seven stanza written by a bore,
> Prevent Your Ladyship from taking snuff!"

CREDITS: Page 134: Unidentified artist, *Charity Moore*, reproduced in *Recollections of Clement C. Moore*, by Mary Moore Sherman. Rare Book – *Nancy H. Marshall Collection*, Special Collections Research Center, William & Mary Libraries.

Page 135: Artist - Louis Gauffier, *Portrait of Elizabeth, Lady Webster, later Lady Holland* (1795). Public Domain.

NOTE: Holland House was destroyed on September 27, 1940, during the Blitz of London.

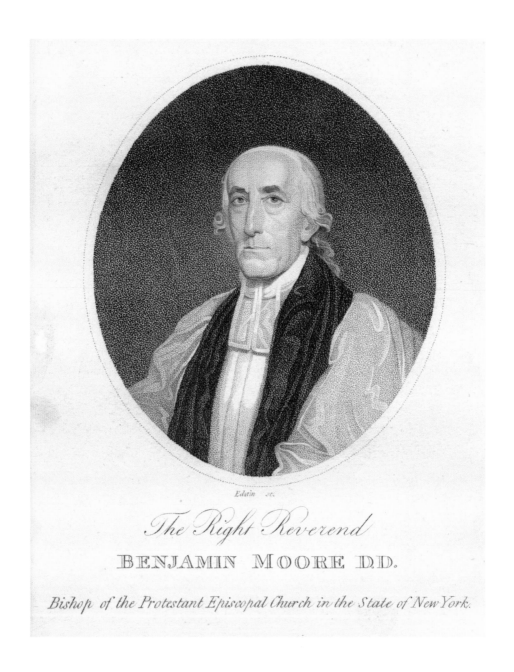

Edwin sc.

The Right Reverend

BENJAMIN MOORE D.D.

Bishop of the Protestant Episcopal Church in the State of New York.

Episcopal Bishop Benjamin Moore of the Diocese of New York, who was C.C.M.'s father, administered the last rites to Alexander Hamilton (American 1755-1804) who was mortally wounded in a duel with Aaron Burr on July 11, 1804. Hamilton was one of the Founding Fathers of the United States.

CREDIT: *The Right Reverend Benjamin Moore, D.D. Bishop of the Protestant Episcopal Church in the State of NY*, 1816, New York Public Library, 1748-1816. CC01.0 Dedication. *The Miriam and Ira D. Wallach Division of Art, Prints and Photographs: Print Collection.* Retrieved from: (https://digitalcollections.nypl.org/items/6ae9a0ec-b335-d6e5-e040-e00a1806584a).

"A recent act of the Legislature had made the sending and accepting of a challenge punishable with disenfranchisement and incapacity to hold office for twenty years; but such had been the state of public sentiment hitherto that parties concerned in a duel only had to maintain secrecy beforehand, and the world ignored the consequences, as well as the law. A number of persons knew that Burr and Hamilton were making preparations for a duel, yet no hindrance was interposed. It is said that but for the testimony of Rev. Dr. John M. Mason, who visited Hamilton at his request in his dying moments, and of Bishop (Benjamin) Moore, who administered the sacrament to him, and remained at his bedside until all was over, there would never have existed a word of legal evidence that the duel had been fought." - MARTHA J. LAMB, Mrs. Burton Harrison, *History of the city of New York: its origin, rise and progress*, (A.S. Barnes, NY, 1877).

The pages of the *Troy Sentinel* newspaper for December 23, 1823, did not mention Christmas, which was days away, but rather reported extensively on the atrocities taking place over the battle for Greek independence. "Among the most vocal, eloquent, and effective were American poets and journalists. The poets here were especially influenced by the example of Lord Byron who wrote, fought, and died for Greece." – ALEXANDER KARANIKAS (*Greece Through American Eyes 1820-1840*, text of a talk, March 21, 1993).

"In the United States the drama of the Greek Revolution evoked strong emotions. Americans were drawn to the Greeks for a number of reasons. For one, the Greeks were fellow Christians engaged in a veritable "holy war" of survival against their Moslem oppressors. National pride – which fueled a burgeoning commitment to the dissemination of republican ideology – formed another source of pro-Greek thought. Having themselves risen from tyranny, Americans were not indifferent to another people striving to achieve the same liberties they had fought for and maintained." – ANGELO REPOUSIS (*The Pennsylvania Magazine of History and Biography*. Vol. CXXXIII, No. 4 October 1999).

On December 23, 1823, William Cullen Bryant gave a speech on the conflict: "Nothing ignoble or worthless can spring from so generous a stock. It was in Greece that civilization had its origin . . . It was there that poetry, sculpture, all the great arts of life, were invented or perfected, and first delivered down to succeeding generations. Greece was the cradle of liberty in which the earliest republics were rocked. We are all pupils of her great men, in all the principles of science, of morals, and of good government." – Documented in *Greece Through American Eyes 1820-1840* (1993).

C.C.M. drafted a poem in response to the conflict ca. 1827-1828 - *To the Nymphs of Mount Harmony* (Excerpt):

> Here, as the swain at even strayed,
> Wooed by the grove's sequester'd shade,
> With thoughts unfix'd, and vacant eye,
> And idly sad, he scare knew why,
> A mournful spirit of the wood,
> Touch'd haply, by his kindred mood,
> Soft-sighing from a hawthorn near,
> Thus whisper'd in his wond'ring ear.

In a letter addressed to the Greek Committee in 1827 Sarah Sackett of Troy expressed her support of the Greeks through her association with the Female Industrious Society of the First Presbyterian Church. Records show that both Sackett and C.C.M. were supporters of the charitable relief "Greek Fund".

Clement Clarke Moore died on July 10, 1863, at his summer home in Newport, RI. He was laid to rest at Trinity Church Cemetery and Mausoleum in New York City.

Obituary of Clement C. Moore, The New York Herald, August 16, 1863, New York, NY: "During the terrible period of excitement, which for years to come will be memorable as the riot week, there appeared one morning, in some of our journals, an announcement of the death of Newport, of one of our wealthiest and once one of our most respected citizens. So far as my knowledge goes not an obituary notice nor the least reference to his death has appeared, and, whether crowded out by the pressure of riot-news or omitted for other reasons nothing but the bare mention of CLEMENT C. MOORE'S decease has found its way into any of our papers.

CREDIT: *Page 138: Artist – Anne Hall (American, 1792-1863), engraver Edward Gallaudet (American, 1809-1847) Portrait of Garafilia Mohalbi, Boston Christmas Magazine, Youth Christmas Keepsake,* (George A. Levitt Publisher,1831).

NOTES: Garafilia Mohalbi (Greek, 1817-1830) was a young girl enslaved by her Turk captors after her parents had been killed in the revolution. Sarah Hale wrote of Garafilia and of her tragic death at the age of 13 from tuberculosis in *Woman's Record, Sketches and Distinguished Women* (1853). Hiram Powers (American, 1805-1873) sculptured the Greek Slave in 1844 in her likeness, which is now in the collection of Raby Castle, in the UK.

Anne Hall was the most prominent artist of miniature-portraits in New York throughout the first half of the 19th century.

Twas The Night is celebrated at The Clement Clarke Moore Park located in Chelsea District of NY, and at C.C. Moore Homestead Playground in Elmhurst, Queens during the holiday season. The poem is read aloud and the poet honored.

CREDIT: Artist – Frederick Waugh (American, 1861-1940). *Waiting For Santa Claus* (New York Public Library, CCO 1.0 Universal Public Domain Dedication, 1899).

CREDIT: Artist - Thomas Lochlan Smith (American, 1835-1884) *The Old Estate in Winter*, 1867.

NOTE: On July 13, 1863 riots erupted in response to new conscription measures with attacks on New York military and government buildings, black citizen's and white abolitionist's homes and businesses. The 1863 New York Draft Riots remain the deadliest riots in U.S. history.

Thus, silently has been permitted to drop out from among us one who was the pioneer in this country, of Hebrew Lexicography, by the publication of the 1809 of a Hebrew and English Lexicon which paved the way literally for the general cultivation of that ancient language and literature in the Theological seminaries of the United States. In 1821, Mr. Moore was appointed "Professor of Biblical Learning" in the General Theological Seminary of the Episcopal Church. Subsequently his professorship became that of "Oriental and Greek Literature." A princely fortune has descended to him, by inheritance, consisting of plats of land by the acre in and about the Sixteenth ward of this city, and much of it lying from Nineteenth street to Twenty-third street between the Ninth and Tenth avenues - now covered with brown stone palaces or business structures erected by capitalists who pay a liberal rent for the ground. While connected with the Theological Seminary, Professor Moore bestowed upon the institution an entire block of this valuable ground.

Mr. Moore (or Dr. Moore, for he was an L.L.D.) was also somewhat celebrated as the author of several lively poems, among which was one which has been mouthed by every schoolboy of the last two generations and annually reproduced in thousands of our papers about Christmas time. This was "A Visit From St. Nicholas' ' Few specimens of American poetry have had so long continued in popularity as this Christmas poem. All the "Speakers" have included it in their tables of contents and in one form or another it has been published or republished until every line has become as familiar as a household word. During the last holiday season an edition of the poem was brought out by James G. Gregory of this city in luxurious style - the paper, type, illustrations, and tout ensemble displaying a rare combination of good judgment and good taste. Since 1850 Dr. Moore has lived a retired life, but, for what he had previously accomplished, his death, after four score years of usefulness, should not have been suffered to pass unnoticed." - *Nor'wester* (Frank W. Ballard).

"Happy the man who can add even a single leaf to the evergreen garland of the poetry of home – the verse that children love, and that wakens even in older hearts cheerful memories of childhood! Such, at least, if no higher, has been the lot of late Dr. Clement Moore, the author of *A Visit From St. Nicholas*, which has now been a household friend of American children for nearly seventy-five years, and promises to be dear to them for many and many a year to come.... In the case of Dr. Moore, nothing he has written is likely to survive except the *Visit From St. Nicholas*; and this lives, not by right of poetry, but by its innocent realism and its direct appeal to the matter-of-fact imagination of childhood." - CLARENCE COOK (*Century Magazine*, December 1897).

Written accounts of people close to C.C.M. portray him as a humble, gentile man with a generous personality. He sought neither fame nor fortune from his writing and like many of his peers wrote poetry throughout his life for pleasure and to satisfy a personal interest in artistic pursuits.

" . . . dear old Clement Moore." - Henry T Tuckerman, *The Atlantic Monthly*, Vol. 18, 1866.

" We are yet in the very rudiments of the Hebrew, and our advances are perfectly snail-like and imperceptible. If Professor Moore was not one of the most mild and unassuming men of learning in the world, he could never tolerate the stammering and blundering of such full-grown novitiates in the Hebrew horn book. But he is Clement by nature, as well as by name. It is related of HUTCHINS, that he once indulged his disposition for pleasantry by playfully translating a passage of Scripture, "I love CLEMENT C. MOORE (clemency more) than sacrifice." - *Memoirs*, Rev. William Croswell, D.D. (1826).

"Of the Bard for joyous children, our immortal Clement Moore."– A. Oakey Hall (American 1826-1898), author, poet, and Mayor of New York from 1862-1872, *St. Nicholas Dinner Raving*, Delmonico's, NY, December 7, 1874; published in the *New York Herald* on December 8, 1874.

" . . . one of the best of men (C.C.M.)." Evert. A. Duyckinck, *Frank Leslie's*, June 1854

C.C.M. left a legacy to the city of New York through his donation of lands to the General Theological Seminary and for his personal involvement in the development of Chelsea Village, later to be known as the Chelsea district of New York City.

The New York Times (April 17, 1904): "Presently (after the bishop's death) the good Clement C. Moore was annoyed by the boys and adolescent hoodlums, who came out from 'the city' to depredate(sic) his vines and fig trees. The annoyance became intolerable insomuch that he started one day into 'town' determined to rid himself of the annoyance by disposing himself of the estate (Chelsea). His intention was to sell the property for $40,000 On his way to consummate this suicidal transaction the good, unworldly man met an acquaintance of his, a carpenter named Wells, and confided to him his intention. 'Nay,' said the well-counseled Wells. 'Lay it out in streets and city lots corresponding to the 'system' (the Street Commissioners of 1807 had already got in their deadly work) and invite settlers'" In 1811, the *New York Commission Plan* had laid out a grid of streets and avenues that crossed through the Moore's Chelsea Farm. C.C.M. lived to see Chelsea House torn down and thrown into the Hudson River.

In developing the Chelsea lands C.C.M. restricted the buildings for commercial use, and specified details for the building of neighborhoods of single-family homes and row-houses. In 1836 C.C.M. built a home in Chelsea Village located at 444 W. 22 St. Today

CHRISTMAS WAITS

An aged pair were roused from sleep,
One Christmas Eve, by sounds appalling –
Dogs bayed the moon with growlings deep,
Cocks crowed, and cats were caterwauling.
"Sure, there are thieves about," quoth he,
And straight the blunderbuss he fetches;
While, with a kindred spirit, she
A poker takes to brain the wretches.

CREDIT: Artist – Stanley Berkeley, *Christmas Waits, Illustrated London News, Christmas Number,* London, and NY, 1887.

the home remains a residential property. In 1847, the installation of tracks for the Hudson River Railroad had cut off portions of the Chelsea lands from the Hudson River, and with increasing industrialization portions of Chelsea Village were developed with piers, warehouses and factories and the "village" was incorporated into the city of New York.

C.C.M. may have read Gottfried August Burger's translation of Rudolf Erich Raspe's *1785 - Baron Munchausen's Narrative of his Marvellous Travels and Campaigns in Russia*: a parody of Freiherr von Munchhausen. The narrative depicts a character who flies to the moon, is swallowed by a fish, and enlists a wolf to pull his sleigh. Robert Southey referred to it as "a book which everybody knows because all boys read it."

The Wild Huntsman was a translation by Sir Walter Scott of the *Wilde Jager* by A.G. Burger (Excerpt):

> "The Wildgrave winds his bugle-horn,
> To horse, to horse! halloo, halloo!
> His fiery courser snuffs the morn."

CREDIT: Artist: William Hogarth (British, 1697-1743) *Travels throughout Europe, Asia and into Part of Africa*, written by Aubry de la Mottraye (London, 1724) *Harris Brisbane Dick Fund*, 1932.

Robert Southey's quote is cited in: *Telling Tales: The Impact of Germany on English Children's Books 1780-1918* (OBP collection, Cambridge, Open Book Publishers 2009).

As a youth C.C.M. read the classics, including *Hamlet*, and the other plays of William Shakespeare.

"Not a mouse stirring." – *Hamlet* (Act I, Scene I.) Francisco to Barnardo.

Among C.C.M.'s favorite poets were Robert Southey (English, 1774-1843) and Michael Drayton (English, 1563-1631).

Drayton's *Nymphidia, The Court of Fairy* (Excerpt):

> With the thistle-down they shod it
> For all her maidens much did fear it,
> If Oberon had chanc'd to hear.

CREDIT: Artist – Charles Hunt (English, 1803-1877). *Children Acting the Play Scene from Hamlet*, 1863.

NOTE: "Through the Moores, Da Ponte became a private Italian tutor for the offspring of elite New York families." *Lorenzo Da Ponte's Second Act. Columbia Magazine*, Paul Hond, Winter 2020-21. Lorenzo Da Ponte (Italian, 1749 – 1838, America) tutored C.C.M. Da Ponte collaborated in writing librettos including for Mozart's; *Le Nozze di Figaro, Dan Giovanni*, and *Cosi Fan Tutte*. Da Ponte opened the Italian Opera House in NY, NY, in 1833.

CHAPTER 8

In Print

Within weeks of the poem's debut in the *Troy Sentinel* on December 23,1823 *Twas The Night* appeared in numerous other publications, with each editor making slight editorial changes.

January 1, 1824 - *New-York Spectator*, NY, NY, January 5, 1824 - *Essex Register*, Salem, MA, January 12, 1824 - *Watchtower*, Cooperstown, NY, January 14, 1824 - *Norwich Courier*, Norwich, CT, and in *The Palladium* of Geneva, Ontario County, NY, for January 21, 1824.

A digitalized copy of the 1824 published edition of the poem in the newspaper *The Palladium*, accessed on the *New York Historical Newspapers* website, shows a set of interesting notations that appear as: author CLEMENT C. MOORE, by Clement C. Moore and Clement C. Moore. It is not known who added the three notations. The poem appears in the *Palladium* with Holley's preface published with SAINTE CLAUS in bold as a heading.

The poem was included in four almanacs prepared in 1824 and released in 1825: *The New Brunswick Almanac for The Year of Our Lord 1825*, *The Grigg's Almanac, for the Year of Our Lord 1825* and the *Citizen's Farmer's Almanac, for the Year of Our Lord*. *The United States National Almanac* released from Philadelphia in 1825 gave the poem distribution across America. The *Saturday Evening Post* (*Atkinson & Alexander*, Philadelphia) first printed the poem for January 7, 1826.

The poem appeared in the *Poughkeepsie* for January 16, 1828. Henry Livingston Jr. died on February 29, 1828 in Poughkeepsie, NY and his family would decades later report that a newspaper edition of the poem had been found in his desk at the time of his passing. Members of his family also claimed that the discovered newspaper edition not only predated 1828 but was published years before the *Troy Sentinel* publication of the poem in 1823. The Troy edition remains the earliest known printing of the poem.

The first fully illustrated book edition of the poem was published in 1848 by Henry M. Onderdonk, embellished with seven woodcuts designed and engraved by Theodore Boyd. *Santa Claus* was printed on the cover of the edition, with the subtitles of *Santa Claus's Visit*, and *A Visit From Santa Claus — A Present For Good Little Boys and Girls* printed on the book's front pages and with C.C.M. named as the author. The Onderdonk-Boyd edition was reprinted in *The Evergreen* in December 1849.

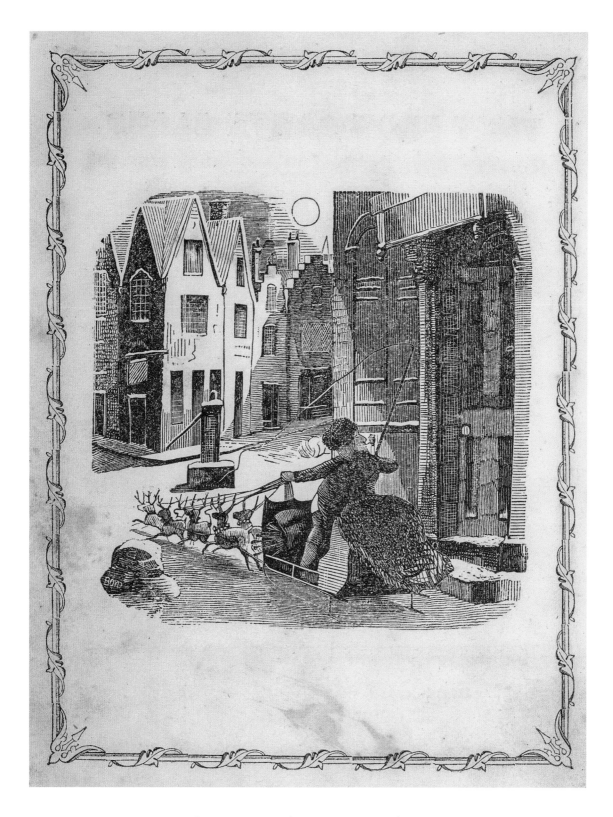

CREDIT: Artist - Theodore C. Boyd (NY, 1830-1902 CA.). *A Visit From St. Nicholas*, (Henry M Onderdonk, New York, 1848). Courtesy of the American Antiquarian Society.

NOTE: Onderdonk also published materials for the General Theological Society while C.C.M. was on the faculty. It is likely Moore was aware of the edition. In the Onderdonk edition the word reindeer is written as red-deer.

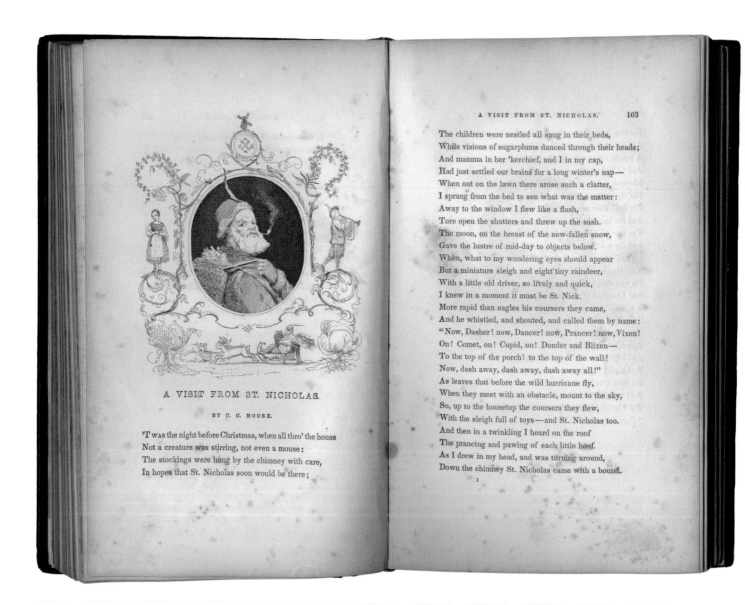

A VISIT FROM ST. NICHOLAS.

BY C. C. MOORE.

'T WAS the night before Christmas, when all thro' the house
Not a creature was stirring, not even a mouse:
The stockings were hung by the chimney with care,
In hopes that St. Nicholas soon would be there;

The children were nestled all snug in their beds,
While visions of sugarplums danced through their heads;
And mamma in her 'kerchief, and I in my cap,
Had just settled our brains for a long winter's nap—
When out on the lawn there arose such a clatter,
I sprang from the bed to see what was the matter:
Away to the window I flew like a flash,
Tore open the shutters and threw up the sash.
The moon, on the breast of the new-fallen snow,
Gave the lustre of mid-day to objects below.
When, what to my wondering eyes should appear
But a miniature sleigh and eight tiny raindeer,
With a little old driver, so lively and quick,
I knew in a moment it must be St. Nick.
More rapid than eagles his coursers they came,
And he whistled, and shouted, and called them by name:
"Now, Dasher! now, Dancer! now, Prancer! now, Vixen!
On! Comet, on! Cupid, on! Donder and Blixen—
To the top of the porch! to the top of the wall!
Now, dash away, dash away, dash away all!"
As leaves that before the wild hurricane fly,
When they meet with an obstacle, mount to the sky,
So, up to the housetop the coursers they flew,
With the sleigh full of toys—and St. Nicholas too.
And then in a twinkling I heard on the roof
The prancing and pawing of each little hoof.
As I drew in my head, and was turning around,
Down the chimney St. Nicholas came with a bound.

The *American Monthly Magazine* published the poem in January 1837, citing C.C.M. as the author. The poem was published along with the following comment: "The lines which follow have been much admired, and have appeared in a variety of publications, but never, we believe under the name of the author - Clement C. Moore."

The *New York Book of Poetry*, edited by Charles Fenno Hoffman (George Dearborn, Publishers, NY.) was released in 1837 and included four poems attributed to C.C.M., including *Twas The Night*. The *New York Book of Poetry* included 150 poems by thirty-five authors. *Twas The Night* appeared in *Selections from the American Poets*, compiled by William Cullen Bryant; published by Harper & Brothers of New York in 1840.

The Poets of America: Illustrated by One of Her Painters, edited by John Keese was published in eight volumes with ninety poets in 1840, with illustrations provided by William Croome. *Twas The Night* was included, and again C.C.M. given credit for its authorship. This was the first time an illustration had appeared with the poem in a book format, predating the Boyd illustrations by several years. It was not the first illustration to accompany the poem, as Myron King of Troy, NY, had provided an illustration and engraving for a *Troy Sentinel* holiday giveaway – a broadsheet in 1830.

In 1847, the publishers of *The Golden Christmas Book* printed the poem with the subtitle: "the poem by Clement Moore which you already know." The poem issued as: *Visit From St. Nicholas or The Night Before Christmas*, appeared in *The American Magazine: Gems of American Literature*, for October 1851 (W.S. Johnson, London) and was introduced as: "This little poem is a great favorite in the United States, and, if we mistake not, Professor Moore is an American. This pleasing fable, although in great vogue with Trans-Atlantic children is of German origin." This was the first printing of the poem to use the words - *The Night Before Christmas* as a subtitle.

In 1855, C.C.M.'s daughter Mary Clarke Moore Ogden, created a calligraphic illumination of the poem, with the lines written out in elaborate Gothic script. The book was a gift for her husband John D. Ogden. This very special edition remains in the possession of Moore/Ogden descendants. On December 10, 1951, *Life Magazine* reproduced the edition, along with portraits of Mary and her parents. The portrait of C.C.M. is one of many works painted at various stages of his life. The portraits of Mary Moore Ogden and her mother - Catherine Elizabeth Taylor Moore are of the very few or only paintings known to have been painted of either of these women. *Life* also published a retelling of the legend of the writing of the poem with C.C.M. reading the poem to his family gathered on Christmas Eve at their home in Chelsea, New York.

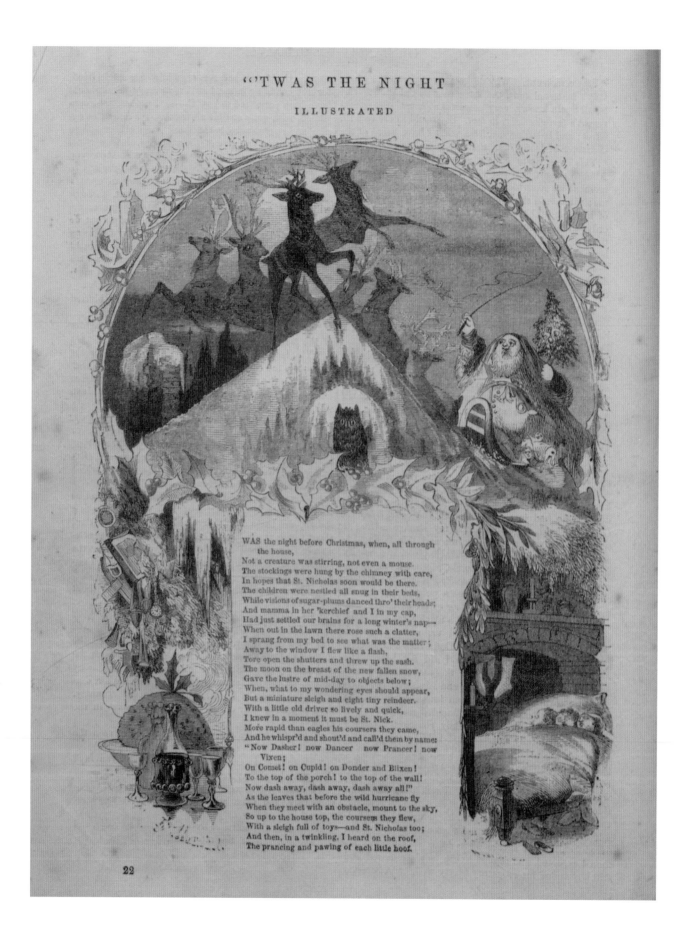

WAS the night before Christmas, when, all through
 the house,
Not a creature was stirring, not even a mouse.
The stockings were hung by the chimney with care,
In hopes that St. Nicholas soon would be there.
The children were nestled all snug in their beds,
While visions of sugar-plums danced thro' their heads;
And mamma in her 'kerchief and I in my cap,
Had just settled our brains for a long winter's nap—
When out in the lawn there rose such a clatter,
I sprang from my bed to see what was the matter;
Away to the window I flew like a flash,
Tore open the shutters and threw up the sash.
The moon on the breast of the new fallen snow,
Gave the lustre of mid-day to objects below;
When, what to my wondering eyes should appear,
But a miniature sleigh and eight tiny reindeer.
With a little old driver so lively and quick,
I knew in a moment it must be St. Nick.
More rapid than eagles his coursers they came,
And he whispr'd and shout'd and call'd them by name:
"Now Dasher! now Dancer now Prancer! now
 Vixen;
On Comet! on Cupid! on Donder and Blixen!
To the top of the porch! to the top of the wall!
Now dash away, dash away, dash away all!"
As the leaves that before the wild hurricane fly
When they meet with an obstacle, mount to the sky,
So up to the house top, the coursers they flew,
With a sleigh full of toys—and St. Nicholas too;
And then, in a twinkling, I heard on the roof,
The prancing and pawing of each little hoof.

22

BEFORE CHRISTMAS."

BY J. A. DALLAS.

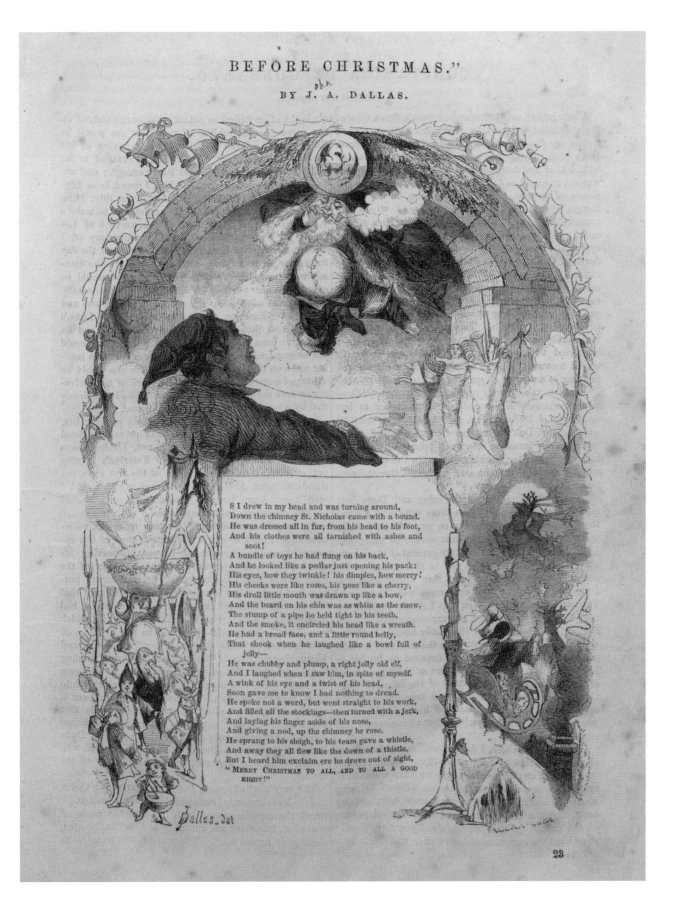

S I drew in my head and was turning around,
Down the chimney St. Nicholas came with a bound.
He was dressed all in fur, from his head to his foot,
And his clothes were all tarnished with ashes and
 soot!
A bundle of toys he had flung on his back,
And he looked like a pedlar just opening his pack:
His eyes, how they twinkle! his dimples, how merry!
His cheeks were like roses, his nose like a cherry,
His droll little mouth was drawn up like a bow,
And the beard on his chin was as white as the snow,
The stump of a pipe he held tight in his teeth,
And the smoke, it encircled his head like a wreath.
He had a broad face, and a little round belly,
That shook when he laughed like a bowl full of
 jelly—
He was chubby and plump, a right jolly old elf,
And I laughed when I saw him, in spite of myself.
A wink of his eye and a twist of his head,
Soon gave me to know I had nothing to dread.
He spoke not a word, but went straight to his work,
And filled all the stockings—then turned with a jerk,
And laying his finger aside of his nose,
And giving a nod, up the chimney he rose.
He sprang to his sleigh, to his team gave a whistle,
And away they all flew like the down of a thistle.
But I heard him exclaim ere he drove out of sight,
"MERRY CHRISTMAS TO ALL, AND TO ALL A GOOD
 NIGHT!"

23

151

A
VISIT
FROM
SANTA CLAUS

WITH ILLUSTRATIONS
BY
SCATTERGOOD.

Presented by F. A. HOYT & BRO., cor. 10th and Chestnut Sts., Philadelphia.

A VISIT FROM SANTA CLAUS

PHILADELPHIA:
DAVID SCATTERGOOD, 400 CHESTNUT STREET.

CREDITS: Pages 150-151: Artist- J.A. Dallas, *Twas The Night Before Christmas* (*Mrs. Stephens' Illustrated New Monthly* - magazine, NY, January 1857). Rare Book – *Nancy H. Marshall Collection*, Special Collections Research Center, William & Mary Libraries.
Pages 152-153: Artist - David Scattergood, *A Visit From Santa Claus*, (David Scattergood, Philadelphia, ca. 1860). Rare Book – *Nancy H. Marshall Collection*, Special Collections Research Center, William & Mary Libraries.

Felix Octavius Carr (F.O.C.) Darley was the most sought-after illustrator in America for most of his forty-year career. Darley's breakout commission came in 1848 with a request that he illustrate Washington Irving's *Rip Van Winkle*. Darley illustrated works written by Henry Wadsworth Longfellow, Harriet Beecher Stowe, James Fenimore Cooper, Charles Dickens, Nathaniel Hawthorne, and many others. Darley created eight engravings for an 1862 edition of *Twas The Night*.

President Abraham Lincoln and Mary Todd Lincoln's son Tad (1853-1871) may have read the Darley 1862 edition, as may well have a young Thomas Edison (1847-1931). A first edition of the Darley edition was kept in the private library of the 26th President of the United States, Theodore "Teddy" Roosevelt (American, 1858-1919), which is held at *President Theodore Roosevelt Sagamore Hill National Historic Site* in Cove Neck, NY. Theodore Roosevelt would have been four years of age when the Darley edition was first issued.

Darley's home in Claymont, Delaware is on the *National Register for Historic Places* and *Darley House*.

He was dressed all in fur from his head to his foot,

And his clothes were all tarnished with ashes and soot;

A bundle of toys he had flung on his back,

And he looked like a peddler just opening his pack:

His eyes how they twinkled! his dimples how merry!

His cheeks were like roses, his nose like a cherry:

His droll little mouth was drawn up like a bow,

And the beard on his chin was as white as the snow;

The stump of a pipe he held tight in his teeth,

And the smoke, it encircled his head like a wreath.

He had a broad face, and a little round belly

That shook when he laughed, like a bowl full of jelly.

CREDITS: Pages 154-155: Artist – F.O.C. Darley (American, 1822-1888). *A Visit From St. Nicholas* (James G. Gregory, Publishers, New York, 1862). Rare Book – *Nancy H. Marshall Collection*, Special Collections Research Center, William & Mary Libraries.

The publishing house of McLoughlin Brothers launched their New York operations in 1858. The company's juvenile picture book division soon was distributing across the United States and shipping books to Latin America as well as to Europe. McLoughlin Brothers are credited today with pioneering the use of color printing technologies in American books produced for children. The *McLoughlin Brothers – Hosmer Archival Drawings and Prints Collection* is held by the American Antiquarian Society.

Other early American publishers of the poem included Charles E. Graham & Company Inc., Porter & Coates, Harper and Brothers, Hurd and Houghton, Prang & Co., Charles Scribner's Sons, Spalding and Shepherd and White Stokes & Allen.

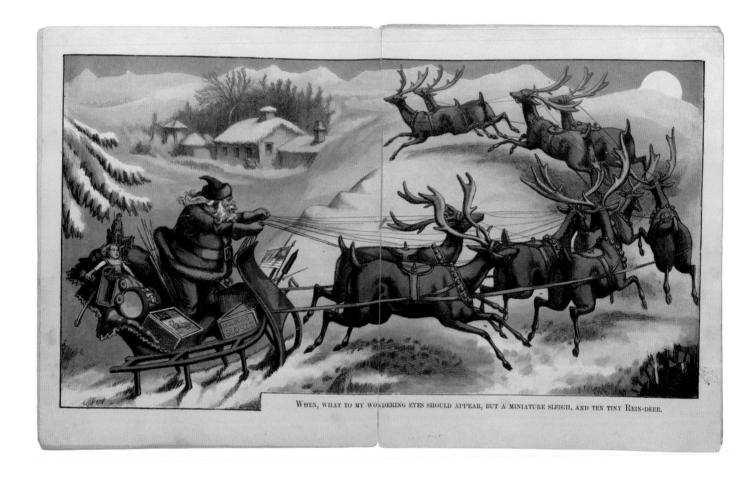

WHEN, WHAT TO MY WONDERING EYES SHOULD APPEAR, BUT A MINIATURE SLEIGH, AND TEN TINY REIN-DEER.

CREDIT: Unidentified illustrator. *Visit From St. Nicholas* (McLoughlin Bros.ca. 1869). Rare Book – *Nancy H. Marshall Collection*, Special Collections Research Center, William & Mary Libraries.

NOTE: An illustration produced for the McLoughlin 1869 edition depicts ten rather than the customary eight reindeer - perhaps the first sighting of Rudolph and Clarice!! The edition is the first of many editions of the poem printed by McLoughlin.

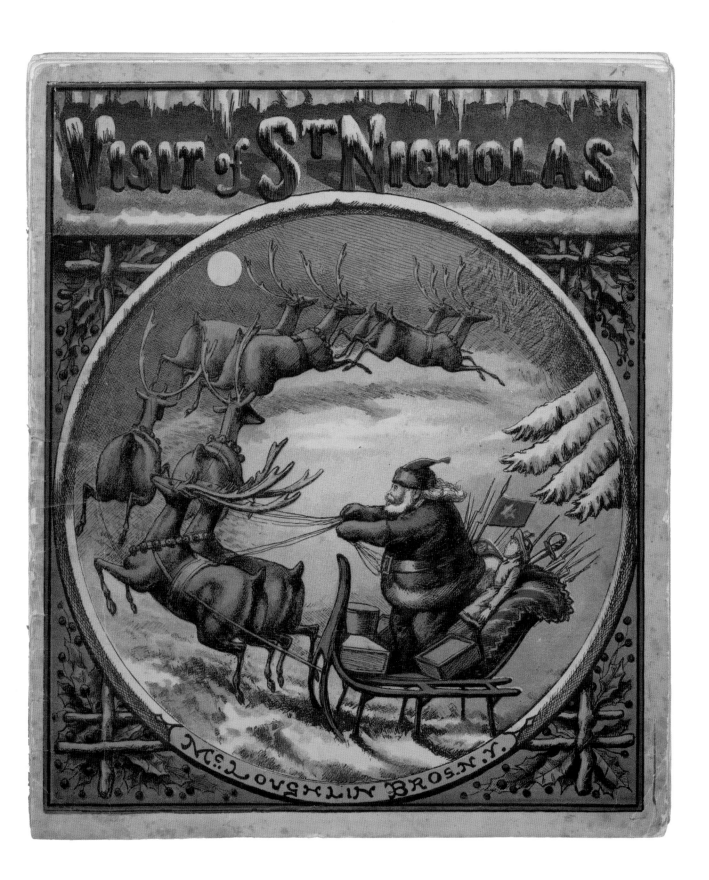

The Night After Christmas, a parody of the poem, was published in 1858 in *The Night Before Christmas: or Kriss Kringle's Visit, With Other Christmas Poems*, illustrated by Nick, Philadelphia: Willis P. Hazard, at *Kris Kringle's Head Quarters*. It is considered the first parody of the poem - countless more would follow.

'Twas the night after Christmas, when all thro' the house

Every soul was abed and as still as a mouse –

The stockings, so lately Saint Nicholas's care,

Were emptied of all that was eatable there;

The darlings had duly been tucked in their beds,

With very full stomachs and pains in their heads.

I was dozing away in my new cotton cap,

And Nancy was rather far gone in a nap,

When out in the nursery arose such a clatter,

I sprang from my sleep, crying, "What is the matter?"

I flew to each bedside, still half in a doze,

Tore open the curtains and threw off the clothes,

While the light of the taper served clearly to show

The piteous plights of those objects below;

For what to the father's fond eye should appear

But the little pale face of each sick little dear;

For each pet that had crammed itself full as a tick

I knew in a moment now felt like Old Nick.

Their pulses were rapid, their breathings the same –

What their stomachs rejected I'll mention by name:

Now turkey, now stuffing, plum-pudding, of course,

And custards, and crullers, and cranberry sauce;

Before outraged Nature, all went to the wall –

Yes lollypops, flagdoddle, dinner and all.

Like pellets which urchins from popguns let fly,

Went figs, nuts and raisins, jams, jelly and pie,

Till each error of diet was brought to my view,

To the shame of mamma and Santa Claus too.

I turned from the sight, to my bedroom stepped back

And brought out a vial marked "Pulv. Ipecac:"

When my Nancy exclaimed, for their sufferings shocked her,

"Don't you think you had better, love, run for the doctor?"

I ran, and was scarcely back under my roof

When I heard the sharp clatter of old Jalap's hoof:

I might say that I hardly had turned myself round

When the doctor came into the room with a bound;

He was covered with mud from his head to his foot,

And the suit he had on was his very best suit;

He had hardly time to put that on his back

And he looked like a Falstaff half fuddled with sack.

His eyes how they twinkled! Had the doctor got merry?

His cheeks looked like port and his breath smelt of sherry;

He hadn't been shaved for a fortnight or so,

And the beard of his chin wasn't white as the snow.

But inspecting their tongues in despite of their teeth,

And drawing his watch from his waistcoat beneath,

He felt of each pulse, saying, "Each little belly

Must get rid" – here he laughed – "of the rest of that jelly."

I gazed on each chubby, plumb, sick little elf,

And groaned when he said so in spite of myself;

But a wink of his eye, when he physicked our Fred,

Soon gave me to know I had nothing to dread.

He didn't prescribe, but went straightway to his work

And dosed all the rest, gave his trousers a jerk.

And adding directions while blowing his nose,

He buttoned his coat, from his chair he arose,

Then jumped in his gig, gave old Jalap a whistle,

And Jalap dashed off as if pricked by a thistle;

But the doctor exclaimed, ere he drove out of sight,

They'll be well by to-morrow — good-night, Jones, good-night.

NEW-YORK MIRROR.

A WEEKLY GAZETTE OF LITERATURE AND THE FINE ART

Embellished with Fine Engravings, and Music arranged with Accompaniments for the Pianoforte.

FIVE DOLLARS A YEAR.] SUBSCRIPTIONS RECEIVED AT THE OFFICE OF PUBLICATION NO. 148 NASSAU-STREET. [PAYABLE IN ADVANC

VOLUME NINETEEN. NEW-YORK, SATURDAY, JANUARY 2, 1841. NUMBER ON

ST. NICHOLAS, ON HIS NEW-YEAR'S EVE EXCURSION, (AS INGHAM SAW HIM,) IN THE ACT OF DESCENDING A CHIMNEY.

In this number of the Mirror we had intended giving a Steel Plate engraving of Weir's celebrated painting of St. Nicholas, but were disappointed by the artist, and in consequence have substituted the Ruins of Carthage as this month's picture ; but, not being perfectly satisfied under disappointment, and having a very great reverence for the good old Saint who so often made our hearts jump with joy when we were boys, we prevailed upon our friend Ingham to give us a sketch of him, just as he saw him one bright, frosty, moonlight night, as he was returning home late from a party of friends. As we had not time for a copper or steel plate engraving, we got our young friend Roberts to do his prettiest on wood, that our subscribers might have an opportunity of becoming familiar with the good-natured countenance of our old patron, who, in these degenerate days, is very seldom seen among us New-Yorkers ; and we feel that our friend Ingham has been a very highly favoured mortal in being permitted to see him whom we have so many years longed to get a peep at. St. Nicholas knows how often we have hung up our stockings by the fire, and hied off to bed on New-Year Eve a full hour earlier than usual, lest he might pass our house because we were not yet asleep, and we find our stockings empty in the morning in consequence of our being night spooks. He knows how often we have anxiously and fearfully peeped up the chimney to see if he was not yet there ; and yet he has never deigned to show himself to us, but has allowed friend Ingham to have a full and deliberate view. We can see no reason for it except that the good old Saint knew our friend to be a first-rate limner, and that he would furnish a correct likeness for us of one whom we could never forget to love. But where are we going——Dear readers, we must beg your pardon for forgetting to recollect that many of you were not brought up in this

tion to him. Yet how to do it half as well as our old acquaintance, Diedrich Knickerbocker, we know not, and must therefore turn to his authentic history of what was formerly called Manna-hata, then Nieuw-Amsterdam, and now Gotham, or New-York.

We find that after telling a great many interesting facts, he goes on to say :

"It was some three or four years after the return of the immortal Hendrick, that a crew of honest Low Dutch colonists set sail from the city of Amsterdam for the shores of America. It is an irreparable loss to history, and a great proof of the darkness of the age and the lamentable neglect of the noble art of bookmaking, since so industriously cultivated by knowing sea-captains and learned supercargoes, that an expedition so interesting and important in its results should be passed over in utter silence. To my great-great-grandfather am I again indebted for the few facts I am enabled to give concerning it—he having once more embarked for this country, with a full determination, as he said, of ending his days here—and of begetting a race of Knickerbockers that should rise to be great men in the land.

"The ship in which these illustrious adventurers set sail was called the *Goede Vrouw*, or good woman, in compliment to the wife of the president of the West India Company, who was allowed by every body (except her husband) to be a sweet-tempered lady—when not in liquor. It was in truth a most gallant vessel, of the most approved Dutch construction, and made by the ablest ship-carpenters of Amsterdam, who, it is well known, always model their ships after the fair forms of their countrywomen. Accordingly it had one hundred feet in the beam, one hundred feet in the keel, and one hundred feet from the bottom of the stern post to the tafferel. Like the beauteous model, who

in the bows, with a pair of enormous cat-heads, a copper botto and withal a most prodigious poop !

"The architect, who was somewhat of a religious man, from decorating the ship with pagan idols, such as Jupiter, Ne tune, or Hercules, (which heathenish abominations, I have doubt, occasion the misfortunes and shipwreck of many a nob vessel,) he, I say, on the contrary, did laudably erect for a he a goodly image of St. Nicholas, equipped with a low, broad-brimed hat, a huge pair of Flemish trunk hose, and a pipe th reached to the end of the bowsprit. Thus gallantly furnishe the stanch ship floated sideways, like a majestic goose, out of t harbour of the great city of Amsterdam, and all the bells th were not otherwise engaged rang a triple bobmajor on the joyf occasion.

"My great-great-grandfather remarks that the voyage was u commonly prosperous, for, being under the especial care of t ever-revered St. Nicholas, the Goede Vrouw seemed to be e dowed with qualities unknown to common vessels. Thus s made as much lee-way as head-way, could get along very near as fast with the wind a-head as when it was a-poop—and w particularly great in a calm ; in consequence of which singul advantages she made out to accomplish her voyage in a very fe months, and came to anchor at the mouth of the Hudson, a litt to the east of Gibbet Island.

"Here lifting up their eyes they beheld, on what is prese called the Jersey shore, a small Indian village, pleasantly en bowered in a grove of spreading elms, and the natives all co lected on the beach, gazing in stupid admiration at the Goed Vrouw. A boat was immediately despatched to enter into a trea with them, and, approaching the shore, hailed them through trumpet, in the most friendly terms ; but so horribly confounde

CHAPTER 9

Good Cheer

Well into the 19th century, the arrival of Santa Claus on Christmas Eve was not anticipated by young folks right across America as it is today. While some children at this time looked forward to his arrival on December 24th, others looked for him on New Year's Eve. A review of editorials, printed for holiday periodicals in the first half of the 19th century, found editors frequently writing to explain to their readers various Christmas customs that were being discussed in the literature they were publishing. Christmas remained a regional celebration and America had yet to find a national expression of the holiday. Santa Claus was still finding his way.

"Nothing could exceed the joy of the children on New Year's morning, when awakening with the first dawn of light, they jumped eagerly to examine their stockings, which, certain of "Santa Claas'" bounty, they had had suspended the evening before from the bed post – and which, according to their anticipation were full to overflowing." - Elizabeth E. Sedgwick, January 12, 1828. "New Year Day, as usual was a most joyous day to the children. They were loaded with presents from all their friends – whips, tops, dolls, guns, books, teacups, &c. Never was any thing like it. And never was such happiness." – Elizabeth Sedgewick, January 9, 1831. Both Sedgewick letters documented by Stephen Nissenbaum, *The Battle for Christmas* (Random House, NY, 1996).

The editors of *The New York Mirror* for January 2, 1841 titled the front page to read: *St. Nicholas, On his New-Year's Eve Excursion, As Ingham saw him in the act of descending a chimney.* The lines of the poem *Twas The Night* were changed from the original text to have St. Nicholas/St. Nick arrive on December 31st. The editorial copy that accompanied the poem set up the scene: "St. Nicholas knows how often we have hung up our stockings by the fire and hied off to bed on New-Year Eve a full hour earlier than usual, lest he might pass our house because we were not yet asleep, and we find our stockings empty in the morning in consequence of our being night spooks. He knows how often we have anxiously and fearfully peeped up the chimney to see if he was not yet there; and yet he has never deigned to show himself to us but has allowed friend Ingham to have a full and deliberate view "

CREDIT: Artist – Charles Ingham (Irish, 1796- 1863) *The New York Mirror*, January 2, 1841.

NOTES: The Sedgewick family papers are with the Massachusetts Historical Society.

"In London, no yule-log now blazes in the contracted chimney as in the days of yore/But the humbler ranks have been accused of superstition because the stocking is still thrown, the pod of nine peas bid over the door". Extract: *London Monthly Magazine* published in the *Ontario Repository*, December 24, 1822.

While young and old so gay and pleasant
Exchange their New Year's wish and present;
While children round their parents press
With clamor, - anxious to possess
The Stocking, hoped with riches fraught;
Which good old Santaclaus has brought;
Who yearly down the chimney comes
With Rods and Toys and Sugar-Plums,
And leaves for naughty girls and boys
The whips – but for the good, the toys

— *Ladies' Museum*, January 9, 1819.

CREDIT: Page 162: Artist – P.S. Newell, *Santa Claus Among the Poor* (*Harper's Weekly*, December 25, 1886).
Page 163: Artist – Thomas Nast (American, 1840-1902). *Christmas Eve — Old Faces For Young Hearts, Thomas Nast's Christmas Drawings for the Human Race* (Harper & Brothers, NY, 1890).

ODE TO SAINT CLAUS,
WRITTEN ON NEW YEAR'S EVE.

Now's the time for fun and glee,
Quip and dance and jollity;
Come lads and lasses, sport with me!
Frolic from his slumber wakes,
And Plenty, cloth'd in New-Years cakes,
Capers within doors and without,
Among the little merry rout; -
Old winter with a gen'rous smile,
Shakes his white flowing locks awhile,
And when he hears the merry strain,
Jumps up and thinks he's young again.
While ent'ring without noise or knocking,
Old Santa Claus fills every stocking.

- *New York American*, January 4, 1828.

"Thrice, and three times thrice, jolly St. Nicholas! On this, the first day of the new year 1826, with an honest reverence and a full bumper of cherry bounce, I salute thee! To St. Nicholas! Esto perpetuo." – James K. Paulding.

St. Nicholas could be expected on either St. Nicholas Eve or December 31st, during this era: "The old Dutch settlers, and those who have fallen insensibly into their habits, have transferred the observance from the Eve of St. Nicholas, whom you know as the especial patron of little children, to that of New Year." - *The English Gentleman's Magazine*, 1827.

"The Dutch, a kindred nation, carried over their national custom to America; but singular enough, one of the chief features of their New-Year's Eve is the arrival of Santa Claus, with gifts for children " – *Howitt's Journal of Literature and Popular Progress*, January 1, 1848.

Twas The Night was published on December 24, 1853, in *Notes & Queries* a Pennsylvania periodical along with editorial comment: "This anniversary

holds the same rank in the middle, southern and western states as Thanksgiving Day in the eastern states of New England, where, owing to Puritan origin of the bulk of the inhabitants, Christmas is not much celebrated. In Pennsylvania many of the usages connected with it are German origin and derived from the early settlers of the Teutonic race, whose descendants are now a very numerous portion of the population. The Christmas tree is thus devised: It is planted in a flowerpot filled with earth, and its branches are covered with presents, chiefly of confectionary, for the younger members of the family. When bed-time arrives on Christmas Eve, the children hang up their stockings at the foot of their beds, to receive presents brought them by a fabulous personage called Krishkinkle, who is believed to descend

the chimney with them for all the children who have been good the previous year The functions ascribed to Krishkinkle in Pennsylvania are attributed to Saint Nicholas, or Santa Claus in the State of New York, first settled by the Hollanders. The following poem, written by Clement C. Moore, L.L.D., of New York, describes the performance of St. Nicholas on Christmas Eve, and is equally applicable to our Krishkinkle."

" this Saint Nicholas, for that is his proper name, he is the tutelary saint of the city, and chiefly favours the rising generation to whom, on every Christmas eve, he brings various presents, adapted to the age of capacity of the receiver – he is a little short hump-backed man, with sharp grey eyes buried beneath ponderous black brows, which curve forward to join the sides of a long crooked hawk-bill nose, which overhangs a toothless trench beneath, that serves him for a mouth, though the beaked chin curves up so near the end of the nose, that it's difficult to conceive of anything passing between without being impaled on the one or the other; his head is immensely large, and sets like a huge extinguisher upon his small body beneath, whose form is concealed by an immense wrapper coat filled with pockets, each stuffed to its limits with cake, almonds, raisins, toys, &c.; his feet are armed with a pair of skates, indicating that he comes from Holland, and thus accoutred, he skates up and down the nursery chimneys, leaving his largeness behind him in every direction, and there's not a grown person but recollects with pleasure, nor a child but anticipates with delight, the well stuffed stocking of Santa Claus." - The New York American, January 3, 1824: –Documented by Scott Norsworthy, *Search For Old Santa Claus, Melvilliana.*

"Happy, happy Christmas, that can win us back to the delusions of our childish days; that can recall to the old man the pleasures of his youth; that can transport the sailor and the traveller, thousands of miles away, back to his own fire-side and his quiet home!" - CHARLES DICKENS (British, 1812-1870), *The Pickwick Papers.*
Dickens' first fictional work, *The Pickwick Papers*, was originally published as *The Posthumous Papers of the Pickwick Club* (1836-1837), with Dickens writing under the pseudonym *Boz*. He had been commissioned to write a series of captions to accompany artwork created by caricaturist Robert Seymour. Dickens' tales of Samuel Pickwick were released as a book in 1837, which made Charles Dickens a literary success.

Dickens wrote *A Christmas Carol in Prose* over a six-week period between October and December of 1843 and on its release the first printing sold out immediately. William Makepeace Thackerey (India, 1811 – 1863 England) wrote: "I believe it (Christmas Carol) occasioned immense hospitality throughout England, was the means of lighting up hundreds of kind fire at Christmas time, caused a wonderful outpouring of Christmas good-feeling; of Christmas punch-brewing; an awful slaughter of Christmas turkeys, and roasting and basting of Christmas beef."

Dickens wrote five Christmas-themed books: *A Christmas Carol in Prose. Being a Ghost Story of Christmas* (1843), *The Chimes* (1844), *The Cricket on the Hearth* (1845), *The Battle of Life* and *The Haunted*

CREDIT: Artist - Robert Weir (American, 1803-1889) *Saint Nicholas* (1837).

NOTES: German settlers where among the early arrivals to Jamestown, Virginia. They also founded colonial settlements in Pennsylvania and in New York. Close to 8 million Germans migrated to the United States between 1820 and 1870, mostly settling in the upper Midwest states of North and South Dakota, Minnesota, and Wisconsin.

The original Weir painting is with the Smithsonian Institute. A second painting was donated to the New York Historical Society, Museum and Archives by George A. Zabriskie. A complete list of the location of both the sketches and other versions of the works are listed in full on http://www.robertwalterweir.com/RWW.htm The only version of the painting that is signed and dated Saint Nicholas is in the Butler Institute of American Art. In this version the stocking hanging on the fireplace is inscribed with the initials of two of the artist's sons. Weir is best known for painting *Embarkation of the Pilgrims* that hangs in the United States Capitol rotunda, in Washington, D.C.

Man in 1846. After his Christmas series of books concluded in 1846, Dickens continued to write on what he called "The Carol Philosophy", producing further works for publication in periodicals.

Dickens' genuine concern for the welfare of children was reflected in many of his novels. In *Christmas Carol* he presents the two children called "Ignorance" and the other "Want" to represent the poor children of mid 19th century Victorian England. They peer out from behind the robes of the "Ghost of Christmas Present" and are far from the image of the ideal of children at Christmas time.

Washington Irving's influence on the Christmas story characters, the sense of nostalgia for kinder Christmas' of the past, the merriment is all there – but Dickens sets his story of charity and redemption at the seat of the family hearth and home and for this his work remains not only celebrated but relevant and enjoyed the world over. "Scrooge was better than his word. He did it all, and infinitely more; and to Tiny Tim, who did not die, he was a second father. He became as good a friend, as good a master, and as good a man, as the good old city knew, or any other good old city, town, or borough, in the good old world

NOTE: The British Poor Law of 1834 had diminished the amount of help the poor could receive with the result in even greater poverty for many children. Just three years later the Slave Compensation Act was signed into law on December 23, 1837. The act authorised the Commissioners for the Reduction of the National Debt to compensate slave owners in British society, including the wealthy plantation owners in the Caribbean in the amount of twenty million pounds sterling. The amount paid out constituted 40% of the Treasury tax receipts at the time. This injustice and lack of regard for the welfare of British children must have outraged men of moral conscience and conviction such as Charles Dickens. In *American Notes* Charles Dickens wrote of his impressions on his travels in America in 1842, and harshly criticized and the institution of slavery in the southern states. For a period of time the sale of his books in America faltered but on his second tour to America in 1867 he was once again very popular with American readers.

CREDITS: Page 166 top: Artist unidentified, *Portrait of Charles Dickens*, Courtesy Austrian National Library.
Bottom: Artist – A.C. Michael (British,1851-1965) Dickens, Charles, et al. *A Christmas Carol*. (New York: Hodder and Stoughton, 1911). Pdf. Retrieved from the Library of Congress, loc.gov/item/47037729.
Page 167: Artist unidentified, ca. 17th century. Public Domain *Artvee*.

NOTES: Every year during the holiday season, The Morgan Library and Museum places on public display the original manuscript of Dickens' - *A Christmas Carol*. He had the manuscript bound in red leather as a gift for his solicitor, Thomas Milton. It was passed through several hands before being acquired by the Morgan in the 1890s. American illustrator Jessie Willcox Smith illustrated an edition of *Christmas Carol* in 1912, the same year she illustrated *Twas The Night*. For the cover painting Smith chose to depict the two Christmas Carol characters, Bob Crachit and Tiny Tim. The painting is titled: *Tiny Tim and Bob Crachit on Christmas Day*. It also appeared in, *The Children of Dickens*, published by Samuel McChord Crothers, published in 1925.

When Charles Dickens visited America with his wife Catherine, he was met with a large reception. Dickens wrote to his friend John Foster: "I can do nothing that I want to do, go nowhere where I want to go, and see nothing I want to see. If I turn in the street, I am followed by a multitude." While in America he visited with Washington Irving, the writer who had greatly influenced his own writing and specifically the Christmas series. At a dinner held in New York during his visit to America, hosted by Washington Irving, Dickens told those gathered: "I say, gentlemen, I do not go to bed two nights out of seven without taking Washington Irving under my arm upstairs to bed with me." - FRED KAPLAN, *Dickens A Biography* (William Morrow, NY, 1988).

I will honour Christmas in my heart and try and keep it all the year. I will live in the Past, the Present, and the Future. The Spirits of all Three shall strive within me. I will not shut out the lessons that they teach." – CHARLES DICKENS, *A Christmas Carol*.

Between the debut of *Twas The Night* in 1823 and the release of *A Christmas Carol* in 1843, an American family Christmas developed. During these two decades Americans were introduced to Santa Claus, Tiny Tim, and Christmas trees in the parlor. They embraced the practise of sending Christmas cards, lavishly decorating one's home for the holiday, and hosting a family festive meal. Holidaying at harvest time or at weddings had been the main occasion for celebrating in American society. By the middle of the 19th century, Christmas had become the pre-eminent holiday of the year, in large measure due to these two specific literary works.

Throughout the second half of the 19th century authors wrote of the Christmas season, either from their personal experience or inspired by the personification of the spirit of Christmas and the ever increasingly popular character of Santa Claus. In her 1835 short story, Catherine Sedgewick describes a family gift exchange and how the character of "Lizzy" rather than buying gifts made hand-crafted items for the members of her family. The first known image of a Christmas tree on display inside an American home was published in 1836 in *The Stranger's Gift*, published by Harvard Professor Herman Bokum of Boston, MA. *Kriss Kringle's Christmas Tree* was published in 1845 with an image of Santa Claus and a decorated tree on its cover. Sarah Pryor in her memoirs wrote of the first tree in Virginia in the 1842: "The beautiful Christmas custom of lighting a Christmas tree – bringing 'the glory of Lebanon, the fir tree, the pine tree, and the

box,' to hallow our festival – had not yet obtained in Virginia. We had heard much of the German Christmas tree but had never seen one. Lizzie Gilmer, who was to marry a younger son of the house, was intimate with the Tuckers, and brought great reports of the preparation of the first Christmas tree ever seen in Virginia." - "The tree loaded with tiny baskets of bonbons, each enriched with an original rhyming jest or sentiment, was magnificent, the super delicious, the speeches and poems from the two old judges (Tucker) were apt and witty." – Excerpt (*My Day: Reminiscences of a Long Life of Sarah Pryor* (1909). Documented by *Christmas Trees in the Era of Gone With The Wind*, December 24, 2010.

HUSKING THE CORN IN NEW ENGLAND.

CREDIT: Artist unidentified – *Husking The Corn in New England*, *Harper's* 1858, Boston Public Library.

NOTES: A theatrical presentation, based on the original script created by Charles Dickens for his American tour of 1867, has been performed in recent years by Michael Muldoon at Lyndhurst Mansion, Tarrytown, NY, and at Bartow-Pell Mansion, Bronx, NY.

Gerald Charles Dickens (British, 1963-) in 1993 began touring solo performances of works authored by his great-great grandfather - Charles Dickens. His performance of *Christmas Carol* at Vaillancourt Folk Art, in Sutton, MA, has become a tradition. During the holidays performances are held across the UK, including at Highclere Castle (Downton Abbey).

Susan Fenimore Cooper, the daughter of James Fenimore Cooper, kept a diary of 1848-1849 in which she writes of Christmas in her hometown of Cooperstown. "It is well for Santa Claus that we have snow, if we may believe Mr. (Clement Clarke) Moore, who has seen him nearer than most people, he travels in a miniature sleigh, with eight tiny reindeer". Cooper retells the legend of the St. Nicholas: "Strange indeed has been the two-fold metamorphosis; he began as an 'Asiatic bishop' and was transformed into a sturdy, kindly, jolly old burgher of Amsterdam, half Dutchman, half 'spook'."

Susan Fenimore Cooper's diary was published as *Rural Hours* (also released as *Journal of a Naturalist* in the United States) in 1850 by George Putnam, NY.

The Christmas Stocking written by Susan Warner was an American bestseller in 1854.

"The New-England Boy's Song about Thanksgiving Day", also titled "Over the River and Through the Woods", was written in 1844 by Lydia Maria Child (American, 1802-1880). Variations include the words; Thanksgiving for Christmas and Grandfather's House for Grandmother's.

> Over the river, and through the woods,
> To Grandmother's house we go;
> The horse knows the way to carry the sleigh
> Through the white and drifted snow.
> Over the river, and through the wood,
> To Grandmother's house away!
> We would not stop for doll or top,
> For 'tis Christmas Day.

STOCKINGS IN THE FARM-HOUSE CHIMNEY (Excerpt)

Happy, believe, this Christmas Eve
Are Willie and Rob and Nellie and May
Happy in hope! In hope to receive
These stockings well stuffed from Santa Claus' sleigh.

A DUTCH CHRISTMAS UP THE HUDSON IN THE TIME OF THE PATROONS (Excerpt)

Sleigh-bells a' jingle! 'Tis Santa Claus: hail!
Villageward he goes thro' the spooming of the snows;
Yea, hurrying to round his many errands to a close,
. . . All the same to all in the world's wide ways -
Happy harvest of the conscience on many Christmas Days.

- HERMAN MELVILLE (American, 1819-1891)

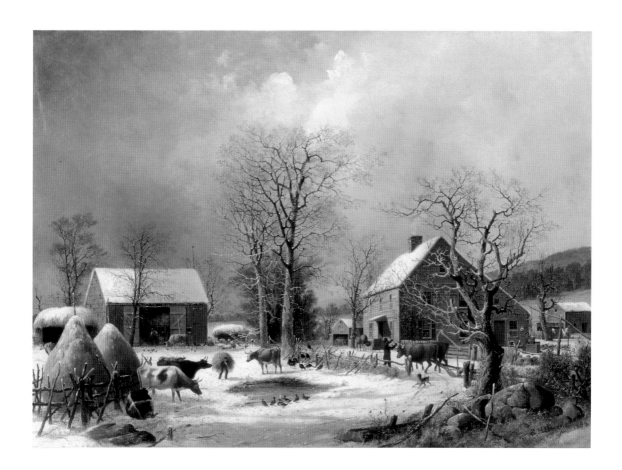

CREDIT: Page 170: Artist – Alfred Thompson Bricher (American, 1837-1908). *Winter in Maine* (1887).
Page 171: Artist – George Henry Durrie (American, 1820-1863), *Farmyard in Winter*.

NOTE: The poems are part of the *Weeds and Wildings* collection of Melville's poetry and prose.

The Wonders of Santa-Claus, His Astonishing Castle, His Beautiful Gifts for All Good Children, And His Real Name (*Harper's Weekly, A Journal of Civilization*, New York, December 26, 1857). Ralph Hoyt (American, 1806 - 1878). Artist unidentified. (Excerpt)

BEYOND the ocean many a mile,
And many a year ago,
There lived a wonderful queer old man
In a wonderful house of snow;
And every little boy and girl,
As Christmas Eves arrive,
No doubt will be very glad to hear,
The old man is still alive.

In his house upon the top of a hill,
And almost out of sight,
He keeps a great many elves at work,
All working with all their might,
To make a million of pretty things,
Cakes, sugar-plums, and toys,
To fill the stockings, hung up you know
By the little girls and boys.

It would be a capital treat be sure,
A glimpse of his wondrous shop;
But the queer old man when a stranger comes,
Orders every elf to stop;
And the house, and work, and workmen all
Instantly take a twist,
And just you may think you are there,
They are off in a frosty mist . . .

But it were an endless task to tell,
The length that the list extends,
Of the curious gifts the queer old man
Prepares for his Christmas friends.
Belike you are guessing who he is,
And the country whence he came.
Why, he was born in Germany,
And St. Nicholas is his name.

CHAPTER 2

December's four and twentieth day
Though its course was almost run
St. Nicholas stood at his castle door
Awaiting the setting sun.
His goods were packed in a great balloon,
Nearby were his horse and sleigh;
He had his skates upon his feet
And a ship getting underway.

For he was to travel by sea and land,
And sometimes through the air,
And then to skim on the rivers smooth,
When the ice his weight would bear.
The wind blew keen, and the snow fell fast,
But not a whit cared he;
For he knew a myriad little hearts,
Were longing that night to see.

CHAPTER 3

Up, up my gallant sailors all,
Swiftly your anchor weigh,
The wind is fair, and we must sail,
For far America.
By wind and steam for New Amsterdam,
Three thousand miles an hour,
Onward he drove his elfin ship,
With a thousand- fairy power.

Down at the Battery he moored
And gave a grand salute,
With cannon charged with sugar-plums,
And powder made to suit.
Then he hoisted out a score of bales,
Of his cakes, and nuts, and wares;
You would have been amazed to see
The heaps on the ferry stairs....

When all were good and went to church,
And heeded what they heard,
And children never learned to speak
A bad or saucy word.
With plenty smiling everywhere,
Like Christmas every day,
Content and love at every hearth,
O what rare times were they!

But long before all this was said,
The stockings were all filled,
And Santa-claus was skating home,
With his nose a little chilled.
He whistled as he skimmed along,
Till the day began to dawn,
Then giving a twirl in the frosty air,
St. Nicholas was gone!

CHAPTER I.

Four Harper brothers began the publishing company of Harper & Brothers in 1825, which was followed by *Harper's Magazine* in 1850. The publication featured popular authors including Charles Dickens. In 1857, the company began publishing *Harper's Weekly: A Journal of Civilization* which by 1860 had reached a circulation of 200,000. *Harper's Weekly* would become the most widely read magazine during the American Civil War.

Katherine Lee Bates gave Mrs. Claus her first active role in the 1889 poem *Goody Santa Claus on a Sleigh Ride* (1889). Mrs. Claus wants to go along on the magical Christmas Eve sleighride. In *Wonders of Santa Claus* (1857) Santa is joined by his hard-working elves and lives in an ice castle.

"In the Bay Psalm Book, the hymnal used in New England churches well into the nineteenth century, not a single Christmas hymn was found."- *How the Unitarians and Universalists Saved Christmas A Sermon* by Rev. Fred Small First Parish in Cambridge, Unitarian Universalist December 11, 2011.

For the Episcopalian church, of which C.C.M. and his family were parishioners, by the 1850s Christmas had become the greatest event in the church calendar. Episcopalian churches were festively decorated, the services had been elaborated, and more music was performed – including the singing of Christmas carols. In 1822, *Some Ancient Carols, With the Tunes to Which They Formerly Sung in the West of England* had been published which started a resurgence of interest in century old carols in their original form. In 1833, a history of carols was published in *Christmas Carols, Ancient and Modern* and thereafter carols began to be composed across Britain as they would be in America. In 1850, Richard Storrs Willis published "It Came Upon A Midnight Clear" in the publication "Church Chorals and Choir Studies". We "Three Kings of Orient Ore" was written in 1857 for a Christmas pageant performed at the General Theological Seminary in New York and C.C.M. along with his family may well have been at the debut performance. The Bishop of the Episcopal Church of Massachusetts Phillip Brooks wrote "O Little Town of Bethlehem" in 1866.

CREDIT: Page 174: Artist – Thomas Lachlan Smith (American, 1835-1884) *Christmas Services*, 1867.

NOTES: Katherine Lee Bates is well known for writing the anthem – "American the Beautiful".

In 1842, a tabletop Christmas tree was introduced by Charles Minnigerode to St. George Tucker House in Williamsburg, VA.

For Christmas 1844 the *New York Tribune* published an editorial written by journalist Margaret Fuller in which she describes the German Christmas tree tradition: "The evergreen tree is often reared on Christmas evening, and its branches cluster with little tokens that may, at least, give a sense that the world is rich, and that there are some in it who care to bless them. It is charming sight to see their glittering eyes, and well worth much trouble in preparing the Christmas tree." Fuller also offered the readers a morality tale and wrote: "that what they have must bestow Were all this right in the private sphere, the public sphere would soon right itself also."

A letter written by Hattie Stowe, dated December 27, 1850, tells of a tabletop Christmas tree, decorated with gilt stars and an angel dressed by her mother – Harriet Beecher Stowe. The letter is in the collection of the Harriet Beecher Stowe Center, Hartford, CT.

SANTA CLAUS AND HIS PRESENTS.

selected some weeks before from the forests. It is known that the Yule-log must be something enormous in size—so large as to blaze brightly and fiercely in the hearth until the feast is over. Herrick gives the following song on the subject:

"Come bring with a noise,
 My merry merry boys,
The Christmas log to the firing;
 While my good dame she
 Bids ye all be free,
And drink to your heart's desiring.
 With the last year's brand
 Light the new block, and

For good success in his spending,
 On your psalt'ries play,
 That sweet luck may
Come while the log is trending.
 Drink now the strong beer,
 Cut the white loaf here,
The while the meat is a-shredding;
 For the rare mince-pie
 And the plums stand by
To fill the paste that's a-kneading."

The favorite dish for Christmas Day in this part of the world seems to be—as on Thanksgiving Day in New England—roast turkey. It is curious to note, in this connection, that turkeys were introduced into the land of our forefathers contemporaneously with the Protestant religion.

DOMESTIC INTELLIGENCE.

POLITICAL.

CONGRESS.

On Monday, the 13th, in the Senate, the list of Standing Committees was read and adopted by a vote of 51 to 20. Senator Mason gave notice of a bill to equalize the compensation of our foreign ministers. Senator Cling-

man introduced a resolution calling for all the correspondence on the Clayton-Bulwer Treaty. Laid over. On motion of Senator Gwin, the Pacific Railroad Bill was taken up by 30 to 13, and a speech thereon made by the Senator.—In the House, Mr. Clay moved a resolution calling for information as to recent British visits of American vessels off Nicaragua: adopted. The Watrous impeachment case was then discussed by Messrs. John Cochrane, Taylor, Maynard, Adrain, and Houston.

On Tuesday, 14th, in the Senate, a memorial was presented by J. Horsford Smith, praying to be allowed to import iron duty free. The Pacific Railroad Bill was then taken up in connection with an amendment of Senator Wilson to make the road follow the 42d parallel, and was discussed by Senators Stuart, Mason, Shields, Doolittle, Iverson, Brown, Foot, Green, Polk, Gwin, and

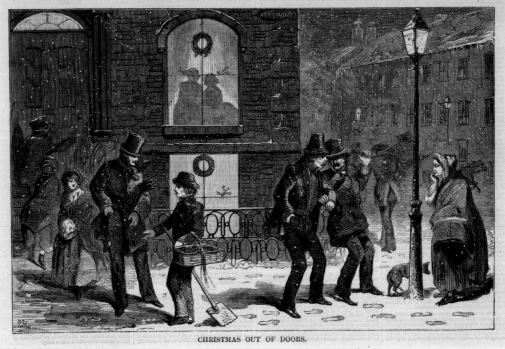

CHRISTMAS OUT OF DOORS.

NOTES: In 1827, Bishop Chase wrote to his wife: "The devil has stolen from us . . . Christmas, a day of our spiritual redemption, and converted it into a day of worldly festivity, shooting and swearing." - WILLAM WILSON MANROSS - (*The Episcopal Church In The United States 1800-1840, A Study in Church Life, 1938*). Manross also wrote: "Another Episcopalian, Professor Moore, of General Seminary, unintentionally fostered this tendency, for his rhymed version of the Dutch legend of St. Nicholas did much to popularize the Santa Claus ritual in this country." At the time of the debut of *Twas The Night* night-watchmen watched over the streets of the increasingly dangerous urban cities, as many still did not a full-time police force. Christmastime to New Years was notorious for the shooting off of guns and for members of gangs to roam the streets under the guise of misrule creating a menacing environment. In 1826, the Eggnog Riots that took place at the West Point academy in New York, wherein a group of students became so inebriated that a riot broke out, resulted in New York implementing its first full-time police force. As the *American Medical Times* reported on July 14, 1860, New York was still a town given to episodes of social misrule: "Happy the citizens of New York who rose on the morning of July 5th with a whole akin and unbroken bones," wrote Elisha Harris in 1860: "Indeed, never did the Roman Saturnalia present scenes so dangerous to life, as did the streets of New York on the 'Fourth of July'. Clearly the fault, as laid at the feet of C.C.M. for the shenanigans of Christmas revelry by Manross, was certainly misplaced. Harris documented by The Aporetic: *The American History of Santa Claus*, 2010.

"The use of flowers in church was still generally regarded as implying an improper regard for externals in worship, but the use of evergreens, for some reason, was not supposed by most Episcopalians to be open to the same objections." - William Wilson Manross, Fellow and Tutor in General Theological Seminary in 1938.

"An 1845 genre painting by Carl August Schwerdgeburth, depicting Martin Luther's family gathering around a lighted tree, was often reproduced in church tracts; the legend that Luther had invented the Christmas tree enlisted a wholly secular symbol in the service of religion. Finally in the 1850s and 1860s, clergyman brought the tree into the church, as the cornerstone of Christmas exercises for Sunday school classes." – KARAL ANN MARLING, *Merry Christmas, Celebrating America's Greatest Holiday* (Harvard University Press, Cambridge, MA, London, England, 2000).

The poem *Twas The Night* and Santa Claus were welcome additions to Sunday school classes and in school classrooms across America, which gave the work unprecedented exposure and captured the full breath of a generation of American children of various heritages and religious affiliations.

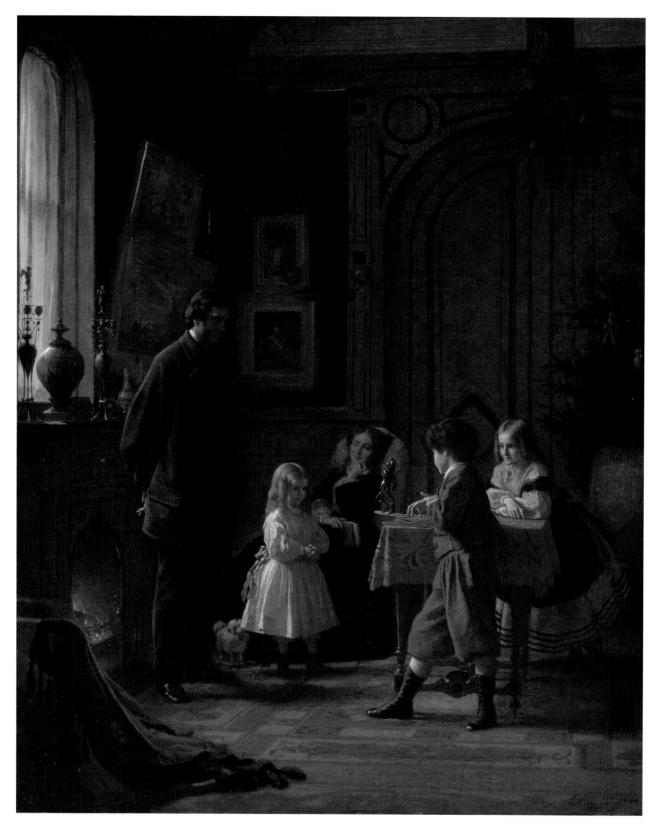

CREDIT: Artist – Jonathan Eastman Johnson (American, 1824-1906) *Christmas-time, The Blogett Family*, 1864. The Metropolitan Museum of Art, NY, NY.

Sarah Hale (American, 1788-1879) was one of America's original tastemakers and the first female editor of an American magazine, editing *Ladies Magazine* and then *Godey's Lady's Book*. Hale enjoyed sharing with her readership the fashions and preferences of Queen Victoria and Prince Albert, including the way the royal couple and their children celebrated Christmas. She was careful to cater to American tastes. In reproducing an engraving printed in the *Illustrated London News* for 1848, in which the royal family were depicted in front of a Christmas tree, Hale had the image altered, removing the Queen's crown and Prince Albert's mustache and regal sash before printing the images for the American public. Other images were often borrowed or obtained from British publications at this time by Hale along with other American publishers. On one occasion Hale had stars and stripes of the American flag added to the decorations on an engraving of a decorated Christmas tree - again done to better suit her readers.

"In 1860, as families anticipated being separated by the Civil War, Hale ran the picture (1848) again. She called it *The Christmas Tree* and accompanied it with instructions on how to make a Christmas tree stand up in a sand-filled stoneware jar. She showed how to put a green chintz skirt around it and how to dress it with ornaments for children. And she described stringing holly berries and attaching candles to the branches with wires. *Godey's* 150,000 readers paid attention." *The Stealth Campaign to Bring the Christmas Tree Into American Homes* (New England Historical Society, 2021).

By the end of the century, Christmas trees on display in American homes would become the norm rather than the exception.

CREDIT: Artist - W.H. Chambers, *Sarah Josepha (Buell) Hale* (American, 1788-1879) *Godey's Lady's Book*, front piece, December 1850. Library of Congress.

NOTES: *Mary Had a Little Lamb*, written by Hale was chosen by Thomas Edison to launch his invention of the phonograph in 1877.

Queen Victoria wrote about tabletop trees in her teenage diaries: *The girlhood of Queen Victoria: A selection from Her Majesty's diaries between the years 1832 and 1840.* Edited by Viscount Esher; 1912; J. Murray in London: Monday, 24th December. "At a ¼ to 7 we dined with the whole Conroy family and Mrs. Hore downstairs, as our Christmas tables were arranged in our dining room. After Mamma had rung a bell three times, we went in. There were two large round tables on which were placed two trees hung with lights and sugar ornaments. All the presents being placed round the tree. I had one table for myself, and the Conroy family had the other together. Lehzen had likewise a little table."

1856: President F. Pierce and First Lady Jane Pierce are credited with placing the first Christmas tree in the White House. They invited a Sunday school class of children to join them in decorating the tree.

The Pageant of Peace is an annual event that began in 1923 under President Calvin Coolidge. It includes the lighting of the National Christmas Tree.

Catherine Beecher and her sister Harriet Beecher Stowe wrote *The American Woman's Home* in 1869, which became the most popular book on domestic advice in 19th century America.

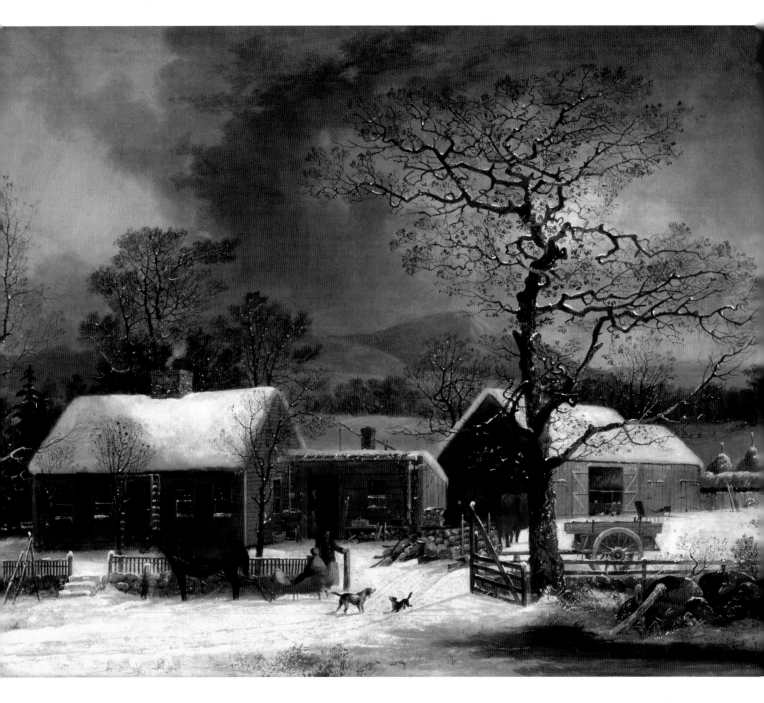

CREDIT: Page 180: Artist - George Henry Durrie (American, 1820-1863) *Winter Scene in New Haven*, ca. 1858.

NOTES: *Poem's on Slavery* was written by Longfellow and Charles Sumner in 1842. Longfellow spent much of his publishing earnings to buy enslaved persons safe passage to freedom. Paul Revere (American, 1734-1818) silversmith, printer, engraver, and patriot. The midnight ride of 1775 was to alert the colonial army of the approaching British forces.

CHAPTER 10

Home For The Holidays

Snow-Flakes

Out of the bosom of the Air,
Out of the cloud-folds of her garments shaken,
Over the woodlands brown and bare,
Over the harvest-fields forsaken,
Silent, and soft and slow
Descends the snow.
Even as our cloudy fancies take
Suddenly shape in some divine expression,
Even as the troubled hearts doth make

In the white countenance confession,
The troubled sky reveals
The grief it feels
This is the poem of the air,
Slowly in silent syllables recorded;
This is the secret of despair,
Long in its cloudy bosom hoarded,
Now whispered and revealed
To wood and field.

— HENRY WADSWORTH LONGFELLOW.

The Atlantic Monthly, founded in 1857 in Boston, MA, set out to publish articles on the arts, politics, and the abolition of slavery. Henry Wadsworth Longfellow, Ralph Waldo Emerson, and other abolitionists were the first generation of writers published in *The Atlantic.* In January of 1861, *The Atlantic* published Longfellow's *Paul Revere's Ride,* as a rallying call to a nation on the eve of war:

PAUL REVERE'S RIDE (Excerpt)

In the hour of darkness and peril and need,
The People will waken and listen to hear
The hurrying hoofbeats of that steed,
And the midnight message of Paul Revere.

- HENRY WADSWORTH LONGFELLOW (American, 1807-1882).

The American Civil War was fought between April 12, 1861, and April 9, 1865. *Twas The Night* appeared in newspapers and magazines during Christmas throughout the American Civil War, often printed with editorial comment, some of which was politicized.

"The following, from the pen of Prof. Moore, has been in print a long time; but it wears well, and we think some of our young readers may like to see it. The troubles of war are transient; but the great fact on which Christianity is based, is as fixed as the everlasting hills." - *The Hartford Daily Courant*, Hartford CT, December 25, 1861.

"CHRISTMAS! – To-morrow will be *Christmas Day*: The community has become accustomed to the changed conditions of affairs which the war of independence has wrought since this day twelve months ago, and though the rattle of musketry and roar of cannon upon the battle field are almost audible here – though the prices of many articles of luxury and subsistence have been carried up to inordinate rates, and other drawbacks may be encountered – the disposition of all persons is to make the most of the holidays, strengthened in their purpose by the trite truism: *Christmas comes but once a year.* We wonder if Santa Claus will be around tonight. The juveniles certainly expect him and will be grievously disappointed should he fail to come. Our belief is that he will surely be here and will distribute his gifts liberally to all the little folks, who hang up their stockings, expect the children of the poor.... But we have said that Santa Claus will be here, and he will come no doubt, in the *good old way*, which has been so felicitously described by Dr. Clement C. Moore, in the following lines:"– Editorial (Excerpt), *Richmond Whig*, Richmond, VA, December 24, 1861.

"Christmas – There is almost unanimous anticipation of a "dull Christmas." Every creature comfort which usually contributes to the festive enjoyment, at this season, is scarce and high; the toy stores are almost bare.... We do not believe that Santa Claus will fail to visit this latitude to-night, as some have expected. He may have lightened his load so as to "run the blockade" and escape the accursed Yankees more easily, but we are sure he will come to bring something to the little ones, and, so believing, we annex, for the entertainment of our juvenile readers, the familiar lines of Dr. C.C. Moore, descriptive of Santa Claus's visit." – Editorial (Excerpt), *Richmond Whig*, Richmond, VA, December 26, 1862.

A VISIT FROM ST. NICHOLAS.

Louis Prang (Poland-Prussia, 1824-1909 American) emigrated from Europe to Boston, MA, in 1850 and within five years he and his partner Julius Mayer had created a lithograph press. Prang with the outbreak of war began printing war maps and scenes of the conflict. By the 1870s, Prang owned most of the steam printing presses in the United States and by 1875 Prang was printing millions of Christmas cards. *The Louis Prang & Company Collection* is held at the Boston Public Library.

R.H. Pease, a printer and store owner in Albany, NY, printed the first known American Christmas cards in the 1850s. These early cards displayed images of Santa Claus and reindeer.

CREDITS: Page 184: *A Visit From St. Nicholas*, Christmas card. Illustrator not identified. (L.Prang & Company, Boston, MA, ca. 1870). Rare Book – *Nancy H. Marshall Collection*, Special Collections Research Center, William & Mary Libraries. Page 185: Artist unidentified. Banner, Santa Claus, late 19th century. Cooper-Hewitt, Smithsonian Design Museum. Made by Oriental Printworks. Public Domain.

Santa Claus is coming

with compliments of Santa Claus

SANTA CLAUS

the stockings in the house
were hung to be filled,
Santa Claus.

His eyes how they twinkled! his dimples how merry!
His cheeks were like roses, his nose like a cherry.

Santa Claus gave all these toys
Because we were good girls and boys.

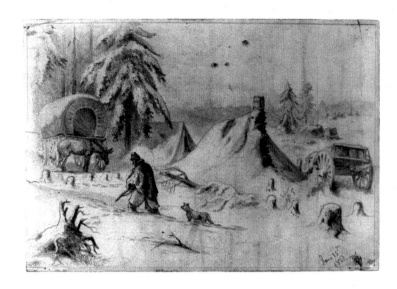

Thomas Nast's first Christmas drawings for *Harper's Weekly* were published in the January 3, 1863, issue. Appearing on the cover was a patriotic and politicized Santa Claus, garbed in the stars and stripes of the American flag, shown visiting and distributing gifts to Union-Northern soldiers. In a second illustration for the issue, entitled *Christmas Eve*, Nast places Santa Claus in the top right corner. An editorial printed with the poem describes the scene:

"Christmas Eve – The dearly cherished anniversary of so many hundred years comes back to us again in all its sacred beauty and antiquity, kept by some with the time-honored custom of gathering together all the members of the family, near and distant, and distributing among them welcome tokens of affection, of which kind old Santa Claus is supposed to be the donor. The happy few may, perhaps, again this year celebrate their annual festivities; but oh! to how many will it be a season of sad, sad memories! Notwithstanding the anxiety so painfully weighing on the mother's heart, it shall still be "Merry Christmas" with the little ones; and as they lie nestling so sweetly in their little crib, she carefully fills the little stockings, which have been expectantly hung in the chimney, with all they have so eagerly desired. Then she decks the room tastefully with greens and hangs a wreath below the dear absent father's portrait, which greets the little ones with loving eyes as they awake. Meanwhile the vision of Santa Claus showering his gifts down the chimney comes to them in their merry, happy little dreams, while his sleigh, laden with gifts, is impatiently waiting to jingle off to the next of his favorites."

CREDIT: Artist – Edwin Forbes (1839-1895), *Winter Camp near Stoneman's Switch*, Fairmouth, VA, January 25, 1863. Gift J.P. Morgan 1919, *Morgan Collection of Civil War Drawings*, Library of Congress.

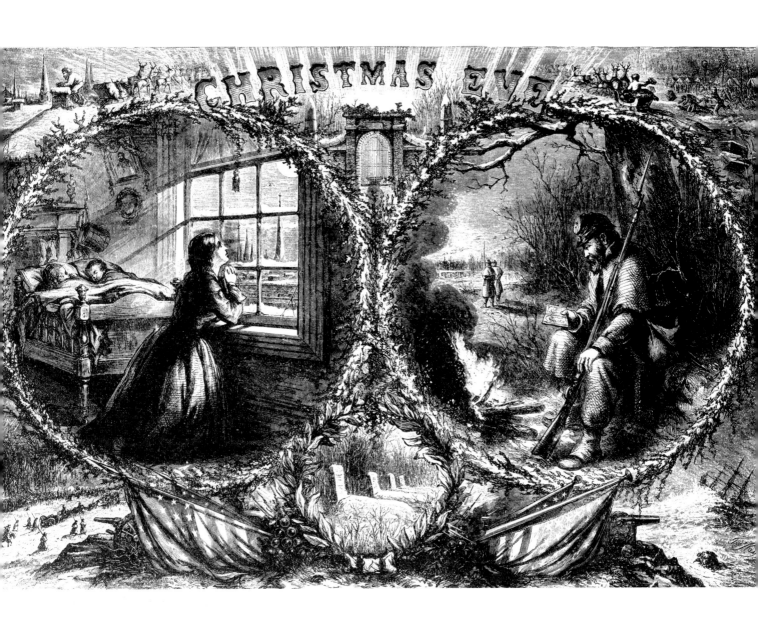

CREDIT: Artist – Thomas Nast (American 1840-1902) *Christmas Eve, Harper's Weekly*, January 3, 1863.

HARPER'S WEEKLY.
A JOURNAL OF CIVILIZATION.

VOL. VII.—No. 314.] NEW YORK, SATURDAY, JANUARY 3, 1863. [SINGLE COPIES SIX CENTS.
$2 50 PER YEAR IN ADVANCE.

Entered according to Act of Congress, in the Year 1862, by Harper & Brothers, in the Clerk's Office of the District Court for the Southern District of New York.

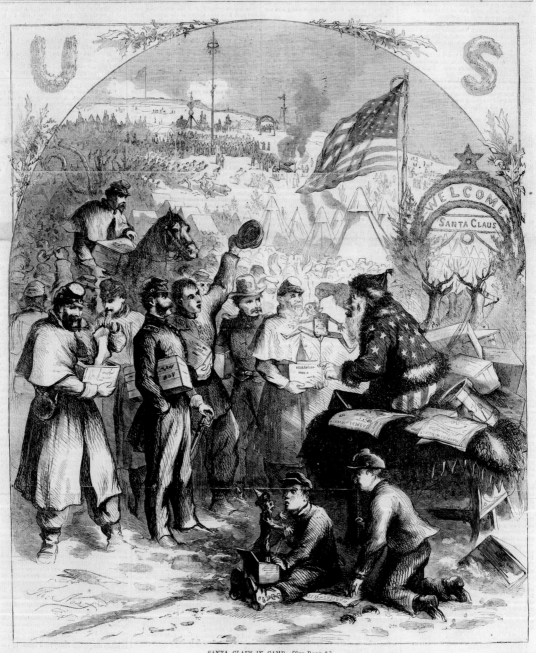

SANTA CLAUS IN CAMP.—[SEE PAGE 6.]

SANTA CLAUS'S BALL.

"Children, you mustn't think that Santa Claus comes to you alone. You see him in the picture on page 8 and 9 throwing out boxes to soldiers, and in one on page I you see what they contain. In the foreground you see a little drummer-boy, who, on opening his Christmas-box, behold a jack-in-the-box spring up, much to his astonishment Santa Claus is entertaining the soldiers by showing them Jeff Davis's future. He is tying a cord pretty tightly around his neck, and Jeff seems to be kicking very much at such a fate." – *Santa Claus Amongst Our Soldier's*, Editorial (Excerpt) *Harper's Weekly*, January 3, 1863.

A short story for children was also published in the January 3, 1863 issue of *Harper's Weekly*.

"Santa Claus had appointed this November as a dress rehearsal for Christmas Santa Claus expected to hear from his spies, the Old Dolls, full accounts of the conduct and behavior of his little friends the Children, in order to know who deserved his rich prizes, and who might merit the traditional "rod in the stocking," as the penalty for misbehavior. The gala was held in Santa's favorite winter palace, an immense snow-cave on the side of Mount Hecla. Santa Claus found the climate better with his health than a more southern situation, and likewise he found here, in this sequestered spot, the quiet and seclusion so necessary to the mystery in which he is accustomed to investing his good deeds. The palace was all of a glow with warmth and light from the numerous fires in a huge fireplace . . . The cheerful blaze illuminated the glittering ceiling and sparkling walls, and mellowed the atmosphere to almost tropical geniality, the palace was placed under a perpetual spell or charm by the certain witch. This witch when young had been a famous beauty, and a great favorite of the good saint, who was a gay bachelor in those days." – Excerpt.

CREDIT: Page 188: Artist - Thomas Nast, *Santa Claus in Camp* (*Harper's Weekly*, January 3, 1863)
Page 189: Author and artist unidentified, *Santa Claus's Ball, or, A Plea For Children* (*Harper's Weekly*, January 3, 1863). (Excerpt).

NOTE: Between 1863 and 1886 Nast contributed 33 Christmas drawings to *Harper's Weekly*.

Henry Wadsworth Longfellow wrote *Christmas Bells* on Christmas Day, 1863. The poem debuted in *Our Young Folks* for February 1865. The American Civil War came to an end two months later. As soldiers returned home, and the displaced began to rebuild their lives, the poem touched accord with many.

CHRISTMAS BELLS

I heard the bells on Christmas day
Their old, familiar carols play,
And wild and sweet
The words repeat
Of peace on earth, good-will to men!

CREDIT: Artist – George Henry Durrie (American, 1820-1863). *Winter-Time On The Farm*, ca.1862-1863.

NOTE: C.C.M.'s grandson fought in the Civil War. Longfellow's eldest son was badly injured in the conflict. Both men fought for the Union army.

The way Christmas was celebrated in the Southern states prior to the Civil War is well documented through firsthand accounts. These accounts reflect a wide disparity in the way Christmas was experienced in the South during the Antebellum period.

Yuletide in Dixie suggests that the time is overdue for Americans to divest themselves of all romantic illusions about Christmas in slave times, not only because they distort history but also because any quasi-justification of human bondage – "the 'slavery wasn't-all-that-bad' trope – hampers racial reconciliation today." *Yuletide In Dixie, Slavery, Christmas, and Southern Memory*, written by Robert E. May, (University of Virginia Press, Charlottesville & London, 2019).

CREDIT: Artist - Winslow Homer (American, 1836-1910). *Dressing for the Carnival*, 1877. Metropolitan Museum of Art, *Amelia B. Lazarus Fund*, 1922.

NOTE: "Homer's challenging subject evokes both the dislocation and endurance of African American culture that was a legacy of slavery. The central figure represents a Jonkonnu character, a Christmas holiday celebration once observed by enslaved Blacks in Virginia and North Carolina. After the Civil War, aspects were incorporated into Independence Day events, to which the painting's original title, *Sketch – 4th July in Virginia*." – Metropolitan Museum of Art.

McLOUGHLIN BROS., NEW YORK.

In 1864, Thomas Nast supplied pen and ink drawings for *A Visit From St. Nicholas*, published in *Christmas Poems and Pictures A Collection of Songs, Carols and Descriptive Poems Relating to the Festival of Christmas* published by James G. Gregory of New York. *Merry Christmas To All*, printed by

Harper's Weekly for December 30, 1865, features a double page centerfold with eight vignettes all with Christmas themes, with a portrait of Santa Claus in the center. *Santa Claus and His Works* - appeared in *Harper's Weekly* on December 29, 1866. In this multi-frame illustration, Santa Claus is shown spying on children through a telescope, keeping track of the children's behavior in a ledger, and on a border surrounding the image were the words - Santa Claussville, N.P. (The North Pole). Over the next two decades, Nast would create a variety of Santa Claus images, with the character morphing into an ever larger and more human-like form, with Santa's outfit consistently printed in red with the fur delegated to the trim of his suit and hat and the pipe Santa smokes far from the stump of a pipe ca. 1823.

Thomas Nast immigrated from Germany to the United States as a young boy with his family in 1850. By the age of fifteen, he had embarked on a career as an illustrator. In 1860 he travelled to Europe, sending illustrations of the Giuseppe Garibaldi campaign liberating Sicily to both, London and American publications. The following year he was back in America, and with the outbreak of the American Civil War the editors of *Harper's Weekly* hired Nast at the age of 22 as a political cartoonist and illustrator. Nast worked for the periodical until 1877, returning briefly from 1895-1896.

In 1870, Thomas Nast illustrated an edition of *Twas The Night* for McLoughlin Bros. with six color renderings along with black and white drawings. Nast incorporated a small American flag in the artwork created for the cover of this edition.

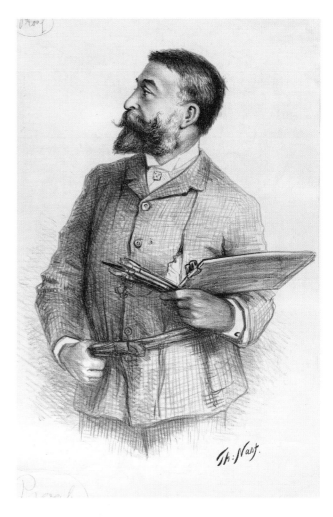

CREDITS: Page 192: Artist – Thomas Nast: *Santa Claus and his Works*, written by George Webster. (McLoughlin Brothers, NY, 1870).
Page 193: Thomas Nast, *Self Portrait* (German, 1840-1902 American). Metropolitan Museum of Art, ca. 1879-1889. CCO 1.O Dedication.

NOTE: *Santa Claus and His Works* was a rhyming story based on *Twas The Night*.

"Thomas Nast, the most successful, most widely known, and the most gifted humorous artist whom the genius of America has produced. Though of foreign birth, he came to this country at an early age that his mental and moral development belongs wholly to the land of his adoption. A more thorough American does not breathe. The whole range of his art is instinct with the best and highest thought of the New World. No other country could have afforded the same kind of culture which had made him what he is - the foremost caricaturist of the age. He thoroughly appreciates the boundless hospitality which makes every foreigner welcome to our shores, and in recognition of the free boon of citizenship sinks his own nationality in that of his adopted country and devotes his best talents to her service."- *Harper's Weekly*, NY, April 26, 1871.

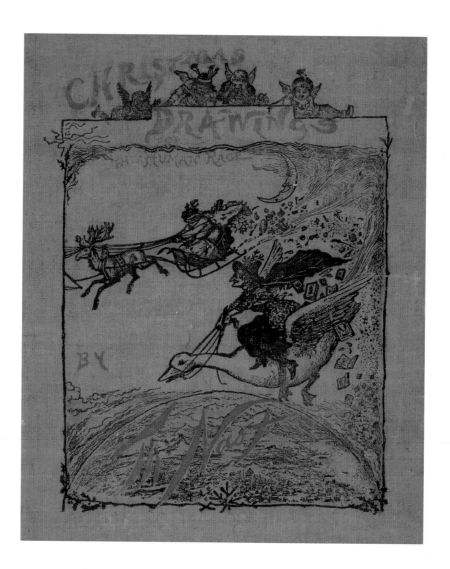

CREDIT: Artist - Thomas Nast (German, 1840-1902 American). *Christmas Drawings for the Human Race* – cover. (Harper and Brothers, NY, 1889).

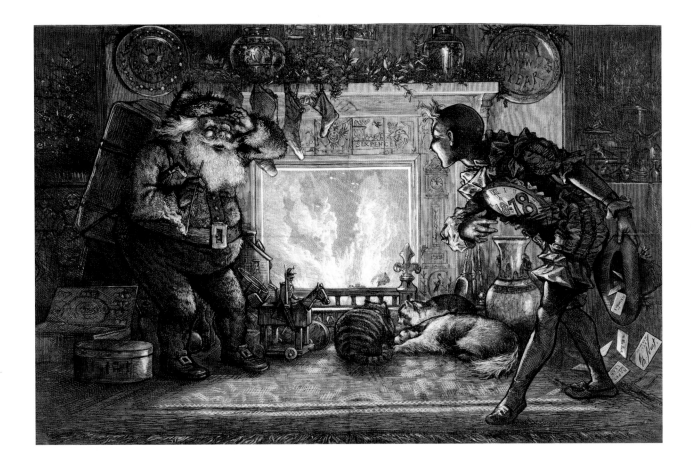

"Mr. Nast's hand, when dealing with current topics of the time, tips the flashing shafts of wit and morality; with relentless patience in the pillory; and exposes the public wrong to the fatal merriment which laughs it away. But the artist's hand is never happier than when, with the lambent light of the same humor, it irradiates the play of domestic affection, and makes the home circle gay. It is the bluff, honest Santa Claus of *Twas The Night Before Christmas*: the Santa Claus of the reindeer with his wondrous pack of treasures; the Santa Claus of unsuspecting childhood, and the Mother Goose of undoubting infancy, to whom these pages introduce us. There is no child who cannot understand them, no parent who cannot enjoy them. Mr. Nast is fairly without a rival in this kind. His Santa Claus is old Father Christmas himself, and his welcome will be as general as heartily as that which salutes the crammed and enchanted stocking, on Christmas morning." – Harper and Brothers: Introductory remarks to; *Christmas Drawings for the Human Race*, NY, 1889.

CREDIT: Artist - Thomas Nast (German, 1840-1902 American), *Here We Go, Drawings for the Human Race*, (Harper and Brothers, NY, 1889).

NOTES: Samuel Clemens (American, 1835-1910), professionally known as Mark Twain, wrote to his four-year-old daughter Susy on December 25, 1875, signing the letter -"Your Loving Santa Claus – whom people sometimes call The Man in the Moon."

The *man in the Moon* - refers to the legend of Cain who was sentenced to circle the earth, carrying a bunch of sticks, sometimes portrayed with a dog and a lantern. The character is mentioned by Shakespeare in *A Midsummer Night's Dream*, and other literary works.

"Joy, & peace be with you & about you, & benediction of God rest upon you this day! . . . There is something so beautiful about all that old hallowed Christmas legend! It mellows a body – it warms the torpid kindnesses & charities into life. And so, I hail my darling with a great big whole-hearted Christmas blessing – God be & abide with her evermore – Amen . . . And now to bed – for I have worked hard all day . . . " - Sam Clemens to his wife Livy in December 1871.

Clemens added in closing: "Get vaccinated – right away – no matter if you were vaccinated 6 months ago Smallpox is everywhere – doctors think it will become an epidemic. Here it is $25 fine if you are not vaccinated within the next 10 days. Mines takes splendidly – arm right sore."

"When Christmas Eve arrived at last, we children hung up our stockings in the schoolroom next to our nursery and did it with great ceremony. Mother always recited the trilling little poem, 'Twas the night before Christmas, when all through the house,' etc. Father (Samuel Clemens) sometimes dressed up as Santa Claus and, after running about a dimly lit room (we always turned the gas down low), trying to warm himself after the cold drive through the snow, he sat down and told us some of his experiences on the way." – Clara Clemens recalled in *Recollections of Mark Twain: Part 1: Her Childhood Memories, The North American Review*, University of Northern Iowa, 1930.

Christmas With the Clemens Family — Mark Twain House at Christmas Eve 1881: "You pull up to the house in your horse-drawn sleigh and your coachman helps you step down. You walk up to the front door and know and wait for their butler George to greet you and welcome you into the house. As you enter the home you are in awe at how the lights twinkle off the stenciling in the front hall, and the beautiful greenery they have carefully placed on the mantle and above the doorway.

As you enter further you glance at the fireplace, and you see two boot prints on the floor. George takes your coats and from the next room a little girl runs out to say hello. She sees you looking at the boot print and tells you that Santa left those years back and told the girls not to clean it up as it would be a reminder to them to be good all year long. She leads you into the next room where Mr. Clemens, Mrs. Clemens and the other two daughters, Clara and Jean are waiting to greet you and wish you a Merry Christmas. Susy, Clara, and Jean show off their decorations that they've made for the Christmas tree. Paper ornaments, crochet snowflakes, popcorn and cranberries and tinsel adorn the tree. The tree has just been decorated and the scent of fresh green tree fills the room. You sit near Mrs. Clemens and tea is brought into the room. She tells you that this holiday season has been so busy and a bit hectic with the decorators still finishing the decoratings within the first floor of the house, and putting together all of the gift baskets that you saw in the front hall which are to be delivered to some of the needy families in Hartford this evening and of course, shopping for the girls." – Courtesy of the Mark Twain Museum, Hartford, CT. (Excerpt).

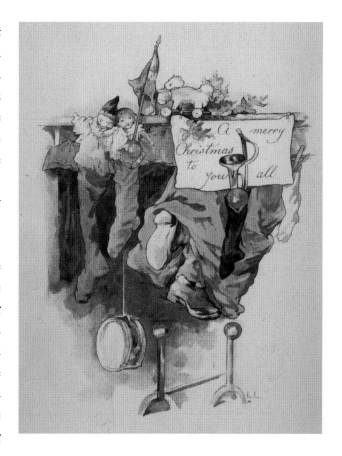

CREDIT: Pages 197-199: Artist - Lizzie Larson, *The Night Before Christmas* (Ernest Nister and E.P. Dutton, London, and New York, ca. 1909).

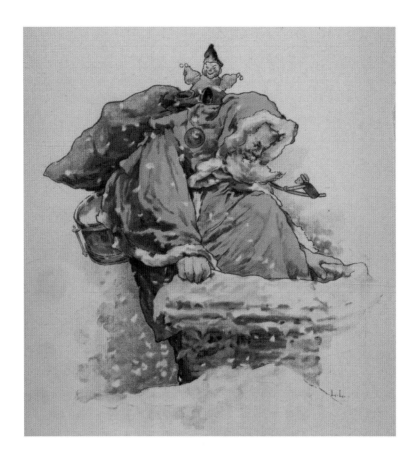

In 1891, Helen Keller (American, 1880-1968) submitted her story *The Frost King* to the Perkins School for the Blind's literary magazine. Keller found herself accused of plagiarizing *Canby's Birdie and His Frost Fairy Friend*; a story written by Margaret Canby. Keller was 11 years of age at the time. It was decided that Keller had suffered from a case of cryptomnesia. Mark Twain after reading in Keller's 1903 autobiography of the ordeal wrote to her: "Dear Helen: Oh, dear me, how unspeakably funny and owlishly idiotic and grotesque was that "plagiarism" farce! As if there was much of anything in any human utterance, oral or written, except plagiarism! The kernel, the soul—let us go farther and say the substance, the bulk, the actual and valuable material of all human utterances in plagiarism. For substantially all ideas are second hand, consciously or unconsciously drawn from a million outside sources and daily use by the garnerer with a pride and satisfaction born of the superstition that he originated them; whereas there is not a rag of originality about them any where except the little discoloration they get from his mental and moral calibre and his temperament, which is revealed in characteristics of phrasing.

It must be a very rare thing that a whole page gets so sharply printed on a man's mind, by a single reading, that it will stay long enough to turn up some time or other to be mistaken by him for his own. No doubt we are constantly littering our literature with disconnected sentences borrowed from books at some unremembered time and how imagined to be

our own, but that is about the most we can do. In 1866 I read Dr. Holmes's poems, in the Sandwich Islands. A year and a half later I stole his dedication, without knowing it, and used it to dedicate my "Innocents Abroad" with. Ten years afterward I was talking with Dr. Holmes about it. He was not an ignorant ass—no, not he; he was not a collection of decayed human turnips, like your "Plagiarism Court," and so when I said, "I know now where I stole it, but who did you steal it from," he said, "I don't remember; I only know I stole it from somebody, because I have never originated anything altogether myself, nor met anyone who had!"

To think of those solemn donkeys breaking a little child's heart with their ignorant rubbish about plagiarism! I couldn't sleep for blaspheming about it last night. Why, their whole histories, their whole lives, all their learning, all their thoughts, all their opinions were one solid rock of plagiarism, and they didn't know it and never suspected it. A gang of dull and hoary pirates piously setting themselves the task of disciplining and purifying a kitten that they think they've caught filching a chop! Oh, dam—But you finish it, dear, I am running short of vocabulary today. Every lovingly your friend.

Mark: *River-dale on the Hudson*, St. Patrick's Day, 1903."

"The only real blind person at Christmas time is he who has not Christmas in his heart. The best Christmas gift of all is the presence of a happy family all wrapped up with one another." – HELEN KELLER.

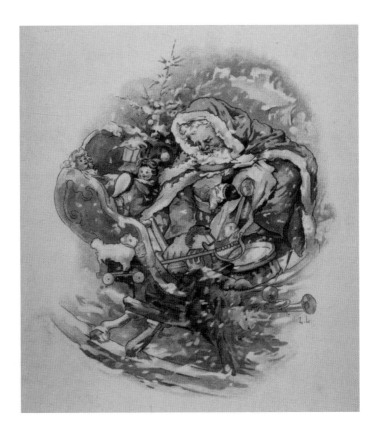

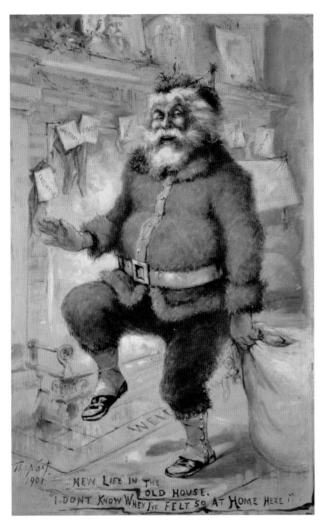

Former president Theodore Roosevelt (American, 1858-1919), celebrated Christmas in his magnanimous style.

In 1902, the Roosevelt family was celebrating a second Christmas in residence at the White House. President Theodore Roosevelt writes of the festivities on December 26, to James Abram Garfield, grandson of former president James A. Garfield: "Yesterday morning at a quarter of seven all the children were up and dressed and began to hammer at the door of their mother's and my room, in which their six stockings, all bulging out with queer angles and rotundities, were hanging from the fireplace. So, their mother and I got up, shut the window, lit the fire (taking down the stockings of course), put on our wrappers and prepared to admit the children. Then all the children came into our bed and there they opened their stockings. Afterwards we got ready and took breakfast, and then all went into the library where each child had a table set for his bigger presents. Quentin had a perfectly delightful electric railroad which had been rigged up for him by one of his friends, the White House electrician, who has been very good to all the children Then all our family and kinsfolk and Senator and Mrs. Lodge's family and kinsfolk had our Christmas dinner at the White House, and afterwards danced in the East Room, closing up with a Virginia reel." (Excerpt: Letter of 1902, Library of Congress, Manuscript Division).

In 1903, Theodore Roosevelt wrote to his sister Corinne: "I wonder whether there ever can come in life a thrill of greater exaltation and rapture than that which comes to one between the ages of say six and fourteen, when the library door is

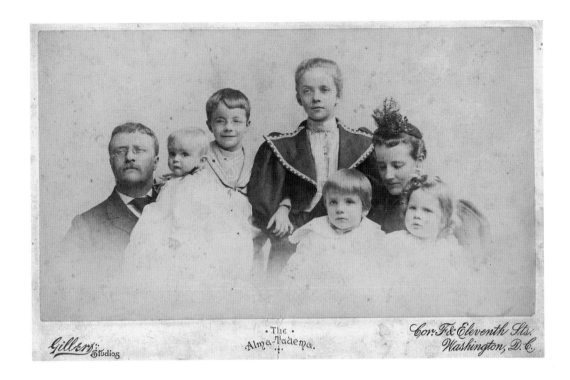

·The·
Alma-Tadema.

Gillers Studios

Cor. F & Eleventh Sts.
Washington, D.C.

thrown open and you walk in to see all the gifts, like a materialized fairyland, arrayed on your special table?"

The 32ⁿᵈ president of the United States - Franklin Delano Roosevelt (American 1882-1945) - read *Twas The Night* to his children and grandchildren on Christmas Eve, continuing this custom during the Christmas' the family spent at the White House. Eleanor Roosevelt (American 1884-1962) wrote *Christmas: A Story*, a fictional tale about a young Dutch girl's struggle to find strength after her father is killed during W.W. II. – "ST. NICHOLAS EVE, 1940, was cold and the snow was falling. On the hearth in Marta's home there was a fire burning . . . " Eleanor Roosevelt wrote: "The times are so serious that even children should be made to understand that there are vital differences in people's beliefs which lead to differences in behavior." A collection of her writings on Christmas; *Eleanor Roosevelt's Christmas Book* (Dodd, Mead, 1963) was published posthumously.

CREDITS: Page 200: Artist - Thomas Nast (German, 1840-1902 American) *New Life in the Old House. Don't Know when I've Felt so at Home Here.* (The drawing expressed the excitement of having a young family living in the White House.)
Page 201: Theodore and Edith Roosevelt with their children, Archibald, Theodore III, Alice, Kermit, and Quentin. Photograph, Gilbert Studios, ca. 1894.
Pages 202/203: *Illustrated News of London*, London, England, and NY, December 1892

NOTE: The Theodore Roosevelt family held a pew at the St. Nicholas Collegiate Church (Reformed Church of America) located in Manhattan, NY. The church had been erected in 1872, replacing a church built on the site in 1847. On his death in 1919 T. Roosevelt was memorialized there. The church was demolished in 1949, with the land leased to the Rockefeller Center.

CHAPTER 11

Spreading the News

"Nineteen newspapers, of which eight were dailies, together with several monthly and occasional publications, entertained New York in 1807. The expansion of the press during the eventful years since the adoption of the constitution of the State, when the editor of an almost solitary newspaper was content to the be compositor, pressman, folder, and distributor, and considered himself doing a fair business if he sold three to four hundred. It should furthermore be observed that art and literature could hardly be said to have an existence in New York in 1807. Through the suggestion of Chancellor Livingston, a subscription had been opened in 1801 for raising means to purchase statues and paintings for the instruction of artists, and a Fine Art Society was finally organized in 1802. A school for drawing and painting had been successfully taught by Robertson for some years. But it was not until February 13, 1808, that an act of the Legislature incorporated the American Academy of Fine Arts. Emperor Napoleon presented to the academy valuable busts, antique statues, twenty-four large volumes of Italian prints and several portfolios of drawings; he was made an honorary member There was also no dearth of literary talent in the city, but it had been almost exclusively directed to political subjects, and to organizing theories and testing untried institutions." - *The History of the City of New York: its Origin, Rise, and Progress:* Martha J. Lamb (1829-1893) Mrs. Burton Harrison (1843-1920). A.S. Barnes, NY.

American publishing flourished in the last decade of the 19th century, a result of population growth, higher literacy rates, with advances in printing technology and through more efficient distribution channels. Many artists entered the field of illustration during this era and some of the most iconic editions of the poem were produced during the early years of the 20th century.

By 1903, *Ladies Home Journal* became the first American magazine with a readership of a million, followed by *Collier's Once A Week* whose subscription base climbed to one million by 1917. At the turn of the century 11,000 magazines and periodicals were being published in America. By 1910, all magazine covers were being printed in full color. The Christmas issues displayed holiday images often inspired by the poem or that depicted Santa Claus. These covers were prestigious, and publishers were able to attract the great talents of the era including Norman Rockwell, N.C. Wyeth, Jessie Willcox Smith, and Joseph Leyendecker to work for their publications.

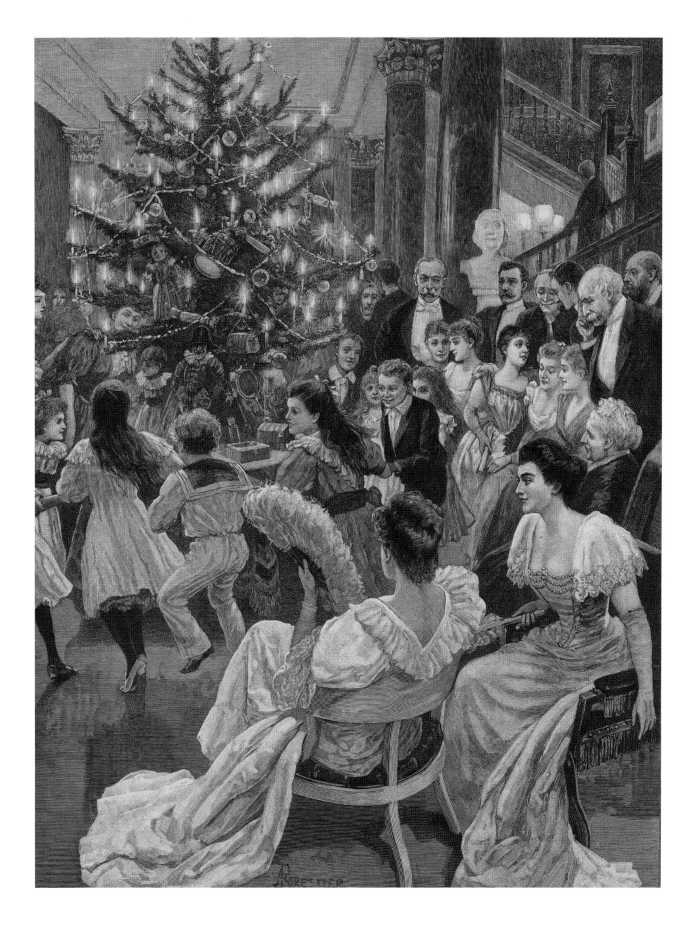

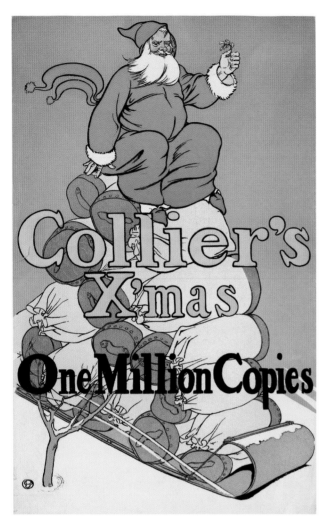

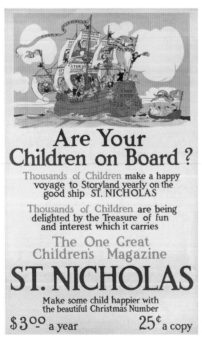

Many publications produced during the early 1900s created special pages for "little folk"; printing *Twas The Night* along with original Christmas stories in their holiday issues. *The Evening Star* of Washington D.C. for Christmas of 1902 published *The Life and Adventure of Santa Claus* written by L. Frank Baum, with an illustration by Mary Cowles. *A Kidnapped Santa Claus*, also written by L. Frank Baum, was published in 1904, with illustrations by Frederick Richardson. *Ladies' Home Journal* for Christmas 1910 issued a one-page board game which incorporated *Twas The Night*, created by Esperanza Gabay. Grace Drayton illustrated sixteen scenes that were to be used to perform a play of the poem that was printed in the December 1913 issue of *Pictorial Review Magazine*. (Drayton created the Campbell Soup Kids in 1904). *Ladies' Home Journal* in December 1914 published a game using a cut out paper doll based on the poem created by artist Mary A. Hayes.

St. Nicholas Magazine For Young People, Scribner's nationally distributed monthly magazine was published between 1873 - 1940. The magazine's editor Mary Maples Dodge wrote of her choice of name for the magazine in the premier issue: "Is he not the boy's and girls' own Saint, the especial friend of young American?... And what is more, isn't he the kindest, best, and jolliest old dear that ever was known? He has attended so many heart-warmings in his long, long day that he glows without knowing it, and, coming as he does, at a holy time, casts a light upon the children's faces that lasts from year to year. Never to dim this light, young friends, by word and token, to make it even brighter, when we can, in good, pleasant helpful ways, and to clear clouds that sometimes shut it out, is our aim and prayer."

The *Saturday Evening Post* went to press in 1821, operating with the presses and in the premises of

Benjamin Franklin's original printshop – *The Pennsylvania Gazette* (1729). In 1897, the *Post* with a subscription base of 2,000 was acquired by publisher Cyrus Curtis who saw potential for the publication. He initiated an innovative advertising business model, included color images on every page, and increased the paper's format and page count to accommodate more color images. He hired the top writers and illustrators of the day. By 1920, the *Post* had the highest subscriber base of any American magazine' and by 1937 the publication had become the largest selling weekly magazine in the world.

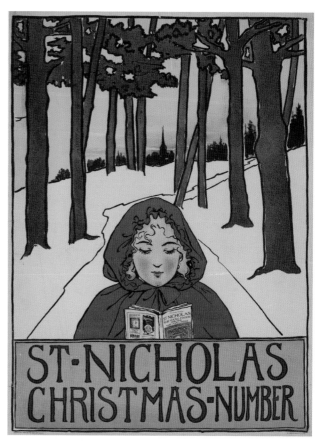

CREDITS: Page 205: Artist – A. Forestier. *The Merry-Go-Round* (*The Illustrated London News - Christmas Number,* NY,- edition, Ingram Brothers, 1892).

NOTES: Between 1870-1900 the population of the United States tripled and between 1860 and 1910 the country's urban population had grown from six to forty-five million.

In the 1890s, the term *Knickerbocker* was a reference to four hundred New Yorkers, whose names appeared on *Ward McAllister's* index of the "best families in New York" published to the *New York Times*. Clement Clarke Moore (1843-1910) son of C.C.M.'s eldest son Benjamin Moore, made the list along with his wife in 1892. The list also accounted for the number invited to attend the Astor's celebrated balls. Clement Clarke Moore (1843) had fought in the American Civil War for the Union Army and was an architect in the city of New York.

CREDITS: Page 206: Artist - Edward Penfield (American, 1866-1925) *Collier's Xmas* – magazine cover, 1917.
Bottom: Boston Public Library, 1890-1910.
Page 207: Artist - Frank Berkeley, *St. Nicholas For Young People* – magazine cover; *Little Red Riding Hood,*1869. Library of Congress.
Bottom image: *Santa on Sleigh*, 1890. Boston Public Library.

NOTES: Edward Penfield was the art director and staff illustrator for Harper's from 1890 to 1901. Penfield designed covers to standout on newsstands, using strikingly simple and bold shapes - including for his Santa Claus figures.
Mary Maples Dodge authored the novel *Hans Brinker, or the Silver Skates: A Story of Life in Holland* in 1865.
Author E.B. White (American, 1899-1985) wrote of the influence of *St. Nicholas For Young People*: "The fierce desire to write and paint that burns in our land today, the incredible amount of writing and painting that still goes on in the face of heavy odds, are directly traceable to St. Nicholas (magazine)." E.B. White wrote *Charlotte's Web* in 1952.

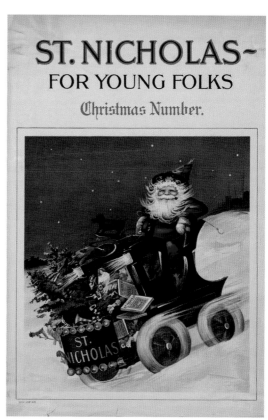

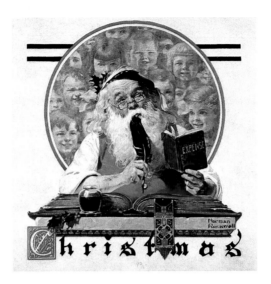

CREDITS: Artist - Norman Rockwell (American, 1894-1978). *Santa and His Expense Book*, (*Saturday Evening Post*, 1920).
Artist - Joseph Leyendecker (German,1874-1951 American). *Christmas Prayers* (*Saturday Evening Post*, December 1921).
Page 209: Poem: Edgar A. Guest (English, 1881-1959 American). *The Christmas Gift for Mother*, published in *When Day Is Done* (The Reilly & Lee Co., U.S.A.,1921).

NOTE: In 1916, Guest's *A Heap O' Livin'*, a collection of verses, sold over one million copies.

Joseph Leyendecker was one of the most popular illustrators of the early 20ᵗʰ century and lived a luxurious lifestyle that embodied the *Roaring Twenties*. The artist created over 400 magazine covers from 1896 to 1950, with 322 for the *Post*. In 2017, Lance Ringel wrote *In Love With the Arrow Man* dramatizing the life of Leyendecker and his partner and muse Charles Beac.

In 2021, the *Saturday Evening Post* marked its bicentennial. The publication's website is an excellent resource, with a section entitled - *The Best Santa Covers Ever* of particular interest.

THE CHRISTMAS GIFT FOR MOTHER

In the Christmas times of long ago,
There was one event we used to know
That was better than any other:
It wasn't the toys that we hoped to get,
But the talks we had – and I hear them yet –
Of the gift we'd buy for Mother.
If ever love fashioned a Christmas gift,
Or saved its money and practiced thrift,
'Twas done in those days, my brother –
Those golden times of Long Gone By,
Of our happiest years, when you and I
Talked over the gift for Mother.
We haven't gone forth on our different ways
Nor coined our lives into yesterdays
In the fires that smelt and smother,
And we whispered and planned in our youthful glee
Of that marvelous "something" which was to be
The gift of our hearts to Mother.
It had to be all that our purse could give,
Something she'd treasure while she could live,
And better than any other.
We gave it the best of our love and thought,
And. Oh, the joy when at last we'd bought
That marvelous gift for Mother!
Now I think as we go on our different ways,
Of the joy of those vanished yesterdays.
How good it would be, my brother,
If this Christmastime we could only know
That same sweet thrill of the Long Ago
When we shared in the gift for Mother.

CHRISTMAS DAY

WITH ITS EVER NEW STORY OF HAPPINESS
HAS ALWAYS BEEN FIRST IN THE HEARTS OF
YOUNG AND OLD, OF RICH AND POOR ALIKE.
FRUGALITY THROUGH THE YEAR WILL ENABLE
YOU TO MAKE A FULL PACK FOR SANTA CLAUS
AND BRIGHTEN THE GREAT DAY FOR SOMEONE.

Come, sing a hale heigh-ho
 For the Christmas long ago!
When the old log-cabin homed us
 From the night of blinding snow,
 Where the rarest joy held reign,
 And the chimney roared amain,
With the firelight like a beacon
 Through the frosty window pane.
 Ah! the revel and the din
 From without and from within,
The blend of distant sleigh-bells
 With the plinking violin;
 The muffled shrieks and cries
 Then the glowing cheeks and eyes
The driving storm of greetings,
 Gusts of kisses and surprise.

- JAMES WHITCOMB RILEY (American, 1849-1916)

Newell Convers Wyeth (American, 1882-1945), professionally known as N.C. Wyeth, studied with Howard Pyle at the Drexel Institute and is considered one of the greatest illustrators of the 20th century. He did not illustrate an edition of *Twas The Night*, however he drew inspiration from the poem for his Santa Claus paintings, which were published on the covers of magazines and used in advertisements. On December 1, 1925, his painting - *Twas The Night Before Christmas*, appeared on the cover of the *Saturday Evening Post*.

Prior to the artist's tragic death in 1945, he had been working on a composition of the pilgrim's arrival at Plymouth. His son Andrew Wyeth, a prominent American artist of the 20th century, assisted by John McCoy completed the painting. The Brandywine River Museum has an extensive collection of N.C. Wyeth's work. Andrew Wyeth's only Christmas themed painting, a watercolor on card stock 3⅜ x 5.5 inches *Open Window*, depicts a striped stocking hung from a bedpost beside an open window.

CREDIT: Page 210: Artist - N.C. Wyeth (American, 1882-1945). *Christmas Day*, 1921, oil on canvas. N.C. Wyeth Papers, 1904-1995. Digital image courtesy of the Helen Farr Sloan Library & Archives, Delaware Art Museum.

NOTES: The Cantebury Company of Chicago commissioned the painting *Christmas Day* as an advertising poster in 1921. Decades later the company's CEO Charles Frey could not account for the location of the original artwork.

Christmas Ship in Old New York painted by Wyeth appeared in the *Post* for December 8, 1928. The work was a commercial commission for the *Interwoven Stocking Company*.

N.C. Wyeth illustrated James Fenimore Cooper's *The Last of the Mohicans* in 1919 and his novel *The Deerslayer* in 1925. He illustrated Washington Irving's *Rip Van Winkle* in 1921. Wyeth illustrated more than 112 books, 25 of which were for Scribner's Classics, and created over 3,000 paintings throughout his career.

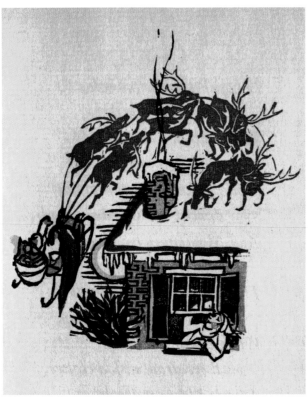

Popular illustrated editions of *Twas The Night* in the early decades of the 20th century included the 1902 edition illustrated by W.W. Denslow and Jessie Willcox Smith's 1912 edition.

Margaret Evans Price (American, 1888-1973) illustrated the poem for the Stecher Lithograph Company of New York, issued with the title *The Night Before Christmas*, in 1917. Margaret Evans Price and her husband Irving Lanouette Price co-founded the Fisher-Price Toy Company located in East Aurora, New York in 1930.

Florence Wyman Ivins (American, 1881-1948) provided three color woodcuts for a 1921 edition of the poem for the limited-edition publication, designed by Bruce Rogers. Ivins was the first women to have a solo exhibition at the Metropolitan Museum of Art in New York, NY, exhibiting at the museum in 1921.

Helen Chamberlin (American, n.d.) illustrated an edition of the poem in 1921.

Frances Brundage (American, 1854-1937) created images for the poem in 1922 for Saalfield Publishing Company of Akron, OH. Illustrators of editions post 1930 are presented in Chapter 14 of this publication.

CREDITS: Page 212: Artist – Helen Chamberlin. *The Night Before Christmas* (M.A. Donohue & Company, Chicago, IL, ca.1920). Top image. Rare Book – *Nancy H. Marshall Collection*, Special Collections Research Center, William & Mary Libraries.
Artist - Florence Wyman Ivins. *A Visit From St. Nicholas* (*Atlantic Monthly Press*, Boston MA, 1921). Bottom image. Courtesy of *Archives and Special Collections*, Davidson College.
Page 213: Artist -William Wallace Denslow (American, 1856-1915). *Denslow's Night Before Christmas* (G.W. Dillingham Co., Publishers, NY, 1902). Heinemann of London published a 1903 edition. Rare Book – *Nancy H. Marshall Collection*, Special Collections Research Center, William & Mary Libraries.

NOTE: Postcard artist and publisher Ellen Clapsaddle (American, 1865-1934) popularizing a cheerful, grandfather styled Santa Claus in the early 20th century. More than 500 million postcards were produced of her work.

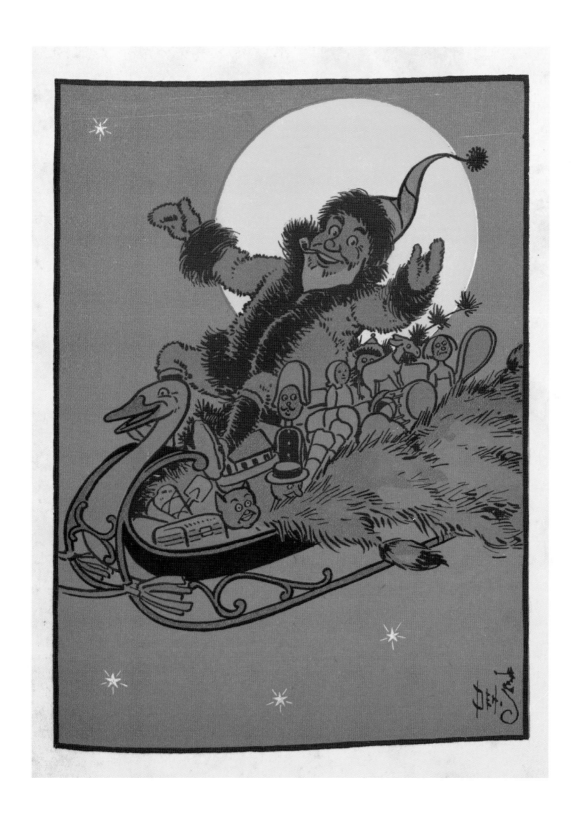

William Wallace Denslow was the original illustrator of L. Frank Baum's 1900 - *The Wonderful Wizard of Oz*. Denslow incorporated characters from the Oz story, along with others from *Mother Goose Nursery Rhymes*, in his illustrations for *Twas The Night* published in 1902. In Baum's book *The Road to Oz* (1909), Santa makes a guest appearance.

Jessie Willcox Smith (American, 1863-1935) trained at the Philadelphia School of Design for Women, then at the Philadelphia Academy of the Fine Arts before joining Howard Pyle's class at the Drexel Institute. In 1897, Pyle arranged for Smith and fellow student Violet Oakley to collaborate on illustrations for Henry Wadsworth Longfellow's *Evangeline*, which launched both woman's careers. Smith would go on to illustrate 60 additional books throughout her career, including *Dicken's Children*, *Little Women*, and *Heidi*. In 1912, she created twelve illustrations for an edition of *Twas The Night*. The edition is still available in a reprinted format and remains a popular edition. Smith illustrated *When Christmas Comes Around* by Priscilla Underwood in 1915.

Smith illustrated for many periodicals throughout her accomplished career including for *Century*, *Collier's*, *Leslie's Weekly*, *Harper's*, *McClure's*, *Scribner's*, *Ladies' Home Journal*, *St. Nicholas Magazine*, and *Good Housekeeping*.

"Her (Jessie Willcox Smith's) eventual tenure as cover illustrator for *Good Housekeeping* lasted 15 years (1917-1933), featuring her idyllic imagery of childhood on nearly 200 covers for the publication, which reached millions of households across America." - *theillustratorsgallery.com*.

In 1991, Jessie Willcox Smith became the second woman to be inducted into The Hall of Fame of the Society of Illustrators. Smith bequeathed fourteen original works to the Library of Congress and are part of a collection that documents the Golden Age of American Illustration.

CREDIT: Page 215: Artist - Jessie Willcox Smith, *Twas The Night Before Christmas: A Visit From St. Nicholas*. (Houghton Mifflin Company, printed by Riverside Press, Cambridge, MA, October 1912).

NOTE: Smith wrote that Pyle " . . . swept away all the cobwebs and confusion that so beset the path of the art-student.": *Report of the Private View of Exhibition of the Works of Howard Pyle at the Art Alliance* (1923). Smith's work with *Good Housekeeping* magazine included illustrations for a long running *Mother Goose* series.
A facsimile reproduction of the 1912 edition released in 2003 reproduced an interior image from the original edition, depicting a parade of children for the cover. The original cover artwork for the 1912 edition depicts Santa with two children.

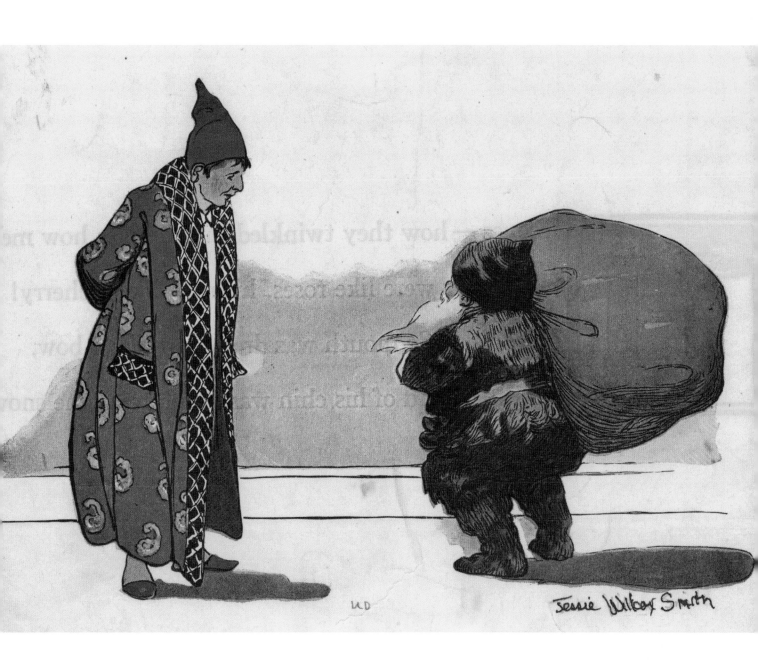

Several images reproduced in this publication remain unidentified, although efforts were made to source the artist.

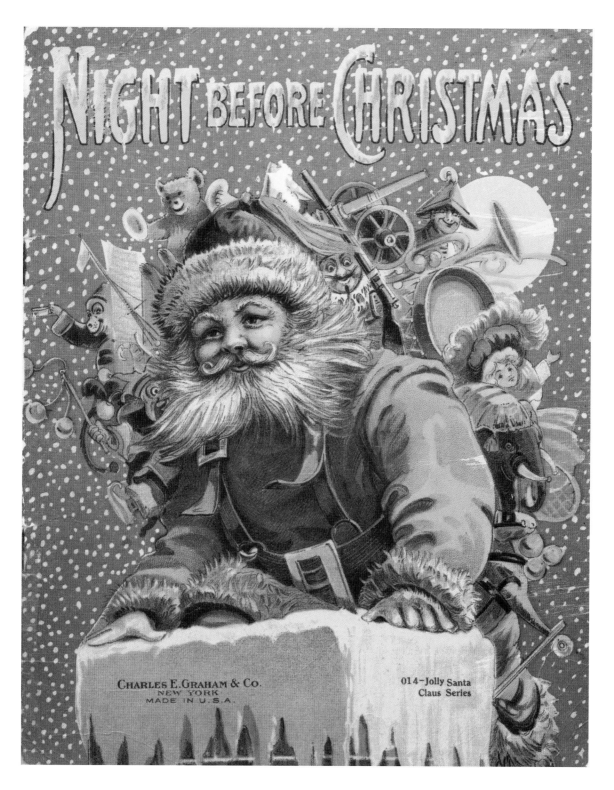

Twas The Night continued to inspire both writers and artists throughout the 20th century, as it had in the previous decades, resulting in the Santa Claus character taking on a broader persona and becoming ever more an icon at the center of American culture.

1922 - *The Boy Who Lived in Pudding Lane*, written by Sarah Addington (American, 1891-1940), published by *The Atlantic Monthly Press* of Boston in 1922, was illustrated by a premier illustrator of the Golden Age - Gertrude Kaye (American, 1884-1939). Addington's story tells of a young Santa and his family who live in Pudding Lane. Santa and his sibling's grandmother is Mother Goose. Santa sets off for the North Pole after his marriage to the candlestick maker's daughter with the help of King Cole.

1939 - *Rudolph the Red-Nosed Reindeer* first appeared in a booklet form written by Robert L. May and illustrated by Denver Gillen. The department store - Montgomery Ward, originally published the booklet. Distributing 2.4 million copies in the first year. May wrote *Rudolph* in the same anapestic tetrameter as *Twas The Night*. The television adaptation of the story first aired in 1964.

1957 - *How the Grinch Stole Christmas,* written and illustrated by Dr. Seuss, was published by Random House. The story also appeared in the January 1, 1957, issue of *Redbook* magazine. The *Grinch* was made into a movie for television in 1966, a live action film in 2000, and in 2018 it was made into an animated feature film.

1968 – *The Christmas Santa Claus Almost Missed,* published in the December issue of *Family Circle* was written and illustrated by Garth Williams (American, 1912- 1996). Williams illustrated E.B. White's *Charlotte's Web* and *Stuart Little*, and Laura Ingall's *Little House on the Prairie* series of books. Williams did not illustrate an edition of *Twas The Night.*

2019 - *Dasher: A Brave Little Doe Changed Christmas Forever* written by Matt Tavares tells the story of young Dasher who sets off to find her destiny and meets up with Santa Claus.

1942 - Ken Darby set the lines of the poem to music for a recording of a Fred Waring and the Pennsylvanias performance.

1952 - Johnny Marks composed *The Night Before Christmas Song,* which Burl Ives sung for a Columbia Records recording. The song was included in the 1964 television special based on Robert L. May's 1939 story *Rudolph the Red-Nosed Reindeer.*

1992 - The first complete musical rendition of the poem, using the lines as written was composed by Lucian Walter Dressel.

A ballet adaptation of *Twas The Night*, performed by Providence Ballet Theatre of Providence, RI, has become an seasonal favorite event for fans of the poem and of dance. The Strand Theatre in NYC, in collaboration with the New York Dance Project, and regional companies have also mounted ballet performances inspired by the festive lines.

CREDITS: Pages 218-219: Artist - Unidentified by original publisher (Raphael Tuck & Sons, Ltd., NY, London, Paris, 1901).

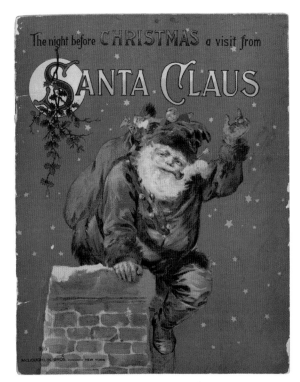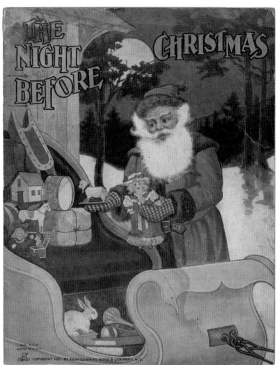

New characters have been introduced to editions of the poem, including teddy bears, mice, and other animal figures:

The Teddy Bear's Night Before Christmas, by Jill Wolff, illustrated by Jean Rudegeair (Antioch Publishing Company, Ohio, 1985).

The Teddy Bear's Night Before Christmas, photo illustrations by Monica Stevenson (Scholastic, Inc. NY, 1999).

Disney's Winnie the Pooh's Night Before Christmas (Random House, NY, 1998). A version based on the characters created by A.A. Milne - " 'Tis the night before Christmas, and Pooh and Piglet are waiting for a very special guest."

The Night Before Christmas as an animated short film based on the work of illustrator Mary Englebreit, narrated by Kevin Kline was released in 2014. The dramatization keeps all the words of the original poem, along with an additional story of a mouse who overhears a fairy planning to keep Santa from coming.

The Mice Before Christmas: A Mouse House Tale of the Night Before Christmas by Anne L. Watson, illustrated by Wendy Edelson (Skyhook Press, 2021). Wendy Edelson illustrated the child's storybook, *The Baker's Dozen: A Saint Nicholas Tale* written by Aaron Shepard (Atheneum, NY, 1995, reissued by Skyhook Press in 2018).

The Night Before Christmas, illustrated by Cyndy Szekeres (Golden Books, NY, NY, 1982). The illustrations feature animal characters with childlike personalities. *Cyndy Szekeres' Christmas Mouse*, written and illustrated by Szekeres was released by Western Publishing of Racine, WI, in 1995.

T'was the Mice Before Christmas written by Diana Kanan, illustrated by Chiara Corradett (DLK Publishing, London, 2019).

A cat lovers' version was written by Pam Rousell in 2018 titled; *Twas The Night Before Christmas: A Cat Poem.*

CREDITS: Page 220: Artist - Unidentified by original publisher. *The Night Before Christmas: A Visit from St. Nicholas,* (McLoughlin Bros., Inc., NY, 1899). Rare Book – *Nancy H. Marshall Collection*, Special Collections Research Center, William & Mary Libraries.

Artist - Alfred E. Kennedy, *The Night Before Christmas* (Gabriel Sons & Company, NY, 1911). Rare Book – *Nancy H. Marshall Collection*, Special Collections Research Center, William & Mary Libraries.

Page 221: Artist and author – L.J. Bridgman, *Mother Wild Goose and her Wild Beast Show, The Santa Claus Rat,*1900. Courtesy the Library of Congress.

In 1981, pop artist Andy Warhol included Santa Claus in his *Myths* series. *Santa Claus* joined other American cultural icons including *The Star, The Witch, Howdy Doody, Uncle Sam, Superman, Mammy, Dracula, The Shadow,* and *Mickey Mouse.*

The poem has been dramatized in a variety of formats and produced for the stage, the screen and for television.

Santa Claus Filling Stockings (1897, USA) presents the first film images inspired by the poem. Followed by *Santa Claus* (1898, UK) and *The Night Before Christmas* (1905, USA), produced by Edwin S. Porter. The seven-minute silent film is accessible on *YouTube*. Script adaptations of the poem include the 1906 – *The Night Before Christmas: A Play for Young People,* by Alice E. Allen, the 1910 – *The Night Before Christmas: A Play in Three Acts,* by William Patterson Taylor, the 1947 – *Twas The Night Before Christmas: A Comedy in One Act,* by Leslie Manners, the 1951 – *Twas The*

Night Before Christmas: A One-Act Play, by Lee Hendry, and the 1956 – *The Noel Candle: A Christmas Play in One Act*, by Ruth Fuller.

Twas The Night Before Christmas, 1953 Puppet Show, a production with a reading of the poem and dramatized with puppets on film is accessible on *YouTube*. *Twas The Night Before Christmas*, a short, animated film with voice-over by actor Joel Grey was released in 1974.

Twas The Night Before, a seasonal Cirque du Soleil show that "reimagined" the poem premiered at the Chicago Theatre on November 29, 2019, in Chicago, IL.

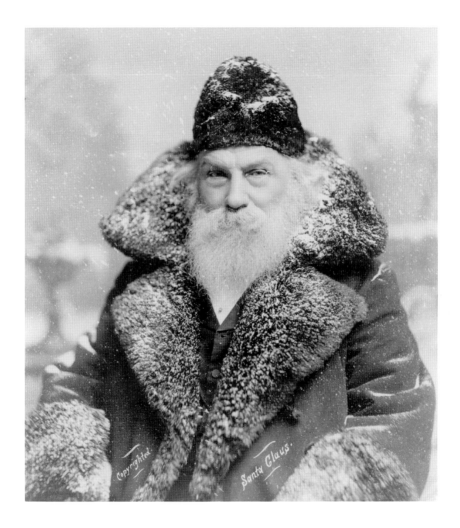

CREDIT: Page 222: Artist - Andy Warhol (American, 1928-1987), *Santa Claus*, 1981 from the *Myths* portfolio, screenprint with diamond dust on Lenox Museum board, *38 x 38* inches. Courtesy Ronald Feldman Gallery, New York. Copyright The Andy Warhol Foundation for the Visual Arts/Artists Rights Society (ARS), New York/Ronald Feldman Gallery, New York/ SOCAN.

Page 223: Artist unidentified. *Man portraying Santa Claus* (1895). Library of Congress.

A Xmas Story
By Sir Gilbert Parker

PRICE 15 CENTS

Two Xmas Songs
By Reginald DeKoven

The Circle

Xmas
1907

FUNK & WAGNALLS COMPANY
PUBLISHERS
NEW YORK and LONDON

CHAPTER 12

The Silver Lining

George Bernard Shaw stated: "Christmas is simply a nuisance. The mob supports it as a carnival of mendacity, gluttony, and drunkenness. Fifty years ago, I invented a society for the abolition of Christmas. So far, I am the only member. That is all I have to say on the matter." – *Reynolds News*, 1946.

The editor countered with a reply: "Mr. Shaw's campaign has met with serious obstacles. The public reads his books and went to his plays, but they read Dickens, too. They couldn't be made to stop singing carols, lighting up Christmas trees, making presents, and feeling more than usually amiable toward their relatives, friends, and the world in general. Many of them paid attention to Mr. Shaw's ideas about other things, including vegetarianism and Fabian socialism, but they would not pay attention to his ideas about Christmas. His failure is as apparent to him as it is to the rest of us." – *Reynolds News*, 1946.

In the 1990s, an anti-Santa Claus campaign, supported by members of the German and Dutch community, was launched to protect the tradition of St. Nicholas. There was growing concern that the traditions of St. Nicholas were facing strong competition from a commercialized and predominately North American Santa Claus. A Dutch country band released a song composed to embody the theme of the campaign with the lyrics directing Santa Claus to head back to the USA. Posters were put up at markets and in shop windows with the image of Santa Claus covered with an "x". Buttons were handed out for people to share the message that Santa Claus was not welcome. All of this was done with the hopes of keeping Santa Claus and his reindeer away – at least until St. Nicholas Day had been celebrated.

Santa Claus has been adopted by commercial entities to sell everything from furnaces to socks. The Christmas retail season in North America begins months before Santa's arrival on Christmas Eve. The silver lining in the massive, global marketing of the character Santa Claus from *Twas The Night* has been to the benefit of the poem. It has been publicized throughout the world. The poem has been translated into many languages.

CREDIT: Page 224: Artist – Joseph Leyendecker (German, 1874-1951 American), *The Circle* – cover, December 1907.

NOTE: *Erev Krismes* - a Yiddish translation of *Twas The Night* by Marie B. Jaffe, was broadcasted by NPR on November 28, 2021.

Entered according to Act of Congress, in the year 1868, by the United States Confection Company, in the Clerk's Office of the District Court of the United States for the Southern District of New York.

In 1887, Peoria, Illinois held the first Santa Claus Parade in the United States, with decorated boats sailing down the river. The parade moved to main street Peoria the following year in an expanded format with sponsorship provided by Schipper and Block Department Store.

The first Macy's Christmas Parade was held in 1924 featuring Santa Claus, floats, bands, and animals on loan from the Central Park Zoo, NY. The parade route finished at Macy's department store at 34th Street and Broadway in New York City. In 1927, giant helium balloons replaced the live animals who had been found too frightening by some of the young parade watchers. The parade was broadcasted on television for the first time in 1945. In recent years, the parade has featured the famous giant character balloons, hundreds of clowns, and marching bands, performance groups, and Santa Claus. Christmas parades are held in cities to celebrate the opening of the Christmas season with Santa Claus - the featured star with his sleigh and team of reindeer.

The first Toronto Santa Claus Parade was held in 1905, sponsored by Eaton's Department Store Toronto, Ontario, Canada. It continues to be one of the largest Santa Claus parades held.

No Christmas is complete for the Kiddies without good candy, and when one thinks of good candy one must think of Loft.

Wishing you the Season's Greetings.

Loft, Inc.
G. W. Loft
President

James Edgar, the owner of a dry good store in Brockton MA, became the first department store Santa Claus when he outfitted himself in a custom costume and made his appearance in his store for Christmas 1890. The next year the idea of attracting shoppers with a meet and greet with Santa had spread to other cities.

In the 1920s Brockton fell on hard times and when the President of Edgar's Department Store learned that hundreds of children living in the town were unable to attend school because they did not have suitable footwear, he decided to act. He converted a floor of Edgar's to the manufacturing and repairing of shoes and within a few months, the James Edgar Shoe Shop – named in honor of the man who not only realized a good marketing strategy but took great pleasure in bringing delight to the faces of children at Christmas, provided over 5,000 pairs of shoes, all free of charge to the children of Brockton.

CREDIT:Page 228: Rare Book – *Nancy Marshall Collection*, Special Collections Research Center, William & Mary Libraries.
Page 229: *White Rock Mineral Water and Ginger Ale Santa Claus Ad*, 1923.

NOTES: In 1842, *The Albany Evening Journal* printed an advertisement with an image of Santa Claus that had appeared in *The New York Mirror* in 1841. (See page 160 in this publication). Printed on *St. Nick's* pack: "*From Pease's/50 Broadway*". Beneath the image reads: "*Santa-Claus — in the act of descending a chimney to fill children's stockings, after supplying himself with fancy articles, stationary, cutlery, perfumery, games, toys, etc. at Pease's Great Variety Store, No. 50 Broadway….*"

The first explicit ad for Christmas presents found in the United States is from Salem, Massachusetts, dated 1806. Documented by Stephen Nissenbaum, *The Battle for Christmas*, 1996.

In the 1920s, the producers of the popular summer "pop" beverages were interested in developing a year-round market. Coca-Cola placed their first Christmas ad in the *Saturday Evening Post* for Christmas 1922, featuring a bottle of Coca-Cola and customers ordering a case, but no sign of Santa Claus.

"For all the Santa credit Coca-Cola might deserve, they were not the first soda to depict a jolly Santa figure enjoying a fizzy beverage! White Rock, who marketed a sparkling mineral water and Ginger Ale, ran a Santa Claus ad in *Life Magazine* in 1923 Interestingly, Santa also has an opened bottle of Whiskey on his desk during the height of prohibition!" – ERIC TROY, *Was Coca-Cola the first Soda to use Santa in Advertisements?*, *Culinary Lore*, 2019.

Commercial illustrators were hired by both Cola-Cola and other companies to create a suitable Santa Claus for their campaigns.

In the 1930s Coca-Cola mounted an advertising campaign to market their beverage products to be enjoyed year-round. They selected Fred Mitzen to create a Santa-themed image for the campaign, who painted a department store Santa character in front of the world's largest soda fountain machine at Famous Barr Co. in St. Louis MO. Fred Mitzen was followed by Haddon Sundblom (American, 1899-1976) in 1931. Sundblom relied heavily on the poem *Twas The Night* in the images he created, with his Santa that of a jolly, smiling, and robust figure, dressed in a bright red suit trimmed with white fur, and fastened with a wide black belt that would become the signature of Sundblom's Santa. The Coca-Cola character was repeatedly depicted either drinking or holding a bottle of *Coke*. Sundblom's Santa appeared in Coca-Cola ads from 1931 to 1964. Coca-Cola published an edition of *Twas The Night*, along with other stories with reproductions of the commercial artwork of Hadden Sundblom. *Dreams of Santa, Haddon Sundblom's Advertising Paintings for Christmas, 1931-1964*, text by Barbara Fahs Charles and J.R. Taylor (Gramercy Books, NY, 1992). In *The Night Before Christmas, a Collection of Christmas Stories* (Publications International, Ltd., no pub date specified), a bottle of Coke sits on a fireplace mantel, Santa is shown, with reindeer, drinking the beverage, and a third image shows a cheerful Santa with a beverage in hand.

The company disallowed their brand of Santa to be depicted as smoking. Some families still follow a tradition of leaving a a bottle of Coke for Santa on Christmas Eve, with cookies left out for his reindeer. The Coca-Cola Company exhibits the work of Haddon Sundblom at their museum at the The World of Coca-Cola, in Atlanta, Georgia.

—also *White Rock Ginger Ale*

Christmas advertisements for tobacco products, produced throughout the 20ᵗʰ century until 1998, often featured the image of Santa Claus. Santa Claus was shown carrying a sack full of cigarettes, stuffing stockings with packages of cigarettes and trimming Christmas trees with the products. *The Stanford Research into the Impact of Tobacco* (SRITA) collection, at Stanford University, contains 59,333 tobacco advertisements including the insidious images of the tobacco-Santa.

'Old Joe'- Joe Camel, created in 1974 by the R.J. Reynolds Tobacco Company, came under fire in 1991 when a study released a finding that the character Joe Camel was recognized by six-year-olds as readily as Mickey Mouse. A further study published in the *Journal of the American Medical Association* established that cigarette advertising was inducing minors to smoking. "If the purpose of the ad campaign is to attract adults, then they've missed the boat. But it seems to be pretty successful at targeting children," Dr. Paul Fischer of the Medical College of Georgia told a reporter with the *Chicago Tribune* on December 10, 1991.

"Joe Camel represented an icon that refueled the moral outrage of the anti-smoking movement," Eric Solberg, executive director of Doctors Ought to Care, an anti-tobacco group in Houston, told the New York Times: "On Joe Camel, a Giant in Tobacco Marketing, Is Dead at 23." – Stuart Elliott, *The New York Times*, July 11, 1997. In 1998, the Master Settlement Agreement put into effect a ban on the use of any cartoon characters in the advertising, promotion, packaging or labelling of tobacco products. The ban included the use of the image of Santa Claus or Joe Camel in association with the products.

In 2011, a survey of 1,000 children, seven to thirteen years of age, was conducted by the UK Department of Health. The results of the survey discovered the lengths some children would go to in efforts to get their parents to stop using tobacco products: 59% would give up monetary allowances, 76% would go to bed when told, and 37% offered to give up Christmas presents. The study also found the 54% of children with a parent who smoked said their biggest wish for Christmas was that their Mum or Dad would quit for good.

In 2012, Grafton and Scratch Publishers published a smoke-pipe free edition of the poem: *Twas The Night Before Christmas: Edited by Santa Claus for the Benefit of Children of the 21st Century.* The book was produced to offer children the opportunity of reading the magical poem without the risk of bumping into dear Santa puffing away on a pipe with smoke billowing around his head. The editing of the few words in the poem that pertain to Santa and a pipe became a hotly debated topic. The changes made in this edition were not an act of censorship as thousands of editions that depict or describe a smoking Santa remain readily available without issue.

CREDIT: Artists - Elena Almazova & Vitaly Shvarov, *Twas The Night Before Christmas: Edited by Santa Claus for the Benefit of Children of the 21st Century* (Grafton and Scratch Publishers, 2012).

NOTES: Old Joe was created by British artist Nicholas Price for a French advertising campaign.

"News flash: Santa quits smoking! This version of the famous Christmas poem has one unique feature: The reference to Santa's pipe and the smoke that "encircled his head like a wreath" has been edited out of the text. Purists may decry mucking about with a beloved classic; but plenty of parents might not want to introduce old St. Nick as a smoker. An author attribution on the cover reads, "Edited by Santa Claus for the benefit of children of the 21st century," and a commitment to non-smoking is a legitimate goal in materials intended for children. A clever note to readers from Santa on the back cover flap explains the excision of the smoking text and also affirms in a humorous way that Santa's costume uses only fake fur out of respect for "my dear friends the arctic polar bears." *Kirkus Reviews* 8/2012.

ST. CLAUS

Composed, Lithographed, Printed & Published at MEJINSKY'S Establishment 319 Pearl St. New York.

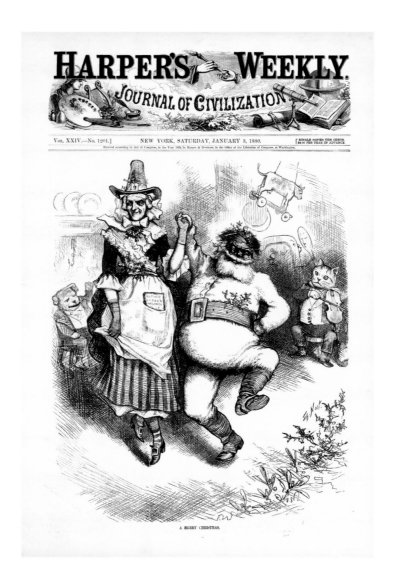

HARPER'S WEEKLY.

JOURNAL OF CIVILIZATION

VOL. XXIV.—No. 1201.] NEW YORK, SATURDAY, JANUARY 3, 1880. [SINGLE COPIES TEN CENTS. $4.00 PER YEAR IN ADVANCE

Entered according to Act of Congress, in the Year 1879, by Harper & Brothers, in the Office of the Librarian of Congress, at Washington.

A MERRY CHRISTMAS.

Popular brands have incorporated their own characters into editions published of the poem.

In 1883, the poem appeared in *Mother Goose's Christmas Original and Selected Holiday Entertainment* by Kriss Kringle, illustrated by Walter Satterlee (White, Stokes & Allen, NY); in 1937 it was published in the *Shirley Temple Christmas Book*, (Saalfield Publishing Company, Akron, OH, 1937); in 1972 McDonalds joined their character with the poem with the *Ronald Mc-Donald Presents The Night Before Christmas*, recording composed by William Goldstein, illustrator unidentified, (McDonalds Corporation, CBS Records, NY), followed by *Jim Henson's Muppet Babies' Christmas Book*, illustrated by Tom Brannon, (Smithmark Publishers, NY, Jim Henson Muppet Book Press Book, 1991); *The Care Bear's Night Before Christmas* adapted by Peggy Kahn, illustrated by Diane Kamm, (Random House, NY, 1985); *Garfield's Night Before Christmas*, written and illustrated by Jim Davis, (Grosset and Dunlop Publishers, NY, 1988), and

CREDITS: Page 232: Artist - S. Merinsky, *St.Claus*, New York, 1872.
Page 233: Artist – Thomas Nast (German, 1840-1902 American) *Harper's Weekly*.

Mickey's Night Before Christmas, illustrator unidentified. (Walt Disney Company, Grolier Enterprises Corporation, 1988).

The Night Before Christmas: Walt Disney Silly Symphony Film, released December 9, 1933, was one of 75 musical short films produced by Walt Disney Productions between 1929 and 1939. A book produced in 1934 from the *Silly Symphony* titled *The Night Before Christmas*, used six lines from the poem with an original story. In 1934, the song *Twas The Night Before Xmas*, written by Leigh Harline for *Silly Symphony*, used lines from the poem along with original lyrics. The poem was included in *A Collection of Songs From Walt Disney's Famous Cartoon Mickey Mouse and Silly Symphony*, published and illustrated by Walt Disney. *McCall's* commissioned Walt Disney to illustrate *Twas The Night* for their December 1941 issue. Disney incorporated many of his characters into the illustrations.

In 2019, Disney released *Frozen: Olaf's Night Before Christmas*, written by Jessica Julius, illustrated by Olga Mosqueda, with a CD featuring a narration of the poem by Olaf. Many other brands and characters have shared the stage with the classic poem.

A Pokémon version of *Twas The Night* was released in 2001 on *Pokémon Christmas Bash* (CD): "Jessie: But I heard him exclaim, as he drove off to the mall: Happy Pokemon Christmas – Catch 'em all, Catch 'em all."

In the 1980s, the United States Supreme Court handed down two landmark rulings regarding the use of religious symbols in displays placed on public property. Under the United States Constitution and the First Amendment, private citizens have the right to display religious symbols on their own property. This right extends to places of worship, but it does not extend to public institutions or public property. Public institutions are governed on such matters by the Establishment Clause. Displays of religious symbols in public spaces are required to have a secular purpose, are not to advance or inhibit religion, and must not associate government with religion.

In 1984, the Supreme Court reversed a lower court decision in a case that had ruled that a municipal display that included a nativity scene, a Santa Claus house, and a Christmas tree was unconstitutional. Chief Justice of the U.S. Supreme Court Warren Earl Burger (1907-1995) wrote on the matter: "It would be ironic if . . . the creche in the display, as part of the celebration of an event acknowledged in the Western World for 20 centuries, and in this country by the people, the Executive Branch, Congress, and the courts for 2 centuries, would so "taint" the exhibition as to render it violative of the Establishment Clause. To forbid the use of this one passive symbol . . . would be an overreaction contrary to this Nation's history."

CREDIT: Page 235: Illustrator Unidentified, *The Night Before Christmas*, (M.A. Donahue & Company, Chicago, IL., 1916). Rare Book – *Nancy H. Marshall Collection*, Special Collections Research Center, William & Mary Libraries.

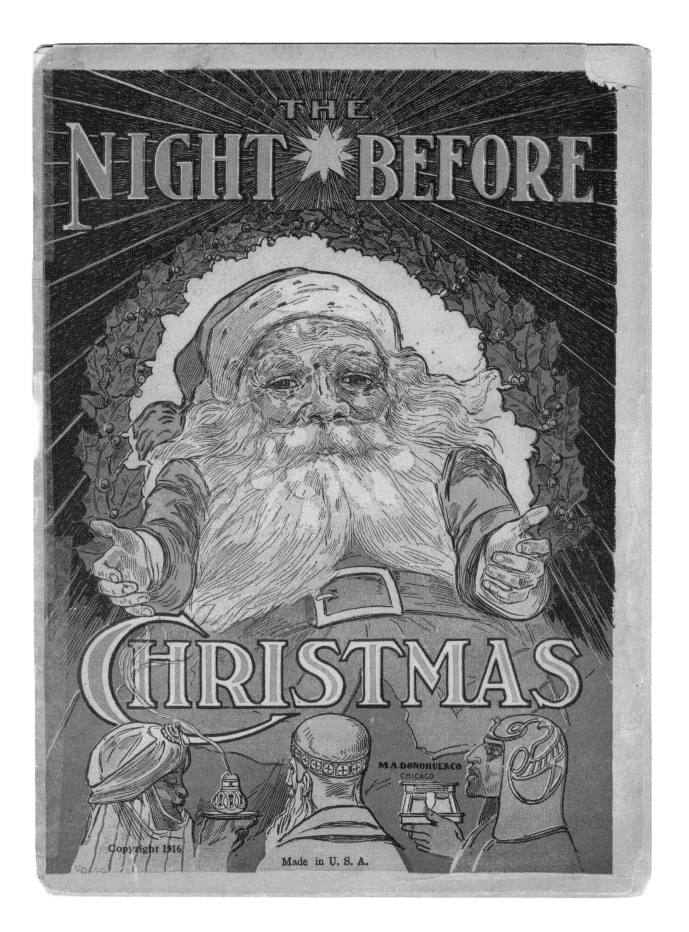

THE NIGHT ✶ BEFORE

CHRISTMAS

M.A.DONOHUE&CO
CHICAGO

Copyright 1916.

Made in U.S.A.

In 1989, a creche on display at a county courthouse was determined to be unconstitutional, however a menorah in the Jewish faith on display alongside of a Christmas tree outside a municipal building was ruled constitutional because of the inclusion of the secular item. In 2018, a high school in Oregon issued an advisory to their teachers regarding the use of secular and non-secular items in school displays: "We will not be holding a door decorating contest this year. You may still decorate your door or office if you like, but we ask that you be respectful and sensitive to our community and refrain from using religious themed decorations or images like Santa Claus."

Christmas songs, including religious themed carols, are permitted under the American Constitution with the caveat that the singing of these songs serves to advance students' knowledge of the country's cultural and religious heritage, and opportunities for students to perform a full range of music, poetry and drama, that is likely to be of interest to the students and their audience, is also offered.

In 1953, Bess Truman as First Lady of the United States, started the tradition of reading *Twas The Night* to children at Christmastime. Since 1954, the Great Hall of the Library of Congress has customarily hosted similar readings to the delight of children.

In 1955, a young boy attempting to put a phone call into Santa Claus mistakenly dialed the Continental Air Defense Command Operations Center of NORAD - North American Aerospace Defense Command in Colorado Springs, CO. The commander on duty at the time instantly recognized the mistake and responded as Santa Claus so as not to disappoint the child. Every year since, NORAD tracks Santa's journey around the globe on Christmas Eve by live feed broadcasted to viewers and is popular with millions of visitors visiting the site annually - from two hundred countries.

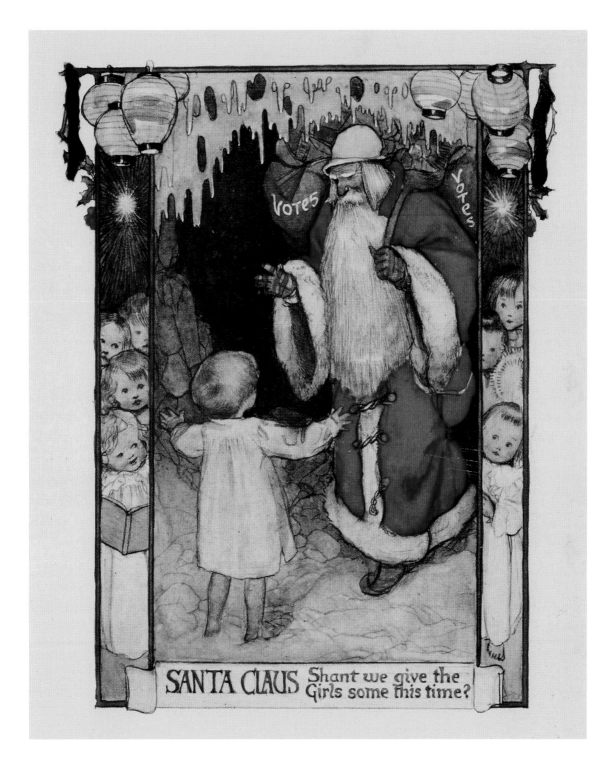

SANTA CLAUS Shant we give the Girls some this time?

CREDITS: Page 236: Artist – John H. Eggers, *The Night Before Christmas,* (John H. Eggers, NY, 1923).

Artist - Joseph Leyendecker (German, 1874- 1951 American) - (*Saturday Evening Post* – cover, December 7, 1918).

Page 237: Artist unidentified. *Santa Claus giving votes to girls* (1910). Public domain.

NOTE: Prince Charles, heir to the British throne and Camilla, Duchess of Cornwall joined with British actors to record *Twas The Night* in 2020, in partnership with the Actors' Benevolent Fund, to help raise money and awareness for the charity amidst the coronavirus pandemic. Actors Ncuti Gatwa, Tom Hardy, Dame Judi Dench, Dame Maggie Smith, Daniel Craig, Joanna Lumley, and Dame Penelope Keith participated.

CHAPTER 13

Poetic License

"That's what we storytellers do, we restore order with imagination. We instill hope again and again and again." - WALT DISNEY

"For so many people, the 'truth' about Santa Claus signifies the end of a child's innocence, yet, it does not have to be that way Mary Poppins, The Little Prince, Santa Claus, and Pooh Bear are not real, but they are still alive in the imaginations of all children. While they are not real, they are nevertheless true. Whether you're reading J.R.R. Tolkien on the *Importance of Fairy Stories* or Bruno Bettelheim's *The Uses of Enchantment*, the function of the fairy tale is to teach developing kids the important qualities of character that could be applied to their own lives. Because they are so bright and huge and unreal, fairy tales help a child with their growth more than history or standard dramas Fairy tales can teach us to be brave, to love, to forgive, to grow, to be part of community There doesn't have to be a complete end of innocence when we lose the belief in Pooh or Santa Claus because the love they represent remains. If we tell or read the tales of the many Clauses like the poets we are, the fancies of childhood shall fade away, but the love endures." – DAVID PAUL KIRKPATRICK

"Beyond myth, beyond dogmas, we look into the eyes of our loved ones, we look to the needs of those who are suffering, we look to the stars in the winter sky, and find there the meaning of Christmas." – REV. FRED SMALL, "How the Unitarians and Universalists Saved Christmas", December 11, 2011.

CREDIT: David Paul Kirkpatrick (American, 1951) *How To Talk To Your Kids About Santa Claus*, December 21, 2018: the goodagemedium. com (Excerpt). Kirkpatrick is an award-winning movie maker and author.

NOTES: Rockwell's painting, *The Night Before Christmas* appeared on the cover of *The Grade Teacher* for December 1946. Rockwell's painting *Santa Looking at Two Sleeping Children* appeared on the cover of the Decca Records 1955 musical rendition of *Twas The Night* by Fred Waring and the Pennsylvanians. *Norman Rockwell's Christmas Book: An Anthology of Christmas Stories and Art*, (Harry H. Abrams, Inc. NY. 1993) included Jessie Willcox Smith's 1912 illustrations of the poem, for Rockwell did not illustrate an edition of the poem. Rockwell's first commission was for a Christmas card in 1911. Rockwell received the Presidential Medal of Freedom, the nation's highest peacetime award in 1977.

"We certainly must not demolish the imagination of children but draw examples from it that are positive for life, so Santa Claus is an effective image to convey the importance of giving, generosity and sharing." – An apology issued in December 2012 by a Roman Catholic diocese in Sicily, Italy, after a bishop was criticized by the public for telling children that Santa Claus was not real. Perhaps the bishop might enjoy Ogden Nash's humorous poem – *The Boy Who Laughed at Santa Claus* - "Donner and Blitzen licked off his paint"!

CREDIT: Artist - Norman Rockwell (American, 1894 – 1978) *The Night Before Christmas (Literary Digest* - magazine cover, Funk & Wagnalls, Company, NY, December 22, 1923).

Playing Santa (1916) was Norman Rockwell's first Christmas cover for the *Saturday Evening Post*. For the painting he explored an end-of-innocence theme, a theme that he revisited throughout his career. *The Discovery*, Rockwell's January 1956 cover painting for the *Post*, depicts a boy's reaction upon discovering a Santa Claus costume in a bedroom dresser drawer. Of the 321 covers Norman Rockwell created for the *Post* in his 47-year career with the publication, *The Discovery* received the most attention and greatest public reaction. The *Post's* readership expressing their concern that the image broke with the wonder and magic of the legend of Santa Claus.

<div align="center">

CHRISTMAS AFTERTHOUGHT

</div>

After a thoughtful, almost painful pause,
Bob sighed, "I'm sorry for old Santy Claus: –
They wuz no Santy Claus, nor couldn't be,
When he wuzist a little boy like me!"

- JAMES WHITCOMB RILEY (American, 1849-1916)

"A Wonderful Lie" appeared in the December 2016 issue of the psychiatry journal *The Lancet*, with researchers arguing that the Santa Claus story leads to distrust in the parent-child relationship, and that the morality of making children believe in such myths should be questioned. Child psychologist Michel Carr-Gregg offered a reply to news.com.au: "For many families, the excitement of leaving stuff out for Santa, watching through the window at night, they're just lovely traditions. It makes Christmas magic and none of (my kids) have every been traumatised, it is part of growing up."

CREDITS: Page 240: Artist - Norman Rockwell (American, 1894-1978) *Playing Santa* (*Saturday Evening Post* - magazine cover, December 9, 1916).

Page 241: Artist - Norman Rockwell (American, 1894-1978), *Happy Hour* (*Red Cross Magazine* - cover, December 1919). *Happy Hour* appeared on the cover of *Elks Magazine* for December 1922.

NOTE: "Why It's OK for Kids To Believe in Santa Claus" (*Psychology Today*, December 5, 2016) by Vanessa LoBue, shared insights on the disadvantages of offering children rewards to motive good behavior. LoBue wrote that the use of Santa Claus or an Elf on the Shelf to promote favorable behavior is not the best of strategies. She reported that she had found no evidence that children are traumatized on learning the truth about Santa Claus nor did she find evidence that it eroded trust in the child-parent relationship.

September 21, 1897 - "We take pleasure in answering at once and thus prominently the communication below, expressing at the same time our great gratification that its faithful author is numbered among the friends of THE SUN: 'Dear Editor: I am 8 years old. Some of my little friends say there is no Santa Claus. Papa says "If you see it in *THE SUN*, it's so". Please tell me the truth: Is there a Santa Claus? Virginia O'Hanlon, 115 West Ninety-Fifth Street.'

VIRGINIA, your little friends are wrong. They have been affected by the skepticism of a skeptical age. They do not believe except they see. They think that nothing can be which is not comprehensible by their little minds. All minds, VIRGINIA, whether they be men's or children's, are little. In this great universe of ours man is a mere insect, an ant. In his intellect, as compared with the boundless world about him, as measured by the intelligence capable of grasping the whole of truth and knowledge.

Yes, VIRGINIA, there is a Santa Claus. He exists as certainly as love and generosity and devotion exist, and you know that they abound and give to your life its highest beauty and joy. Alas! How dreary would the world be if there were no Santa Claus. It would be as dreary as if there were no VIRGINIA. There would be no childlike faith then, no poetry, no romance to make this existence tolerable. We should have no enjoyment, except in sense and sight. The eternal light with which childhood fills the world would be extinguished.

Not believe in Santa Claus! You might well not believe in fairies! You might get your papa to hire men to watch in all chimneys on Christmas Eve to catch Santa Claus, but even if they did not see Santa Claus coming down the chimney, what would that prove? Nobody sees Santa Claus, but that is no sign that there is no Santa Claus. The most real things in the world are those that neither children nor men can see. Did you ever see fairies dancing on the lawn? Of course not, but that's no proof that they are not there. Nobody can conceive or image all the wonders there are unseen and unseeable in the world.

You may tear apart the baby's rattle and see what makes the noise inside, but there is a veil covering the unseen world which not the strongest man, nor even the united strength of all the strongest men that ever lived, could tear apart. Only faith, fancy, poetry, love, romance, can push aside that curtain and view and picture the supernatural beauty and glory beyond. Is it all real? Ah, VIRGINIA, in all this world there is nothing else real and abiding. No Santa Claus! Thank God! He lives, and he lives forever. A thousand years from now, VIRGINIA, nay, ten times ten thousand years from now, he will continue to make glad the heart of childhood."

When asked whether she still believed in Santa Claus a 70-year-old O'Hanlon replied: "Well, of course I do. Everybody wants to know — particularly at Christmastime — that there's some kindly person interested in his well-being. It gives a glow to living. Whether it really is a person or a spirit doesn't really matter very much — does it? Some people say we shouldn't believe in things we can't see. This is most unrealistic. Look at all the nice things

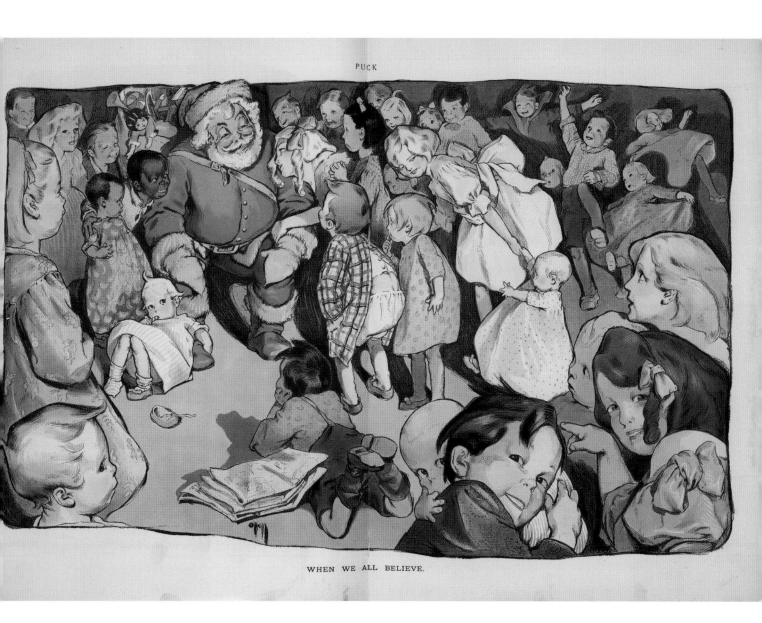

WHEN WE ALL BELIEVE.

CREDIT: Page 243: Artist - Rosie Cecil O'Neill (American, 1874-1944) *When We All Believe*, (*Puck* - magazine centerfold, December 2, 1903).

NOTE: Francis P. Church penned the letter to Virginia O'Hanlon which appeared in the *New York Sun* for September 21, 1897. The letter of reply was printed anonymously. Church had covered the American Civil War as a journalist. He was a self-proclaimed atheist.

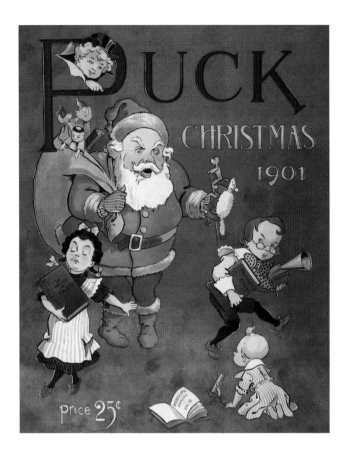

that have happened to me because of Santa Claus." - "Is There A Santa Claus How Child's Letter Inspired 'Yes Virginia Response'" - *Washington Post*, December 22, 2018.

The Polar Express was released in 1985 and has become a Christmas classic. The story tells of a young boy who takes a magical train ride to visit Santa. He is given a magical bell that only those who believe in the spirit of Christmas can hear.

"At one time most of my friends could hear the bell. But as years passed, it fell silent for all of them. Even Sarah found, one Christmas, that she could no longer hear its sweet sound. Though I've grown old, the bell still rings for me . . . as it does for all who truly believe." — Chris, *The Polar Express*, written and illustrated by Chris Van Allsburg (Houghton Mifflin, 1985).

CREDIT: Page 244: *Puck* – magazine, Christmas issue, 1901. (William Randolph Hearst).
Page 245: Artist – Edmund Dulac (French British 1882-1953) *The Snow Queen*, published in *Stories from Hans C. Anderson* (Hodder and Stoughton, London, 1991).

NOTES: O'Neill's *Kewpie* cherub characters debuted for Christmas 1909 and were the most popular cartoon characters in America until Walt Disney's Mickey Mouse arrival in 1928. *Two Christmas Classics,* illustrated by Fritz Kredell. (*Columbia University Press*, New York 1968), includes *Twas The Night* and the letter and reply to *The Sun*.

Auction records for 2001, show the painting *The Snow Queen* with a hammer price of $125,000.00. The caption that appears in the story with the illustration reads: "Many a Winter's night she flies through the streets and peeps in at the windows and then the ice freezes on the panes into wonderful patterns like flowers."

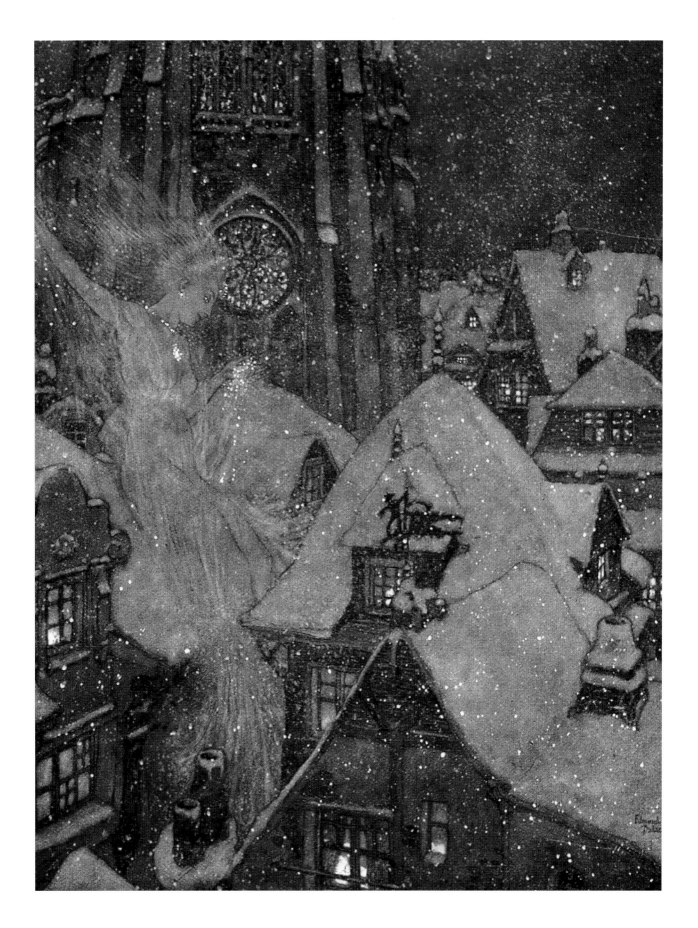

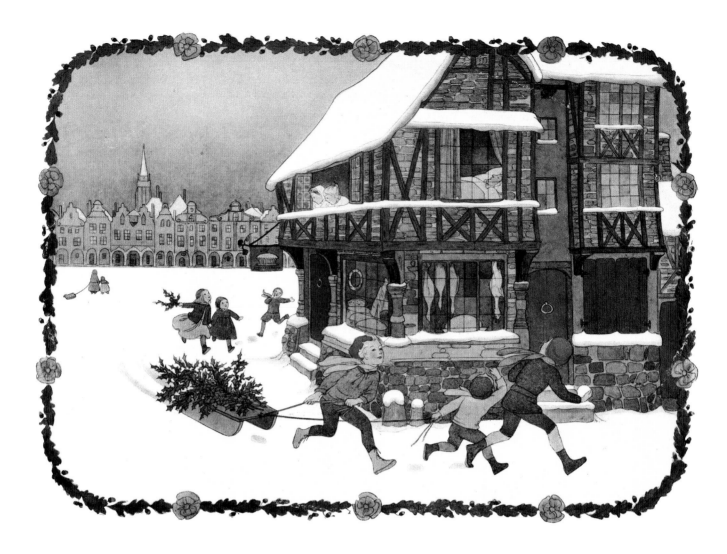

"Are you really alive?" she asks. "I certainly am," replied Santa Claus, "and very busy these days, too." - *Interview with Santa Claus* written by renowned anthropologists Margaret Mead and Rhoda Metraux for *Redbook Magazine* in December 1977 and as a book in 1978. The idea for the interview came to Mead when her three-year-old granddaughter had a flurry of questions for her grandmother after hearing *Twas The Night* read aloud to her.

N.C. Wyeth noted in 1918 that his family carried the illusion of St. Nicholas as far as possible, believing from his own experience as a child that "disillusionment is a myth, providing the parents can always enter into the fairy spirit of Christmas traditions and become, for a while, children themselves." N.C. himself recalls having "straddled the

CREDIT: Page 246: Artist - Hennette Willebeek le Mair (Dutch, 1889-1966). *Little Songs of Long Ago — More Old Nursery Rhymes* (1912). Public Domain.
Page 247: Artist - N.C. Wyeth (American, 1882-1945) *Santa Claus Driving His Sleigh, Judge Magazine* - cover, December 17, 1921. *A Wyeth Family Christmas, Resource Library Magazine*, 2004. Reprinted with permission from the Traditional Fine Art Organization.

roof in the dark morning hours, thumping and stamping, ringing a great loop of bells down the bedroom fireplace chimney and calling in a rumbling voice, and then quickly sliding down the ladder to take my next position inside the house by the fireplace in the big room," and noting "the dazzled faces of the children." Years later, James Wyeth would observe, "Maybe the Wyeth's great overdoing of Christmas is because it's the one time of the year when we don't have to hide the child, hide our unbounded joy, and we can go screeching around, putting holly everywhere and hanging spiders, lots of little animals on windowsills, little men, little scenes, toys everywhere creating this whole different world within our own room." - *A Wyeth Family Christmas* (Excerpt).

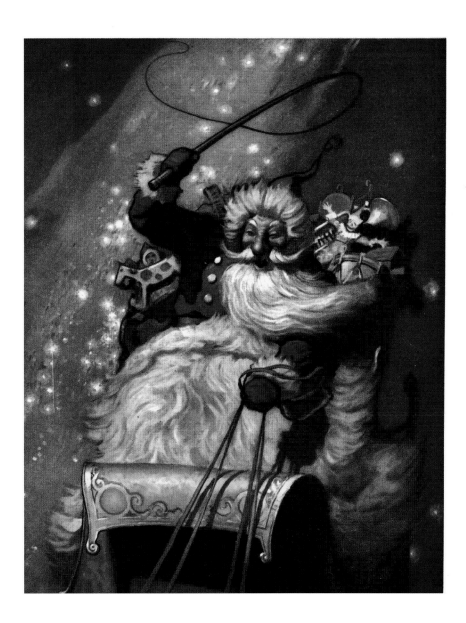

The song, "I Saw Mommy Kissing Santa Claus" was recorded in 1952, performed by a 13-year-old Jimmy Boyd, with music and lyrics created by British songwriter Tommie Connor. The song reached No.1 on the Billboard pop singles chart in December of 1953.

The song's lyrics were criticized by officials of The Roman Catholic Church in Boston who considered the lyrics suggestive of adultery and as a result placed a ban on the song. Boyd met with the officials to defend his song and the ban was subsequently lifted. A movie based on the song aired on television in 2001.

The song "Santa Claus is Comin' To Town", written by J. Fred Coots and Haven Gillespie, was first recorded in 1934, performed by banjoist Harry Reser and his band. "Santa Claus is Coming to Town: He's Gonna Find out Who's Naughty or Nice", is how the song is now known. It has been re-recorded by numerous artists, including by Michael Bublé for Christmas 2011. The concept of reward and punishment continues to be associated with the Saint Nicholas/Santa Claus story through written works, through images created by illustrators, and in songs.

CREDIT: Page 248: Artist – Joseph Christian Leyendecker (German, 1874-American, 1851) *I Saw Mother Kissed Santa*, 1921.

Page 249: Artist – Ronald Lee Anderson (American, 1886-1926). *Christmas Surprise*. Public domain. Front cover of magazine.

NOTES: The carol "Silent Night (Stille Nacht Heilige Nacht)" was first performed in 1818 before attendees at Christmas Eve mass in St. Nicholas Church in Oberndorg, Austria; written by Joseph Mohr and Franz X. Gruber.

The song "Jingle Bells" was written by James Lord Pierpont (American, 1822-1893) in 1851; first published as "The One-Horse Open Sleigh".

Collecting the Poem

Many of the editions featured in this publication are highly sought-after collectibles, and while some of the images were sourced through antiquarian booksellers, others were accessible only through public collections and archives. The American Antiquarian Booksellers Association is a useful resource for individuals interested in collecting the rare early editions.

Nancy H. Marshall started collecting antique glass Christmas tree decorations and gradually her holiday collection grew. "As our four children were born, I also started to purchase inexpensive editions of Clement C. Moore's poem, *The Night Before Christmas*, to put into their stockings "hung by the chimney with care " and to place around the fireplace and other areas of our home during the holidays. For many years, it was more of a haphazard and serendipitous "see it, buy it" method of collecting, but in the early 1980s I became passionate (my family sometimes used the word "obsessed") about acquiring the title." – Nancy H. Marshall, *The Night Before Christmas: A Descriptive Bibliography of Clement Clarke Moore's Immortal Poem*, Oak Knoll Press, New Castle, DE, 2002.

Marshall's bibliography is an indispensable resource for anyone pursuing the enjoyable pastime of collecting *Twas The Night*. In 2005, Marshall donated an estimated one thousand editions of the poem to the *Special Collections Research Center* in the Swem Library, at the College of William and Mary in Williamsburg, VA.

Collectors interested in acquiring original illustrations published in editions of *Twas The Night* are referred to private galleries, art auction houses, and to the American Illustrators Gallery in New York City. The gallery was founded in 1974 by Walter Reed, who made a significant contribution to the appreciation of American book illustration as a collectible art form. The gallery hosts past auction records online and often partners with the National Museum of American Illustration in Newport, RI, in loaning works for public exhibitions. The Norman Rockwell Museum's website is an excellent resource for furthering the study of American illustration, as is a series of online tutorials provided by the Metropolitan Museum of Modern Art in New York, NY.

CREDIT: Page 251: Artist - Jessie Willcox Smith (American, 1863-1935), *The Child: A Calendar/November/December* (Philadelphia: Charles W. Beck, 1903). Commercial lithograph, Sheet: 20 ⅛ x 14 inches Delaware Art Museum, Gift of Mrs. J. Marshall Cole, 1973.

November. ❄ December.

	November	December
Sun	1 8 15 22 29	6 13 20 27
Mon	2 9 16 23 30	7 14 21 28
Tue	3 10 17 24 —	1 8 15 22 29
Wed	4 11 18 25 —	2 9 16 23 30
Thu	5 12 19 26 —	3 10 17 24 31
Fri	6 13 20 27 —	4 11 18 25 —
Sat	7 14 21 28 —	5 12 19 26 —

NOTES: In 2004, C.C.M. was inducted into the Rhode Island Hall of Fame.

25 Catherine Street, Newport, RI, was original parcelled to Henry B. Hazard in 1851; Hazard sold the property to C.C.M., who deeded the property to his daughter Maria on his death in 1863.

In 1960, James Henry Van Alen II acquired the property - with the intent of turning it into a museum in honor of C.C.M. The plan did not come to fruition. Van Alen II wrote a sequel to the poem called *Postscript*. Documentation on poetry readings, hosted by the Van Alen family at the property between 1953 and 1999, are with the *James H. and Candace Van Alen Papers*, RLC.MS.003, Redwood Library and Athenaeum, Newport, RI.

The National Museum of American Illustration, founded in 1998 by Laurence and Judy Cutler, is located at Vernon Court, Newport, RI. The mansion was built for Anna Van Nest Gambrill during the Gilded Age – a term coined by Mark Twain to define the era between the 1870s-1910.

John "Jock" Elliott (American, 1921-2005), acquired his collection of over three thousand Christmas related books, illustrations, pamphlets, and ephemera, following the completion of his service in W.W.II, and throughout his career as a top executive with Ogilvy & Mather. Works in Elliott's collection included an illuminated leaf of *The Adoration of the Magi* from a *Book of Hours* (1430-1450), and a copy of the *Troy Sentinel* for December 23, 1823. Elliott authored, *A Ha! Christmas, An Exhibition of Jock Elliott's Christmas Books* (1999) and *Inventing Christmas, How Our Holiday Came to Be* (2001). Jock Elliott died in 2005. Items from his collection were offered by Sotheby's in New York in December of 2006.

Betsy Beinecke was one of the earliest collectors of American literature for children. Over a thirty-five-year period, which began in the 1970s, Beinecke sought out rare children's books, related manuscripts, and drawings. A feature of the Beinecke collection is original illustration. Artists F.O.C. Darley, W.W. Denslow,

Howard Pyle, Maxfield Parrish, and Maurice Sendak are represented along with many others. One of the earliest works in the collection is Cotton Mather's *Address to Old Men, and Young Men, and Little Children* (Boston, 1690). A copy of the 1821 publication *The Children's Friend*, is in the collection and is one of only two copies known to exist. Beinecke donated her collection to the *Beinecke Rare Book and Manuscript Library of Yale University*. An obituary notice, written for the American Antiquarian Society on Betsy Beinecke's passing, quotes the collector as having said:

> "My underlying scheme is to present historically the books American children read – from the beginning to the present day. These books were not always the ones intended for them – but somehow, they knew better and from their nursery library came the genesis of the American spirit. There is, in fact, no better guide to the history and development of any country than its literature for children."

The Anne Lyon Haight Collection of A Visit From St. Nicholas, was initiated by Anne L. Haight (American, 1891-1977) in the 1930s. The collection is a near complete representation of the early editions of the poem. In 1982, Haight's family donated four hundred editions of *Twas The Night* to the Carnegie Mellon Hunt Library at Carnegie Mellon University in Pittsburgh, PA.

The Barbara Loftus Perrone Collection of hundreds of twentieth century and early editions is held at the Francis Harvey Green Library at West Chester University, in West Chester, PA.

CREDITS: Artist – Unidentified, *The Legend of the Mistletoe* (*Harper's New Monthly Magazine*, January, 1872).
Page 255: Artist -William Wallace Denslow (American, 1856-1915). *Denslow's Mother Goose*, (McClure, Phillips, 1901).
The American Antiquarian Society obituary for Barbara Beinecke was written by Justin G. Schiller in 2004.

NOTE: *The Wonderful Wizard of Oz*, written by Baum in 1900 was originally illustrated by W.W. Denslow.
Anne L. Haight was an author/essayist. She was interested in aviation and joined pilot Charles A. Lindbergh on the first passenger trans-Atlantic flight in 1939.

NOTE: *Santa and Scouts in Snow* was published on the cover of *Boys' Life* in December 1913. It was the first published illustration of Santa Claus by Norman Rockwell. There are dozens of paintings by Norman Rockwell of Santa Claus, *Deery Santa Claus* painted for the *Hanska Herald* for December 16, 1921, is another example of an early depiction of the character by Rockwell.

The American Antiquarian Society was founded in 1812. The society's collection includes the 1849 edition of *Twas The Night*, illustrated by Theodore Boyd. The only other known copy is with the New York Fifth Avenue Library.

Significant collections of the poem are held at the University of North Carolina Chapel Hill Libraries; Baldwin Library of Historical Children's Literature in the Department of Special Collections at the University of Florida's George A. Smathers Libraries; The New York Historical Society; The Museum of the City of New York; General Theological Society; The New York Public Library; and The Morgan Library & Museum, of New York, NY, The Library of Congress, Washington, D.C.; The Troy Public Library of Troy NY; and with The American Antiquarian Society in Worchester, MA.

Publications bearing the signature of C.C.M. are of particular interest to collectors of the poem. He is known to have signed his name with the initial L or as C.C.M., to write it as Clement Clarke Moore, C.C. Moore, and as Clement C. Moore; the latter being the way he signed four hand-written copies of the poem. Ten copies of *Poems* (1844) have been located to date - several are inscribed by C.C.M.

Numerous images in this publication were discovered in newspapers and magazines that had been acquired for a particular work. "The Wonders of Santa Claus", *Harper's Weekly*, December 26, 1957 was discovered in this way. Building a collection of the poem based on vintage magazines can be both an affordable entry point to the world of collecting, and rewarding in terms of images and content.

The United States Postal Service has issued thirty stamps featuring Santa Claus. In 1972, a series of stamps was designed by Steven Dohanas, inscribed with the words *Twas The Night Before Christmas*. For a series in 2018, five stamps were issued with reprinted images of the classic Coca-Cola advertising images originally designed by artist Hadden Sundblom. In 2021, 400 million stamps

were issued of a series of four images produced from original artwork designed by Brad Woodard and entitled, *A Visit From St. Nicholas*. There has been a long-standing USPS policy that disallows the depiction of smoking on the stamps they issue.

In 1856, the residents of Santa Fe, Indiana discovered that the name of their town would have to be changed to allow them to operate a post office. According to local folklore, a meeting was held to discuss the new name. With the meeting underway a door suddenly flew open in the hall and the tinkling of jingle bells could be heard at which time a child cried out, "It's Santa Claus!" The town had found a new name. Attractions opened in Santa Claus in 1935, followed by *Santa Claus Land* in 1946. The Santa Claus post office continues to accept letters addressed to Santa Claus at 45 North Kringle Place, Santa Claus, Indiana, 47579. Children who write are assured of a response.

CREDIT: Top: Artist – William Balfour-Ker (Canadian,1877-1918). *Life Magazine* cover, December 22, 1904.
Bottom: Artist – Louis Rhead (English, 1857-1926 American). *The Bookman*, Christmas number, 1895. Library of Congress.

NOTES: *Beeton's Christmas Annual* for 1887 sold at a Sotheby's auction in 2007 for $156,000 USD. This publication was the first to publish the writing of Arthur Doyle *A Study of Scarlett*.

Hallmark Cards Inc., founded in 1910 by Joyce Hall released their first Christmas card in 1917. The company grew into the largest global greeting card publisher. 2023 marked the 50th anniversary of the Keepsake Ornament Collection. *Twas The Night* was featured in 1997. The Hallmark Chanel (2001) and Hallmark Movies & Mysteries (2004) have released hundreds of holiday movies so successfully that they are credited with spurring a new film genre.

Benjamin Bradley, known as "Mr. Christmas", owns thousands of Christmas items, antiques and collectibles. *Holiday Home Makeover with Mr. Christmas*, hosted by Bradley aired on Netflix in 2020.

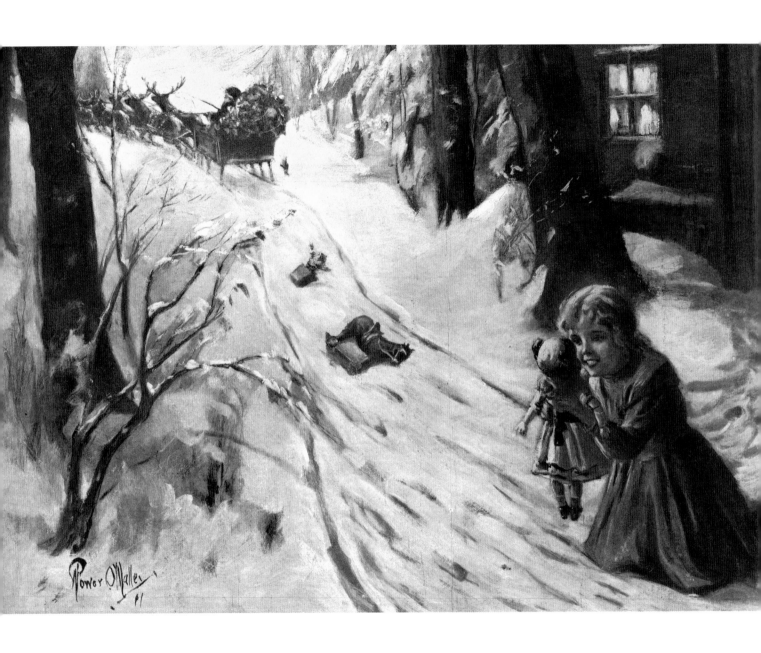

CREDIT: Artist – Power O'Malley (Irish, 1877-1946 America) *The Passer-by, Harper's Weekly*, (Harper and Brothers, NY. - December 16, 1911).

Vintage illustrations associated with *Twas The Night* from the second half of the 1850s to the mid 1920s are the most sought after by collectors of the poem, however many editions of subsequent decades are also of interest. The following illustrators are but a few of the hundreds of illustrators who produced popular editions from the 1930's onward.

Arthur Rackham (British,1867-1939) in 1931 illustrated a limited edition for George G. Harrap & Co. Ltd, London, with 275 copies made available for both the British and American market. The edition features four tipped in color plates designed by Rackham. The book was published in various editions by Harrap throughout the 1930s. J. B. Lippincott Co., of Philadelphia also published the Rackham edition in 1931 and subsequent editions.

Fern Peat (American, 1893-1971) illustrated the poem in 1932 for the Saalfield Publishing Company in Akron, Ohio. Her work reflected the American Art Deco movement. Peat illustrated hundreds of books and magazines. Her first illustrations were done for an edition of *Mother Goose*. From 1933 to 1955 she edited and provided cover illustration for *Children's Play Mate Magazine*, published in Cleveland, Ohio. The illustrations for this edition of the poem were also used to create a series of puzzles.

Ilse Bischoff (American, 1901-1990) provided eight woodcuts for an edition published by Holiday House of NY, in 1937. The book *Drive Slowly — Six Dogs* published by Viking Press, New York in 1953 is Bischoff's best-known work.

Everett Shinn (American, 1876-1953) illustrated *The Everett Shinn Illustrated Edition of The Night Before Christmas* for the John C. Winston Company, of Philadelphia in 1942. Shinn illustrated *A Christmas Carol* in 1938. Jock Elliott chose an illustration by Shinn for the cover of *A Ha! Christmas, An Exhibition of Jock Elliott's Christmas Books* (1999).

Cornelius Hugh DeWitt (German, 1905-1995 American) illustrated the poem for the *Little Golden Book* series for Simon and Schuster of NY, in 1946. The *Little Golden Book* series appeared in 1942. The eighth book in the series *The Poky Little Puppy*, remains one of the top selling children's titles in American publishing history. In 1949, Corinne Malvern

illustrated *Twas The Night* for the series, followed by an edition in 1955 by Eloise M. Wilkin (American, 1904-1987).

Florence Sarah Winship (American, 1900-1987) illustrated a distinctive die-cut and flocked edition of the poem for the Whitman Publishing Company of Wisconsin in 1954.

Gyo Fujikawa (American, 1908-1998) illustrated an edition for Grosset & Dunlop, NY, in 1961. *Babies* published in 1957, written and illustrated by Fujikawa, was one of the first children's books to integrate multi-racial characters in illustrations, and Fujikawa's work for the poem four years later reflected this feature of her work.

Tasha Tudor (American, 1915-2008) used the backdrop of her rural home setting in Vermont for the illustrations she produced for Achille J. St. Onge, of Worcester, Mass in 1962. The 1962 edition was limited to 1200 copies and was produced as a miniature book. In 1975, she produced new illustrations of the poem for Rand McNally & Company of Chicago, IL.

In 1962, illustrations of the poem by Grandma Moses (American, 1860-1961) were published by Random House, NY, and in the December issue of *Good Housekeeping Magazine*. Moses was a member of the Society of Mayflower Descendants and Daughters of the American Revolution. Norman Rockwell placed her likeness in his painting *Christmas Homecoming*, published on the Christmas 1948 cover of *Saturday Evening Post*.

Holly Hobbie (American, 1944) illustrated the poem for American Greetings Corporation, Cleveland, OH in 1970 and in 2013 for Little Brown & Company.

Hobbie wrote an introduction to her 2013 edition: "The prospect of illustrating a long-revered classic is intimidating. You must honor the timeless quality of the piece while somehow making it your own... Just what should this jolly old elf look like ? Should the setting be rural or urban? Do the interiors denote a contemporary or more traditional world? My home environment helped me resolve such issues Frequently I was transported back to the Christmases of my childhood, as well as those charmed occasions with my own young family. These memories have been my inspiration." (Excerpt).

Scott Gustafson illustrated the poem in 1985 for Alfred A. Knopf, NY, and is well known for his illustrations of classic fairy tales, and is also one of the leading American illustrators today.

Greg Churchill created a pop-up book for Hallmark Cards Inc., NJ, in 1987.

Jan Brett illustrated the poem for G.P. Putnam's Sons of NY, in 1998. The edition was also published by Scholastic, Inc. Brett illustrated other Christmas titles including *Christmas Trolls* in 1993, and *The Wild Christmas Reindeer* (1990), *The Twelve Days of Christmas* (1986), *Who's That Knocking on Christmas Eve?* (2002), *Home for Christmas* (2011), *The Animal's Santa* (2014), *Gingerbread Christmas* (2016).

Robert Sabuda's *Night before Christmas* Pop-Up for Little Simon in 2002 applied intricate paper engineering to the production of the book. Sabuda produced *The Christmas Alphabet*

(2004) and *The 12 Days of Christmas* (2006) also as popup books. Michael Haque illustrated a pop-up edition of the poem *The Night Before Christmas* published in 1981 by Henry Holt & Company, NY, designed by John Stejan, paper engineered by James R. Diaz.

Elena Almazova and Vitaly Shvarov illustrated *Twas The Night Before Christmas: Edited by Santa Claus for the Benefit of Children of the 21st Century* in 2012 for Grafton and Scratch, Canada. Published in French - *C'etait La Veille De Noel*, and Spanish - *Era la Vispera de Navidad*, the editions have read-along functions, with interactive, enhanced functions in the eBook/iBook editions. The publications are smoke/pipe-free.

Robert Ingpen (Australian, 1936) illustrated the poem with an elfin character for Templar Publishing, UK in 2014. The artist illustrated *A Christmas Carol* in 2018.

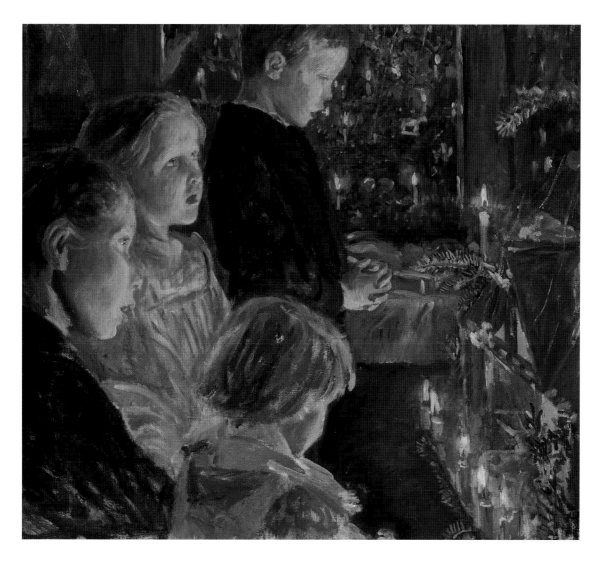

CREDIT: Artist - Leopold Klackreuth (German, 1855-1928) *Children By The Christmas Tree* (1901).

CREDIT: Artist - Ed Wheeler (American) *Santa Classics, The Night Watch*, 2012 Copyright Ed Wheeler. (Inspired by Rembrant van Rijn, *The Night Watch* (1642).

Index

In 2022, the St. Nicholas Church and National Shrine opened in Manhattan as a functioning church, with a non-denominational, ecumenical remembrance room, and a shrine for all to visit to honor those who died in the attack of 9/11. The original 1916 church at 155 Cedar Street, NY, had been destroyed in the attack on the World Trade Center. Pentelic marble covers the exterior of the new construction; the stone used to build the Parthenon in the 5ᵗʰ century. At the consecration on July 4, 2022, the right hand of St. Nicholas was placed within the altar table.

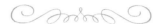

ACKNOWLEDGMENTS

Dedicated to Taylor Jakubke and Maxine Jakubke.

With appreciation to Margaret Gobie, Willa Anderson, Matthew Lanni, Holly Menzie, Curtis Smith, Ryan Hyman, Peter Hayes, Jennifer Longon, Karen King, Leah Grandy, Ronald McColl, Mary Ann Antley, David Paul Kirkpatrick, Scott Norsworthy, Kathy T. Sheehan, Steve Silverman.
A very special thank you to book designer Elisa Gutiérrez.

· · ·

LIBRARY AND ARCHIVES CANADA CATALOGUING IN PUBLICATION

Title: Twas the night : the art and history of the classic Christmas poem / Pamela McColl.
Names: McColl, Pamela, 1958- author.
Description: Includes index.
Identifiers: Canadiana 20210387653 | ISBN 9781927979303 (hardcover)
Subjects: LCSH: Moore, Clement Clarke, 1779-1863. Night before Christmas. | LCSH: Christmas—History. | LCSH: Christmas in art. | LCSH: Santa Claus.
Classification: LCC PS2429.M5 Z66 2022 | DDC 813/.4—dc23

Distributed by Baker & Taylor Publisher Services, Ashland, Ohio.
twasthenightbook.com
Email twas4kids@gmail.com

Printed in South Korea by Sung in America.

10 9 8 7 6 5 4 3 2 1

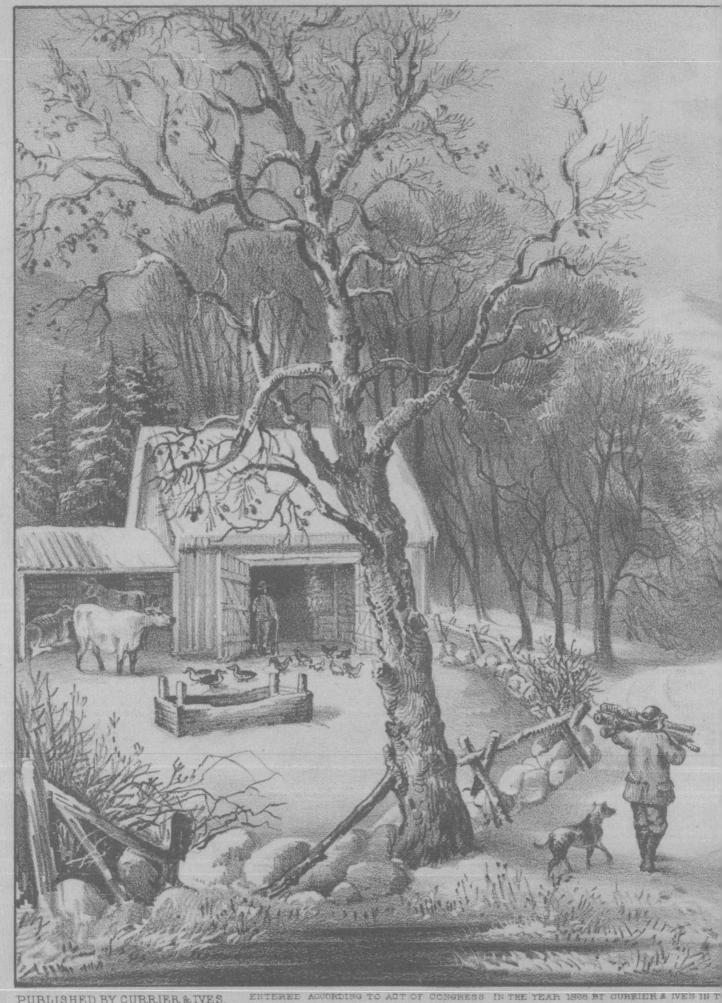